This publication is openly available online thanks to generous support from Arcadia, a charitable fund of Lisbet Rausing and Peter Baldwin.

The publisher and the University of California Press Foundation gratefully acknowledge the generous support of the Sonia H. Evers Endowment Fund in Renaissance Studies.

Renaissance Futurities

This book is freely available in an open access edition thanks to TOME (Toward an Open Monograph Ecosystem)—a collaboration of the Association of American Universities, the Association of University Presses, and the Association of Research Libraries—and the generous support of the UCLA Library Fund. Learn more at the TOME website, available at: openmonographs.org.

Renaissance Futurities

Science, Art, Invention

———

Edited by

Charlene Villaseñor Black and Mari-Tere Álvarez

UNIVERSITY OF CALIFORNIA PRESS

University of California Press
Oakland, California

Suggested citation: Villaseñor Black, C. and Álvarez, M-T. (eds.)
Renaissance Futurities: Science, Art, Invention. Oakland: University of
California Press, 2020. DOI: https://doi.org/10.1525/luminos.79

Cataloging-in-Publication Data is on file at the Library of Congress.

Library of Congress Cataloging-in-Publication Data

ISBN 978–0–520–29698–5 (pbk. : alk. paper)
ISBN 978–0–520–96951–3 (ebook)

29 28 27 26 25 24 23 22 21 20
10 9 8 7 6 5 4 3 2 1

CONTENTS

ILLUSTRATIONS

ACKNOWLEDGMENTS

Many people and institutions have helped us bring this volume to fruition. It is a pleasure to take this moment to extend our thanks.

We initially explored these ideas about art and futurity at two conferences, one supported by UCLA's Center for Medieval and Renaissance Studies in November 2016, and a summer colloquium at the Château de la Bretesche in Missilac, France, in July 2017. The Missilac colloquium took place thanks to the generous support of a Borchard Foundation Summer Colloquium Grant. We were delighted to meet the heads of the Borchard Foundation, Anna Beling, PhD, and Kristen Beling, DDS, who shared their visionary leadership in humanities scholarship with us as well as their enthusiasm for French culture. Without this institutional support, we could not have produced this study.

Our meeting during the summer colloquium in a picturesque, fifteenth-century chateau was a unique opportunity to create dialogue and transdisciplinary points of connection. We carefully selected participants from a wide range of fields in the humanities, sciences, and from the museum world, all thought leaders in their respective disciplines. The summer colloquium participants, their work, and contributions at the symposium contributed greatly to the formation of this volume. We wholeheartedly thank the following colloquium participants: Roger Malina, Professor of Arts and Technology and Professor of Physics at the University of Texas at Dallas and Editor Emeritus of the MIT journal *Leonardo*; Rocio Bruquetas, PhD, Head of Conservation, Museo de Américas; Vanda Vitali, Director of Canadian Museum Association; Sylvana Barrett, artist and authority on Old Master materials and technique; Cathy Carpenter, producer of contemporary art-

ists; cardiologist Francis C. Wells and Morteza Gharib, Professor of Aeronautics and Bio-Inspired Engineering at CalTech; François Delarozière, director of the artist-collective *Les Machines de l'île* in Nantes, France; as well as historian Agnès Marcetteau-Paul, head of Libraries in Nantes and the Jules Verne Museum, who shared with us Leonardo da Vinci notebook fragments held in the city's library. We especially wish to mention the late physicist and scientific director of "La Caixa" Foundation Jorge Wagensberg who, although too sick to travel, still contributed a paper to be read at the colloquium.

The editors would also like to thank UC Press editor Nadine Little for her encouragement. The anonymous peer reviewers provided generous and thoughtful suggestions, for which we are deeply grateful. We are grateful to our intrepid copy editor, Martha Groves.

Thanks in no small part to generous grants from the Arcadia Foundation for Open Access and the Sonia H. Evers Endowment Fund in Renaissance Studies, as well as support from UC Press and UCLA, this volume will be available via open access, thus disseminating scholarship to the widest possible audience. In this manner, we hope to ensure that the fruits of the contributors' labors will generate new thinking for future generations to come.

The Future is Now

Reflections on Art, Science, Futurity

Charlene Villaseñor Black
Mari-Tere Álvarez

What can I see more than I have already seen?

—Sancho Panza

Thou hast seen nothing yet.

—Don Quixote

—MIGUEL DE CERVANTES, *DON QUIXOTE DE LA MANCHA*, CHAPTER 11,
BOOK 1, PART 1 (1605)[1]

The Renaissance was a period defined, one could argue, by visions of the future. Petrarch's *Letter to Posterity* (ca. 1372) and Dante's *Divine Comedy* (ca. 1308–20) represent early manifestations of this concern with the future, fame, and posterity, followed by Renaissance historian and humanist Leonardo Bruni's histories and biographies of the 1440s and Giorgio Vasari's celebrated *Lives of the Most Excellent Painters, Sculptors, and Architects* of 1550. At the same time, European explorers, merchants, soldiers, and missionaries traversed the globe in search of new lands to conquer, new natural resources to acquire, and new souls to convert to Christianity. Like Renaissance humanists, they, too, were fueled by visions of the future, coupled with imperial ambition. The Renaissance thus gave rise to the Scientific Revolution and the greatest cultural flowering in the West since ancient times, along with European imperialism. Such ambition inspired ingenuity.

This book focuses on the intersection of Renaissance art, ingenuity, and futurity. The essays represent a fertile variety of fields—art history, literature studies, social history, the history of science and technology, the history of medicine, intellectual history, and material science studies. The authors are scholars in the

humanities, sciences, social sciences, and the arts. Our goal in these essays is to examine the connections among the new science, artistic rebirth, and European imperialism in the overlapping worlds of science, technology, and art, with the ultimate objective of transcending disciplinary specialties to forge new, more productive dialectical discourses.

The topic of Renaissance art and science is not entirely new, having emerged in the 1980s and 1990s with the advent of interdisciplinary studies. At that time, a number of symposia and resulting publications began discussion of the interactions between science and the arts from the Renaissance to the twentieth century.[2] In the 1980s, the journal *Leonardo* published series of bibliographies on the general topic of science and the arts.[3] A 1995 exhibition in London examined connections between art and medicine, putting historical medical devices in dialogue with the work of contemporary art.[4] The essays in *Renaissance Futurities,* in contrast to these earlier publications, contextualize the history of art and science in the specific historical, political, and artistic moment of the Renaissance, supplemented by significant new primary source research.

One scholar, in particular, has shaped the study of the topic at hand: Martin Kemp, the leading authority on science and art in the Renaissance and a major expert on Leonardo da Vinci. Kemp has training in both art history and natural science. An early and influential text is his 1990 study of optics, *The Science of Art: Optical Themes in Western Art from Brunelleschi to Seurat,* which focuses on optics and one-point perspective.[5] In a more recent 2006 publication, Kemp examines intuition, a subject also broached in an essay in this volume by a scientist, a medical doctor, and an art historian (Gharib, Wells, Álvarez). In *Seen/Unseen: Art, Science, and Intuition from Leonardo to the Hubble Telescope,* Kemp examines how scientists and artists visualize and represent the world, from Renaissance Italy to contemporary photography.[6] In a recent publication assembled to honor the illustrious Kemp's career, Assimina Kaniari and Marina Wallace collected essays also focused on intuition. Various authors theorize how structural intuition, a concept that Kemp first articulated, links the way scientists and artists think.[7] Kemp's many publications have stimulated much new research and have been formative for the scholarship in this volume.[8] Inspired by his foundational work, authors in *Renaissance Futurities* look concretely at the interactions between art and science; they ponder specific inventions, in conjunction with Renaissance notions of futurity and new theories of temporality.

The work in this volume also builds on the scholarship linking the emergence of Early Modern science to craftsmen, workshop practices, and the artist-engineer. Key foundational studies include investigations by Viennese historian Edgar Zilsel (1891–1944) and Italian philosopher Paolo Rossi Monti (1923–2012).[9] In 1985, Katharine Park highlighted the importance of artisans in the emergence of medicine in early Renaissance Florence.[10] In 1994, William Eamon, one of the contributors to *Renaissance Futurities,* published *Science and the Secrets of Nature,* docu-

menting the emergence of methods for scientific experimentation among artisanal craftsmen.[11] More recently, Pamela H. Smith proposed "artisan epistemology" as a foundation of Early Modern science, a way of understanding the world based on practice, not theory. She describes the important role played by artisans and their workshops, who, as they created new art objects, developed new technologies through experimentation.[12]

Pamela H. Smith's later work engages the material turn in the humanities, arguing for the importance of transdisciplinary work that brings together the history of science and the history of art.[13] Other scholars whose work lies at this intersection include Sven Dupré and Alex Maar, currently involved in a project investigating Early Modern art, science, and ingenuity.[14] Volume contributor Claire Farago addresses this same intersection—between artists' workshop practice, the new science, and ingenuity—in the concluding chapter. Finally, a great deal of new research focusing on the materiality of artworks, arising from technical art history, brings together art historians, conservation scientists, and museum curators.[15]

Recent developments in the history of science in Spain and the Iberian empire have also been fundamental to this volume. The earliest literature tracing the emergence of the Scientific Revolution in Europe, from 1543, the year that Copernicus published *De revolutionibus orbium coelestium* (*On the Revolution of the Heavenly Spheres*), to the Enlightenment, completely neglected Spain and its empire, due to the "Black Legend." According to Eamon and others, these negative stereotypes, dating to the colonial era and traceable to imperial rivals, such as England, portrayed Spain as backward and repressive.[16] A flurry of new scholarship, much of it produced after the 1992 quincentenary, contests this rhetoric by demonstrating the importance of scientific developments in Spain and its vast imperial empire during the Scientific Revolution, from colonial contact to the Enlightenment. Key historians include Eamon, Paula S. De Vos, Jorge Cañizares-Esguerra, and Daniela Bleichmar.[17]

Conceptions of futurity are central to this undertaking. Our concern is inspired by the Renaissance itself, with its interest in fame and posterity. By "futurity" we denote theorizations of the future, prospective events, as well as an attitude or mode of thinking about the world. The term first appears in Shakespeare in 1603, in *The Tragedy of Othello, the Moor of Venice*, as Álvarez points out in her essay. Temporality has been an important theme in recent works in Renaissance studies, such as Alexander Nagel and Christopher Wood's *Anachronic Renaissance*, which influenced several of the essays. That groundbreaking book suggests that Renaissance artworks are "anachronic"; that is, they reflect temporal instability, because they encode references to Europe's multiple pasts, an example of what Nagel and Wood describe as time "folding" over on itself.[18] Jonathan Goldberg's suggestion that Europe had multiple histories, an idea influenced by queer theory, opens up standard Renaissance histories to new interpretations.[19] As art historian Keith Moxey contends in his recent book *Visual Time*: "[H]istorical time is heterochronous rather than monochronous."[20]

Futurity is a mode of thinking bound up with European conquest and imperialism, a stance adopted in several of the essays (Álvarez and Eamon, for example) and in much decolonial thinking. We understand "decolonize" as drawn from "decolonial," as opposed to colonial, or coloniality, or "the coloniality of power," to use a phrase employed by Aníbal Quijano in 2000 and Walter Mignolo in 2011.[21] Decolonial approaches challenge Eurocentrism, and Eurocentric notions of universality; they make visible Foucault's history of power as they perform what Mignolo calls "epistemic disobedience."[22] Mignolo's "epistemic disobedience" is elaborated from postcolonial theorist Gayatri Chakravorty Spivak's "epistemic violence."[23] According to Spivak (and others, such as Edward Said), the subaltern, defined as former colonial subjects, are othered and silenced by Eurocentric discourse, the latter cloaked as universalizing. Mignolo's call for epistemic disobedience is particularly useful to unsettle art historical assumptions that some art is of higher quality than other art or that we should respect national and chronological borders. His approach thus encourages intellectual rebellion against accepted discourse about the Renaissance.[24] This gives rise to important questions: Which histories are authorized, and who is empowered to narrate them?

Furthermore, looking at the past and how we describe it also affects our future. Futurity, as distinct from the future, "will always retain the essential structure of a promise and as that which can only arrive as such, as to come," according to Jacques Derrida, an idea that frames co-editor Álvarez's essay.[25] Literary scholar Amir Eshel writes that "[f]uturity marks the potential of literature to widen the language and to expand the pool of idioms we employ in making sense of what has occurred while imagining whom we may become. . . . Futurity marks literature's ability to raise, via engagement with the past, political and ethical dilemmas crucial for the human future. In turning to the past, the works here keep open the prospect of a better tomorrow."[26] Our conceptualization of "futurity" is also conditioned by theorizing in the realm of ethnic studies, especially recent work on Afro and Chicana/o/x futurisms.[27] Futurist scholars, writers, activists, and artists in ethnic studies posit new, more just futures for people of color, alternative futurisms inspired by non-Western notions of temporality, as they simultaneously question Eurocentric constructions of history, a topic addressed by de Armas in chapter 4 and co-editor Villaseñor Black in the conclusion to chapter 7. A recent book by Matthew D. O'Hara takes notions of futurity back to colonial Mexico, employing archival documents to attempt to reconstruct a notion of "futuremaking" in colonial times.[28]

The chapters in *Renaissance Futurities* are rich and varied, at the cutting edge of the humanities, medical humanities, scientific discovery, and *avant garde* artistic expression. Authors examine developments in Renaissance art and science in Spain and the Americas, England, the Netherlands, Germany, France, Italy, China, and the Middle East between the fifteenth and mid-seventeenth centuries. By including the work of humanities scholars and scientists from Europe and the

United States, we arrive at parallax understanding of art and science in the Renaissance. Comparative and transdisciplinary analysis of primary sources such as artists' notebooks, royal correspondence, and scientific treatises has already revealed the clear links among art, science, global trade, and even daily life at the time.

In chapter 1, "Moon Shot: From Renaissance Imagination to Modern Reality," volume co-editor Mari-Tere Álvarez demonstrates the connections between European imperialism and futurity in her examination of Early Modern tales of space travel. Employing visual art—such as maps and medals, as well as a play by John Lyly, a novel by Juan Maldonado, and a satirical poem about the Jesuits by John Donne—Álvarez draws attention to Early Modern fantasies of space travel and their connection to Spanish conquests in the Americas.

In chapter 2, "Machines in the Garden," Jessica Riskin contrasts twenty-first-century anxieties about machines' potential to encroach upon or replicate human consciousness with Renaissance fascination with automata, machines that imitated human beings. Through copious historical data, she documents the existence throughout Europe of animated figures of Christ on the cross, flying angels, soaring Virgin Marys; lifelike mechanical animals, dragons, birds, nymphs, satyrs, and mythological figures; and elaborate waterworks on palace grounds designed to trick and entertain. For example, Leonardo da Vinci created an automaton lion in 1515; Juanelo Turriano designed mechanical automata to amuse Charles V; and Tommaso Francini delighted the young Louis XIII with elaborate hydraulics in the gardens at Saint-Germain-en-Laye. The Catholic Church was the major patron of these mechanical creations, and not surprisingly, automata played a role in conversion. Riskin also examines the Early Modern proliferation of texts about creating automata, including *Le diverse e artificiose machine* (1588) by Agostino Ramelli and Salomon de Caus's *Les raisons des forces mouvantes avec diverses machines tant utiles que plaisantes* of 1615.

In chapter 3, "Inventing Interfaces: Camillo's Memory Theater and the Renaissance of Human-Computer Interaction," Peter Matussek addresses Renaissance ideas about memory theaters and their links to current developments in human-computer interaction, or HCI. He traces strategies employed today back to Giulio Camillo's memory theater, described in Camillo's text *L'idea del theatro*, posthumously published in 1554, as well as to Robert Fludd's *Ars Memoriae* of 1619. As in computer interfaces today, Camillo's memory theater called upon spectators to actively acquire and recall knowledge. This required viewers to combine *ars memoria*, a set of strategies derived from Neoplatonic thought, with the newer *ars combinatoria*, which, Matussek suggests, is the current model for twenty-first-century HCI. He additionally connects this fascination with memory theaters to new media-artists, including Robert Edgar, Bill Viola, Kate Robinson, and Ronald T. Simon. Although Camillo's theater does not actually survive, Matussek attempts to re-create it, using surviving textual descriptions, the architecture itself, and a painting by Titian, his *Allegory of Prudence*, which once adorned the space.

Chapter 4, "Futurities, Empire, and Censorship: Cervantes in Conversation with Ovid and Orwell," by Frederick A. de Armas, addresses censorship, another current concern, and links it, also, to the Renaissance, in a close examination of Cervantes's masterpiece, *Don Quixote de la Mancha*. *Don Quixote*, the first modern novel, was published in 1605 and 1615, and de Armas reads it in dialogue with Ovid and George Orwell. According to de Armas, "latent futurity" was central to Spain's Golden Age, evident in the country's imperial ambitions, and central to Cervantes's novel. His consideration of the mechanisms of imperial control in the Spanish Empire lead to close analysis of self-censorship, or steganography, in the novel; these were tactics to conceal and hide, including whimsy, ugliness, and fragmentation, all strategies employed to camouflage. The figure of Don Quixote, the failed, impossible knight who fashions his own future, prompts reconsideration of his figure from the viewpoint of queer temporality. Finally, de Armas outlines strategies of resistance as seen in *Don Quixote* as inspiration in our current political climate.

Three of the authors—a medical doctor, a professor of aeronautics, and an art historian—are engaged in projects centered on Leonardo da Vinci and Renaissance futurities; their research forms the core of chapter 5, "Anticipating the Future: Leonardo's Unpublished Anatomical and Mathematical Observations." The first part closely examines the artist's anatomical drawings and their prediction of future developments in medicine; the second investigates Leonardo's mathematical equations and their anticipatory relationship to differential calculus. Francis Wells carefully studies Leonardo's drawings of the heart to demonstrate their prescient nature. Many of the discoveries notated in drawings and accompanying texts would not be known again until the twentieth century. Leonardo, for example, wrote the first description of coronary atherosclerosis, in 1507–8. His dissections reveal the heart's internal structures, including how the heart valves work, and the connections between the lungs and heart. Wells recreated the dissections performed to confirm Leonardo's findings. The scientific approach of Leonardo's drawings, which showed the artist experimenting with possibilities, anticipates modern scientific method, by presenting evidence of the tight links between art and science in the Renaissance. In the second half of chapter 5, focused on Leonardo's mathematical equations, Morteza Gharib builds on Martin Kemp's work on analogy in Kemp's *Seen/Unseen* as a tool to decipher natural laws, looking specifically at Leonardo's investigations into ballistic trajectories and the law of gravity. By closely studying Leonardo's drawings and annotations in his notebooks, including the Arundel manuscript and the example in Madrid, Gharib demonstrates Leonardo's understanding of natural laws purportedly not discovered until the seventeenth century. His trajectories and profiles of falling objects illustrate the equations of motion described in the seventeenth century by René Descartes, Isaac Newton, and Gottfried Leibniz. His drawings of parabolas in the *Codex Madrid* illustrate his experiments try-

ing to deduce the law of gravity. One drawing seems to describe "the parabolic nature of ballistic trajectories," a discovery ascribed to Galileo.

Chapter 6, "Medicine as a Hunt: Searching for the Secrets of the New World," by William Eamon, suggests that Early Modern Spanish imperialism fostered the creation of a new model for the future of science and medicine—the hunt, or *venatio*, for nature's secrets. This chapter assesses the various expeditions to the Americas, such as King Philip II's sponsorship of court physician Francisco Hernández to travel there to identify and collect botanical specimens, described by Eamon as "the most ambitious organized hunt for new medicinal plants ever attempted." This chapter examines a number of other important figures: Gonzalo Fernández de Oviedo; Jesuits José de Acosta, Bernabé Cobo, Juan Eusebio Nieremberg, and Athanasius Kircher; plus Giambattista Della Porta, Sir Francis Bacon, and Nicolás Monardes. Building upon the previous work of Carlo Ginzburg, Eamon suggests that "the hunt" encapsulates a new evidential and conjectural paradigm, one that rejects previous Platonic models reliant on ancient authorities. Thus, it fosters the creation of a radical new future for medicine. The model of the "hunt" is still much in use in medical research: Consider the search for a cancer cure.

Chapter 7, "The Half-Life of Blue," by volume co-editor Charlene Villaseñor Black, considers blue as the color of the future as it considers why Spanish artists would employ blue pigments that degraded within decades of use when other more stable pigments were available. Does the use of these blue pigments upset accepted notions about Renaissance temporality and claims to fame and posterity? Contextualized within Early Modern quests for new sources of blue pigments, this essay examines the semiotic value of blue in Spain and its associations with the culture of *al-Andalus* in the Iberian Peninsula. Inspired by the notion that Europe was home to multiple histories, as theorized by Jonathan Goldberg, this essay suggests that Spain's interest in blues during the Renaissance was a prediction of what would transpire in the rest of Europe. The fashion for blue in Spain was based in its Islamic past, including knowledge of technological advances that made possible the creation of desired blue pigments.

This anthology closes with an essay by Claire Farago on Early Modern ingenuity and artistic invention, "'Ingenuity' and Artists' Ways of Knowing." The author performs a close transverse analysis of this concept (*ingegno*), in a study of important texts on art and imitation by such luminaries as Cennino Cennini, Leonardo da Vinci, Giorgio Vasari, Filarete, and Leon Battista Alberti. *Ingegno* is closely associated with Renaissance conceptions of great genius and thus of central importance to studies of the period. Her findings are significant, including the observations that the categories of art and science were more fluid during the Renaissance than they are now and were closely linked by practical knowledge. She demonstrates this through her close study of how certain artistic skills and procedures—imitation, for example—were passed down orally in workshops. Furthermore, because Leonardo considered the painter a mirror of nature, painting in

the Renaissance was therefore science, a break with Medieval conceptions of visual images as embodiments of the sacred. These new conceptions of art, particularly an art based in mimesis, or naturalism, were not "innocent," as Farago points out. They served as tools of European imperialism.

A primary goal of this book is to break down disciplinary divisions and foster new transdisciplinary dialogues on the topic of Renaissance art, science, and futurity. The methodologies of humanities scholars are combined with research approaches from aeronautics, medicine, artificial intelligence, computers, mathematics, chemistry, and natural science. Embedded here, too, is a belief in the value of the past. Our concern is not solely with how the Renaissance predicted the future, but also with how knowledge of the past can help us in the contemporary moment, by providing strategies to combat challenges to come. We are inspired by the fantastic creations of Leonardo da Vinci—his flying machines or robots or weapons, which were perceived during his lifetime as fantastic, even hallucinatory. Today, we similarly assess the future worlds of later writers such as Jules Verne, H. G. Wells, and contemporary science-fiction authors. But many of the inventions of the Renaissance have now come to fruition. To quote Don Quixote: "Thou hast seen nothing yet."[29]

1

Moon Shot

From Renaissance Imagination to Modern Reality

Mari-Tere Álvarez

First used by Shakespeare in 1603, the term "futurity" is referred to in the lexicon as the "quality or state of being future."[1] Distinct from "future," futurity is a vision of the future; it is not a fixed event. Futurity is essentially a forward-driven mode, but it does not simply mean development. Much as Europeans aspired to reach India via a western sea route in the Middle Ages, futurity is an image and a horizon: seen and discussed but just out of reach.[2] This essay explores a number of future-oriented speculations in the practices and theories of sixteenth- and seventeenth-century art worlds (both visual and literary), with a particular emphasis on the ways in which future-making was a critically fundamental part of the ambitious imperial ventures of Early Modern Europe.

Human beings have always had a penchant for the marvelous, for that which seems beyond our reach. Perhaps not surprisingly, the motto for the Holy Roman Emperor Charles V (1500–1558) was *Plus Ultra,* "further beyond," that is, going beyond the known reaches of Europe stretching into the unknown, the future.[3] The Early Modern period was marked by individuals who saw beyond known boundaries and were seeking to create future worlds. Whether it was Columbus attempting to circumnavigate the globe or Francis Bacon's new utopian society— emperors sought and dreamers dreamed. It was left to the artisans, writers, and cartographers to make visual these imagined futures and thereby help us, the readers and viewers, to see these imagined futures as possible reality.[4] This essay looks at the futurists of the Early Modern period who first gazed into the night sky and began to dream of new possibilities, which would take an additional four hundred years to make reality.

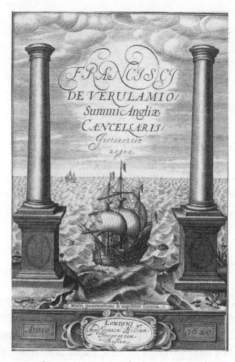

FIGURE 1.1. Artist unknown, title page, engraving from Francis Bacon, *Instauratio magna*, 1620.
SOURCE: Wikimedia Commons. https://commons.wikimedia.org/wiki/File:Instauratio_Magna.jpg

A POST-COLUMBIAN WORLD

Etched on the Pillars of Hercules, *Non Plus Ultra* (nothing further beyond) marked
the westernmost entrance to the Mediterranean at the Strait of Gibraltar, warn-
ing travelers that nothing lay beyond (figure 1.1). In other words, the only thing
beyond the strait was the end of the then-known world.[5] Consequently, before the
Renaissance, most people across Western Europe simply believed that the juncture
of the Mediterranean with the Atlantic was in fact the limit of the known world.[6]

Any remaining doubts regarding the known boundaries of the world were com-
pletely eradicated by the Spanish expedition to the West Indies in 1492.[7] Celebrat-
ing the transgression of *"non plus ultra,"* that is, the encounter with the Americas,
Plus Ultra ("there is more beyond") was adopted by King Charles V of Spain and
I of the Holy Roman Empire (1500–1558), who chose to apply the motto along
with the Pillars of Hercules as his coat of arms. This risk-taking call-to-arms to
go further, to challenge oneself to move beyond that which is understood, to go
where no one has gone before, would have particular resonance to a nation at the
vanguard of global exploration.[8]

THE WORLD IS NOT ENOUGH

Not to be outdone by his father, King Philip II of Spain (1527–1598) expanded Spanish power to encompass global domination.[9] Exploiting the unexpected demise of Philip II's nephew, King Sebastian of Portugal (1557–1578), which left Portugal and its territories without an obvious heir, Philip II asserted his familial rights to Portugal and, more significantly, its entire colonial enterprise. This land coup, coupled with new acquisitions in New Spain, Tierra Firme, and the Philippines, as well as areas on the continent of Africa, created the first empire in history on which the sun never set.[10] And it seems that global domination might not have been enough; in 1583, Philip II's imperial aspirations were recorded on a special medal. To commemorate Philip II's annexation of the Portuguese dominions and celebrate all he had accomplished to date, a medal was coined with a portrait of Philip II circled with the words *Philippus Hispaniarum et Novi Orbis rex* (Philip, King of Spain and of the New World). While that is impressive, it is the medal's obverse that is of greater interest. Philip II's motto on the reverse represents a horse sitting atop a terrestrial globe surrounded by the legend *Non sufficit orbis* ("*The world is not enough*").[11] By 1583, the motto was adopted into the Spanish coats of arms.[12] Not surprisingly, like his father before him, Philip II had adopted a mantra that captured the new futurist sentiment of the sixteenth century: truly, the world was not enough. With the terrestrial world now conquered, the Spanish monarchy turned its thoughts to a vaster universe to conquer, starting with the moon.

With Spain, and by extension, greater Europe, drunk on these ever-expansive imperial real estate grabs, it would not be long before everyday people considered a future that would include exploration of worlds beyond our own. From the mid-sixteenth century forward, the moon would figure prominently in the European imagination. In 1551 George Ferrers, the Lord of Misrule, organized that year's annual Christmas festivities for the Royal House; the festivities' theme was space.[13] So popular was the theme that the following Christmas festivity at Greenwich Palace focused on "outer space."[14] This fascination with a world beyond our terrestrially bound Earth was not limited to monarchs; people across Europe and the Americas were captivated by the idea of other worlds. And so Early Modern writers and artists began to feed this growing fascination by creating narratives about life on the moon.

THE MOON AND THE EARLY MODERN IMAGINATION

Well before humans could fly, a literary and visual tradition for space travel developed.[15] In the sixteenth and seventeenth centuries, fiction writers dreamed of a new world filled with cosmic voyages, and artists created images to accompany the fantastic tales.[16] Guy Consolmagno reminds us that we should not be surprised to find a strong interaction between science-fiction stories, the science behind

those stories, and the popular culture from which those stories sprang.[17] And, whereas it is true that these tales of wonder were never understood by sixteenth-century readers to have been based in reality, the tales did sow seeds of possibility, dreams of what might be someday possible. Of course, these seeds of futuristic possibility were possible only in the post-Columbian world in which Europeans were living, one in which the inconceivable was made real. It was once unimaginable that Europeans could circumnavigate the globe, much less that Europeans could encounter a whole then-unknown hemisphere. Yet these once unbelievable achievements allowed Europeans to begin to conceive of other impossible ideas as being possible. Europeans, particularly the English, were filled with feelings of envy, suspicion, and even awe toward Spain. Before sailing the West Indies, Columbus had visited other ruling houses for sponsorship, including the Tudors. As history has recorded, it would be only Isabel of Castile who would support this expedition and consequently change Spain's course of history.

To make matters worse, the Treaty of Tordesillas, drafted in 1494, divided the trade and colonization rights of the globe between the Portuguese and the Spanish.[18] The official reason for the treaty was to prevent confrontation between these two exploring nations. Although initially successful at maintaining an armistice between the powers, the 1494 treaty eventually backfired and had sweeping repercussions on history, unleashing nearly two hundred years of espionage, piracy, smuggling, and warfare between the European nations. By the sixteenth century, the division of the Earth by the Treaty of Tordesillas had propelled Spain into global superpower status. And England, which had its own aspirations, had developed a strong envy-hate relationship with Spain.[19] Imagine, just as new navigational technologies and knowledge were about to open the world's oceanic routes, a treaty was put in place that sought to restrict access exclusively to two nations (Spain and Portugal). Thus began the struggle for control of the seas; with the Crown's blessings, English privateers attacked Spanish ships throughout the Atlantic and the Pacific. The English viewed Spain as the default, but unworthy, inheritor of the Earth. So not surprisingly, it would be English writers who viewed Spain as the natural inheritor of the moon. I postulate that post-Columbian encounters coupled with advances in astronomy began to plant possibilities in the minds of the futurist Europeans, so much so that when writers began to write about otherworldly encounters, they envisioned the conqueror of these lands as the Spanish, then the most logical inheritors of the greater universe.[20]

It is similarly not surprising to find an incredible growth in what can only be described as a type of Early Modern space-colonizing science fiction, with the first explorations focusing on the moon. And to give those early space explorations even more credibility, Early Modern writers often created explorers-protagonists who were Spaniards, not unlike their real-life counterparts who explored the Americas. Historian Richard Kagan has focused attention on one of the most

interesting and understudied stories in the Early Modern space-travel genre.[21] Written in 1532 by Juan Maldonado, a cleric and teacher residing in Burgos, the novel *Somnium* (*The Dream*) describes a dream in which the author journeys to the moon. The text, which became an international bestseller, was owned by both Charles V and Philip. It opens with Maldonado, who wakes up to observe a comet with his female students. His friend María de Rojas journeys to the moon and discovers an untouched society whose citizens are known as Selenites.[22] The second half of *Somnium* describes the "noble savages" found in the "new world" who are now Christians, making clear the case for the connection between imperial projects of the time and futuristic aspirations toward space.[23] Kagan points out quite aptly that this was written while Spain was in the midst of securing its imperial control over Mexico and Peru.[24] This very critical point should not be glossed over, and I do not think it coincidental that rising interest in futuristic moon journeys coincided with imperial aspiration and assertions. Already in the sixteenth century the idea of Philip II's imperial acquisitions was being subsumed into futuristic lunar narratives such as that of Maldonado. Both this world and the next were all trophies for Spain.

This idea of potential "discovery," acquisition, and incorporation into the greater empire, which began in the terrestrial world and moved out into interstellar space, would only grow stronger as time passed, allowing the next generations of the Spanish royal house to think of the moon as a Spanish trophy. Theatrical productions devoted to the theme of the moon attempted to sate European interest in the topic. The 1588 sellout Elizabethan production of *Endimion, the Man in the Moone* by John Lyly tells the story of Endymion, who falls in love with the moon goddess.[25] As in all great rom-coms, the wrong goddess ends up with the wrong boy, but in the end it all has a way of working out. In this case, although Endymion, a human, cannot marry the moon goddess because she is too far above his station in life, he lives a life of eternal devotion from afar.[26]

With each new conquest and new "discovery," the impossible and fantastic increasingly seemed to be more possible, and consequently the body of work devoted to the moon grew exponentially more fanciful.[27] By 1611, rumors surfaced throughout England that the Jesuits were engaged in a plan to colonize the moon.[28] This bizarre story had its source in John Donne's *Ignatius His Conclave*, which describes Lucifer and the Jesuits establishing "a church in the moon" to "reconcile the lunatic church" with the Church of Rome.[29] Less than a decade later, the Lord Bishop of Chester, John Wilkins, founder of the famed Royal Society, produced a curious book titled *The Discovery of a New World in the Moone, or, A Discourse tending to Prove that 'tis probable there may be another habitable World*. This book became one of the earliest attempts to establish similarities and relationships between Earth and the moon. Wilkins postulated that birds migrated to the moon during their annual autumn migration, an event of great mystery to some Euro-

peans at the time. Basing his theories on Wilkins, science, and scripture, Charles Morton, an English natural philosopher who himself emigrated to the American colonies, theorized that since no one had ever seen where birds migrated in winter, it followed that one could hypothesize that they left the Earth.[30] And, really, because some species seemed to disappear entirely, the only logical conclusion was that they set off into space, for as Morton notes: "Now, whither should these creatures go, unless it were to the moon?"[31]

Five months after the publication of Wilkins's work, Francis Godwin published the tale of the adventurer Domingo Gonsales (figure 1.2). Forced into exile after killing a man in a duel, the book's protagonist Gonsales, a Spanish merchant and nobleman, travels to the West Indies. He is then stranded on the remote but "blessed Isle of St. Helens," where he trains twenty-five swans, probably somewhat hesitant, to ferry him around. To his amazement and fear, "with one consent" the *gansas* rise up, "towering upward, and still upward" (figure 1.3).[32] Free of the Earth's atmosphere, after twelve days of flight Gonsales eventually lands on the moon in the year 1599. Influenced by Morton's theory of bird-moon flight, science fiction, both literary and visual, became science in the 1600s.[33] Thanks to the widespread dissemination via multiple editions in multiple languages sold in bookstalls across the continent, stories like the moon exploration of Gonsales became part of the European vernacular. This was the lunar moment, inspired by the age of exploration across the ocean and projecting a new age of exploration across the cosmos.[34]

For example, in 1700 a London bookseller, Nathaniel Crouch (ca. 1632 to after 1700), also known by the name Richard Burton, using the initials R.B., published the book *The English Acquisitions in Guinea and East-India*, a proto-encyclopedic encapsulation, which described the new colonial possessions of an ever-growing British Empire as well as provided counsel on the "Religion, Government, Trade, Marriages, Funerals, strange Customs, &c., Also the Birds, Beasts, Serpents, Monsters and other strange Creatures found there." One of the most incredible things about a book clearly about British imperial colonization and expansion is that the tale of the moon explorer Gonsales is included in the larger text. Although little known today, Crouch attended meetings of the Royal Society, and his writings were admired by both Samuel Johnson and a young Benjamin Franklin, who mentions Crouch's work in his autobiography.

FROM SCIENCE FICTION TO SCIENCE FACT

European conversations about a populated moon during the Early Modern period were an extension of a much more expansive European discourse on voyaging and geography to uncharted territories such as the Americas. The works discussed above, and others, share a common feature: They conflate futurist fantasy and actual reality. Writers make overt connections between the voyages of Columbus and other explorers and space travel. To the European mind, it stood to reason that

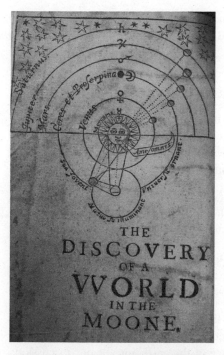

FIGURE 1.2. Artist unknown, frontispiece and title page, engraving from Francis Godwin, *The Man in the Moone,* 2nd edition, 1657.
SOURCE: Wikimedia Commons. https://commons.wikimedia.org/wiki/File:Godwin_man_in_the_moone.jpg

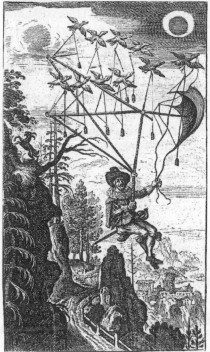

FIGURE 1.3. Artist unknown, frontispiece, engraving from Francis Godwin, *Der Fliegende Wandersmann nach dem Mond,* German translation of Bishop Godwin's *The Man in the Moone,* 1659 (Wolfenbüttel).
SOURCE: Wikimedia Commons. https://commons.wikimedia.org/wiki/File:Fliegende_Wandersmann_1659.jpg

if Europeans were able to encounter immense and previously unknown lands by traveling across seas, then similar marvels awaited those who would venture into the sky.

MAPPING IMPERIAL FUTURITY

Cartography was an essential weapon to imperial powers. The creation of "accurate" maps demarcated boundaries and consequently identified and established colonial territories. David Turnbull comes to some acute inferences concerning the symbiotic relationship between mapping and controlling:

> [T]he real distinguishing characteristic between Western maps is that they are powerful because they enable forms of association that make possible the building of empires, disciplines like cartography and the concept of land ownership that can be subject to juridical processes. The use of such means of geographic representation may not be an overt assertion of power, yet its influence on how regions and nations are perceived is undeniable. Thus the power to map was crucial to the power of European nations to control much of the world: to map at least in part implies claiming it.[35]

Rulers, via the creation of maps, would shape and define their worlds: "Land is empty, apparently unintelligible until individuals anthropomorphically project [their own internal images] upon the face of the earth [or, for our discussions, the moon], so that the earth bears or carries [their] own face—a face determined by political, cultural and personal factors."[36] And so, maps were created to manage and assert control efficiently over colonial possessions. And, perhaps of even greater significance, it is under the guise of scientific rendering and geographic description that maps in fact exert control; maps define how the boundaries of the world are understood. Not surprisingly, the cartographer held a critical position within the empire. It was the cartographer who, by creating a miniature living version of imperial possessions or "trophies," created visually perfect similitudes of imperial ambition. With each new imperial "discovery," acquisition, or political change, the cartographer would also alter the model (add boundaries, reflect natural or political changes, identify monuments). Once fixed on the map like a self-affirming Möbius band, the map then fixes in the minds of others imperial ambitions and futurities, affirming belief.

By the time of his birth in 1605, King Philip IV of Spain and Portugal (1605–1665) had inherited an empire, which his grandfather King Philip II had solidified; the former would spend most of his reign trying to maintain it. One critical aspect of maintaining an empire is to be able to visualize it; the Golden Tower (*la torre dorada*) of the Royal Alcazar in Madrid held all the visual evidence of this great empire.[37] It was in the tower where maps that illustrated the many villages, territories, countries, and colonies which made up this great empire were dis-

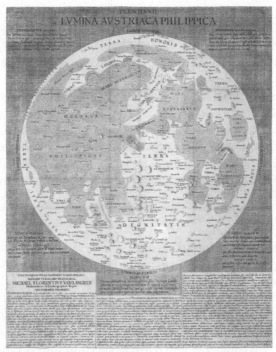

FIGURE 1.4. Michael van Langren, *Map of the Moon, Plenilunii Lumina Austriaca Philippica*, engraving, 1645.
SOURCE: Wikimedia Commons. https://commons.wikimedia.org/wiki/File:Langrenus_map_of_the_Moon_1645.jpg

played prominently on critical sight lines for both the king's perusal as well as to impress and instruct all who visited. The Golden Tower thus became a synecdoche for the vastness and greatness of the empire.[38] Of course, the Golden Tower not only held what was already part of the imperial holdings; it also housed the futurity of empire.

In 1645, the cosmographer in service to King Philip IV, Michael Florent van Langren (1598–1675), drew several lunar maps for the king. While lunar maps had previously existed, none before had been created with such specificity. Galileo had identified the geographic structures (i.e., mountain, sea, lake) but not given these structures proper names, thus leaving a door open. This obvious cartographic *lacuna* on the lunar map was not lost on the imperial cosmographer Van Langren, who filled this gap and christened each topographical item on the lunar map with the names of key figures, which directly related to the Spanish royal house: The ocean was named after King Philip IV, the seas after royalty (and himself), and the lands after royalty and nobility.[39] In one fell swoop, Van Langren both named the

moon after the Spanish monarchy and via these very names laid claim to the moon for Spain as a future acquisition. (figure 1.4) When a draft of the lunar map was presented to Philip IV in 1633, according to Van Langren himself, the king "liked that the names of illustrious men were applied to the mountains of the lunar globe, luminous and resplendent, which could be used in astronomical, geographical and hydrographical observations and corrections."[40] The world might have been enough for Philip II, but not for his grandson, who, in addition to presenting himself as the Planet King, could also dream of nothing less than being the lunar king, the true "man in the Moon." For when authority is emblazoned upon a territory via a map, what was once an abstract idea becomes a reality; it makes the relationships of power tangible by making them visible.

THE FUTURE IS NOW

In the 1420s, the Portuguese set their flag on the Azores Islands. At the time it was hard to envision what could surpass such an incredible feat. Before the end of the century, however, the Spanish and Portuguese would plant their flags across the globe, dividing up the world forever. And once the terrestrial globe had been carved up by the various European powers, it would not be long before cosmographers, writers, monarchs, and artists began to turn their sights to worlds beyond our own territorial home. Whereas efforts in the sixteenth century were valiant and impressive, it would be another colonizing empire, the United States, that would plant its flag on *orbe novo* in 1969.[41] The day that U.S. astronauts Buzz Aldrin and Neil Armstrong pierced the moon's surface with the Stars and Stripes, a chapter of science fiction became science fact, and the future became the present. Alas, when a once-conceptual futurity is replaced by a specious present, a new conception will rise. For the astronauts had not even yet returned to Earth when a new futurity replaced five hundred years of lunar fantasy. Futurists now focused new literary and visual traditions on Mars and beyond. It is not an exaggeration to say that since the transgression of *Non Plus Ultra* and its resulting encounter with the Americas, our conceptions have been forever altered. From that point onward, everyone to some extent became a futurist.

2

Machines in the Garden

Jessica Riskin

What does it mean to be alive and conscious: an aware, thinking creature? Using lifelike machines to discuss animation and consciousness is a major cultural preoccupation of the early twenty-first century; but few realize that this practice stretches back to the middle of the seventeenth century, and that actual lifelike machines, which peopled the landscape of late Medieval and Early Modern Europe, shaped this philosophical tradition from its inception. By the early 1630s, when René Descartes argued that animals and humans, apart from their capacity to reason, were automata, European towns and villages were positively humming with mechanical vitality, and mechanical images of living creatures had been ubiquitous for several centuries. Descartes and other seventeenth-century mechanists were therefore able to invoke a plethora of animal- and human-like machines. These machines fell into two main categories: the great many devices to be found in churches and cathedrals, and the automatic hydraulic amusements on the grounds of palaces and wealthy estates.

Neither category of contraptions signified, in the first instance, what machine metaphors for living creatures later came to signify: passivity, rigidity, regularity, constraint, rote behavior, soullessness. Rather, the machines that informed the emergence of the Early Modern notion of the human-machine held a strikingly unfamiliar array of cultural and philosophical implications, notably the tendencies to act unexpectedly, playfully, willfully, surprisingly, and responsively. Moreover, neither the idea nor the ubiquitous images of human-machinery ran counter to Christian practice or doctrine. Quite the contrary: not only did automata appear first and most commonly in churches and cathedrals, the idea as well as the technology of human-machinery was indigenously Catholic. The church was a primary sponsor of the literature that accompanied the technology of lifelike machines, and the body-machine was also a recurrent motif in Scholastic writing.[1]

Automata were therefore theologically and culturally familiar, things with which one could be on easy terms. They were funny, sometimes bawdy, and they were everywhere. To understand what Descartes and other seventeenth-century mechanists did with the idea of animal and human machinery, one needs to take into account its familiarity and pre-existing meanings. From the early to mid-seventeenth century, at the hands of mechanist philosophers, matter and its mechanical combinations would be divested first of soul and then of life. This essay tours a mechanical culture that flourished before that development, in which machines represented precisely the capacities that the mechanists would later deny them: divinity and vitality.

DEUS QUA MACHINA

A mechanical Christ on a crucifix, known as the Rood of Grace, drew great flocks of pilgrims to Boxley Abbey in Kent during the fifteenth century. This Jesus, which operated at Easter and the Ascension, "was made to move the eyes and lipps by stringes of haire."[2] Moreover, the Rood was able

> to bow down and lifte up it selfe, to shake and stirre the handes and feete, to nod the head, to rolle the eies, to wag the chaps, to bende the browes, and finally to represent to the eie, both the proper motion of each member of the body, and also a lively, expresse, and significant shew of a well contented or displeased minde: byting the lippe, and gathering a frowning, forward, and disdainful face, when it would pretend offence: and shewing a most milde, amiable, and smyling cheere and countenaunce, when it woulde seeme to be well pleased.[3]

Even before approaching the Rood for benediction, one had to undergo a test of purity administered by a remote-controlled saint:

> Sainct Rumwald was the picture of a pretie Boy sainct of stone . . . of it selfe short, and not seeming to be heavie: but for as much as it was wrought out of a great and weightie stone . . . it was hardly to be lifted by the handes of the strongest man. Nevertheless (such was the conveighance) by the helpe of an engine fixed to the backe thereof, it was easily prised up with the foote of him that was the keeper, and therefore, of no moment at all in the handes of such as had offered frankly: and contrariwise, by the meane of a pinne, running into a post . . . it was, to such as offered faintly, so fast and unmoveable, that no force of hande might once stirre it.[4]

Having proven your "cleane life and innocencie" at the hands of the rigged Saint Rumwald, you could proceed to the mechanized Jesus. Automaton Christs—muttering, blinking, grimacing on the cross—were especially popular.[5] One, a sixteenth-century Breton Jesus, rolled his eyes and moved his lips while blood flowed from a wound in his side. At his feet, the Virgin and three attendant women gesticulated, while at the top of the Cross, a head symbolizing the Trinity glanced shiftily from side to side.[6]

Mechanical devils were also rife. Poised in sacristies, they made horrible faces, howled and stuck out their tongues to instill fear in the hearts of sinners. The Satan-machines rolled their eyes and flailed their arms and wings; some even had moveable horns and crowns.[7] A muscular, crank-operated devil with sharply pointed ears and wild eyes remains in residence at the Castello Sforzesco in Milan.[8]

There were also automaton angels. A host of these, in one Florentine festival, carried the soul of Saint Cecilia up to heaven.[9] For the feast of the Annunciation at San Felice, the fifteenth-century Florentine architect Filippo Brunelleschi sent the archangel Gabriel in the reverse direction in a mechanical "mandorla," an almond-shaped symbol in which two merging circles represent heaven and earth, matter and spirit. Brunelleschi, a master of holy mechanics (*ingegni*), mechanized heaven too. His mechanical paradise was "truly marvellous . . . for on high a Heaven full of living and moving figures could be seen as well as countless lights, flashing on and off like lightning."[10]

Brunelleschi was outdone in the second half of the century by Cecca (Francesco D'Angelo), who engineered Christ's Ascension at the Church of Santa Maria del Carmine. Here, where Christ was borne aloft on "a Mount very well made of wood" the "said Heaven was somewhat larger than that of S. Felice in Piazza." Moreover, the festival planners added a second heaven over the chief tribune, with "certain great wheels" that "moved in most beautiful order ten circles standing for the ten Heavens." These were filled with stars: little copper lamps suspended from pivots so that they would remain upright as the heavens turned. Two angels stood on a platform suspended from pulleys.

> These angels, when a little rope was unwound from the Heaven above, came down the two larger ropes . . . and announced to Christ that He was to ascend into Heaven, and performed their other functions. And since the iron to which they were bound by the girdle was fixed to the platform on which they stood, in such a way that they could turn round and round, they could make obeisance and turn about both when they had come forth and when they were returning . . . ; wherefore in reascending they turned towards the Heaven.[11]

The heavenly machinery was balanced beneath by engineered hells. The Passion play at Valenciennes in 1547 featured a hell with a "great mouth" specially rigged for "opening and closing when needed."[12] Another mechanical inferno's moving gates gaped ajar amid rumbling thunder and flashes of lightning to spew forth writhing automaton serpents and dragons.[13]

A menagerie of mechanical beasts played in religious theater, especially the mammoth mystery plays. A mechanical bear menaced David's sheep.[14] Daniel's lions gnashed their teeth,[15] and more lions knelt before Saint Denis.[16] Balaam's ass balked and swerved before the angel of the Lord.[17] The serpent twined itself round the trunk of the Tree of Knowledge to proffer its apple to Eve.[18] A wild boar tracked by hunters, a leopard that sniffed Saint André, a dromedary that

wagged its head, moved its lips and stuck out its tongue, a host of dog- and wolf-shaped devils surging up from the underworld, and serpents and dragons spewing flames from their mouths, noses, eyes and ears rewarded the stunningly devoted spectators at the forty-day performance of the *Mystère des actes des apôtres* in Bourges in 1537.[19] The machines were commissioned from local artisans, usually clockmakers.[20]

Mechanical enactments of biblical events spread across the European landscape, reaching a crescendo during the late fifteenth and early sixteenth centuries.[21] Nor was the holy machinery the sole province of the cities. In May 1501, an engineer in the village of Rabastens, near Toulouse, was engaged to build an endless screw that could propel the Assumption of the Virgin. The following August, the Virgin rose heavenward, attended by rotating angels, and disappeared into paradise (its entrance hidden in clouds). Meanwhile a golden, flaming sun also rotated, carrying more angels on its rays.[22] Another mechanical Ascension of the Virgin took place annually in Toulouse, moving in alternate years between the Église Notre-Dame de la Daurade and the Église Saint-Etienne.[23] At home, in the region around Toulouse, children built small replicas of the Virgin-elevator for the Assumption in the same way that they arranged crèches at Christmas.[24]

Even the Eternal Father appeared in mechanical reenactments. In Dieppe, for example, he loomed at the top of the Église Saint-Jacques, a "venerable old man" astride a cloud in an azure, star-sprinkled canopy of heaven. Mechanical angels flew about him, flapping their wings and swinging their censers. Some played the "Ave Maria" in time to the organ on handbells and horns at the end of each office. After the service, the angels blew out the altar candles.[25] At the feast of Whitsuntide, the Holy Ghost, in the form of a white dove, flew down from the main vault of Saint Paul's Cathedral in London, breathing a "most pleasant Perfume" over the congregation.[26]

Most Early Modern mechanical figures were found in cathedrals and exhibited religious themes. Many were connected with clocks, outgrowths of the church's drive to improve time-keeping for the better prediction of feast days,[27] or with organs. A mechanical man gripping a mallet to ring the hour became a familiar sight on clocktowers across Europe in the mid-fourteenth century. He went by the name "Jack" in England; in Flanders, he was "Jean"; in France, "Jaquemart"; and in Germany, "Hans."[28] Over the next century, Jack-Jean-Jaquemart-Hans acquired crowds of company. On the clock in the Piazza San Marco in Venice, beginning in 1499, two giant shepherds struck the hour while an angel playing a horn emerged, followed by the three Magi. The Magi bowed before the Virgin and Child and removed the crowns from their heads with one hand while using the other to extend their gifts. They then stood, replaced their crowns, and exited through a door that opened automatically.[29] The scene of the Magi was a common motif on church clocks, which also often included calendars indicating feast days; the positions, oppositions, and conjunctions of the stars; the signs of

the zodiac; the phases of the moon; and, as in the San Marco clock, astronomical models of a Ptolemaic cosmos.[30]

There were also roosters: mechanical cocks crowed and flapped their wings on clocks across Europe from about the mid-fourteenth century.[31] Perhaps the earliest, built around 1340, performed on the hour at Cluny Abbey, near Macon. Meanwhile an angel opened a door to bow before the Virgin, a white dove representing the Holy Spirit flew down from above and was blessed by the Eternal Father, and fantastic creatures emerged to stick out their tongues and roll their eyes before retreating inside the clock.[32] Another rooster did its flapping and crowing on the town clock in Niort from about 1570. This bird presided over three separate scenes involving some forty figures. Care appeared in a window to exhort Servitude to come out and strike the hour. An automaton Gabriel enacted the Annunciation with a mechanical Mary, Holy Ghost, and Eternal Father. Finally, a mechanical choir of angels sang in time to their conductor's baton, while Saint Peter appeared from behind a door, looked about, opened another door, and, at the admonition of two children, disappeared back into his own chamber to make way for the twelve apostles. These arrived holding hammers with which they rang the hour while the children nodded their heads in time. The clock had a false door with two automaton Hercules on either side, ready to drop their clubs on anyone who tried to enter; above them, Vulcan with his hammer also stood guard.[33]

The Cluny, Niort, and other roosters were outdone by one unrivaled among mechanical fowl, the renowned rooster of Strasbourg Cathedral. For nearly five centuries, the Strasbourg rooster cocked its head, flapped its wings, and crowed on the hour atop the Clock of the Three Kings, originally built between 1352 and 1354, and refurbished by the clockmaker brothers Isaac and Josias Habrecht between 1540 and 1574. Beneath the rooster, the astrolabe turned and the Magi scene played out its familiar sequence. In the Habrecht version, the rooster, Magi, Virgin, and Child were joined by a host of other automata: a rotation of Roman gods who indicated the day of the week; an angel who raised her wand as the hour was rung, and another who turned her hour-glass on the quarter-hour; a baby, a youth, a soldier, and an old man representing the four stages of life, who rang the quarter-hours; and above them, a timid, mechanical Christ, who came forth after the old man finished ringing the final quarter-hour, but then retreated in haste to make way for Death to strike the hour with a bone.[34] In a similarly dark scene at the Frauenkirche in Munich, from 1514, a vengeful God brandished a sword hourly over fallen mankind; Christ and Mary, begging for clemency, made him lower it to the crowing of the ever-present rooster.[35]

Apart from church clocks, the other prime spot for mechanical figures was church organs.[36] Organ-driven mechanical angels came in whole choirs of bustling figures, including the conductor waving a baton, sometimes accompanied by flocks of singing birds. Automaton angels lifted horns to their mouths and played

drums and carillons.[37] At the cathedral in Beauvais, Saint Peter towered atop an organ of the late fourteenth or early fifteenth century and blessed the congregation on his feast day by nodding his head and moving his eyes.[38] Strasbourg Cathedral was hectic with mechanical activity, having automata connected with its organ as well as its clock. Three moving figures, known as Rohraffen, were attached to the strings of the organ in the late fifteenth century (where they remain): Samson boldly opening and closing the jaws of a lion; the *Héraut de la ville,* lifting his trumpet to his lips; and the *Bretzelmann* in a red and black cape.

The *Bretzelmann,* still in place, has long hair and a shaggy beard, an aquiline nose and an evil look. When set in motion, he seems to speak with great emphasis, opening and shutting his mouth while shaking his head and gesticulating with his right arm.[39] At Pentecost, throughout the service, the *Bretzelmann* mocked the priest, laughing, hurling insults and coarse jokes, and singing nasty songs:

> By disordered movements, profane and improper canticles shouted at the top of his lungs, he disturbs the hymns of the arriving pilgrims and covers them with ridicule. In this manner, he turns the devotion of the visitors into distraction, their pious sighs into laughs, but he also troubles the priests who chant the holy office, and he is the cause of an abominable and execrable perturbation during the sacrifice of the holy mass.[40]

Other organs sported disembodied heads that frowned, contorted their faces, rolled their eyes, stuck out their tongues and opened and closed their mouths as the music played. A colossal automaton head animated the church organ in Neustadt-an-der-Harth in Bavaria, and others were to be found across Germany and the Low Countries from the fifteenth century.[41] From the organ gallery of the cathedral in Barcelona, the head of a moor hung by its turban. It made mild facial expressions when the music played softly; when the strains grew louder, it rolled its eyes and grimaced as though in pain.[42] And in the Cloître des Augustins in Montoire, in the Loire Valley, a mechanical head on the organ gallery gnashed its teeth with a noisy clatter.[43]

Early Modern Europe, then, was alive with mechanical beings, and the Catholic Church was their main patron. The church was also a primary sponsor, between the late fifteenth and late sixteenth centuries, of the translation and printing of a small flood of ancient texts on mechanical and hydraulic automata, which then informed the construction of such devices throughout the Renaissance. For example, the first printed edition of Vitruvius's *De Architectura*—containing descriptions of the third century B.C. engineer Ctesibius's water organ and other automata—appeared in 1486 as a key part of the Renaissance popes' project to build a Christian Rome.[44]

To be sure, automata also appeared in secular settings: on town halls, municipal clock towers,[45] and the grounds of noble estates. Early Modern engineers mechanized purely political icons as well as religious ones. A very early example is the

clock that Charles IV commissioned for the Frauenkirche in Nuremberg to com-memorate his Golden Bull, which established the constitutional structure of the Holy Roman Empire and set the number of electors at seven. On the clock, which was inaugurated in 1361, seven figures known collectively as the *Männleinlaufen* (parade of little men) emerge at noon to bow before the emperor.[46] Another leg-endary instance was the automaton lion built by Leonardo da Vinci in 1515 for a banquet hosted by Florentine merchants in Lyon in honor of Francis I: "wherefore Leonardo being asked to devise some bizarre thing, made a lion which walked several steps and then opened its breast, showing it full of lilies."[47] The lion repre-sented Lyon and the lilies the French throne.

Clockwork automata, often exhibiting secular themes, were the playthings of princes—especially the Holy Roman emperors—from the late fifteenth century. Hans Bullmann of Nuremberg built android musicians, for which Ferdinand I summoned him to Vienna.[48] Henry VIII, according to a 1542 inventory, had an automaton clock at Westminster.[49] Hans Schlottheim, a clockmaker in Augsburg, designed automaton-embellished utensil holders to sit on banquet tables. These were wrought in gold, silver, or brass, typically in the form of a ship. One, which Schlottheim made for Rudolph II around 1580 and is now at the British Museum, has figures moving around a sundial and passing before a throne. Schlottheim also devised two automaton crayfish—one crept forward and the other backward—that were bought by the Prince Elector of Saxony in 1587.[50]

Noble houses hummed and whirred with clock-automata that were miniatur-izations of the ones in churches and, indeed, designed by the same people. For example, the Habrecht brothers, who renovated the Strasbourg Cathedral clock in the mid-sixteenth century, also did a brisk business in household automaton clocks.[51] Automata figured too in lay theater.[52] In 1547, John Dee, the future magus and court philosopher to Queen Elizabeth I, but then a nineteen-year-old reader in Greek at Trinity College, Cambridge, built what seems to have been a mechani-cal flying dung beetle for an undergraduate production of Aristophanes's *Pax*. At the point in the play when Trygaeus, determined to reach Jupiter's Olympian pal-ace, leaps onto his unlovely Pegasus and exhorts it to fly, Dee's artificial insect took to the air, inspiring "a great wondring, and many vaine reportes spread abroad of the meanes how that was effected."[53]

But automata were first and most extensively to be found in churches and cathedrals. Indeed, even before the clock and organ automata, as early as the mid-thirteenth century, the sketchbook of Villard de Honnecourt included rope-and-pulley controlled mechanisms, one for a mechanical angel that turned to point its finger at the sun and another for a mechanical eagle, the caption to which reads: "How to make the eagle face the Deacon while the Gospel is being read."[54] Later, automaton Christs, angels, devils, and Virgins prepared the ground for mechanical animals of every variety and clockwork models of the cosmos itself. The Catholic Church was the cradle of the clockwork universe and its mechanical inhabitants.

In the interest of calendar reform and of accurate predictions of feast days, the church sponsored both the astronomy and the technology of timekeeping.[55] And the church also promulgated, in association with clockwork, the plurality of Early Modern mechanical images of people and animals.

A Franciscan monk of iron and linden-wood built around 1560 and attributed to a man named Juanelo Turriano offers a final example of the Early Modern mechanization of faith.[56] Turriano's life is a tale in itself. Clockmaker, architect, and engineer to the Holy Roman Emperor Charles V, and then to his son and heir, King Philip II of Spain, Turriano went into retreat with Charles, after his abdication in 1556, at the monastery of Yuste, near Plasencia.[57] There, the imperial clock-maker built automata to comfort the gouty ex-emperor: an automaton lady who danced and played a tambourine, a flight of wooden sparrows that fluttered and "flew about the room as if alive," a miniature army of prancing horses, and soldiers playing diminutive trumpets.[58] According to legend, Philip II asked Turriano to build the automaton after Philip's son, Don Carlos, made a miraculous recovery following a head injury. A fifteenth-century Franciscan monk, Diego de Alcalá, whose relics were brought to the prince's bed at the moment of crisis, received credit for the cure, and the king, to express his eternal gratitude, asked Turriano to build the mechanical monk.

The monk, wearing a tunic, cowl, and sandals, and with its mechanism hidden beneath its habit, is a fully self-contained device, sixteen inches high. It clutches a crucifix and rosary in its left hand. Elizabeth King, the monk's eloquent biographer, describes its performance thus:

> Slowly the monk comes to life. He turns his head to single out one among the company. Left foot stepping forth from under the cassock hem, then right foot, the monk advances in the direction of his gaze, raising the crucifix and rosary before him as he walks. His eyes move: turning his head, he looks to the raised cross and back to his subject. His mouth opens, then closes, affording a glimpse of teeth and interior. He bends his right arm and with the gathered fingers of his hand he strikes his breast. The small blow is audible. And now he is lowering and turning his head as he walks: the elbow and shoulder in synchronized motion he brings the cross higher, up to his lips, and kisses it. Thirty seconds into the act, he's taken eight steps, beat his chest three times, kissed the cross, and traveled a distance of twenty inches. At what seems like the last moment—for doubtless the subject of his attention has backed away from the table's edge—he looks away, arms still aloft, executes a turn to his right, and makes a new appointment. He will make seven such turns and advances in his campaign if the mainspring has been fully wound. The uninterrupted repetition corresponds exactly to a trance-like performance of prayer, incantation.[59]

Just over a foot in height and weighing five pounds, the monk is somehow formidable. Perhaps even more than his contemporaries—the muttering Christs, the horn-playing angels, the eye-rolling devils, the teeth-chattering heads—he

embodies the power of an image, the peculiar power of a moving image,[60] and the extraordinary sway of a moving, devotional image.

Mechanization is often taken as an index of modernization. But automaton icons had a Medieval impetus in a tradition of imagery in which the tangible, visible, earthly representations of Christian lore and doctrine were pushed ever farther.[61] The icons were representations in motion, inspirited statues: they were mechanical and divine. Rolling their eyes, moving their lips, gesturing, and grimacing, these automata dramatized the intimate, corporeal relation between representation and divinity, icon and saint. As this relation became increasingly fraught, the machinery took on new meanings. Reformism and clockmaking developed side by side from Augsburg to Strasbourg to Geneva. The flood of mechanized religious images coincided both in time and, most importantly, in place with the heating-up of the questions of whether and how religious images blurred the boundary between image and deity.

The Reformation cast a partial hush over the humming, groaning, chirping, whistling, chattering ecclesiastical machinery. The uncouth *Bretzelmann* of Strasbourg Cathedral was silenced along with many of his fellow organ-automata and, indeed, with many of the church organs themselves, which became emblematic of Catholic ritual.[62] Henry VIII, in establishing the Anglican Church, banned mechanical statues from English churches.[63] The grimacing Rood of Boxley Abbey gave its last performance in 1538, after being snatched from Boxley by Geoffrey Chamber as part of his commissioned defacement of the abbey. Chamber wrote to Thomas Cromwell that he had found in the Rood

> certain engines and old wire, with old rotten sticks in the back, which caused the eyes to move and stir in the head thereof, "like unto a lively thing," and also, "the nether lip likewise to move as though it should speak," which was not a little strange to him and others present.[64]

But can it have been any surprise that the Rood was made of wood and wire? It and its many cousins had been built by local artisans—clockmakers, carpenters— and treated by its local beholders with great familiarity, inspiring, by the accounts of contemporary chroniclers, at least as much laughter as awe. The *Bretzelmann* of Strasbourg Cathedral was obviously funny. Similarly, in the case of the lever- and-pulley-operated Saint Rumwald, "many times it mooved more laughter than devotion, to beholde a great lubber to lifte at that in vaine, which a young boy (or wench) had easily taken up before him."[65]

That mechanical icons were mechanical cannot have been big news. But Chamber and his fellow iconoclasts introduced the idea that such icons were deceptions by virtue of being mechanical. Machinery, that is, could not represent divinity other than deceitfully. One could not know a thing to be mechanical and simultaneously believe it to be divine. The destruction of mechanized icons represented only small swells inside the larger surges of iconoclasm that spread across Europe

during the middle decades of the sixteenth century.[66] But the demolition of the Rood and its ilk reveals that one core logic of iconoclasm—the rigorous distinction between the divine and the artifactual—brought with it a fundamentally transformed view of the ontology of machines.

The abbot and monks, when Chamber questioned them, predictably denied any knowledge of the mechanical Rood.[67] But it had inspired great devotion in the people of Kent, as well as pilgrimages from across the realm,[68] so Chamber deemed it an immediate danger and promptly removed it to Maidstone. There he displayed it in the public market and instilled in the townspeople a "wondrous detestation and hatred [of the Rood] so that if the monastery had to be defaced again they would pluck it down or burn it."[69] The chronicler Charles Wriothesley described the events as follows:

> Allso the sayde roode was sett in the market place first at Maydstone, and there shewed openlye to the people the craft of movinge the eyes and lipps, that all the people there might see the illusion that had bene used in the sayde image by the monckes of the saide plaace of manye yeares tyme out of mynde, whereby they had gotten great riches in deceiving the people thinckinge that the sayde image had so moved by the power of God, which now playnlye appeared to the contrarye.[70]

The Rood was then transported to London where John Hilsey, bishop of Rochester, exhibited it during a sermon at Saint Paul's Cross, after which it was torn apart and burned before a crowd of duly admonished onlookers.[71] Again, Wriothesley recorded the occasion:

> This yeare, the 24th daie of Februarie, beinge the Soundaie of Sexagesima and the Sainct Mathias daie, the image of the roode that was at the Abbey of Bexley, in Kent, called the Roode of Grace, was brought to Poules Crosse, and their, at the sermon made by the Bishopp of Rochester, the abuses of the . . . engines, used in old tyme in the said image, was declared, which image was made of paper and cloutes from the legges upward; ech legges and armes were of timber; and so the people had bene eluded and caused to doe great adolatrie by the said image.[72]

Three decades later, the lawyer and historian William Lambarde gave a caustic account of the Rood and "the Monkes, which were in love with the Picture." Of the Rood, Lambarde wrote sarcastically, "it needed not Prometheus fire to make it a lively man, but onely the helpe of the covetous Priestes of Bell, or the aide of some craftie College of Monkes." As for the Rood's colleague, Saint Rumwald, Lambarde revealed it to have been operated by "a religious impostor standing out of sight." He recalled Cromwell's triumph over the monks and their machines: "But what? I shall not neede to reporte, howe lewdly these Monkes, to their own enriching and the spoile of Gods people, abused this wooden God . . . because a good sort be yet on live that sawe the fraude openly detected at Paules Cross."[73]

As with other Reformist initiatives, both sides of the confessional divide participated in this partial rejection of mechanized religious images. By the mid-sev-

enteenth century, certain Catholic monarchs had developed a distaste for automaton angels and mechanical Ascensions. In 1647, Louis XIV and the Queen Mother came to view the automaton angels of Dieppe and found them not to their liking; that was the end of the angels.[74] An interdiction of 1666 put an end to the Virgin's annual mechanical Ascension in Toulouse on the grounds that it distracted the congregation and caused "irreverent reflections."[75]

Still, mechanized devotional objects did not disappear; on the contrary, they survived and flourished. Thus, during the late sixteenth and seventeenth centuries, the proliferating and elaborating machines coexisted with proliferating and elaborating theological and philosophical suspicions of them. The Council of Trent, in its 1563 decree on the use of sacred images, placed a ban on "unusual" images except when they were approved by a bishop.[76] Rather than eliminating mechanical icons, this ban helped to motivate a thematic shift. For example, in the wake of the Council's decree on images, the three-dimensional nativity scene (*presepio*) rose to prominence in Catholic settings as an acceptable representation of the divinity and an answer to the Lutheran Christmas tree. The Jesuits embraced the *presepio* and made it their own, in large part by mechanizing it. Within a few decades, a fad for mechanical and talking *presepi* was in full swing in aristocratic and wealthy bourgeois homes as well as in churches. The sixteenth-century architect Bernardo Buontalenti built a clockwork *presepio* for his pupil, Francesco, son of Cosimo de' Medici, with opening and closing heavens, flying angels, and figures walking toward the manger. And Schlottheim built an elaborate mechanical *crèche* around 1589 for the Court of Saxony. The *crèche*, which is now in the Museum für Sächsische Volkskunst in Dresden, includes shepherds and kings proceeding past the manger while angels fly down from heaven; Joseph rocks the cradle, as an ox and ass rise up to stand before the holy Infant.[77]

A prominent representative of the Jesuitical love of mechanical devotional images was the polymath Athanasius Kircher, who served as a major fulcrum of philosophical activity during the middle decades of the seventeenth century. Among many other devices, Kircher designed a hydraulic machine to represent the Resurrection of the Savior and another device "to exhibit Christ walking on water, and bringing help to Peter who is gradually sinking, by a magnetic trick." In this contraption, the operative features were a strong magnet placed in Peter's chest and the steel out of which were wrought Christ's outstretched hands "or any part of his toga turned toward Peter." The two figures, propped on corks in a basin of water, would then be drawn inexorably together: "the iron hands of Christ soon feel the magnetic power diffused from the breast of Peter . . . The artifice will be greater if the statue of Christ is flexible in its middle, for in this way it will bend itself, to the great admiration and piety of the spectators."[78]

More generally, as historians of religion have often noted, the Jesuits made clockwork automata a principal tool in their promulgation of Christianity. They arrived before a succession of Chinese emperors bearing gifts of automata.

One such offering, dispatched in 1618 by Nicholas Trigault, the Jesuit ambassador of the Chinese Mission, was an elaborate mechanized nativity scene. The works were fully internal and spring-driven. As Trigault described it, the scene included the three Magi giving homage with bows, the Holy Virgin responding with gracious gestures, Joseph rocking the cradle where the Holy Child lay, an ass and an ox thrusting their heads toward the cradle, the Holy Father making a benediction, two angels continuously ascending and descending, and even moving shepherds.[79] The Jesuits included worldly themes as well as religious ones in their automatic offerings. The Jesuit priest Gabriel de Magalhaens, who arrived in China in 1640, presented to the Emperor Kang'hi a spring-driven android knight that marched about with a drawn sword for a quarter of an hour.[80] The Jesuits spread explicitly Christian automata as well as secular ones with missionary purposes around the world.

Secular automata proliferated alongside religious ones. Many of the same clockmakers and engineers who designed religious automata for churches also built secular ones for private patrons or public settings. In the clockmaking region of southern Germany during the late sixteenth and early seventeenth centuries, mechanical animals like Schlottheim's mechanical crayfish became popular: automaton spiders; Neptune astride a creeping bronze tortoise; a life-sized bear, wearing real fur and beating on a drum.[81] In the 1680s and 1690s, clockmakers began to fabricate animated paintings (*tableaux mécaniques*) depicting hunting parties and other rustic scenes.[82]

Waterworks on the grounds of estates constituted the main secular tradition in automata. The wealthy and powerful found in lifelike machinery an endless source of comedy, and of the most bawdily uproarious, knee-slapping variety. The first part of this article has traced the predominantly Christian origins of androids and other mechanical creatures and described an early intimacy between machinery and divinity. The second part takes up the relation of machinery to the vitality represented by a remarkably vivacious vulgarity. From the sublime, onward to the ridiculous.

WATERWORKS

Over a period of several centuries, spraying their unsuspecting guests with water automatically and other mechanized acts of hospitable abuse was a favorite pastime of Italian, French, and German aristocrats.[83] "Frolicsome engines" (*engiens d'esbattement*)[84] were to be found as early as the late thirteenth century at the chateau of Hesdin (in present-day Pas-de-Calais), seat of the *comtes d'Artois*. The machines are mentioned, beginning in 1299, in the account books of Robert II (Robert the Noble), *comte d'Artois*. The following year, the family appointed a castle "Master of Engines" (*Maistre des engiens du chastel*). After that, the *engiens* make regular appearances in the accounts, continuing through the reign of

Robert II's successor, Mathilde (known as Mahaut), *comtesse d'Artois*. From these entries, we gather that the engines included mechanical monkeys with real (regularly replaced) skins,[85] monkeys which, after 1312, sported horns.[86] There were also "an elephant and a he-goat"[87] and a machine referred to as "the boar's head."[88] From 1419 until his death in 1467, the *comtesse* Mahaut's descendant, Philippe le Bon, Duke of Burgundy, conducted a thorough refurbishment of the stock he had been left by his forebears and expanded it considerably. His own account books contain a meticulous catalog of the many mechanized tricks he inflicted on visitors. These included

> painting of 3 personages that spout water and wet people at will . . . a machine for wetting ladies when they step on it . . . an "*engien*" which, when its knobs are touched, strikes in the face those who are underneath and covers them with black or white . . . another machine by which all who pass through will be struck and beaten by sound cuffs on their head and shoulders . . . a wooden hermit who speaks to people who come to that room . . . 6 personages more than there were before, which wet people in various ways . . . eight pipes for wetting ladies from below and three pipes by which, when people stop in front of them, they are all whitened and covered with flour . . . a window where, when people wish to open it, a personage in front of it wets people and closes the window again in spite of them . . . a lectern on which there is a book of ballades, and, when they try to read it, people are all covered with black, and, as soon as they look inside, they are all wet with water . . . [a] mirror where people are sent to look at themselves when they are besmirched, and, when they look into it, they are once more all covered with flour, and all whitened . . . a personage of wood that appears above a bench in the middle of the gallery and fools [people] and speaks by a trick and cries out on behalf of Monsieur le Duc that everyone should go out of the gallery, and those who go because of that summons will be beaten by tall personages dressed like "sots" and "sottes," who will apply the rods afore-said, or they will have to fall into the water at the entrance to the bridge, and those who do not want to leave will be so wetted that they will not know where to go to escape from the water . . . a window in which there is a box suspended in the air, and on that box there is an owl which makes various faces in looking at people and gives an answer to everything that one wishes to ask it, and its voice can be heard in that box . . .[89]

The Hesdin *engiens d'esbattement*, in all their malicious glory, achieved great notoriety and inspired many imitations in the following century.[90]

By 1580 and 1581, when Montaigne was traveling through Europe, hydraulic automata had grown so commonplace in noble palaces and on the grounds of bourgeois estates that he grew bored with them. Outside Augsburg, at the summer place of the rich banking family Fuggers, Montaigne saw sprays of water from "little brass jets which cannot be seen," activated by concealed springs. "While the ladies are busy watching the fish play, you have only to release some spring: immediately all these jets spurt out thin, hard streams of water to the height of a man's head, and fill the petticoats and thighs of the ladies with this coolness." Elsewhere, hidden jets could be triggered to gush directly into the face of a visitor who

stopped to admire a particular fountain.[91] In one room, the Fuggers palace also had an automaton lion that sprang forward when a door was opened.[92]

At Pratolino, a palace of Francesco I de' Medici, Grand Duke of Tuscany, Montaigne marveled at Buontalenti's elaborate installations. In one "miraculous" grotto he saw

> not only music and harmony made by the movement of the water, but also a movement of several statues and doors with various actions, caused by the water; several animals that plunge in to drink; and things like that. At one single movement the whole grotto is full of water, and all the seats squirt water on your buttocks; and if you flee from the grotto and climb the castle stairs and anyone takes pleasure in this sport, there come out of every other step of the stairs, right up to the top of the house, a thousand jets of water that give you a bath.[93]

The grotto at Pratolino also had singing birds and an automaton lady who emerged from behind a door to fill a cup with water.[94] Another of the Grand Duke's residences boasted a grotto bustling with hydraulically driven "water mills and windmills, little church bells, soldiers of the guard, animals, hunts, and a thousand such things."[95]

Montaigne was unimpressed even by the already famous Villa d'Este in Tivoli. The Tivoli palace and gardens had been built during the 1550s and 1560s by Cardinal Ippolito II d'Este, then Governor of Tivoli, as consolation after an unsuccessful campaign to win the papacy. Completed in 1572, the grottoes were already old news, and Montaigne, arriving in 1580, declined to write a lengthy description of them since there were already "published books and pictures on the subject." Moreover, the "gushing of an infinity of jets of water checked and launched by a single spring that can be worked from far off, I had seen elsewhere on my trip." He then provided a jaded, if meticulous, account of the water organ:

> The music of the organ, which is real music and a natural organ, though always playing the same thing, is effected by means of the water, which falls with great violence into a round arched cave and agitates the air that is in there and forces it, in order to get out, to go through the pipes of the organ and supply it with wind. Another stream of water, driving a wheel with certain teeth on it, causes the organ keyboard to be struck in a certain order; so you hear an imitation of the sound of trumpets. In another place you hear the song of birds, which are little bronze flutes . . . this by an artifice like that of the organ; and then by other springs they set in motion an owl, which, appearing at the top of the rock, makes this harmony cease instantly, for the birds are frightened by his presence; and then he leaves the place to them again. This goes on alternately as long as you want. . . . All these inventions, or similar ones, produced by the same natural causes, I have seen elsewhere.[96]

Twenty years after Montaigne's travels, when Henri IV decided his palaces needed embellishment, he lured away Tommaso Francini, engineer to Ferdinando

I de' Medici, then Grand Duke of Tuscany, to supply the requisite waterworks. Francini began at Saint-Germain-en-Laye, where he mechanized a small throng of classical gods and heroes and other moving figures all in bronze.[97]

There were grottoes devoted to Neptune, Mercury, Orpheus, Hercules, Bacchus, Perseus, and Andromeda. John Evelyn visited the palace at Saint-Germain-en-Laye in 1644 and recorded in his diary what he had seen there.[98] He and other visitors described an automaton Neptune with a streaming blue beard, brandishing his trident, naked astride a chariot pulled by seahorses, accompanied by three round-bellied, horn-playing tritons. Farriers, "their faces black with filth and sweat," hammered iron on an anvil and—"that which is most pleasant and seems made to provoke laughter"—drenched their eager audiences with surprise sprays of water. Mercury posed by a window with one foot carelessly propped, "loudly intoning a trumpet." Elsewhere, Orpheus played his lyre for an audience of animals and trees who, including the trees, stretched and craned toward him.[99] A towering Perseus descended upon a mighty dragon arising from beneath the waves. Perseus swung his sword to behead the fearsome beast, sending it, slain, back down into the watery depths; whereupon farther back in the grotto, Andromeda promptly lost her chains. Meanwhile busy figures of artisans—blacksmiths, weavers, millers, carpenters, knife-grinders, fishermen—went about their sundry tasks.[100]

Another dragon appeared in the Dragon Grotto, shaking its terrible head and wings while belching steam. This Dragon, despite its ferocity, was surrounded by "various little birds, which really one would say were not painted & counterfeit, but living and fluttering their wings, which make the air resound with a thousand sorts of song; and above all the Nightingales there vie to make music in several choirs." There were cuckoos, too, and in yet another grotto, a nymph played at an organ.[101] The Grotto of Torches—a subterranean chamber lit only by flames—displayed a heady sequence of scenes "by force of water": first, an idyllic, island-dotted sea in which fishes and sea-monsters sported happily beneath a rising sun; then, a violent storm, thunder and lightning, wrecked ships heaved up on shore. Next came a calm and fertile vista, a flowerbed in bloom and trees filled with fruit. In the distance, the king and his family strolled, all except the dauphin, who arrived from on high in a chariot carried by two angels. The angels crowned the prince with a glittering coronet. Finally, there was a desolate landscape, a desert littered with ruins where reptiles, insects, and other wild creatures crawled about. At the last, a fairy emerged playing a flute and the animals gathered round to listen.[102]

What was it like to live amidst such machines, to be familiar with them, to have them shape one's earliest intuitions about machinery: how it works, what it does, how it compares to living creatures? We can form a reasonable impression thanks to a meticulous daily record of the life of a child who grew up with the hydraulic grottoes of Saint-Germain-en-Laye in his garden. The record includes every passing fancy, every lisping pronouncement, the menu at each meal down to the numbers of prunes or grapes consumed and careful descriptions of all bowel

movements. The child was the future Louis XIII, the son of Henri IV and Maria de' Medici, born just when Francini was working on his father's fountains. The dauphin's birth was recorded by his doctor and caretaker, Jean Hérouard, on September 27, 1601, as having taken place at "ten-thirty and a half quarter according to my watch made in Abbeville by M. Plantard."[103] The prince would spend his childhood mostly at Saint-Germain-en-Laye where he developed a passion for mechanical things.

As a toddler, the dauphin watched the workers from his windows[104] and, from the age of three, in the spring of 1605, he began visiting the grottoes several times each week.[105] Hérouard's diary describes him in bed one morning instructing a chambermaid, "Pretend dat I am Ofus [Orpheus] and you are da fountainee [fountaineer], you sing da canaries."[106] Soon afterward, he was working the grotto faucets, spraying himself and everyone else with water.[107] The prince plagued Francini with visits to his workshop, demanding the name of each instrument and explanations of how they worked.[108] At home, he talked continuously about Francini and pretended to be Francini, making wax models, working the fountains, collecting his pay. He played fountains in bed, in his gilt washbasin, and under the dining table—"fssss" and "dss"—making believe he was spraying people with water. On one occasion, he was rebuked by a nurse for climbing under the table to play fountains to the neglect of a visiting dignitary.[109] Francini built a small wooden fountain for the dauphin, which was installed near his rooms on his fourth birthday.[110] While work on the fountain was underway, the prince went continually to the workshop to see it, begging, "let's go see my fountain at Francino's place."[111]

At first, the dauphin could not be persuaded to enter the Orpheus grotto. Finally his governess, Madame de Montglat, enticed him in with a handful of sugared peas, having first covered the figure of Orpheus with a drape. Thereafter, the prince boasted that he had been to the very back of the grotto and was not afraid even to touch Orpheus himself.[112] In addition to occasional notes of fear, the passion also contained more than a hint of childish eroticism. Hérouard dutifully recorded on one occasion: "says he has a faucet in his ass and another in his willie: 'fs fs.'" The future absolutist—who was given to exposing himself to the servants and whose "willie" was the focus of much teasing attention from all members of the household including the King and Queen—was especially fond of the willie-fountain joke, which he repeated frequently.[113]

The day the dauphin's governor, M. de Souvé (Gilles, marquis de Courtenevaux), arrived at Saint-Germain-en-Laye, shortly before the prince's seventh birthday, Louis insisted on taking the tired traveler on an immediate tour of the grottoes, where he worked the faucets himself.[114] As a child king, having ascended to the throne at age nine after his father's assassination, Louis XIII continued to visit Francini, going straight to his workshop upon arriving at the palace, and amusing himself for hours at a time by forging, soldering, and filing fountain pipes.[115]

Louis XIII liked clockwork as well as hydraulic automata. Hérouard's journal describes the dauphin, age four, beating his spoon against his plate and announcing to his governess: "Maman ga [Mme. de Montglat] I am ringing da hour dan, dan, it rings like da jackamart who beats on da anvil."[116] Here he is at six, shopping in Paris along the rue Saint Honoré, choosing a spring-driven toy carriage on offer for 15 écus.[117] Later in the same year, the dauphin was given a cabinet fabricated in Nuremberg with "a great number of personages doing diverse actions by the movement of sand." The personages enacted Christ's Passion and the taking of Jerusalem. The prince played fervently with the instrument, quickly grasping how to make it stop and go, demonstrating it to everyone in the palace, and discoursing about the works with mispronunciations that charmed his guardian: "*contrepès, pour countrepoids.*"[118]

This intimacy with and predilection for mechanical games persisted through generations of French princes. Louis XIV was born at Saint-Germain-en-Laye and received mechanical toys—automaton clocks, a carriage and company of soldiers, a mechanical theater that enacted an opera in five acts—well into his dotage.[119] His son, Louis XIII's grandson, had an arsenal of automaton toys including another mechanical army of a hundred soldiers.[120]

You didn't need to be a king or a prince: the popes, too, competed in the game of hydraulic trickery. When Ippolito Aldobrandini became Pope Clement VIII in 1592, he assigned his nephew, Cardinal Pietro Aldobrandini, the task of building a villa of unprecedented magnificence. Aldobrandini engaged the hydraulic engineers Orazio Olivieri and Giovanni Guglielmi to design what Edith Wharton, on her tour of Italian villas, would describe as "the inevitable *théâtre d'eau.*"[121] At the Villa Aldobrandini, the waterworks included a room of hydraulic and pneumatic marvels, the Stanza dei Venti (Room of Winds), which would draw visitors throughout the seventeenth and eighteenth centuries. Water from hidden, spring-triggered spouts, it should go without saying, leapt out to spray hapless visitors. Other spouts of water and water-powered jets of air played organ- and fife-music and produced eerie sounds—thunder, wind, rain, whistles, shrieks—while wooden globes danced magico-mechanically across the floor.[122]

The popes, their nephews and their grandnephews, all the little cardinals and archbishops wanted their own hydro-mechanical toys. Markus Sittikus von Hohenems, sovereign and archbishop of Salzburg from 1612 until his death in 1619, installed waterworks at his Schloss Hellbrunn that remain in operation almost four centuries later.[123] When he was elected archbishop, Sittikus was already a connoisseur of automata. He had lived briefly at the Villa Aldobrandini; moreover, his uncle, Cardinal Marco Sittico Altemps, nephew of Pope Pius IV, had built the Villa Mondragone, which had a renowned Water Theater designed by the engineer Giovanni Fontana.[124] In Sittikus's garden, visitors are still invited to seat themselves around a stone table, on stone benches with hidden spouts that release jets of water on command, drenching the obedient from below.

In the Neptune Grotto to which they proceed, dripping and uproarious, guests gape at the Germaul, a stone gargoyle that rolls its eyes menacingly and sticks out its tongue. Fleeing the Germaul, the visitors are again watered down from spring-triggered spouts concealed in the walls. Arriving remoistened in the Birdcall Grotto, they are surrounded by the hydraulically produced sound of chirping and twittering birds. Afterward, they are led along the Royal Way past five small grottoes, each housing a scene enacted by automata: a miller grinding his wheat; a potter working at his wheel; a scissors grinder and his wife sharpening blades on a wheel while their child plays at their feet; Perseus freeing Andromeda from the dragon; Apollo flaying Marsyas. Next, present-day visitors arrive at an elaborate water-driven Mechanical Theater displaying a town square populated by more than a hundred moving figures: carpenters, innkeepers, musicians, and other street performers, a barber giving a client a shave, a butcher slaughtering an ox, a farmer pushing an old woman in a wheelbarrow, a marching military guard, a dancing bear. The Mechanical Theater, completed in 1752, was the contribution of Archbishop Andreas Jakob Graf von Dietrichstein; it replaced an earlier hydraulically powered mechanical scene representing a forge.

At the time that Sittikus's waterworks were being installed, princes across the land were importing hydraulic engineers to install automata on their palace grounds; it was routinely one of their first acts as sovereign. The adolescent Palatine elector, Frederick, brought his hydraulic engineer along with his seventeen-year-old bride, Elizabeth, daughter of King James I. Elizabeth traveled to Heidelberg for her wedding in 1613 accompanied by Salomon De Caus, an engineer from northern France and Huguenot refugee at her father's court.[125] De Caus would remain at Heidelberg as Frederick's engineer until 1620 when the elector, then also king of Bohemia, would lose his crown to the Holy Roman Emperor Ferdinand II and have to flee with his family to The Hague. The brevity of Frederick's Bohemian reign, which lasted a single winter, earned him the nickname "Winter King." But De Caus had time to transform the palace gardens into yet another hydraulic wonderland.

The waterworks' creator described grottoes in which fabulous creatures performed magico-mechanical feats.[126] In one, water poured from the breasts of a woman in the middle of the cavern, and from the mouth of a fish held by a man seated beside her. The couple was serenaded by a Satyr playing a flute, and opposite him, by the Nymph Echo, softly repeating each phrase. In the Grotto of Orpheus, the minstrel played his cello, charming the beasts around him— leopard, ram, lion, boar, stag, sheep, rabbit, and snake—who danced in time to the music. The Grotto of Neptune contained the god of the sea himself and some attendant creatures—a pair of swimming horses whose reigns he gripped, a couple of wading nymphs playing horns, and a cherub astride two dolphins—

all turning in stately circles around a great Gothic rock upon which a siren held a jug spouting water.[127]

A burgeoning literature on automatic machinery informed and accompanied installations such as the Palatine gardens waterworks. This literature began, as we have seen, with a series of ancient texts on mechanical and hydraulic automata, principally, in addition to Vitruvius's Ten Books, the treatises of Hero of Alexandria, which were repeatedly translated and printed over the course of the sixteenth century.[128] In turn, these inspired modern works that borrowed extensively from the classical ones. An influential example is Agostino Ramelli's *Le diverse e artificiose machine* (1588), which contains a plan for an "ingenious and delightful" fountain of twittering birds, based closely on designs from Hero's Pneumatica. Within the fountain, a nest of compartments is joined by a network of siphons. The siphons are connected above, through pipes, to little figures of birds with flutes in them. As water descends through the fountain, the siphons begin to function, emptying certain compartments and filling others, forcing air up through the various pipes in turn. The air, as it comes out the tops of the pipes into the birds with their flutes, makes them flutter and trill.[129]

De Caus was the author of another such work, *Les raisons des forces mouvantes avec diverses machines tant utiles que plaisantes* (1615), which has trees full of automaton birds, including one in direct imitation of a design by Hero, just like the one Montaigne had noted at the Villa d'Este: the birds flutter and chirp while an owl turns slowly toward them. When the intimidating owl faces the birds, they fall silent, but as he turns away, they resume their ruckus.[130] De Caus's treatise also contains meticulous accounts of the mechanisms of hydraulic grottoes like those of the Palatine gardens. In one, Galatea rides astride a big seashell drawn by two dolphins. Behind her, a Cyclops has put his club aside to play on a flageolet, while sheep gambol about. The mechanism is made entirely of wood, driven by two waterwheels. These are put in motion by jets of water from two pipes that emerge from a common reservoir. The pipes have valves that open and close alternately by means of a system of counterpoises, so that the wheelwork turns one way and then the other as Galatea and her dolphins move back and forth across the scene. A third waterwheel, through a train of gear-wheels, drives a pinned barrel that is in turn connected with the keys of the flageolet.[131]

By the 1660s, when Evelyn was at work on his gardening manuals, he considered it a matter of course that an essential part of the business would be to instruct "our docill Gardiner, how he may himselfe make & contrive these wonderfull Automats, . . . which at present so celebrate the Gardens of the greatest Princes; . . . & many other famous Gardens of the most illustrious persons of the World." It was not just an added flourish but actually "necessary," Evelyn counseled, "in these Inventions, to give some motion to the living creatures . . . that they may the [better] imitate nature." The possibilities were legion:

We may . . . people our Rocks with Fowle, Conies, Capricornes, Goates [& rapitary beasts, with] Hermites, Satyres, [Masceras] Shepheards, [rustic workes river gods Antiqs etc] and with divers Machines or Mills made to move by the ingenious placing of wheels, painted & turned by some seacret pipes of waters; The Figures above named may be formed of Potters earth, well moulded and baked; but if the states must be larger, of stone or Mettal: By these motions, histories, [Andromedas] and sceanes may be represented.[132]

In addition to the elaborate networks of levers, wheels, gears, flowing fluids, and falling weights, the advent of organ-barrel programming helped in the building of complex systems of lifelike motions. Kircher—who designed and described many automata including an "automatic organ machine which utters the voices of animals and birds"—was the first to publish a systematic account of the camshaft in 1650.[133] But by then, pinned cylinders had already been in use for several decades.[134] One of the earliest known examples was in an organ clock presented by Queen Elizabeth to the Sultan of Turkey in 1599.[135]

During the first decades of the seventeenth century, the use of camshafts spread quickly. De Caus adopted them to organize the motions in his reproductions of Hero's singing and fluttering birds.[136] The Augsburg clockmaker Achilles Langenbucher put the new technology to work in mechanical musical ensembles composed of many playerless instruments.[137] Evelyn included an extensive description of the camshaft (the "Phonotactic Cylinder") in *Elysium Britannicum*.[138] His discussion included explicit instructions for making such a device, which, like the construction of automata more generally, he considered to be essential to the art of gardening:

A Cylinder may be fitted so as to move, take out, & change the Teeth at pleasure, to place other in their stead: and so new Composition may be applied; . . . For example of this: Divide a Cylinder into 24 Measures, each of these [full] divide againe into 8 equal spaces, as we noted for Quavers; you shall bore holes, at every point of these divisions; as being [furnished] with a greate number [of] Teeth (as the Printers box is with Letters) for all sorts of Notse, which may keepe in a divided Drawer somewhere about the Organ, you may insert a new Composition or Tunes at pleasure in your Cylinder which, the more large & ample it is, will be so much the better for our purpose.[139]

By means of a camshaft, a single flow of fluid could work myriad effects. Evelyn singled out, as most "expeditious" and "ingenious," those waterworks that "onely with the [precipitation] of water alone produce wind sufficient for all our motions."[140] A single "Artificiall Ventiduct" created by filling a chamber with water, thereby forcing out the air, could be "sufficient either to refrigerate a roome in Summer, or to animate any . . . Bird, blow the Fire, [or] turne any Image or wheele."[141] Similarly, through the "rarifaction" of air by heating, one could create a stream of wind; this wind could then turn a cogwheel that could pluck wires to play a tune or

make another patterned sound, as in the case of the "celebrated statue of Memnon, which is reported to have spoaken & uttered a voice like a man, so soone as the Sun arose & darted his rayes upon it." The same wind, Evelyn noted, might "also serve to make artificiall Eyes & hands move; And Birds furnished with proper calls & whistles, will be heard to sing, to move their tailes, heads & clap their wings."[142]

In sum, hydaulic and mechanical figures became commonplace. Treatises such as De Caus's and Evelyn's helped to spread familiarity with hydraulic antics below the sphere of popes and princes. Martin Löhner, a hydraulic engineer and the Master of Wells [Brunnenmeister] for Nüremberg, established a much-visited host of automata at his own comparatively humble house: Vulcan laboring at his forge; Hercules bludgeoning his dragon; Acteon surprising Diana and her nymphs in their bath, whereupon Diana threw water at Acteon, who turned away, grew antlers on his head, and was attacked by his own dogs; Cerberus spitting fire at Hercules; a lion emerging from his cave to drink from a basin, then retiring; the nine Muses, each engaged at her appointed art.[143] Waterworks were *de rigueur* not only for popes, cardinals, archbishops, and kings, but also for ministers. Richelieu had his own at his residence at Reuil. Evelyn, visiting in 1644, pronounced that garden "so magnificent, that I doubt whether Italy has any exceeding it." He recorded having been shot by streams of water, on his way out of one of Richelieu's grottoes, from muskets held by "two extravagant [automaton] musketeers."[144]

One might think the joke would wear thin, but one would be wrong. The sport proceeded right on through the seventeenth century. Evelyn described with malicious satisfaction, circa 1660, the "wayes of contriving seacret pipes to lie so as may wett the [gazing] Spectators, underneath, behind, in front and at every side according as the Fontaneere is pleased to turne & governe these clandestine & prepostrous showers." Evelyn included, for example, a design for making "a chaire which shall wett those that sit upon it, though no water appeare." The functional features are a water-filled cushion attached to a pipe that rises through the back of the chair and has an opening, concealed in "the carvd head of a Lyon or some other beast," at the top. Thus when the victim sits down on the cushion, he unknowingly squeezes water up into the pipe to "spurt into his neck immediately." This "waggish invention," Evelyn said, he had found in the garden of the Pope's cross-bearer.[145]

The gulled continued to take their licks with unflagging surprise and delight. Anne-Louise d'Orléans, *duchesse de Montpensier,* the memoirist and wayward cousin of Louis XIV, cheerfully recorded her experience at the Essonnes estate of the master of finances for the royal household, where she visited with her friend, Madame de Lixein, in the summer of 1656:

> As I passed through a grotto, they released the fountains, which came out of the pavement. Everyone fled; Madame de Lixein fell and a thousand people fell on her. . . . We saw her being led out by two people, her mask muddy, and her face the same; her handkerchief torn, her clothes, her oversleeves, in short, disconcerted in

the funniest way in the world, and I cannot remember it without laughing. I laughed in her face and she started laughing too, finding that she was in a state to inspire it. She took this accident as a person of humor. She took no meal and went right to bed. ... Upon returning, I visited her: we laughed a lot again, she and I.[146]

Robert Darnton has suggested that historians take note of the mystifying jokes of the past, as these indicate "where to grasp a foreign system of meaning in order to unravel it."[147] To what exotic tapestry do these mischievous machines in their endless funniness connect? Bergson described the quintessential comic situation as "something mechanical encrusted on the living": the appearance of a human being as an automaton. We laugh, Bergson claimed, as a "corrective": to reassert the distance between machinery and life.[148] But, as Darnton's recommendation assumes, humor has a history[149] and the need to establish that human beings are not machines cannot have had the same urgency in 1500 or 1600 as it had in 1900. Rabelais's, not Chaplin's, was the sense of humor at play. The frolicsome engines cataloged in this essay represented something like the opposite of Bergson's scenario: not people as rote automata but machines as responsively alive. The machines' human targets, laughing at the machines' whimsical vitality, do not seem to me to have been reasserting their own transcendence of machinery. I think they were doing something more like delighting in a base corporeality that they thought anchored even the very highest of human lives in an actively material world.

Arriving, then, at the mid-seventeenth century, when the idea of the animal-machine began to flourish in philosophical discussion, we can see that mechanical images of living creatures were already everywhere. They were familiar, not only to the nobility and the wealthy bourgeoisie, but to their servants, and to the engineers and the artisans who built the machines, as well as to the audiences who flocked to witness them, and the literate who read about them. The culture of lifelike machinery surrounding these devices projected no antithesis between machinery and either divinity or vitality. On the contrary, the automata represented spirit in every corporeal guise available, and life at its very liveliest. Here, then, was the culture that gave rise to the seventeenth-century animal-machine. That comparatively confined being represented a narrowing of intellectual and cultural possibilities. To make full sense of this development, we must consider the world that preceded it. Before machines became mindless and rote, they were the life of the party.

Chapter 2, "Machines in the Garden" by Jessica Riskin is reprinted courtesy of *Republics of Letters: A Journal for the Study of Knowledge, Politics, and the Arts*, Stanford University.

Inventing Interfaces

Camillo's Memory Theater and the Renaissance of Human-Computer Interaction

Peter Matussek

He called upon future generations of "wise men" (11)[1] to fulfill what he had left unfinished. Throughout the last two decades of his life, Giulio Camillo (1480?–1544) worked on his legendary *Theatro*, a room-size wooden construction in the style of the Vitruvian theater that supposedly contained "the Ideas of everything Celestial and Inferior" in symbolic form, thus enabling its visitor to memorize the entire cosmos. Although, or rather because, his "fabrica" had been seen by only a few people—the king of France and the Dutch statesman Viglius among them—it attracted the curiosity of his contemporaries. During an illness three months before his death, Camillo felt that it was time to consider his project's afterlife and to convince skeptics that he had not made empty promises. From his bed, he dictated to his close friend Girolamo Muzio a treatise in which he described the architecture and the intended contents of his masterpiece. Six years later, this treatise was published under the title *L'idea del theatro*. Formulated in the future tense, it expresses the confidence that someday a genius like him will be able to finish the labor, guided by his tutorial. Certainly, Camillo had not expected that it would take centuries before his theater's construction plan would be revisited.

After Camillo's time, the project fell almost completely into oblivion. It was not until exactly 400 years after the publication of *L'idea del theatro* that Ernst Gombrich—then senior research lecturer at the Warburg Institute—took the little booklet from the library shelves, handed it over to his colleague Frances Yates, and asked her to read it.[2] Yates soon realized that an enormous amount of further reading would be necessary to grasp what Camillo's short treatise was about. It took sixteen years of intensive study before she could publish her findings in her book *The Art of Memory* (1966), which placed Camillo's work within the context of the

mnemonic tradition from Aristotle to Shakespeare. *The Art of Memory* emerged as one of the most influential nonfiction books of the twentieth century.[3] It found a reception far beyond the community of scholars of the history of ideas (who had largely rejected it). The two chapters on Giulio Camillo, in particular, attracted readers from a great variety of fields: artists, architects, and—with increasing frequency—media scholars, who deal with issues of information visualization, interface design, and human-computer interaction (HCI). This comeback of a five-hundred-year-old, enigmatic, premodern, cosmological concept in the context of digital technology is all the more astonishing given that Yates did not emphasize its rational, encyclopedic aspects, but rather (to the disapproval of many historians) its rootedness in Hermeticism and magic. She thus did not suggest any analogies between Camillo's intentions and computer technology.[4] This begs the question: Why was it the digital age, of all ages, that turned out to be the one to perceive itself as the future that Camillo addressed? The question is all the more pressing, given that the book that paved the way for this reception emphasized precisely those aspects of the past that seem to stand in contradiction to the instrumental reason of computerized modernity.

To venture an answer, we must first examine Camillo's *Idea* within the context of his time and find out what about his *Theatro* makes it so unique among the vast *Theatrum* literature from the sixteenth to the eighteenth centuries. Second, we need to understand why the rediscovery of the text through Yates's work had such an enormous effect. Third, we must examine the correspondences between Camillo's invention technique and the invention of human-computer interfaces in order to evaluate the prospects of this correspondence for the future.

CAMILLO'S INVENTION

Nothing is left of Camillo's theater, of which he had reportedly "finished" a first version during his stay in Sebastiano Sauli's villa near Genoa in 1525.[5] Even the contemporary reports about it—his own and those of the very few visitors who were allowed to see it—remain peculiarly vague. If he really had already finished the project, however, why would he have spent the rest of his life searching for patrons to finance it? After having persuaded Francis I to give him the generous sum of 500 ducats, Camillo often explained his secretiveness about the theater's interior by claiming that the king had provided his support on the condition that Camillo not talk about the project to anyone else.[6] This declaration enhanced the aura of mystery among his devotees, who even called him "divine,"[7] but it drew skepticism from others. Solidly on Camillo's side were artists such as Titian and Francesco Salviati, both of whom were supposed to contribute paintings to the theater,[8] whereas contemporary scholars were divided in their judgments. Pietro Bembo, Johannes Sturm, and Johannes Calvin, for instance, sympathized with Camillo; Paolo Giovo, Étienne Dolet, and others regarded him "as a quack and a

pretender."⁹ Accordingly, they expressed suspicion that Camillo's agreement with the king was "a scam."¹⁰ Erasmus, at first friendly with Camillo, later became wary of him when he realized that Camillo opposed his *Ciceronianus.*¹¹

It is important to keep this uneven contemporary reception in mind when evaluating the sole surviving eyewitness account of the mysterious theater's interior. It stems from a letter written by Viglius Zuichemus, who was a close friend of Erasmus. The latter harbored doubts about Camillo. When Zuichemus stayed in Venice in 1532, Erasmus asked him for a report on the project. In language that expresses astonishment and alienation at once, Viglius wrote:

> The work is of wood, marked with many images, and full of little boxes; there are various orders and grades in it. He gives a place to each individual figure and ornament, and he showed me such a mass of papers that, though I always heard that Cicero was the fountain of richest eloquence, scarcely would I have thought that one author could contain so much or that so many volumes could be pieced together out of his writings. . . . He calls this theatre of his by many names, saying now that it is a built or constructed mind and soul, and now that it is a windowed one. He pretends that all things that the human mind can conceive and which we cannot see with the corporeal eye, after being collected together by diligent meditation may be expressed by certain corporeal signs in such a way that the beholder may at once perceive with his eyes everything that is otherwise hidden in the depths of the human mind. And it is because of this corporeal looking that he calls it a theatre.¹²

What Viglius points out here are the oddities of someone who adheres to old-fashioned Ciceronianism and to a concept of memorization that seems so bizarre to him that he does not even try to understand it. In his letter, he admits frankly that he expressed admiration for Camillo only to hear him speak and thus convict himself of quackery: "When I asked him concerning the meaning of the work, its plan and results—speaking religiously and as though stupefied by the miraculousness of the thing—he threw before me some papers, and recited them so that he expressed the numbers, clauses, and all the artifices of the Italian style, yet slightly unevenly because of the impediment in his speech."¹³

Like every scholar of his time, Viglius was, of course, well acquainted with the *ars memoria* as part of the basic education in rhetoric. With origins in ancient Greece, the teaching of rhetoric was divided during the Hellenistic period into five categories, or canons: *inventio, dispositio, elocutio* or *pronuntiatio, memoria,* and *actio.* The proper knowledge of these became obligatory for every student as an essential part of the *trivium,* the lower section of the *septem artes liberales.* And the standard books through which it was taught were Cicero's *De Oratore,* the pseudo-Ciceronian *Rhetorica ad Herennium,* and Quintilian's *Institutionis Oratoriae.* All three begin their explanation of the "art of memory" with a legend about the Greek lyricist Simonides, who supposedly was the only survivor of a banquet in a palace that collapsed; he was able to identify the bodies because he remembered who had been where. The contemporary reports on Camillo's theater contain some hints

that it would function as such a memory palace. During his trip to France in 1530, for instance, he is said to have demonstrated his method to Claudio Rangone, helping him to easily memorize the *Miserere* in Latin and the *Nunc Dimittis* in the vernacular.[14] But it would be absurd to assume that the function of miraculous theater, of which Camillo made such a fuss, would amount to nothing more than learning short texts by heart. To understand its purpose better, we must take a closer look at Camillo's treatise, *L'idea del theatro,* which he dictated to his friend Muzio shortly before his death.

At first sight, the booklet of 86 pages[15] seems to lead us even further into the dark. It starts by declaring that the "wisest writers always have had the habit of protecting in their writings the secrets of God with dark veils" (7). Therefore, Camillo claims, "we use symbols in our own affairs, as signifying those things that should not be desecrated" (9). And what follows is full of enigmatic references to a syncretistic mixture of biblical, Homeric, Orphic, Zoroastrian, Platonic, Aristotelian, gnosticist, neo-Platonist, Hermetic, and cabalistic scriptures. Thus, one might argue that Camillo treats his prospective readers in the same way he treated his contemporaries: leaving clarifications for a tomorrow that never comes. In his dedication to the treatise, the editor, Lodovico Domenichi, concedes that the theater Camillo describes has not progressed beyond the stage of a project; he expresses the "hope that many of those who, for whatever cause, either envy or ignorance, said that M. Giulio Camillo had promised too much, by reading this *Idea* will know that for him it was as easy to fulfill the promise, as he was ready to make it" (4). This explains why the descriptions of the contents of the theater are written in the future tense, but not what the theater was ultimately supposed to look like.

If, unlike Viglius, we attempt to take Camillo's effusions seriously, we can find plausibility in them. First of all, he is very clear in describing the architecture of the construction: a Vitruvian-style amphitheater with a circle of seven tiers for the audience, each divided in turn into seven sections. On each of these 49 seats are placed images. In this respect, the theater fulfills the requirements of the Roman *ars memoria,* which is based on the principle of *loci et imagines*—i.e., placing images in a well-structured building as reminders of the things one wants to memorize. Camillo also seems to stay within the framework of the ancient *ars* when he states: "Therefore, our great labor has been of finding an order in these seven measures, which is capacious, sufficient, clear and which will always stimulate the mind and jog the memory" (11). At first glance, this is just referring to the recommendation of the Roman rhetoricians to use *imagines agentes,* i.e., images that are pregnant with some feature that activates the mind, so that they stick in one's memory. Even the wording about the effect on the memorizer's mind is identical (Camillo: *percossa*; Cicero: *percutere*).[16] However, we must not overlook the difference in the catalyst for this activation of the memory: The Roman rhetoricians ascribe it to the images themselves, whereas for Camillo it is their *order* that should stimulate the

mind. Such an order can only be thought of as being dynamic. And its intended effect to "jog the memory"— or, as Camillo also says, "to awaken memory" (62)— does not align with the model ascribed to Simonides of a fixed seating order of bodies. What Camillo has in mind is a performative turn of the *ars memoria*. To that end, Camillo draws on the Lullistic *ars combinatoria*, which tries to overcome the necessarily limited representation of things in a static topography with a flexible system that could generate any idea by permutation of their elements. It was precisely this idea of performing logical operations in an analogy to acts on a stage that led Camillo to call his construction a "theater." How did it function? To clarify this further, we need to examine Camillo's *L'idea del theatro* within the context of the scientific literature of the Early Modern Age.

Among the eight hundred or so books that appeared between the fourteenth and eighteenth centuries with "theatrum" or something semantically similar in the title, Camillo's is the fourth.[17] The three that appeared before *L'idea del theatro*— and nearly all of the ones that came after (the few exceptions will be discussed below)—use the term only to indicate that they intended to provide an overview of objects of knowledge of any kind (instruments, proverbs, cities, human passions, appearances of devils, professions, cruelties, evil women, etc.) by arranging them in a manner consistent with a mode of presentation established by the Vitruvian-style theaters of the Renaissance: namely, unlike in the Medieval liturgical performances, the public was now separated from the elevated stage and thus excluded from participation.[18]

The contrast with Camillo's theater could not be greater. What makes his conception stand out against the *theatrum* literature of his time and, even more starkly, of future centuries, is above all his inversion of the architectural functionality of the Renaissance theater. By placing the visitor on the stage and the memory images on the surrounding tiers usually reserved for the audience, Camillo turns the user of his device into an actor. This actor's mind is stimulated by the arrangement of the images in an order that prompts him to combine their meanings and perform his own recollection activities. The vast difference between this memory model and the mainstream is already indicated by the title page of the first edition of his book (figure 3.1).

Designed posthumously, but undoubtedly aligned with Camillo's intentions, the page depicts, on the right, Orpheus with his lyre. Son of the Muse Calliope and thus grandson of Mnemosyne (the goddess of memory), Orpheus stands for remembrance through music as a time-based art, in contrast to the spatial understanding of memory in the *ars memoria*. Also time-based, and equally opposed to the memory concept of storage, is the story to which the Orpheus illustration alludes in combination with the figure on the left, Persephone.[19] It points to the narration of Orpheus's descent to the underworld, where he softened the hearts of Hades and Persephone so that they allowed him to bring his beloved Euridice back alive—under the condition that he not turn back to look at her on their way

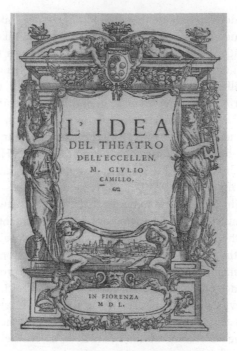

FIGURE 3.1. Title page of Giulio Camillo, *L'idea del theatro* (Florence: Torrentino, 1550)
© Herzog August Bibliothek Wolfenbüttel. http://diglib.hab.de/drucke/qun-139-2-1s/start.
htm?image = 00003

out. This condition, as narrated by Ovid, the well-known source of the mythologi-
cal knowledge of Camillo's time, gives a clear indication that true remembrance
may not rely on fixed images: Orpheus, Ovid writes, may not look at Euridice with
the desire of holding fast her visual appearance.[20] As we know, Orpheus could not
accomplish the task of relying solely on his episodic memory[21] of Eurydice; by
trying to verify her presence physically, he lost her forever. Thus, the message of
the title illustration of *L'idea del theatro* can be seen as a rejection of the memory
concepts of all those books of the Early Modern Age that take the theater model as
an exposition space for the presentation of knowledge objects and whose frontis-
pieces are depicted accordingly.[22]

The most striking characteristic that makes Camillo's treatise unique is, of
course, that it takes the term "theater" not just metaphorically but literally as
something to be built. Let us then enter it now in our imagination and try to fig-
ure out how it works. Standing on the stage and looking at the audience tiers, we
see images, arranged in seven circles, divided in seven sectors (figure 3.2). As we
already know, our task is not simply to keep the places of the images in mind, but
also to understand the dynamics of their architectural order. This order of seven
by seven is meaningful in itself: The seven sectors are to be viewed as the seven pil-

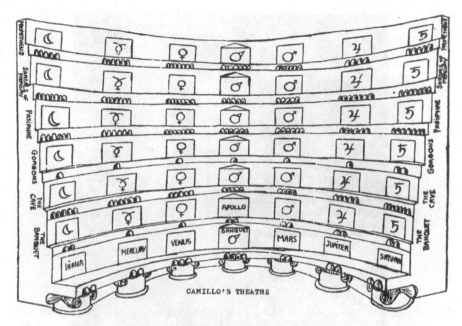

FIGURE 3.2. Sketch of Camillo's Theater (Reconstruction), from Lu Beery Wenneker, "An Examination of *L'idea del theatro* of Giulio Camillo, Including an Annotated Translation, with Special Attention to His Influence on Emblem Literature and Iconography" (Ann Arbor, MI: UMI Dissertation Services, 1970), 446.

lars of Solomon's House of Wisdom, which hold, according to the holy scriptures, the whole universe. To make them distinguishable, Camillo assigns them to the seven planets of the Aristotelian-Ptolemaic universe: Moon, Mercury, Venus, Sun, Mars, Jupiter, and Saturn. Each of these seven planets rules one of the seven segments of the theater, which describe the levels of the Aristotelian cosmos. The first three represent spheres of the macrocosm. On the lowest level (where the highest-ranking people used to sit in the Roman theater) reside the planets themselves—as the spiritual foundations of creation. On the second level we find the basic elements of creation, the *materia prima*, represented by the mythological image of the divine banquet of Oceanos, after Homer's tale. On the third level Camillo places the mixed elements, that is to say, nature, illustrated by the Homeric cave of the nymphs. The fourth level transitions from the macrocosm of creation to the microcosm of man, beginning with the most spiritual aspect—his inner being, his mind and soul. Camillo marks this by an image of the Graeae, the three sisters of the Gorgons who pass a single eye between them in order to see, which he interprets as an indication of the extent to which the "divine ray" of human understanding is external to the self. (Camillo here mistakenly calls these three hags *le Gorgoni*—an error perpetuated by Yates in her reference to this passage.)[23] On the fifth level we find the human body, depicted by Pasíphaë with the bull. The sixth

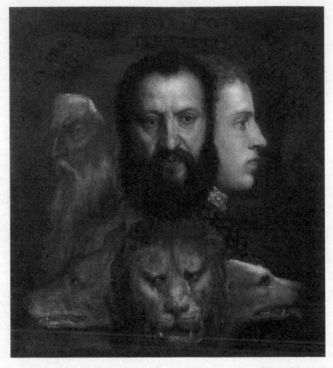

FIGURE 3.3. Titian, *Allegory of Time Governed by Prudence*, ca. 1550, oil on canvas, 75.4 x 173.74 cm (29 ³/₅" x 68 ²/₅"). London, National Gallery. https://commons.wikimedia.org/wiki/File:Titian_-_Allegorie_der_Zeit.jpg

level is reserved for activities connected to biological self-preservation, showing Mercury putting on his sandals. The seventh level, finally, represents man's productive activities—from the crafts through the fine arts to science, represented by an image of Prometheus with a burning lamp.

The images mentioned thus far depict the architectural structure of the theater, like seat tags—albeit ones giving the seating order of the whole cosmos. On the seats themselves, Camillo again places images, at times more than one per seat. In total, his treatise names more than two hundred images, some of which are repeated on different seats. Most of these images can be traced back to the iconographical tradition.[24] For the purposes of this article, I will confine myself to a single prominent example to explain how these images are used (figure. 3.3).

At three of the *loci* of his theater, Camillo places an image described as "three heads of a wolf, a lion and a dog." This description closely matches Titian's famous *Allegory of Time*, which depicts the heads of the same three animals beneath the heads, respectively, of an old man, a man in his prime, and a youth. As Erwin Panofsky and Fritz Saxl have shown in their discussion of this work, the depiction

of Prudence as having three heads—namely those of a wolf, a lion, and a dog—
was commonly known in the artistic circles of Venice in which both Titian and
Camillo moved and is rooted in an old iconographic tradition that can be traced
back to Egyptian Hellenism.[25] Titian is believed to have fully illustrated an edition
of *L'idea del theatro* (see note 8). Although that volume is now lost, the *Allegory
of Prudence,* painted about fifteen years after the publication of Camillo's treatise,
can still offer a unique glimpse of what the images of his theater might have looked
like. Given Titian's close acquaintance with Camillo and his project, there can be
little doubt that Titian's painting aligns with what Camillo had in mind.

In the background of the painting, a Latin inscription associates the pairing of
the old man and the wolf with the past; the middle-aged man and the lion with
the present; and the young man and the dog with the future. It reads: "[F]rom
the past / the present acts prudently / lest it spoil future action." The image there-
fore engages with the phenomenon of time and how it is to be wisely used. Other
images in Camillo's theater also thematize time, but they are assigned to sections
ruled by other planets and therefore represent different aspects of it. For example,
the image of Diana in the Moon sector stands for the months and their parts and
the picture of Geryon in the Sun's sector, for the seasons. These optimistic mean-
ings of time as reproductive cycles of recurring intervals differ from the meanings
in the Saturn section. The planet Saturn is, according to the astrological tradition,
linked to melancholy. In its sector, then, the Allegory of Time is seen from a pes-
simistic perspective as ephemerality. And this general significance again varies in
the three instances the allegory is used in the theater depending on the level at
which the image is placed. With regard to the instance on the cave level (which
represents the macrocosmic level of nature in its basic form of mixed elements),
Camillo writes:

> The three heads of the wolf, lion and dog are so, Macrobius writes,[26] since the an-
> cients, wishing to illustrate the three times, that is, the past, present and future, de-
> picted the abovementioned three heads. That of the wolf signified time past, because
> he has already devoured it. That of the lion is the present (if one can give the present),
> because present troubles thus encountered, strike terror in us, which the face of a
> lion would do, if it overcame us. That of the dog indicates future time, because in
> the manner of a fawning dog, the future always promises us something better. (46)

The perspective corresponding to the cave level thus takes the fleeting nature of
time as its objective natural condition. "The same image of the three-heads under
Pasiphaë," however, Camillo writes, "shall indicate man being subject to time"
(47). For at the Pasiphaë level, we are in the microcosmic sphere of the human
body, which, from the perspective of Saturn, is perceived in its physical transience.
At the level of Mercury's sandals, finally, which represents human activities con-
nected to biological self-preservation, the same image in turn becomes an emblem
for the attempts to stop time or to escape it by breaking off an activity and seeking

a new one, as Camillo notes in shorthand fashion: "The three animal heads, delaying, causing delay, to put an end to, to put off to another time" (78).

What we have seen here is merely a small set of the permutations of possible meanings of the images, which should suffice to suggest the tremendous range of combinational dynamics enabled by Camillo's theater—assuming that the visitor will implement them to full effect in his imagination. The example demonstrates how Camillo embedded the classical *images agentes* into an *ordo agens,* creating emblems that change their meaning in relation to where they are situated within the theater. This transformation of the traditional memory palaces of the *ars memoria* into a playhouse of the entire cosmos, made dynamic by the Lullistic *ars combinatoria* and illustrated with emblematic picture puzzles, had a mixed reception among Camillo's contemporaries. To his devotees from Venetian artistic and hermetic circles, his device appeared to be an innovative path to universal knowledge. From the perspective of his Humanist critics, however, it undermined the idea of an efficient encyclopedia, since the emblematic character of the images had to be interpreted in a complex process of deciphering. They found the approach retrogressive and saw the future of knowledge instead in printed "theater" books. Indeed, if Camillo's primary and fundamental concern had been to design a universal scientific storage device, it remains incomprehensible why he encoded it in such a manneristic way. How, then, did it come to pass that the very distant future of the Information Age would take up Camillo's "visions, which inspire but do not inform"(8)?

CAMILLO'S COMEBACK WITH THE AID OF YATES

Camillo's theater project was all but forgotten when Frances Yates was handed the treatise by Ernst Gombrich in 1950. Although several other publications during the 1950s and up to 1960 had mentioned Camillo,[27] it was not until the great success of Yates's 1966 book, *The Art of Memory,* that he became known to a wider audience. But Yates did not enable Camillo's comeback by adapting the representation of his system of memory to the reception horizon of the dawning computer age. Quite the contrary. She emphasized the very aspects that stood in contrast to the technical rationality of the modern organization of knowledge. Her particular achievement consisted precisely in elaborating the hermetic foundations on which Camillo's theater conception was built. This required extensive research. Five years after she began, she gave the first lecture on Camillo at the Warburg Institute, in which she presented a plan of his theater, placing in it the names of the more than two hundred images mentioned in the treatise.[28] The images and even the cryptic explanations of them that Camillo offered remained for her largely puzzling, but nonetheless she perceived "that there was some historical connection between Camillo's Theatre, Bruno's and Campanella's systems, and Robert Fludd's Theatre system"[29]—works that did not fit in with the generally encyclopedic tendencies of the *Theatrum* literature mentioned above. "Why," she wondered, "when the inven-

tion of printing seemed to have made the great Gothic artificial memories of the Middle Ages no longer necessary, was there this recrudescence of the interest in the art of memory in the strange forms in which we find it in the Renaissance systems of Camillo, Bruno, and Fludd?"[30] She assumed "that the stimulus behind Renaissance occult memory was the Renaissance Hermetic tradition" and that she would have to write a book on that tradition before she could come to explain Camillo's theater within its historical context. She therefore wrote *Giordano Bruno and the Hermetic Tradition*[31] as an extensive preface to the Renaissance chapters of *The Art of Memory*. Here, she worked out, among other things, the influence exerted on the Venetian Renaissance by Marsilio Ficino's translation of the *Corpus Hermeticum*, completed in 1463, as well as the writings of Pico della Mirandola, who was born that same year. She saw this influence particularly strongly in Camillo, whose *L'idea del theatro* was, according to Yates, "full of echoes"[32] of Pico's *Oration on the Dignity of Man*.[33] Moreover, she thought it possible that a passage in the latter text, in which Pico mentions a "theatre of the world *(mundana scaena)*"[34] and relates it to a saying of Mercurius Trismegistus, may have served as the inspirational source for Camillo's *Idea*.[35]

The significant point in Yates's argument, which we take up in detail here, lies in this: It was precisely in the turning back to Hermeticism (believed at the time to be rooted in the archaic wisdom of Egypt) that she perceived the decisive source of a new self-conception of the human being as an autonomous subject, which had first enabled the future progress in science and technology to begin with. In this way, she stood on its head the traditional narrative of the process of rationalization that leads from Renaissance Humanism to modernity. With regard to the competing positions in the above-mentioned *Ciceronius* debate, she determines that the disparaging remarks made by Erasmus and Viglius about Camillo's theater were grounded in a false assumption:

> For the Erasmian type of humanist the art of memory was dying out, killed by the printed book, unfashionable because of its mediaeval associations, a cumbrous art which modern educators are dropping. It was in the occult tradition that the art of memory was taken up again, expanded into new forms, infused with a new life. The rational reader, if he is interested in the history of ideas, must be willing to hear about all ideas which in their time have been potent to move men. The basic changes of orientation within the psyche which are shown to us by Camillo's memory system have vital connections with changes of outlook out of which new movements were to come. The Hermetic impulse towards the world and its workings is a factor in turning men's minds towards science. Camillo is nearer than Erasmus to the scientific movements, still veiled in magic, which are stirring obscurely in the Venetian academies.[36]

Yates's perspective on the history of media and ideas, which was absolutely exceptional and downright "adventurous"[37] for her time, at first garnered sharp criticism from her colleagues. In 1974, they convened a conference on the "Yates

thesis" to counter the "vogue for Hermeticism" that Yates had called into being with her "overly enthusiastic results" about the influence of occult thinking on the scientists of the Renaissance.[38] The assessment of the Bacon expert Brian Vickers was even harsher. In 1979, he wrote in an article in the *Journal of Modern History*: "Yates's proposed rewriting of Renaissance history is an edifice built not on rock nor on sand but on air."[39] With "the infectious energy of her style," she would create a "rhetoric of excitement which will take many readers along with it."[40]

The latter was definitely true. Even as criticism from scholars continued,[41] artists, in particular, felt rather drawn in by Yates's vivid style of writing, which J. B. Trapp characterized as follows: "Entering the past through an intense imaginative effort and in a sympathetic spirit, she recreated its intellectual life by insights and arguments that upset accepted ways of thinking and opened or reopened many doors that had been judged either not to exist or to have been sealed for good."[42]

Although Yates had emphasized the connection between Camillo and the classical *memoria* tradition—and coined the term "memory theater"[43] that was never used in Camillo's writings (he called it *Il theatro della sapientia*[44])—her vivid description made clear that the main purpose of his *ordo* was not just to learn things by heart, but to "jog the memory," thereby activating the imagination of the visitor. To express it in rhetorical terms: It was neither the *dispositio,* the arrangement of subject matters, nor the *memoria,* but rather the *inventio*—the creation of ideas—that was Camillo's main concern.[45] Again and again the treatise focuses on the words "creation" (e.g. 10), "generation" (e.g. 18), and "production" (e.g. 17). And this inventive aspect was best and primarily understood by artists.

The exhibition organizer Harald Szeemann was one of the first who stepped gratefully through the doors, in contrast to Yates's academic colleagues. In 1975, while drafting his concept for the contemporary art exhibition *Documenta,* which takes place every five years in Kassel, Germany, he wrote:

> The core of the plan is the Prototype of the Museum of Obsessions. In its outer form, it follows the Theater of Memory of the Venetian Giulio Camillo (1480–1544), a complex visualization of the systems of memory. . . . The auditorium is thus turned into a scene that the beholder observes from the stage. The entire thing is a *Gesamtkunstwerk* into which Camillo has incorporated all the artists, all the knowledge, all the memory images offered by the analogical thinking of the Renaissance. This reversal of theater finds its correlate in the demand for participation in contemporary art. Marcel Duchamp's call for an eyewitness who would complete the image through the temporal act of beholding proceeds from the same premises; and his main work, which can only be read through seeing and understanding "the decoding of his notes in the Green Valise". . . is the hermetic correlate of our time to Camillo's hermetic-alchemical Theater of Memory.[46]

It can also most certainly be traced back to the influence of Yates that the same year the French painter and sculptor Jean Dubuffet titled one of his series *Théâtres de mémoire,* "which is composed of vast canvases, each created with smaller scenes

and segments to illustrate the abstract and jumbled landscapes that characterize the memory."[47]

In 1993, the Danish artist Mikael Thejll created an installation titled *Anatomical Theater and Memory Theater,* which made exhibition itself into an object of critical reflection by presenting a plaster sculpture of a corpse in the style of eighteenth-century anatomical theater against the backdrop of a stylized rendition of Camillo's amphitheater as portrayed by Wenneker (figure 3.2). The installation, shown as part of an exhibition about *Wunderkammern* (cabinets of curiosities),[48] thus problematized the mortifying nature of museum exhibitions and at the same time elevated it by making it the object of reflection in itself.

Two other, more recent exhibition concepts that were likewise inspired by Camillo via Yates are *THE MUSEUM OF ME (MoMe),*[49] from 2009, by Canadian artist Heidi Ellis Overhill, and Eikoh Hosoe: *Theatre of Memory,* held at the Art Gallery of New South Wales in 2011, presenting the works of the Japanese photographer Hosoe.[50] This reception strand is supported by Yates's view on Camillo, given that she drew associative links between historical configurations to evoke their afterlife—a procedure that certainly was influenced by her acquaintance with Aby Warburg's *Mnemosyne* project.[51]

While these exhibition concepts aim to turn space into the experience of time, another reception strand follows the converse direction within the time-based arts of literature and music, which are then turned into spaces for memorization. In a chapter of his novel *Terra nostra* (1975), Mexican writer Carlos Fuentes introduces fictional Valerio Camillo, who is working on a memory theater.[52] The description conspicuously follows that of Yates, but in Fuentes's novel—which is modeled after James Joyce—Valerio Camillo plans a theater of the complete history of the world, including all possible events that *could* have happened. The novel thus provides "a poetologic model of how it should be read."[53]

It is interesting that poetry as a time-based art could draw inspiration from Camillo's architecture, but it is even more striking that music also did so. John Buller, who initially worked as an architectural surveyor, developed under the influence of Ralph Vaughan Williams and Harrison Birtwistle into an appreciated composer of new music. His symphonic work *The Theatre of Memory,* composed for the 1981 BBC Proms and "dedicated to the memory of the late Francis [sic!] Yates,"[54] arranged the ninety orchestral musicians, in exact accordance with Camillo's theater, in a "semi-circle of seven rising tiers and wedges of players" so that—as Camillo intended—the audience members in the auditorium would have the impression of "looking from the stage"[55] so that they feel similarly stimulated to follow their own trains of recollections while listening to the music. In an analogy to the seven ruling planets of the *Theatro,* Buller placed seven soloists in the front row: celesta, flute, cello, English horn, trumpet, harp, and contrabass clarinet. "Behind these," he explains, "the orchestra is re-ordered in families so that the memory process spreads naturally according to function, as in Camillo's theater. Sometimes these wedges are used in

sticomythia or line-by-line talk, sometimes the cross-rows are used (particularly in the fourth episode, where they form chords)."[56] Thus, time becomes space.[57]

In 1993, the Dutch theatermaker Riek Swarte staged Camillo's *Theatro* in a production titled *The Theatre of Memory or the Mystery of the Lost Secret.* "The team did extensive research into the history of the Ars Memoria, made their own reconstruction of Camillo's memory theater, trained themselves in mnemonic techniques and even used part of their project funding to take a trip to Venice where they studied Camillo's treatise *L'idea del theatro* (1550) in appropriate surroundings."[58] Camillo's theater was reconstructed for the performance in wood. Inside, the audience was instructed to learn a poem by Jorge Luis Borges by heart with the help of the *Theatro,* and the method turned out to be astonishingly useful for the purpose. This experience was contrasted with the loss of memory through external storage, from the printed book to data banks.

The poet and professor of Spanish Carlota Caulfield named one of her volumes of verse *The Book of Giulio Camillo: A Model for a Theater of Memory* (2003), also with the intention of constructing a mental space. In her preface, she states that in her view Camillo "offered the possibility of discovering all of the corners of the human soul and of reaching the inmost depths of the mind."[59] To achieve the same with her poems, she arranges stanzas in seven sections of seven. Each of the stanzas consists of three verses, of which the first always expresses an idea or an image that is expanded upon in the following two lines. It is left to the combinatorial imagination of the reader to decipher the deeper meanings of the tercets.

The novel *Memory Theatre* (2014) by the English philosopher Simon Critchley is rather conventionally written, but with a plot that sheds new light on Camillo.[60] The protagonist (who has much in common with the intellectual biography of the author) one day receives a parcel, anonymously sent, containing a maquette of Camillo's theater. He rereads his copy of Yates's *Art of Memory* and wonders: "Was this the original model that Camillo had used to persuade the King of France to become his patron?" Fascinated by the piece, he decides to construct a life-size theater of memory based on the maquette. His understanding of Camillo's ideas is influenced by an essay by his friend Michel, who reads Hegel's *Phenomenology of Spirit* as a theater of memory, underscoring Hegel's memory concept as one based on the German word "*Erinnerung,*" which "denotes both recollection and the active experience of making inward."[61] As such, it can be opposed to forms of external, mechanical, technologized, or even neuro-physiological memory, captured in the word *Gedächtnis.* "The Hegelian art of memory is the inwardizing of all the shapes of Spirit."[62] Therefore, by reconstructing Camillo's theater, the protagonist seeks to become one with Hegel's absolute spirit through inwardizing all the experiences of his life, arranged in ontological spheres on the seven levels, each segmented in thematic groups, and all represented by statues as reminders, with wooden drawers underneath for papers, records, and photographs that were related to them.

I sat there for hours running through the loci and rehearsing the meanings of the various statues until I recalled everything lucidly. Time had become space. History was geography. Everything was a map and I'd mapped everything. I'd built a vast, living, personal encyclopedia or living intelligence system, where, through mnemotechnics, I would be given a conspectus of the whole. This was the way I would finally overcome my amnesia. Total recall. Lights out.[63]

But nothing happens. In the end, he realizes that he had totally mistaken the concept:

The grotesque scale of the error I had made gradually became clearer to me. What I had built in my Dutch backyard was a flat literalization of the idea of the memory theatre. It was a sort of static, inert, dead rendering of an entity that had to be multi-dimensional, mobile and somehow alive.[64]

He therefore decides to start from scratch and

create something permanently moving. A wheel that turns, returns, and turns again. Hegel's memory theater was a kind of perpetuum mobile, a permanently recreating and re-enacting loop. Knowledge of the Absolute, achieved through recollection, was a vast living organism, a totality endlessly creating novelty out of itself.[65]

And his plan points toward using new media for that purpose:

This would not be another, static memory theatre, but a living machine whose power would be generated by the constant ebb and flow of tides. Moon powered. I began to make little drawings in crayon for a kind of cinematic projection system. I needed to find visual, moving analogues to the entirety of world history that could be projected onto a specially prepared landscape.[66]

Thus, it would be not only a machine for memorizing the past but at the same time a "predictive machine."[67]

In the course of his self-experimentation, the protagonist might have gained some wisdom, but at the same time he goes mad. Here the author seems to play upon Yates's view of the Renaissance theater system:

This madness had a very complex method in it, and what was its object? To arrive at universal knowledge through combining significant images of reality. Always we had the sense that there was a fierce scientific impulse in those efforts, a striving, on the Hermetic plane, after some method of the future, half-glimpsed, half dreamed of, prophetically foreshadowed in those infinitely intricate groupings after a calculus of memory images, after arrangements of memory orders in which the Lullian principle of movement should somehow be combined with a magicized mnemonics using characters of reality.[68]

It was precisely this "scientific impulse" to find "some method of the future" that was seized upon during the second strain of the book's reception, to which we now turn.

IMAGINING THE FUTURE OF HCI THROUGH
REMEMBERING CAMILLO

To understand why it was the modern computer age, of all times, that created a favorable climate for Camillo's reception, we must recognize that both are characterized by a turn away from the culture of the book. Just as in the early era of the printed book Camillo turned away from its humanistic protagonists and, seemingly anachronistically, toward pictorial memory, so in its end phase did digitalization now create a "cultural *dispositif* for visuality, new media, and postmodern narrativity" that, in Barbara Keller-Dall'Asta's words, established this "fascination through Camillo in the waning 20th century."[69] Indeed, Marshall McLuhan's *The Gutenberg Galaxy* is already a swan song to the era of the printed book, which brought with it a linearization of thinking and a narrowing down of an earlier multimediality to a normed typography.[70] At the time that Yates published *The Art of Memory,* however, this cultural capacity was still in its infancy. In 1966 computers were first and foremost calculating machines—which explains why, as mentioned above, Yates only referenced the "mind machine analogy" in relation to the "permutations and combinations of the changing relations" in Bruno's Lullism[71] and not to Camillo's theater. In this early phase, human-computer interfaces depended on punch card readers or keyboards for input and line printers as primary output devices; their cognitive concepts were based on "an amalgam of engineering and human factors," which "saw interaction as a form of man-machine coupling in ways inspired by industrial engineering and ergonomics."[72]

Of course, there were already fantasies about machines of the future that would be able to combine images on displays. The most prominent of these, which turned out to be the most influential for technological development, was Vannevar Bush's concept of *Memex* (the abbreviation alludes to the function of "extending" one's memory), published in 1945.[73] Bush's essay was an important source of inspiration for Ivan Sutherland and Douglas Engelbart, who considerably advanced the development of computer displays and pointing devices. But it was not until the mid-1980s that a new HCI paradigm could establish itself.

Yates's book, however, had already begun to gain attention in technically inclined circles—at first, again, among artists. At Syracuse University in New York, media artist Robert Edgar recalls receiving the book from his friend Robert Polidori, a Canadian photographer, in the early 1970s.[74] Edgar in turn shared it with his classmate Bill Viola, with whom he was working in the Synapse video collective. Both would later pioneer the renaissance of Camillo in cyberspace, once computers had the necessary graphical user interface.

Yet Yates's book seems already to have offered important inspiration for a new HCI paradigm to come. In the mid-1970s MIT formed a working group to research "Augmentation of Human Resources in Command and Control through Multiple Media Man-Machine Interaction."[75] The results were published in 1976 by Richard A. Bolt under the title *Spatial Data Management.* There, he writes: "Intrinsic to the

FIGURE 3.4. Robert Edgar presenting his *Memory Theatre One* (1985), film still, 1986. https://vimeo.com/33134008.

ensemble of studies outlined in the proposal was a study recalling the ancient principle of using spatial cueing as an aid to performance and memory: the 'Simonides Effect.'"[76] What follows is an extensive presentation of classical *loci* methods—with some philological errors that make it evident that the original sources were not consulted and with wording that reveals Yates as the secondary source.[77] With their spatial HCI concept, the MIT researchers paved the way for corresponding developments that were further advanced at Xerox PARC and ultimately led to the Apple Macintosh in 1984.

Even earlier, the Apple II was already equipped with rudimentary graphic capabilities that could be controlled with pointing devices. While the MS-DOS that came with the first PC still forced the user to learn long lists of alphanumeric keyboard commands, the Apple II was already equipped with so-called paddles that moved a cursor with two wheels that the user had to turn for horizontal and vertical positioning. And this was the moment at which media artist Robert Edgar could realize his *Memory Theatre One,* an interactive 3-D computer program, released on an Apple II computer, and programmed in GraForth, with a "Koala Pad," an early precursor of the touch screen, as a steering device (figure 3.4). This was the very first attempt to realize with digital means what Camillo had left to the future to explore.

Edgar's project incorporates some elements of Renaissance cosmology, but at the same time it is driven by the question: "What, I wondered, would an art of memory be like today, when no cosmology can summarize even a single text?"[78]

Edgar's artistic answer, the virtual architecture of his 3-D model, consists of a rotunda with two side rooms: a library and an additional memory room containing the zodiac. These two side rooms represent, as it were, the two poles between which Camillo operated—the encyclopedism of the dawning age of printing and the magic of the Hermetic tradition—to generate a new technique of invention out of the tension between them. Analogously, Edgar attempts the transition from the Gutenberg to the Turing galaxy for our own time. The central piece of *Memory Theatre One* shows two levels with twelve memory rooms each. The upper circle is referred to as a "microcosm," in which we find combinations of images and autobiographical notes that offer the visitor dynamic *loci* for reflection. The lower circle stands for the "macrocosm," in which Edgar has put two pedestals in each room: each pedestal holds an icon, along with a compilation of quotations from newspapers and books. Each of the lower rooms is paired with a room above.

Thus, Edgar does not transfer the historic memory theater model naively one to one, but rather reproduces its *inventive* momentum in the self-referential context of today's information technology: The visitors find themselves in an intermedial space between image and text, a space of intertextuality and interpictoriality in which one literally reads between the lines of words and pictures, thereby filling the semantic gaps with one's own cognition and imagination. That same year, in 1985, Bill Viola created his video installation *Theatre of Memory*, consisting of an uprooted tree with its branches festooned with flickering lights, and a projection of a static-filled video image.[79] Though it appears to be a classical work of video art, it is a thorough reflection on the digital age, as can be inferred from his 1982 article "Will There Be Condominiums in Data Space?"[80]

Edgar and Viola are thus forerunners of a new, cognition-oriented HCI paradigm, which became available with the Apple Macintosh in 1984 and Microsoft Windows in 1985. This new HCI paradigm followed a cognitive psychological model that was "organized around a central metaphor of mind and computer as symmetric, coupled information processors."[81] Instead of communicating with the machine through typed commands that had to follow its algorithmic structure, the user now had icons at hand that were intuitively graspable and thus functioned as "boundary objects"[82] between the computer's cryptic operations and the user's ways of perceiving and thinking.[83]

Once the perception of computers changed—to devices that could model mind processes rather than mere calculating machines—Camillo's *Theatro* could be seen as an important milestone in the prehistory of the neurosciences. As part of an exhibition on that prehistory in Florence in 1989, the art historian and Camillo

expert Lina Bolzoni curated a 3D model of the *Theatro*. In her opening article for the exhibition catalogue, she described Camillo as a "cabbalist programmer" and his theater as an "ultimate computer."[84]

During the 1990s, Mac and Windows computers became ordinary work tools for humanities scholars. Apple's Hypercard, a database development tool with a graphical, user-modifiable interface, released in 1987, allowed many users with no previous programming experience to create their own applications. Among these was a *Theatre of Memory* by Graham Howard and Rob Bevan (1991), which used Camillo's architecture as a user interface for an introduction into the work and time of Shakespeare.[85] With the increasing ability to access the World Wide Web developed by Tim Berners-Lee at CERN, just outside Geneva, Switzerland, certain parallels between the data universe that had newly become populated with images and the *ars memoria* tradition came into focus for Renaissance scholars. Participants from the United Kingdom and the United States attended a symposium at the University of St. Andrews in 1998. The presentations were published two years later under the title *The Renaissance Computer*. In her contribution to the book, Leah S. Marcus devoted herself to a comparison of Camillo's *Theatro* and the graphical user interfaces of the time. She writes: "Just as in classical and Renaissance memory schemes, the computer allows us to imagine the localities of memory operation, with systems of files, folders, and websites fulfilling the earlier role assigned to an imaginary mental edifice."[86] She does add that the normal Windows icons and the icons used by Camillo are not truly analogous because they are lacking "that degree of energized life and impact." However, she continues, "the World Wide Web does offer many examples of animate figures that resemble traditional memory icons in terms of their uncanny power to stay with us; and the web sites where they are to be found, we can speculate, are more likely to be remembered and revisited."[87] And she concludes with the conjecture that the highly theatrical and auditory ways of relating to previous scholarship have become possible once more.[88]

Indeed, throughout the 1990s, theatricality increasingly became a guiding metaphor for scientific modeling—which was not unconnected to the development of computer technology. In 1991, Brenda Laurel, a game designer at Atari and Actrivision and later a consultant for video game companies, published her influential book *Computers as Theater*.[89] And the fact that in this decade cognitive psychology and neuropsychology increasingly made use of theater metaphors can also be linked to an altered view of computers, which had previously offered researchers of memory in cognitive psychology a common functional model as devices for storage and retrieval.[90] In the humanities, as well, the paradigm of theatricality increasingly prevailed over that of textuality;[91] after the linguistic turn and in an extension of the pictorial turn, a new performative turn[92] had been called into being. How should a human-computer interface be designed to do justice to the paradigm of performativity?

FIGURE 3.5. Agnes Hegedüs, *Memory Theater* VR, 1997, archive of the artist.

An idea of this was conveyed once more by a media arts project inspired by reading Yates: the installation *Memory Theater VR* by Agnes Hegedüs, commissioned by the ZKM Center for Art and Media, in Karlsruhe in 1997 (figure 3.5). It is situated in a wooden rotunda with a diameter of about nine meters, reminiscent of Camillo's construction. Inside the rotunda, a panorama projected onto the walls by a computer can be steered with a 3D mouse, according to its positioning within a small model of the rotunda. The projections reflect the construction of the wooden rotunda, so that the real space is mirrored in the virtual and vice versa. This prevents visitors from being immersed in the projections, and instead makes them aware of the situation of their steering activities. Thus, unlike common VR scenarios, which absorb their users, the *Memory Theater VR* empowers them to act self-reflectively like stage directors of their own play on cultural memory. When the mouse is turned, the projection turns around the user; moving the mouse up and down allows the user to virtually "enter" one of four so-called rooms. These rooms deal with the history of virtual reality. Among them is "Fludd's Room," which is designed to resemble a cabinet of curiosities as well as Camillo's memory theater. Using emblematic images, Hegedüs alludes here to early attempts to create virtual realities: from alchemical laboratories, to anamorphotic paintings (Gaudemont), to the artificial rooms of Marcel Duchamp and Bill Seaman. In this way, a transmutative order arises from the constellation of rooms understood by Agnes Hegedüs as an "idiosyncratic history and 'cosmography' of Virtual Reality."[93] Here too, we can observe that the magic and encyclopedic aspects of the memory theater are embedded in an inventive arrangement that appeals to the associations and imagination of the observer: The images provide only fragmentary hints that urge the visitor of the *Memory Theater VR* to generate associative linkages—thus constructing his or her own history of virtual reality.

The Camillo projects produced by Janez Janša (formerly known as Emil Hrvatin) in the subsequent years are literally conceived as performances. *Camillo— Memo 1.0. The Construction of Theatre*, staged in 1998 at the Piccolo Theater in Milan (Italy), was

> driven by the question about how Camillo's Theatre, which assumed the existence and storing of conclusive universal knowledge, could be used as a tool of

manipulation, control and political appropriation. Criticizing such a totalitarian idea, this project sought to explore instead the interactive possibilities of memory. . . . Therefore, an interactive webpage was created alongside, called the *Theatre of Future Memory,* which was also useful for the theatre performance. . . . While online people could imagine and write down their concepts about how the twenty-first century would look, which were then used as scripts for a scene in the theatre performance where the above two controlling positions have been deconstructed.[94]

Another mixed-media performance, *Drive in Camillo,* realized in 2000 on the main square of Ljubljana, Slovenia, was meant as an attempt to translate Camillo's ideas in the urban environment, with projections on surrounding buildings and a "matrix as a huge, 45-meter-tall spider web, stretched between the high-rises, in which a mountain climber . . . links human knowledge with acrobatic stunts."[95]

Media artists have also attempted re-actualizations of Camillo's ideas in the compact format of the ordinary computer monitor. Examples include a website, the *Postmodern Theatre of Memory,* by Ron T. Simon (2000),[96] and a 3D animation, *Theatre of Memory,* by Kate Robinson (2001),[97] that provided the basis for a book of commentary and reflection she published in 2006. The book seeks to draw connections between the *Cosmology of Giulio Camillo* and virtual reality technology.[98]

All these attempts to digitally reanimate Camillo's *Theatro* do not, of course, claim to be more than artistic explorations of how the next generation of human-computer interfaces might be imagined. The demand for them, however, is more and more clearly articulated by scientists in that field of research. In the already-referenced conference paper, *The Three Paradigms of HCI* of 2007, the postulated third paradigm, which is supposed to replace the previous two that were based on the perspectives of engineering and of cognitive science, is described as emerging from a perspective whose "central metaphor is interaction as phenomenologically situated. The goal for interaction is to support situated action in the world, and the questions that arise revolve around how to complement formalized, computational representations and actions with the rich, complex, and messy situations at hand around them."[99]

The articles on HCI that have appeared since then have increasingly seized upon the understanding of Camillo conveyed by Yates. This includes architectural theorists such as Mario Fallini, who posits a "conceptual architecture" as a "digital transposition of Giulio Camillo's 'Theatre of Memory'" and adds this explanation:

The theory mentioned is based on the concept of "magical vision" or an insight able to weave the subtle threads of memory that bind objects, images of objects, events and people in the course of time, revealing the unexpected and sometimes astonishing meanings that beat a human and artistic path. . . . Therefore, as Camillo's *Theatre* encloses a plurality of symbols in continuous recombinations coded according to

internal hierarchies, topics and timelines, it is perhaps possible to rediscover inner images as emblems of our existence, activating a movement of perpetual oscillation that brings the memory to be an instrument of knowledge, in one direction, and to catalyze the creation of new memory, in the reverse motion.[100]

A combination of architectural and virtual environments that operate like theater stages in which users become directors of their own data performances has been attempted in Peter Oldfield's *World Memory Theatre* (2009).[101]

By 2011, Camillo's ideas had become so prevalent that the time had come for *Camillo 2.0: Technology, Memory, Experience*—the title of a Performance Studies International conference. In their announcement, the organizers wrote:

> Camillo's invention took place as developing printing technology allowed for storage of knowledge and information to move outside the brain. Today the "performative turn" and the developments of Web 2.0 make the restrictions of the archive as memory machine tangible and pay homage to the processual, embodied and (inter)active nature of memory. . . . Of course, today's storage options are technically quite different, but the problem is similar: We face a complex accumulation of externalized data that are not accessible for vivid recollection.[102]

In his contribution to the conference, William Uricchio, professor of comparative media studies at MIT and professor of comparative media history at Utrecht University in the Netherlands, takes Camillo's theater as a model for future HCI concepts, which he calls "performative navigation"[103] and envisions as follows:

> Location-aware technologies, together with vast databases, combine to generate personalized assemblages of public information, rendering any particular location—like Camillo's theater—a space of performance. Data are selected based on user profile, interest or choice; they coalesce in different configurations depending on user movement; they can, in the case of augmented reality, offer visual overlays, permitting us to transform the appearance of the world that we see through our screens. The wandering subject of the memory palace, lost in their dreams, here gives way to a new kind of spectator, one whose interactions with an elaborate database permit individual combinations of information and associations, but always through a common taxonomy and an intersubjective frame.[104]

One might ask what remains in such future scenarios of Camillo's magic, which Frances Yates had placed at the center of her presentation. But Uricchio has an answer for this, too:

> Of course, the Hermetic structure of Camillo's creation seems far removed from the binary logics and science of our era. But here, too, things are changing. . . . The algorithmic is not the Hermetic, but in most cases it remains just as carefully guarded, and with workings just as wondrous. . . . The relevance of Camillo's theatre, located on the cusp of the Modern era, grows by the day as we move from the Modern into a new zone of transition.[105]

To interpret the magical as obscure and, therefore, mysterious technology is certainly one possible way to approach the phenomenon. Yates had something similar in mind when she compared the fascination with Lullism in the sixteenth century to the contemporary interest in "mind machines."[106] But the crucial aspect for her was something else, namely that the image would experience an inner self-transformation through the external transformation of the elements. She saw Camillo's contribution to scientific progress precisely in this transformative effect of magical practices, in the creation of a new man:

> Renaissance Hermetic man believes that he has divine powers; he can form a magic memory through which he grasps the world, reflecting the divine macrocosm in the microcosm of his divine *mens*. The magic of celestial proportion flows from his world memory into the magical words of his oratory and poetry, into the perfect proportions of his art and architecture. Something has happened within the psyche, releasing new powers, and the new plan of artificial memory may help us to understand the nature of that inner event.[107]

Indeed, we can see that this transformative aspect of Camillo's magic is also increasingly being taken up by HCI research. The general tendency of the third, phenomenological paradigm to go beyond the merely cognitively conceived notion of usability and toward an all-encompassing user experience[108] is now driven forward by the experimental development of virtual environments that are supposed to enable embodied navigation.[109] This type of navigation was linked to Camillo's memory theater in an empirical study at the University of Maryland, where it was called "memory palace," but understood not in the classical sense of the *ars memoria* as only a mental image, but rather as the "subjective experience of being virtually present in the palace."[110] The authors determine that: "the sensorimotor contingencies of walking and looking around facilitated by head-mounted displays contribute to their higher-order immersion and establishing presence."[111] The study not only concludes that "virtual memory palaces are most effective in eliciting a superior information recall," but also envision that a

> future work would be to allow people to build their own virtual memory palaces, manipulate and organize the content on their own, and then ask them to recall that information. If their active participation in the organization of the data in virtual memory palaces makes a meaningful difference, then that could be further useful in designing interaction-based virtual environments that could one day assist in far superior information management and recall tools than those currently available to us.[112]

Conceptions of active users, who organize the content and layout of their digital environments themselves, have long been proposed under the rubric of user-generated content and user-driven design. What is relatively new, however, is the notion of the user as an actor who moves around *inside* the theater of data arrangements that he or she has built in order to experience combinatorial operations in the flesh.

Even the magical number seven—which the Harvard psychologist George A. Miller declared in the 1950s to be the perfect unit of measure for working memory[113]—is being discussed again in HCI studies after the notion had come under diverse criticism.[114] And it remains to be seen whether, in relation to this, the "seven measures" of Camillo's theater may also one day be re-actualized in those discussions.

It is evident that Camillo's magic gets lost to the extent that it is operationalized. This, indeed, is also true of Yates's explication of the *Theatro.* To demonstrate its magic and its significance for the history of ideas, she had to at the same time demystify it, to lift the "veils" under which Camillo sought to preserve his secret. It is thus the irony of history that Yates's rediscovery of Giulio Camillo as a rather peculiar, hidebound, occult opponent of the humanistic process of rationalization—for which she was heavily criticized by positivistic historians—led to Camillo's adaptation as the precursor of the even-stricter rational workings of computer technology.

In the end, it seems magical that Camillo's reliance on a past mnemonic tradition, seemingly made obsolete by the printing press, would extend its influence into the far-distant future of the digital age. The secret of what turns out today to be a backward-looking prophecy is not to be found in its prediction of things to come but in the inventive processes that the *Theatro* evokes. The arrangement of cultural memory in a way that allows the visitors to be stage directors of their of knowledge perfromances is akin to an alchemical transformation from death to life: It transforms the memory-corpses from the legend of Simonides into vivid recollections; the space-based concept of storage into the time-based one of storytelling; semantic into episodic memories. Therefore, an adequate reception of Camillo's *L'idea* by present-day research in the field of HCI is not to simulate the *Theatro* as such, but instead, to invent interfaces that similarly stimulate the inventive mind.

4

Futurities, Empire, and Censorship

Cervantes in Conversation with Ovid and Orwell

Frederick A. de Armas

At age 57 Cervantes was still a largely unknown writer. His plays were hardly performed, and his pastoral romance seemed forgotten. However, in 1605 he published *Don Quixote*, a work that became immediately popular, not necessarily as a serious work of fiction, but as a humorous book. Its main characters, knight and squire, would appear in parades and carnivals. Only much later would other aspects of his invention amaze the world. This essay, then, studies certain elements of futurity in *Don Quixote*, focusing on notions such as time, empire, and censorship. Before turning to Cervantes, the initial section of this essay seeks to delineate the study of futurities, particularly those that emerged from the Renaissance.

RENAISSANCE FUTURITIES

Exemplifying a concern with the future, Renaissance and other futurities can be conceived as a willful projection into later times of a person's or a people's present and/ or past cultural notions, modes, and materials. Futurities take into account artistic, political, scientific, and philosophical notions or aspirations as they seek to affect later times. As such, futurities can take the form of an imaginary utopia, an invention that will shape later discoveries or affect how they are applied. They can also take the form of a groundbreaking artistic endeavor that finds fulfillment in later times, an idea meant to move forward; or they can be literary genres and devices that will impact the future. In terms of a person's or a character's life, the most pervasive impetus for futurity is fame (which includes, for example, cultural renown, literary legacy, monuments to the person's deeds, and to a lesser extent, name/descendants that entail, for example, "permanent" possessions such as lands, titles, and riches).

Futurities may be also rediscovered retrospectively, when a later work such as a contemporary poem or painting, for example, may trigger echoes of earlier (Renaissance) works, leading to a rediscovery of their latent futurity. By reversing the projection of futurities, we may discern new readings of older texts or artifacts of culture, moments where they echo their future and burst into later times as they seemingly challenge a linear historicity. These later times are not necessarily our present. It is also possible to study effects in previous times such as the nineteenth century. An example of such a past echo and its complexities will suffice. The art of Sandro Botticelli was neglected for centuries, following Giorgio Vasari's first history of art, one that fixed during the Renaissance and into the future the development of painting, culminating with Leonardo, Raphael, and Michelangelo. In his work, Vasari explicitly relegated Botticelli by finding fault, by seeing him as an "eccentric." Thus this artist sank into obscurity (a negative futurity), and his many innovations did not affect his near future. However, he was rediscovered in the late nineteenth century. Henry James gives us this sense of discovery when he speaks of a "Botticelli so obscurely hung, in one of the smaller rooms, that I scarce knew whether most to enjoy or resent its relegation His imagination is of things strange, subtle and complicated—things it at first strikes us that we moderns have reason to know, and that it has taken us all the ages to learn; so that we permit ourselves to wonder how a 'primitive' could come by them."[1] Henry James found in Botticelli modernist echoes that questioned aspects of rationality. The discovery of what I would call Botticelli's futurity becomes, as Melius explains, "an experience of belatedness and historical bewilderment."[2]

Although the discovery of futurities may be found in any culture, it would have less of an effect in traditional societies given their relegation of futurities to mythical repetition.[3] Yearning to remain in mythical time, some of these societies eschewed the "terror of history" and sought to escape any form of linearity. For them, futurities would be almost meaningless. Although I take the term "traditional" from the writings of Mircea Eliade, I by no means imply that these societies are backwards or that Western linearity is a superior mode of thinking. Rather, I use the term to bring together cultures that view time in a different manner. Futurities, then, is a notion that has always been with us, although it has become more prominent in human beings and societies that have veered away from the view of time and of history as circular and repetitive. Although often tied to the past, as in the Vedic concept of the four *yugas* or classical antiquity's notion of the four ages of the world that repeat themselves to infinity,[4] variations on this view appear in the work of modern historians such as Oswald Spengler and Arnold Toynbee. Contemporary theories of political-demographic cycles are inspired by the ancient conceptions.[5]

In terms of time, we can conceive of the Roman Empire as one of the crucial moments when cyclical history is swept away in favor of a linear conception of time. Rome, like most cities, lands, and empires, was destined for destruction (and

cyclical regeneration) from the time of its conception. Virgil transformed cyclical into linear time when he proclaimed that the *pax romana* under Augustus was the return of the most perfect of all ages, the golden age, and that it came without the need of a previous purification or destruction. Furthermore, this new age would last for all time: "For these I set no bounds in space or time; but have given empire without end."[6] Suddenly, the Roman Empire reaches out for futurity, and an extreme one at that, having no end. Paradoxically, in this very eternity, it would have lost the sense of linear history.

Christian empires take their cue from this newly created historicity, their religion now compatible with this linear view, one that ends with the end of creation and without cycles or repetition. During the Renaissance, the Habsburg Empire set itself as a descendant of the Romans, and as an empire that would last to the ends of time. Indeed, this vision of a perfectible future pervaded the Renaissance through its iteration in the two Habsburg lines ruling the German lands and the Spanish Empire. Even before the Habsburgs split, Charles V embodied the notion of a "world emperor." The many wars that took place in Italy between the Habsburg Empire and the French had a notable effect. Renaissance Italy came to reflect the metamorphosis of cyclical time into imperial futurities. Ludovico Ariosto, for example, would have Duke Astolfo listen to the prophecy that a new golden age comes with Emperor Charles V, a time for perfection without end.[7] Numerous rulers throughout Renaissance and early modern Europe would latch on to the myth of the Golden Age of humankind to laud their own rulers. In so doing, they were not espousing cyclical time, but asserting that an Augustan perfection could exist within history and would thus clash with other lands, as each asserted its perfection or perfectibility.[8]

DON QUIXOTE: CYCLICAL TIME AND WAVERING FUTURITIES

This imperial reach for futurities is at the heart of the culture of the Spanish Renaissance and Golden Age. Writers of the period, time and again, proclaim the return of an (imperial) Golden Age with a new monarch. Philip IV is depicted next to the goddess Astraea, whose return to earth serves as a harbinger of a new age.[9] Surrounded by prophecies of mythical return and, paradoxically, of a new empire that will accomplish great things as it reaches into the future, Cervantes will insert these ideas into his work. For some, *Don Quixote* is a work that deals with the past, with a chivalric world that the would-be knight would attempt to re-create. This return to the past is couched in mythical and timeless language. He alone would be able to bring back the age of chivalry and even become emperor. Indeed, in his famous speech to the goatherds, he imagines the return of the Golden Age. This mythical and circular time is used to make him into a timeless hero.

A key Cervantine futurity is suggested by the clash between a hero who wishes to re-establish a golden age (and thus become a new Charles V) and the disordered calendar presented in the text, one that confuses Roman, Julian, and Gregorian calendars, inserting ancient feasts where they do not belong and creating a seemingly anachronistic time.[10] While the protagonist trumpets the new age that he will bring about, the narrative confuses the reader as to the timeline. While the knight points to his own willful projection, one where he self-fashions himself as key to the future, the text revels in instability that drowns him in historical contingencies. The would-be knight parodies past exemplars of chivalry, while at the same time performing the end of chivalry. Compressing time, the knight even points to a modern world without heroes, a practice envisioned since James Joyce's *Ulysses*. As he moves through the constricted spaces of Spain's southern geography, he envisions the immense spaces of past chivalric novels which themselves telescope into the new terrains, new worlds that have just been "discovered" by Europeans, new worlds that can morph into spaces of today. Spaces of imperial Spain become geographies of resistance where the knight unwittingly parodies conquest through failure, a failure that affects his own masculinity.[11] And failure is in itself a way in which theorists today critique capitalism's heteronormativity.[12] The weight of history upon the knight might paradoxically "construct queer futurity as a break with heteronormative notions of time and history."[13] Thus, Cervantes's *Don Quixote* is "novel" in our own time. It is a novel of failure; a novel where a knight fascinates through un-masculine fragility; a novel that breaks with time and history while in the midst of proclaiming its importance. It is an anachronistic work that chronicles the failure of a modern hero, and the fate of this hero is deeply entwined with the destiny of his empire. In all these ways Cervantes points to futurity; his work envisions a future that resembles our own and motifs and struggles that are akin to our own.

It should come as no surprise, then, that the novel includes a veiled praise of Botticelli's *Primavera*. In a grotesque ekphrasis, Cervantes renders homage to a painter, discarded by Vasari but rediscovered in the nineteenth century by John Ruskin, Walter Pater, Henry James, and so many others.[14] It is as if Cervantes points to futurity, to the contemporary praise of Botticelli, while at the same time acknowledging that futurity wavers through time. In other words, an artist may disappear from the canon only to be rediscovered subsequently.

This is precisely what happens to Cervantes's novel. In the seventeenth century, it became popular among the people, as knight and squire were subjects of comic parades and figures of carnival. But the text was not canonized until the eighteenth century. A luxury edition in four volumes was conceived by Lord John Carteret, Earl of Granville.[15] He published it as a present to Queen Caroline. After all, she had a room or museum dedicated to Merlin the Magician in Richmond Park.[16] And since the famed Arthurian magus makes an appearance in *Don Quixote,* it was thought a worthy addition to her room. Carteret commissioned John Vander-

bank to do an illustration for the frontispiece of this edition, which appeared in 1738.[17] Here, Cervantes himself has been transformed into a classical hero or demi-god. As this godlike Cervantes goes to do battle, nine women stand by him with both fear and hope. Having been displaced from their home by monsters, the nine Muses stand and wait. To battle the creatures, a Satyr (satire) grants Don Quixote a mask that will allow him to destroy the monstrous books of chivalry that have taken over Mount Parnassus. Canonicity here somewhat contrasts futurity. The work is appreciated for its connections to the past. Later, with the "romantic" approach, the knight is neither comic figure nor tool for the cleansing of old genres. He becomes a hero imbued with numerous qualities, such as determination and fortitude.

The realization of the novel's instabilities brings it into the modern era and thus creates its futurity as the first modern novel. Critics and writers focus on Cide Hamete Benengeli, an Arabic narrator who by force confronts his main character, a Christian knight. Even before Wayne Booth coined the term "unreliable narrator," Cervantes's narrative joined the ranks of the "modern" novel.[18] Critics pointed to the many levels of narration; they also stressed that characters had become rounded, complex. Critics asked whether the knight was hero or fool, leading to further complex readings. Thus we have today's *Don Quixote*, lauded as the first modern novel, partaking of futurity, deeply influencing modern writers, who often see it as a work before its time, in terms of invention or the structuring of a new genre through shifting perspectives and unreliable narration; or through its capaciousness and genre-bending discourse.[19]

There is also a political subtext in the novel, one that was noticed long before the advent of New Historicism. Here, imperial reach, the writing of empire, and the mechanisms of power and control are questioned. Having glanced at cyclical time and at the wavering of futurities in the history of this novel, let us turn to hidden futurities. I am not speaking here of the very common ways in which futurities are crafted during the Renaissance, such as the notion of fame, name, and renown, one that will propel the knight and his maker to the future. I am speaking of a series of choices made by character and author, choices that impinge on our times. Perhaps this futurity is merely the illusion of what some may call a "universal" work, one that seems to speak to readers in different times and places. But I would argue that some of the futurities of *Don Quixote* have to do with a series of very specific notions that seek to question power and imperial reach. They resonate with the notion of an Orwellian dystopia and even an American Empire, but also bring forward Renaissance ideas on how to deal with questions such as imperial control and censorship.

In the upcoming sections of this essay, I focus on the ways in which Cervantes's visions of censorship and practice of self-censorship are implicated in future concerns and even our own. I look at how societal control echoes through different empires, expansionism leads to perpetual war, fake news seeps into the text; even

at how enhanced interrogation can be located in the novel as a kind of reverse-echo futurity. To make clear the importance of the Roman Empire in the fashioning of the Spanish Empire (and the construction of resistance), I turn to one of Virgil's contemporaries, Ovid, and place him in conversation with Cervantes. Since George Orwell was deeply influenced by Cervantes, I use some of his ideas to clarify the path that is taken by Cervantes as he approaches later empires. About the present American Empire, I will be very brief, although much can be gleaned through the reading of the three writers whom I have chosen to foreground.

THE SITES OF EMPIRE

The play of censorship to be discussed in this essay takes place in imperial sites. Thus, it is important to take these sites and their futurities into account as we proceed. The notions of cyclical versus linear history were accompanied in the West by another important schema that had its own separate trajectory. Although there are many versions of *translatio imperii*, writers envisioned the recurring rise and fall of empires, starting in the East,[20] and then moving west, passing through Persia and Greece and finally reaching Rome. According to this vision, empires rise, reach their apogee, and then fall, allowing for the next one to their west to follow this pattern. Antonio de Nebrija, author of the first Spanish grammar, refers to this movement "in his exposition of the transition from Greece to Rome, motivated by the dissipation of Alexander's empire."[21] If empire does not halt with the Virgilian image of an eternal Rome, and later with the Holy Roman Empire of Charlemagne and his followers, then Spain, being the westernmost European kingdom, might be heir to empire.[22] Nebrija expresses his concern that "just as the decline of empires had led to linguistic corruption and oblivion, the same thing could happen to Spain if the cycle were to be repeated."[23] His grammar would seek to halt any future *translatio.*[24] The notion of *translatio,* then, is deeply entwined with futurities. It underlines the anxieties of the endings of all empires (although they will have a future through fame), and it propels writers and thinkers to develop theories that would stop the procession of empires through time (as in Virgil and Nebrija).

Even in our contemporary world, comparisons between Rome and America abound, pointing to a transatlantic *translatio* (by way of the British Empire). For example, Andrew Bacevich clearly asserts: "Like it or not, America today is Rome, committed irreversibly to the maintenance and, where feasible, expansion of an empire that differs from every other empire in history."[25] And Niall Ferguson explains: "Like Rome it [America] began with a relatively small core . . . which expanded to dominate half a continent. Like Rome, it was an inclusive empire, relatively (though not wholly) promiscuous in the way it conferred its citizenship. Like Rome, it had, at least for a time, its disenfranchised slaves. But unlike Rome, its republican constitution has withstood the ambitions of any would-be Caesars—

so far."[26] Ferguson adds to the "so far" a second ominous note: "The dilemmas faced by America today have more in common with those faced by the later Caesars than with those faced by the Founding Fathers."[27]

Although this essay focuses on Cervantes and the Spanish Empire, it draws upon the Spanish author's conversations with Ovid and the Roman Empire, with Orwell and the remains of the British Empire, and, through the latter, it points to the American Empire.

Cervantes's novel repeatedly refers to Rome, from the speech of the Golden Age with its Virgilian and imperial overtones, to the recurring references to Roman writers in the prologue to Part One and beyond. The speech of the Golden Age, as mentioned above, serves to echo Rome's interest in futurity, its desire to become an empire without end. It thus calls attention to the futurities of the Spanish Empire and its anxieties over a fall, over a "translation" that would stunt its projection into the future, and preserve it only in the hall of fame of past empires. Don Quixote as character already embodies decline. Instead of being a vital and valiant young man in search of fame and adventure, he is a forgotten hidalgo, about fifty years old, who rides a skeletal nag and displays decrepit armor. If he is to be the embodiment of empire, then that empire is already in decline. His many losses in battle recall the defeats that Spain would encounter more and more frequently, and his lack of wealth would remind the reader of the imperial bankruptcies caused by constant war. Through a conspicuous juxtaposition of a false knight's hyperbolic views and the historical realities of imperial overreach, the work embodies the anxious and declining future of empire.

While Virgil may be the most cited of Roman writers in Cervantes's novel, being a reminder of the notion of empire without end, Ovid, yet another Augustan writer, appears throughout the novel. Although the *Metamorphoses* are often cited, the Ovid of the later works, the works of exile, becomes unusually important in Cervantes. These later writings will be key to notions of censorship in Cervantes and beyond. Although it may seem that there are few links between the later Ovid, as he fashions himself in the *Tristia* and the *Ibis,* and the knight from La Mancha, a closer look at each points to a significant connection. The Ovid of exile is overwhelmed by the extreme temperatures and the savagery of the lands by the Black Sea where he is sent. As a representative of Rome, he certainly lacks *virtus*, the main quality expected of its people and suggesting valor and manliness. It is as if the center of empire produces feeble offspring. This leads us to yet another important feature/schema of empire as commonly portrayed: rise or *imperiogenesis,* which, according to Peter Turchin, often occurs through a people "characterized by cooperation and a high capacity for collective action,"[28] a peak and a decline (*imperiopathosis*). Empires, as they reach their peak, accumulate such wealth and bounty that the peoples at their centers may lose the "masculinity" required of a system that promotes constant wars. These new subjects, as they engage in the arts, come to realize that their leisure and comfort stem from a system that seeks

enslavement and conquest. Critiques of the system thus arise. Their fall, according to some theorists, is due not to this "feebleness" but to the excess of the elites, the overreach of power, and the depletion of resources through constant war and the collapse of the economy.

If the Roman example is adduced, then the "contagion" reaches the rulers themselves: "the capacity of effeminate emperors and other political figures to emasculate the state, as it were, to weaken, and ultimately endanger, Roman hegemony."[29] While the Ovid of the later poems seems weak and perhaps even "effeminate" (in a heteronormative sense) and thus performs his own fall from empire through his poems, he does not point to the fall of empire, but to its preservation through critical thinking. Don Quixote's feebleness may point to the "feeble" successors of Emperor Charles V and the eventual downfall of the Spanish Empire. The poverty that surrounds the knight as he travels through the countryside may serve as a contrast to dreams of immense riches, the wealth of the elites. The knight and the novel may be said to embody a critique of empire, hidden by the book's avowed purpose (to bring down the novels of chivalry) and by the work's comic nature. Turning to Orwell's *Nineteen Eighty-Four,* feebleness has been carefully erased by the rulers, as all subjects are considered feeble, totally controlled by power, and constantly watched for any signs of a critique of the system as the state engages in constant war. In today's America, war seems to be a constant, the elites are reaching unparalleled wealth, and the arts and humanities are constantly under fire, as the more "manly" pursuits of the sciences are promoted. Of all three texts being discussed, *Don Quixote* seems to be the one that most closely approaches our historic moment, thus becoming an example of reverse-echo futurities.

THE CENSORS: CATO, AUGUSTUS, AND O'BRIEN

The modern census derives from the one that was conducted in the ancient Roman Republic by two magistrates called *censores.*[30] As their duties expanded over time, they were charged with evaluating Roman character and moral habits. They would give a letter or mark (*nota*) to those who violated proper conduct.[31] The term *censere* (to assess) was used in this context, thus linking the census with censorship. The counting of bodies and the censoring of certain practices became intertwined.[32]

The prohibition of books was unrelated to the term until at least the sixteenth century.[33] Spain used two basic types of textual censorship: *censura praevia* and *censura repressiva.*[34] Before publication, all book manuscripts written during the *Siglo de Oro* had to be approved—that is, they had to be subject to *censura praevia,* to ensure that they contained nothing against the Catholic religion and proper customs.[35] The name given to those charged with these *aprobaciones* was "censores" or censors.[36] In other words, censors were the ones who counted pages and manuscripts, marked passages or texts, and approved or censored. The Inquisition,

on the other hand, prepared Indexes of Forbidden Books and used *censura repressiva* to find and burn forbidden books already in bookstores.[37]

Taking the development of the notion of censorship into account, we can view Cervantes's *Don Quixote* as a body that speaks and can be censored; as a text that self-censors, and more importantly as one that conceals or camouflages meaning, a kind of steganography that hides the notion that something is hidden and thus makes its deeper musings available only to engaged readers.[38] Although I am not aware of Cervantes's knowledge of steganography, he did evince interest in a related area, physiognomy, pointing to hidden traits that reveal a person's character. And he would have known the technique used by playwrights to speak to power: "decir sin decir"—saying without saying, so that some of the transgressive elements could be hidden in plain sight.[39]

We may remember that in the prologue to *Don Quixote* the "author" bemoans the fact that his book is too plain, lacking adornment. A friend arrives and counsels him on clever ways to ornament his text with well-known Latin *sententiae* and commonplace classical allusions.[40] The fifth and last maxim is said to derive from Cato.[41] In an age when classical learning was pervasive among the educated, it would be clear that this particular *sententia* came from Ovid rather than from Cato. The two verses derive from *Tristia*, Ovid's meditations on exile: "So long as you are secure you will count many friends; if your life becomes clouded you will be alone."[42]

The camouflaging of Ovid's authorship is perhaps one of the first instances pointing to meditations on questions of censorship. Cato (who is touted as the author) was often referred to as *Censorius* (the Censor), thus pointing to the last major office he held in Rome (184 BC). And this name was quite apt since he was particularly censorious, always living a simple life while railing against the lifestyle of others.[43] Cervantes, aware of the censorious nature of Cato, places his name in the Prologue so as to camouflage the name of Ovid. After all, Ovid had been banished from Rome by Emperor Augustus for *carmen et error*,[44] something he had written and something he had done (thus bringing together the notion of censoring a person and a book). While Cervantes openly compares his book to Ovid's *Metamorphoses* in the introductory poems to his novel,[45] he hides the Roman poet in this second citation since the *Tristia* belonged to the censored Ovidian body. As an instance of steganography, Cervantes's text first conceals criticism by citing Horace and the Gospels. Thus protected by enumeration of authorities, the work can pretend to err. Instead it may be writing to those who, like Ovid and himself, were without friends in high places, abandoned at the edges of empire, censored and seeking solace.

A very successful writer in Augustan times, Ovid had enjoyed the favor of the emperor, a patron of the arts, for most of his life. But then he was banished to Tomis, a town on the Black Sea.[46] Ovid's works in exile are typified by a lament of his relegation to a barbarous and frozen land and a desire to regain the emperor's

good will, which would allow him to return to Rome. Thus, bursts of praise are accompanied by laments that may border on subversive complaints.[47] By censoring Ovid, Cervantes hides his book of exile as a dangerous text and body, while at the same time creating a secret space for meditation on censorship. The need for such spaces underlines Cervantes's desire for more open conversations. Orwell's dystopia, on the other hand, makes such sites abhorrent and suspect rather than spaces of comfort. Within the novel, Goldstein's clandestine volume, which advocated freedoms and explains the workings of the totalitarian Oceania, was often the object of a daily gathering, "The Hate," in which all party members joined.[48] When O'Brien gives Winston such a book, he does so to further incriminate him, rather than to allow for a place for freedom. In the end, he reveals that the book is a fake, written by a committee including himself.[49] While exposing total control, Orwell's novel is claustrophobic. On the other hand, Ovid's book is a yearning for Rome and for a kinder empire. Ovid, Orwell, and Cervantes point to futurities in the way they point to censorship and its practice in imperial settings, including America today.

A 2013 report by the PEN American Center states: "Writers are self-censoring their work and their online activity due to their fears that commenting on, researching, or writing about certain issues will cause them harm. Writers reported self-censoring on subjects including military affairs, the Middle East, North Africa region, mass incarceration, drug policies, pornography, the Occupy movement, the study of certain languages, and criticism of the U.S. government. The fear of surveillance—and doubt over the way in which the government intends to use the data it gathers—has prompted PEN writers to change their behavior in numerous ways that curtail their freedom of expression and restrict the free flow of information."[50] Given the situation, Cervantes's novel provides an alternate future to the self-censored by exhibiting mechanisms through which the threat of censorship can be sidestepped through cloaking devices.

CRUELTY, CUTS, AND DISMEMBERING

In addition to *sententiae*, the friend in the Cervantine prologue recommends classical allusions to adorn the book. After another concealing *enumeratio*, he asserts: "si de crueles, Ovidio os entregará a Medea" [if you would tell of cruel women, Ovid will acquaint you with Medea].[51] Indeed, Medea's character is carefully delineated in four very different works by the Roman poet: *Heroides, Metamorphoses*, the lost play titled *Medea*, and the exile poem *Tristia*. Most editors who footnote Medea consider that the friend's allusion derives from *Metamorphoses*, book 7.[52] However, only *Tristia* accurately fits the description of Medea as cruel.[53] In the ninth letter of the third part, Ovid explains the origin of the name Tomis, a city on the northern coast of the Black Sea to which he was exiled. He begins by evoking this "wild barbarian world"[54] and narrating how "wicked

Medea" (*impia*)[55] travels to Tomis after abandoning her father at Colchis. But King Aeetes is in pursuit. This is the turning point in her life, as Ovid foreshadows what is to come. The Roman poet describes how she clutches her heart with a guilty hand "that dared and was to dare many things unspeakable" (*nefanda*),[56] thus linking imminent actions to future deeds. Her audacity and wickedness reaches their peak as she looks around for a way to save herself. Gazing upon her brother Absyrtus, she immediately realizes what she must do. She does not even debate her decision but acts with full knowledge of the magnitude of her unspeakable deed. One look at her brother, and she sets her mind upon fratricide to delay her father and have him mourn for his son. Ovid describes the cruel manner of the murder: Medea hacks and tears his limbs apart. Although in some versions she does so already fleeing by ship, in Ovid she scatters the remains through the fields around Tomis. As a final unredeemable act, she places his hands and head on a high promontory. She knows that King Aeetes must gather up all of his son's dismembered parts in sorrow. And this gives her time to escape. This moment is characterized in Stephen Russell's words by its cruelty and "unrelenting darkness."[57] The moment is inscribed upon the name of the city, which Ovid derives from *tomi*, "to cut."[58] Ovid, in his lament, shows quite clearly how the emperor has cut him from empire, has sent him to a sorcerous place: Medea embodies the emperor's cut, his censorship.

Cervantes points to this moment as cruel, reflecting on the sorrows of a censored body. Indeed, Ovid's *Tristia* consists of disparate parts, and Cervantes's novel appropriates the idea of cutting and fragmentation. At the end of chapter 8, for example, the reader is left in suspense as Don Quixote and the Biscayan have their swords held high; the author or editor claims that he cannot narrate the rest of the episode because the manuscript is cut off and ends at this point. In chapter 9 we are treated to a search for the rest of the manuscript, while being told that we must wait for the juicy details: a sword that will come down and cut one of the bodies as it would a pomegranate. The pomegranate, when sliced, shows its red interior, the blood held inside the human body. This fruit, as Eric Graf has pointed out, represents the body politic, both the Catholic kingdom and the ancient Islamic kingdom of Granada.[59] Indeed, when Granada fell, the fruit was added to the shield of the Catholic Kings. Cutting, dismembering, and fragmentation in Cervantes all point to the censored Islamic body and to the empire that seeks to discard the memory of its history. As Orwell states of each member of society: "He must be cut off from the past . . . because it is necessary for him to believe that he is better off than his ancestors"[60] Thus, new histories are written, reminding us of the dictum that history belongs to the victor. In Orwell's case, a new world keeps changing and even inventing its events through "fake news." Since Orwell cuts off a society from the truths of historical accounts, and even artistic endeavors from the past, neither Ovid nor Cervantes would be available to remind people of the cruelty of such a deed. Cervantes and Ovid engage in

futurities, reminding us that discarding history and forgetting the past can lead to situations as dire as those found in Orwell.

THE BOOK'S WHIMSICAL BODY

Authors who wish to grapple with what cannot be said at times create a different aesthetics, one of whimsy, ugliness, and fragmentation. At the very beginning of *Tristia*, Ovid writes an apostrophe to his little book, urging it to go without him to Rome, a place he can no longer enter. By personifying the book and claiming that in his home in the capital of the empire it will find its lost brothers (the other works by Ovid), he treats the tome as his own child. The child, albeit an imperfect creature, will enjoy the empire and plead for him, while the poet will remain in a dark and barbarous place where he is buffeted by winter storms.[61]

Cervantes begins his prologue in a similar manner, calling his book a child of his understanding, which was also engendered in a dark place, in this case a prison.[62] For both Ovid and Cervantes, there is an ideal place where good books are written; but theirs come from a different site and state of mind, and thus are born defective.[63] Both mark the authors and texts as beings that are outside the empire, outside the frontiers of civilization.[64] In modern times, George Orwell does the same, writing of his despair from a remote island. George Woodcock asserts that Orwell "was—in the end—a man as much in isolation as Don Quixote. His was the isolation of every man who seeks the truth diligently, no matter how unpleasant its implications may be to others or even to himself."[65] *Nineteen Eighty-Four* embodies precisely those elements of injustice, censorship, and thirst for unlimited power that he opposed. The book itself is whimsical, mad, fragmented, and claustrophobic.

The result of exile and censorship is the creation of unpolished children, children who lack adornment and beauty. By acting against the censors, these personified books have a voice that seems to penetrate the empire, be it Rome or Madrid. Orwell writes a book about censorship of books and bodies that takes place in 1984 but includes an appendix from the year 2050, when the principles of Newspeak seem to be an item of history, a thing of the past that is no longer censored. Within the book, Winston had started a diary, "a lonely ghost uttering a truth that nobody would ever hear."[66] But the appendix allows for a space where his ugly and fragmented ghost child would enter the world of the future. Cervantes's child also enters our futurities crying out for truths that might be hidden.

THE FLAYED AND THE MAD (*DON QUIXOTE*, 4)

The whimsical body is also assigned to the protagonists, who must be eccentric and thus hide their abilities to say the forbidden through their manias, another

form of steganography. Cervantes hides transgression by creating a crazed gentle-man, since the mad had license to speak and elicit laughter rather than recrimi-nation. Ovid's *Tristia* shares some of the mad melancholy of its successor. Much darker is *Nineteen Eighty-Four,* where madness, straying from the party line, leads directly to the Ministry of Love, the home of the Inquisitors.

In the third book of *Ex Pontus,* Ovid praises the way in which Marsyas taught Olympus to play the pipes. Marsyas, symbol of freedom, held a musical competi-tion with Apollo.[67] After Marsyas lost, the god flayed him alive.[68] In the Early Mod-ern period, artists from Raphael to Jusepe de Ribera and Luca Giordano showed the vengeful nature of power in such depictions. In Ovid, then, Marsyas is a heroic and tragic figure, one akin to the Roman poet himself—a poet who dares to speak of things the emperor disdains, only to be exiled.

The Ovidian image of Marsyas as a censored body is curiously refashioned in chapter 4 of *Don Quixote,* where the flayed and censored body belongs to a vic-tim: Don Quixote would save a youth who is being beaten, and Andrés seeks to reinforce this aspiration. He asserts that he is truly saintly, a martyr who does not deserve such punishment: His master is having him flayed like St. Bartholomew, a Christian Marsyas.[69] Images from art (and their ekphrases) are forever present in these works and are often used to reinforce different notions and ideas, showing the malleability of images and the ability of those in power to manipulate them.[70] We can never be sure that appearances reinforced by religion and myth represent social reality. There is a good possibility that Andrés is a thief. Other questions arise: Why is Andrés ordered to be silent? Juan Haldudo commands: *La lengua queda* [Keep quiet].[71] What is being censored? We are not told. Don Quixote has to make a quick judgment, exact a promise from the attacker, and leave. Timothy Hampton asserts: "For he cannot be a stationary judge and a knight errant unless a judicial system implements his judgments."[72]

From the very beginning of the novel, Cervantes urges the reader to consider matters of punishment and censorship, of a social reality that at times evades the would-be knight. While Don Quixote seeks to free the youth, his actions are not based on the evidence. They are whimsical, perhaps revealing that somewhere within madness he understands that justice is arbitrary.

In Orwell, Winston knows that madness is a sign that he has not accepted, that he has not come to love Big Brother. In the end O'Brien, his inquisitor, tells him that he is deranged and "cures" him through torture and mind control.[73] In today's world, "sleep deprivation, auditory overload, total darkness, isolation, a cold shower and rough treatment" have been used to disorient a prisoner.[74] These "enhanced interrogation techniques" underline Orwell's insight into the future and echo back to Ovid and Cervantes. Although Winston's body is not flayed, his mind is taken apart thought by thought, as he becomes a sad and hopeless martyr. The flayed are images of the censored.

LIBRARIES OF THE CONDEMNED (*DON QUIXOTE*, 6)

Up to this point the censored bodies have been authors, books, madmen, would-be saints, and challengers of gods and the powerful. In his works of exile Ovid obsesses over why his work was condemned and worries that he is no longer read in Rome. As Cervantes's novel progresses, Don Quixote becomes more and more central to meditations on censorship. Perhaps the most famous episode on the subject is found in chapter 6, the scrutiny of the knight's library made by the priest and the barber. Here, Don Quixote's "friends" seek to deprive him of dangerous books—books of chivalry that augment his enthusiasm for adventure. Since at least the eighteenth century, this episode has been viewed as a satire on the control and censorship of books and/or a satire on the Index of Forbidden Books fashioned by the Inquisition.[75] The most recent incarnation of this approach is found in the 2011 book by Ryan Prendergast, who affirms that Inquisitional control is omnipresent.[76] He also evinces "the capricious nature of censorship"[77] in the episode of the examination of the knight's library. It is important to ask, then: If Cervantes's novel satirized censorship, why wasn't it censored?

I would argue that the whimsical protagonist and the comic elements stand as a firewall against any who would criticize it as a vision of censorship in the times: The priest and the barber are accompanied by the niece and the housekeeper as the latter immediately searches for Holy Water to spray the books, since evil enchanters may be hidden in this library. Thus, they camouflage dissent and are part of the steganography of the work. At the same time, these "loving" figures who censor Don Quixote, claiming they do so because they care for him, are not that far removed from Orwell's *Nineteen Eighty-Four.* Let us remember how the Thought Police capture Winston Smith and his beloved Julia and take them to the Ministry of Love for interrogation.[78]

Books are like human bodies and must be punished accordingly.[79] Taking up the famous *Amadís de Gaula,* the priest decrees "este libro fue el primero de caballerías que se imprimió en España . . . y así me parece que, como a dogmatizador de una secta tan mala, le debemos, sin escusa alguna, condenar al fuego" [this is the first book of chivalry published in Spain . . . So it seems to me that since it's the founder of such a bad sect, we ought to condemn it to the flames without a second thought].[80] In Orwell, Winston Smith is subjected to torture and other means "to destroy his power of arguing and reasoning."[81] His memory and bookish nature are dismantled. Through doublespeak he comes to believe in the state's dictum that "Slavery Is Freedom,"[82] as the Thought Police instill in him a mental discipline through which all inhabitants of Oceania are, in Thomas Pynchon's words, "able to believe two contradictory truths at the same time. . . . In social psychology it has long been known as 'cognitive dissonance.'"[83]

While Ovid seems to prefer pardon to resistance, Cervantes's novel clearly shows the way to playfully reply to the censors. It condemns through the comic;

it opens new spaces through madness and eccentricity. Orwell's is by far the more terrifying book—freedom becomes madness, while a constricting madness seems to grip the population through doublespeak, a term that is not so distant from today's fake news.

MAGIC AS MIRACLE (*DON QUIXOTE,* 17)

Steganography, or ways in which authors and characters camouflage their ideas from the censors, are many: whimsical characters and books, madness, silences, hidden allusions, and the comic as firewall.[84] There is also the miracle of which Leo Strauss speaks. In two recent books on Cervantes, both published in the fall of 2011 by the University of Toronto Press,[85] the same quotation by Strauss appears: "For the influence of persecution on literature is precisely that it compels all writers who hold heterodox views to develop a peculiar technique of writing, the technique of writing between the lines But how can a man perform the miracle of speaking in a publication to a minority, while being silent to the majority of his readers?"[86] Anthony Cascardi explains that in Cervantes the "exoteric text responds to the well-established circumstances of a *converso* with Erasmian-humanist leanings."[87] Indeed, the attitude of the censors influenced those who disfigured an image of Erasmus and included the name of Don Quixote and Sancho Panza.[88] In his book, Cascardi delves into Platonic indirections and contradictions; the banishment of the poet from the Republic; the presence of a mendacious historian—all with the aim of teasing out Cervantes's techniques. I would like to turn, instead, from Straussian miracle to magic in Cervantes.

After repeated hurts and defeats, including a pounding at the inn, the knight decides to concoct the Balsam of Fierabrás. The balsam, an invention that became part of pious Christian tales, was made from the liquid that served to embalm Christ. In Cervantes's novel, however, Don Quixote does not need to fight a Saracen giant to obtain the balsam. He brews it with oil, wine, salt, and rosemary.[89] This, of course, is preposterous, since the balsam cannot be made, given that it was the one used to embalm Christ. Parody of the chivalric, the eccentricities of the knight and his comic invention create a firewall that hides the heterodox.

As a reader laughs at his antics, she misses the point—that is, what the knight does with the ingredients. As he mixes and cooks them, he intones prayers and makes the sign of the cross over the potion.[90] He has fashioned an *ensalmo,* a potion and prayer used to cure the sick in a way that was forbidden by the Church. In his 1538 treatise, Pedro Ciruelo, writing against all superstitions, dedicates a whole chapter to the *ensalmadores* who perform these cures. He exhorts those who have suffered wounds and other physical traumas to go to doctors and pharmacists and to pray to God. At no point is the wounded to resort to *ensalmos,* which are of two kinds: of words alone (a prayer) and of words and substances (prayer and balsam).[91] Such words incur the sin of blasphemy since they obtain their power from

the devil. Perhaps the most important treatise on this practice was written some years after Cervantes's novel by Manuel do Valle de Moura, an Inquisitor from Portugal. De Moura's treatise highlights an element neglected by Ciruelo—the use of gestures or ceremonies.[92] They are to "affect reality."[93] Don Quixote "a cada palabra acompañaba una cruz" [with every word he crossed himself].[94] There is no question, then, that Don Quixote is committing a mortal sin and a blasphemy, not only by the standards of Ciruelo, but also by those of De Moura. If we add to the equation that *conversos* and *moriscos* were famous for their *ensalmos,* then what we have is a reputedly Christian knight performing forbidden, devilish magic that was often used by those the Inquisition suspected of reverting to their ancient religions. While he claims to fight the infidel, he becomes one himself, and this is hidden through the magic of laughter and eccentricities.

A similar magic is found in Ovid. We have seen how in *Tristia* the name Tomis derives from Medea's sorcerous evil. Another of his poems of exile, the *Ibis,* contains maledictions against an unknown enemy. His ugly and whimsical children could infect Rome with their verbal magic and reverse the curse of cruelty. There is no magic in Orwell, unless we envision Big Brother as a magician and if we consider doublespeak to be some kind of incantation that makes people act on the wishes of the "magician." In today's world, the internet may enchant in ways that we still cannot fathom, leading to truths, lies, and manipulations—social media, for example, have arguably become a catalyst for rebellions.[95]

PERPETUAL WAR (*DON QUIXOTE,* 18)

It is clear from Orwell that censorship is an instrument of war; or perhaps war is an instrument of censorship. When a state or empire asserts that enemies are threatening it, then it begins to seek unorthodox voices as it claims that the realm must stand united. This unity carries with it a univocal aspiration, one that mutes any difference of opinion, any dissent. All three writers with whom we are dealing present us with meditations on warfare, and all have experiences of conflict. Cervantes had experienced both battle and captivity. The Spanish Empire had been at war constantly through the reigns of Charles V and Philip II. In spite of all the gold from America, Philip had seen more than one bankruptcy. He had defaulted on loans in 1557, 1560, 1575, and 1596.[96] This feeling of constant war is replicated in Cervantes's novel, where the knight is always finding new enemies. Although transmuted by the notion that Christian knights are always in search of adventures, the novel comically represents an empire that is assiduously searching for enemies and converts. A cloud of dust can mean that an army is approaching. Two such clouds mean two armies—but which one will the knight support? Of course, he chooses Pentapolín and his European forces against the Islamic Alifanfarón. Although chivalry was dead, giving way to new forms of warfare with cannons and gunpowder, both Charles and Philip wanted to keep alive the fiction of chivalry;

thus, they held jousts and tourneys, as novels of chivalry with their ancient customs were immensely popular. War was thus idealized, and the romances could be seen as inciting war. Cervantes, through his knight, suggests that enemies can be a mirage, a cloud of dust.

Orwell, having lived through the Second World War and seeing the excesses of two types of totalitarian regimes, writes a novel in which perpetual war is the aim of the state.[97] War welcomes a repressive system: "The scientist of today is either a mixture of psychologist and inquisitor, studying with extraordinary minuteness the meaning of facial expressions, gestures and tones of voice, and testing . . . hypnosis, and physical torture."[98] Orwell's prescience is such that it reminds us of today's facial and voice recognition as a mechanism for control and of war as distraction so that the state can amass more power.

Ovid seems the mildest of the three. Living under the so-called *pax romana,* where peace was proclaimed, he was well aware of Augustus's image as the initiator of this Golden Age. Augustus closed the gates of Janus, claiming that peace should be preferable to war. Ovid, however, would see this as a sham. Although advocating certain freedoms, as time went on, Augustus's rule became more repressive. By 6–8 AD, book burning was encouraged, given spreading rebellions due to famine and the increasing influence of Tiberius.[99] It should come as no surprise that in the year 8 AD Ovid was exiled. Ovid, Cervantes, and Orwell link war and censorship in increasingly dystopian terms.[100]

THE PERILS OF SIGHT

In the second book of *Tristia,* the poet asks: "Why did I see anything? Why did I make my eyes guilty? Why was I so thoughtless to harbor the knowledge of a fault? Unwitting was Acteon when he beheld Diana unclothed; none the less he became prey of his own hounds."[101] Let us remember that the last work cited in the Inquisition of Don Quixote's library is a translation of some myths by Ovid carried out by Barahona de Soto. We preserve at least two of them: *Vertumnus and Pomona* and *Acteon.*[102] It is this last character that personifies Ovid's error in *Tristia.* Thus, the Spanish text further conjoins the burning of books and bodies with Ovid's exile.

In today's world we can photoshop a picture much better than in George Orwell's dystopia.[103] Orwell's is the least complex of the works, having no need for steganography. If Orwell's book misdirects us, it is in the sense that technology would never change. His vision of an impoverished gray realm with booming sounds of repression could easily be replaced by a place of affluence where a screen's dazzling images foreground the trivial and hide a world being depleted of its resources. Reality is forever changing, and the would-be censors, be they religious, political, or corporate, attempt to manipulate what we see or hear for their own purposes. Don Quixote reverses this equation. He claims that what he envisions is authentic and that others are deceived by surface values; and he uses

a "doublespeak" that is far from Orwellian, but one that is meant to involve the reader in deciphering the words and the world. Battling against those (such as the priest and the barber) who insist that there be only one view, one Authorized Version of history and reality, he seeks to metamorphose that constricting singularity into a multiplicity of perspectives.

George Orwell may have looked much like Ovid in exile and has been envisioned as "Don Quixote on a bicycle" as he moved in 1945 to the remote and rustic island of Jura.[104] These authors become and/or create whimsical bodies and characters that seek to escape control. Don Quixote, like the Ovidian textual body, is a figure whose eccentric individuality opposes and mocks the Roman or Orwellian markings of power.

Don Quixote speaks to the present, thus asserting its futurity. It deals with uncertainties, with unreliability, at a time when words and news seem unreliable and when our society seems more and more uncertain as to the future. The work exhibits the clash between historical cycles and linearity; between empire without end and the rise and fall of hegemonic powers, again matters that grant it a clear futurity. Perpetual war, surveillance, and censorship envelop Cervantes's novel in an aura of prescience. Today's disregard for books, and the hopes and perils of reading, affect both the ancient knight and the modern world. Hidden allusions, eccentric sayings, and the firewall of the comic call on Cervantes's wit to become present in a society where we can only speak to those alike, where division is set to tear us apart. His gentle humor calls for gentle reprimands against ideas—never specific people—whereas his warnings against the perils of sight remind us that we are now always seen, even as we seek a place of privacy and seclusion.

These conversations with Ovid and Orwell allow us to listen to Cervantes's novel, to seek a subtle speech or steganography that defies censorship, and allow us to understand through the book's futurities our own present. Ovid begins this conversation, providing Cervantes with numerous motifs and techniques. Orwell closes it by representing the drab and the hopeless. Cervantes challenges censorship through a type of playful and puzzling self-censorship that instead of foreclosing speech (*la lengua queda* [keep quiet]) opens new spaces for dialogue, much as knight and squire will forever speak their differences in what has been called one of the most human books ever written.

Anticipating the Future

Leonardo's Unpublished Anatomical and Mathematical Observations

Morteza Gharib, Francis C. Wells, with Mari-Tere Álvarez

I flung myself into futurity.
—H. G. WELLS, 1895

In 1895, H. G. Wells penned these words in his science-fiction novel *The Time Machine*. For Wells and for Early Modern writers, such as Thomas More (1478–1535), Francis Bacon (1561–1626) (discussed in other chapters), and Margaret Cavendish (1623–1673), publishing science fiction permitted the imaginings of a future, with new ideas and new technology. To these futurists, futurity was not just the future but rather a state of mind, an awareness of the still-to-come, the potential and excess of the not-yet-here. Subjects actively oriented themselves toward this utopic future.

This mindset does not describe fifteenth-century polymath and artist Leonardo da Vinci (1452–1519), despite popular understanding of him as a prescient genius. Leonardo's assumed implausible ideas were misunderstood in the Renaissance and came to fruition only in the modern age as a latent futurity. This essay examines Leonardo's drawings and texts on two seemingly fantastical subjects in the Renaissance—the anatomy of the human heart and his musings on velocity—both instances in which the artist and genius seems to predict the future. In the conclusion, we return to the differences between a fifteenth-century inventor and a futurist writer.

LEONARDO AND THE HUMAN HEART

Leonardo's interest and involvement in anatomical study appears to have begun at a very early stage and continued throughout his life. His extant notes reveal a pro-

gression in his thinking, from a conception of the human heart based on Galenic representations to, in his later years, more original and abstract thinking. His later observations on the human heart, in particular, demonstrate an experimenter in search of knowledge as opposed to an inventor predicting future needs in the field of cardiology three hundred years in the future. In other words, Leonardo's findings were of no applied use for physicians of the time. For example, his descriptions of functional anatomy, including the closure mechanism of the aortopulmonary valves, had no practical application at the time. It would be an additional 150 years before the English physician William Harvey made his seminal contribution to the history of medicine by describing the systemic circulation of blood through the human body.[1] Consequently, there were no therapies for heart-valve disease in Leonardo's time. Indeed, the effect of diseases such as rheumatic heart-valve disease, perhaps the most common affliction of the time, is not mentioned in then-current medical texts and pharmacopeias.[2] Furthermore, based on the evidence of his notebooks, there does not seem to be direct evidence that Leonardo had meaningful relationships with the physicians of his day.[3]

Without a doubt, however, Leonardo's drawings and descriptions of the workings of the heart valves coupled with his visual descriptions of the presence of a dual blood supply to the lungs are strikingly prescient and speak to a distant future. With that said, however, it is important to emphasize that Leonardo was not a futurist, but rather was deeply grounded in the present. Evidence of his mindset includes the fact that he did not bother to publish his findings, which, in fact, were not published until the late nineteenth century, in Sabachnikov's two-volume work reproducing the Windsor anatomical collection.[4] Nevertheless, Leonardo's brilliant deductions about the physiognomy of the human heart—based on his close and accurate observation allied to engineering knowledge, and when combined with the fact that the drawings are still considered valid and accurate descriptions of the heart today— only strengthen Leonardo's icon status to writers and readers of science fiction.[5]

CORONARY ATHEROSCLEROSIS

Leonardo's observations about coronary atherosclerosis present another case where contemporary scholars see a futurist Leonardo. According to his notebooks, in the winter of 1507–8, Leonardo spent time at the local hospital (Santa Maria Nuova) in Florence with a patient who claimed to be one hundred years old. Leonardo recounted how the old man died peacefully in front of him. Intrigued by what he described as a "death so sweet," Leonardo stated that he "made an anatomy," what we would now call an autopsy, in an attempt to understand the cause of this quiet death.[6] This story is confirmed by a contemporary source (Anonimo Gaddiano), who described Leonardo as making a series of noteworthy drawings: "all marvelous things and among them one of our Lady and a Saint Anne, which went to France, and anatomical studies which he drew in the Santa Maria Nuova in Florence."[7]

The dissection of the old man would appear to have been very comprehensive; Leonardo left extensive drawings of the cadaver's upper body and refers in his handwritten notes to the portal venous system and the arterial supply to the small intestine.[8] The most unique information from this particular autopsy is the extensive, detailed description that Leonardo made about the state of the heart; from this description he made a number of important deductions. Through a series of drawings and notes he reported the thickening and narrowing of the coronary arteries and appears to have drawn the correct conclusion that the cause of death was the restriction of blood to the muscle of the heart. This appears to be one of the earliest descriptions of what is known as hardening of the arteries or coronary atherosclerosis, which he then identifies as the cause of death. Leonardo even goes on to issue a health warning suggesting that this process may be attributed to a lack of exercise. Clearly intrigued by this finding, Leonardo then reported the need to study the nature of arteries in the young and old as well as do comparative anatomy on "birds of the air and animals of the field."[9] He concluded that increased thickening and tortuosity of the vessels are significant parts of the aging process.

Unique and important though this description of atherosclerosis is, Leonardo's seemingly futuristic observations on cardiac pathology were not unique. Florentine physician Antonio Benivieni (1443–1502) reported on an autopsy performed on one of his relatives.[10] His documentation of the procedure seems to include one of the earliest descriptions of rheumatic mitral valve stenosis, a condition whereby the narrowed mitral valve does not open properly: "Wherefore the cadaver of the deceased having been cut up for public benefits, it was found that the ventricle of the man was so hardened in the joints of the opening toward its lowest part that since it was able to transmit nothing from there to the inferior parts, by necessity death followed."[11]

THE HEART DISSECTIONS

Without a doubt, Leonardo's examinations of the heart read like modern anatomical medical scans. The heart is a four-chambered muscle pump with two inlet and two outlet unidirectional nonreturn valves. Described thus it may sound like a simple organ whose structure and function should be easy to discern. However, this is far from the truth. Almost all of Leonardo's existing notes and drawings of the ox heart reveal an intense study of the external form of the heart and the related coronary arteries and veins as well as detailed examination of the interstices of the cardiac chambers. A series of small drawings of the heart reveals that Leonardo clearly understood that the heart naturally twists while contracting, otherwise known as cardiac twist, a process that allows the maximum emptying of the cardiac ventricles.[12]

Examination of the heart is most commonly done when it is in the relaxed and nonworking state, both in the postmortem room and in the operating theater.

This flaccid state denies a proper appreciation of its form when it is working and is full of blood and under normal muscular tension. Leonardo appreciated this and described a novel technique to demonstrate the heart in its working state. He injected the chambers of the heart with hot wax under pressure and waited for the wax to set. This gave a cast of the internal shape and, after rigor mortis had developed, caused the heart to set in its working form. Leonardo also used this technique to better understand the ventricles of the brain. Perhaps its best use was in the aortic root at the base of the heart, more of which will be described later. Although he did not publish or disseminate his findings, Leonardo's drawings are incredibly informative, as seen in the case of his drawing of the tricuspid atrioventricular valve.[13] The drawing describes cutting out the valve to demonstrate how the valve works. Both C. D. O'Malley and J. B. de C. M. Saunders rightfully suggest that the drawing is made in such a way that allows the reader to reconstruct the orifice as suggested.[14]

THE MECHANISM OF AORTIC AND MITRAL VALVE CLOSURE

The valves of the heart open and close in response to the flow of blood, which in turn is generated by atrial and ventricular contraction and relaxation (figure 5.1). However, today we understand that the exact mechanism of complete and safe closure is rather more complex and requires vorticeal flow above the aortopulmonary valves, which evenly unfurl the opened leaflets to ensure complete closure. Leonardo discovered this complex mechanism in his later studies while examining ox hearts. The aortic valve sits at the outlet of the left ventricle, where the aorta arises from the base of the heart. The origin of the aorta has distinctive bulges eponymously named the sinuses of Valsalva (the only related contribution in the literature is an engraving in a tractus on the ear by Morgagni with no commentary).[15]

Leonardo explored in detail the reason for this anatomical oddity and was able to explain it in functional (physiological) terms. The coronary arteries arise from two of these sinuses. In the ox heart these are very striking bulges. Applying his knowledge of hydrodynamics, he described the formation of vortices within these sinuses that cause the leaflets of the aortic valve to unfurl from their base and to meet evenly, giving full aortic valve leaflet closure. These vortices arise as the blood expands into the space, having passed through the relatively narrowed orifice of the aortic valve itself. In addition, where the sinuses meet the beginning of the aortic tube, they encounter a relative narrowing. This junction is named the sinotubular junction. It is naturally 10 percent narrower than the opening of the valve, and hence the peripheral blood in the column that is leaving the left ventricle will strike this ridge and be diverted backward along the curved wall of the sinus to the base of the aortic valve leaflet and then along the leaflet as the peripheral blood of

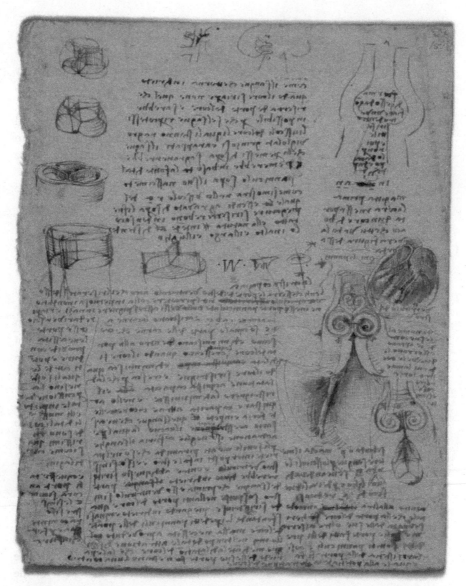

FIGURE 5.1. Leonardo da Vinci, Notes on the valves of the heart and flow of blood within it, with illustrative drawings, ca. 1513, pen and ink on blue paper, Windsor, Royal Library, MS 19082r. Royal Collection Trust © Her Majesty Queen Elizabeth II 2017.

the vortex, which will unfurl the leaflet to give rise to complete leaflet closure. If valve closure relied simply upon the reflux of the column of blood when forward flow ceased, then the leaflets would furl upon themselves, rendering the valve incompetent. Leonardo described all of this and drew a little diagram that very convincingly illustrated his thoughts about this.[16] Moreover, he continued with his thinking, using his knowledge of fluid drag and nonlaminar flow. He drew many diagrams to show the reduced velocity and hence height that any peripheral fluid will reach in a column flowing through a tube as a result of fluid drag giving rise to nonlinear flow.[17] And, although we have these detailed drawings and notes, there is no known dissemination of this profound knowledge.

Leonardo then went even further and wrote a discussion of the importance of the elasticity of the tissues of the aortic root. During ventricular ejection, the aortic root is capable of expanding beyond its natural size at rest to allow maximal ventricular emptying on severe exercise, creating an even more dynamic structure. This elasticity is then converted into a shock-absorbing mechanism upon valve closure.[18] Leonardo correctly ascribed the necessity of this property to prevent avulsion of the aortic valve leaflets closing under high pressure. In our modern world, this property of these structures has real relevance, as the lack of this elasticity in some of the earlier man-made prosthetic tissue valves used in modern heart surgery has resulted in the leaflets tearing away from the supporting stent posts.[19] This potentially life-threatening catastrophic valve failure caused the withdrawal from the marketplace of these valves and a subsequent redesign.

Additionally, Leonardo went on to describe why these valves must have three leaflets, not two or four, using geometry to prove that the three-leaflet option gives the greatest strength and durability.[20] It is a fact that bi-leaflet aortic valves tend to fail before the natural lifespan of the valve is reached and often very early. Patients with bi-leaflet aortic valve abnormalities make up about 10 percent of all patients presenting with aortic valve disease. An interesting aside to these notes by Leonardo is whether or not he ever saw a bi-leaflet valve, since the likelihood of observing such an anomaly in an ox heart is small. Perhaps he found one in a human dissection, or possibly it is more likely that this was a thought game analyzing all options and applying geometry to answer the question. Since Leonardo did not in any way make this knowledge known via publication, none of this work would be of any relevance to any professional in medicine, anatomy, or pathology for the next five hundred years.

THE CLOSURE LINES OF THE HEART VALVE LEAFLETS

It could be assumed that the leaflets of the heart valves close in the way that a door closes within a doorframe, but this is mistaken. For a good seal to occur and to spread the load and shock of closure, the leaflets of the heart valves meet over a vertical distance of approximately 0.7 mm to 1 cm, a closure line that is

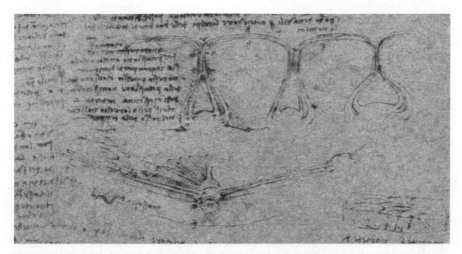

FIGURE 5.2. Leonardo da Vinci, Detail of atrioventricular valve leaflets, ca. 1513, pen and ink on blue paper. Windsor, Royal Library, MS 19074r. Royal Collection Trust © Her Majesty Queen Elizabeth II 2017.

called coaptation in the description of valve anatomy. It is another observation of Leonardo that this is essential for normal valve function. This arrangement is beautifully shown in a detailed drawing on Windsor manuscript RL 19074 *recto* for the tricuspid valve and again on Windsor RL19080 *recto* for the mitral valve (figure 5.2).

This anatomical arrangement is essential to reproduce in modern-day mitral and tricuspid valve reconstruction to ensure proper closure and an efficient seal for these valves. The same principle applies for the aortic and pulmonary valves. This is demonstrated without comment in the drawings of the aortopulmonary valves in another manuscript.[21] Leonardo's ability to document tiny aspects of anatomical form in such detail reinforces his own statement of the intensity of his application and observation.[22]

THE MOVEMENT OF THE HEART

Leonardo's understanding of synchronicity and reciprocity of the movement of the atria and the ventricles of the heart is another of his original contributions. This is to be detected in the only drawing of the heart that is to be found outside of the Windsor collection.[23] In fact, Leonardo was the first individual to describe the heart as a four-chambered structure. Before his description, the heart was considered to consist only of the two ventricles. The atria were not considered to be part of the heart. He continued to interchange the terms for the atria as either ventricles or atria but was the first to ascribe both pairs of chambers to the heart.[24] He used the presence of the atrioventricular valves as proof that the atria and ventricles

were separate and important independent chambers.[25] In this section he described
the important differences in structure, with the atria having thinner walls than
the ventricles. In this passage, he also described the alternating contraction and
relaxation of the upper (atria) and the lower ventricles.

In addition to the synchronized motion of the cardiac chambers, as mentioned
earlier, Leonardo also began a discussion on the rotational movement of the heart
in an observational study that he did in Tuscany. While observing the killing of
pigs with a *spillo* (metal spike) that was plunged into their hearts through the chest
wall, he noticed that, depending on the point of the entry of the spike into the heart,
the rotational movement differed; if the spike penetrated the heart in the midpoint
of the ventricle, there was no movement, a point of equipoise. He described leav-
ing the instrument in the heart until the pig was cut up to test his observation. He
commented that he saw this "many times."[26] This is the earliest description of a key
component of heart motion that is known as cardiac twist. It is an important topic
in the modern study of heart failure. This twisting action allows the heart to empty
more completely than by simple muscular contraction. No heart muscle fiber can
shorten by more than 20 percent of its length. By twisting itself in systolic contrac-
tion, it enhances emptying in the same way as the wringing out of a wet cloth to
extrude water. The relaxed heart is in the shape of a complex cone, a cone with a
twist. The filling of the heart with blood untwists it so that when the filling phase
ceases there is a moment of force returning the heart toward its original state as
contraction commences. This helps to overcome the inertia at the start of cardiac
motion. It is striking that Leonardo should be so interested in this complex motion
of the heart and so observant that he could identify it, presaging modern physi-
ological thought.

THE DUAL CIRCULATION OF THE LUNGS

Another of Leonardo's important observations is that the lung has two contribut-
ing blood supplies (figure 5.3). We now know that deoxygenated blood exits the
heart through the pulmonary arteries to enter the lungs, where the blood's oxygen
is replenished as air is drawn into the lungs and as carbon dioxide produced in the
metabolic processes is removed; these gases are expelled in the exhaled breath.
This gaseous exchange takes place across the membranes of the smallest blood
vessels, the capillaries, which are one cell thick, and the single-celled small air sacs,
to which the capillaries are intimately applied in the walls of the alveolar sacs. The
second source of blood to the lungs is via a series of much smaller vessels called
the bronchial arteries. These are hard to find in the dissection room even when the
prosector knows that they are there. They arise from the underside of the arch of
the aorta and ramify along the main bronchi following their divisions deep into
the lungs to their termination. Unlike the pulmonary artery they carry oxygenated

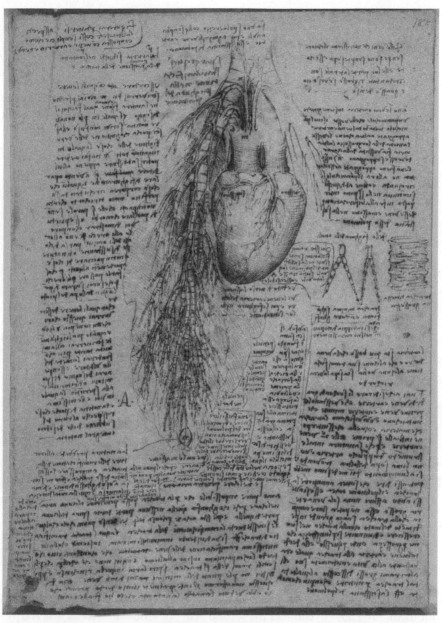

FIGURE 5.3. Leonardo da Vinci, The heart and lungs dissected to reveal the bronchi and the accompanying bronchial arteries, ca. 1513, pen and ink on blue paper. Windsor, Royal Library, MS 19071r. Royal Collection Trust © Her Majesty Queen Elizabeth II 2017.

blood to nourish the major airways. They arise as a result of the embryological development of the lungs.

This detailed understanding of the pulmonary blood supply did not exist in the time of Leonardo who, initially, continued to be influenced by the Galenic description of blood circulation. The physiology of breathing was not at all understood. Galen had postulated that air passed directly across the trachea and from the lungs into the heart and that air and blood mixed directly. As his observational work progressed, Leonardo began to directly challenge Galen's theories. He wrote:

> Whether air penetrates into the heart or not. To me it seems impossible that any air can penetrate into the heart through the trachea, because if one inflates the (lung), no part of the air escapes from any part of it. And this occurs because of the dense membrane with which the entire ramification of the trachea [bronchi] is clothed. This ramification of the trachea as it goes on divides into the minutest branches together with the most minute ramification of the veins which accompany them in continuous contact right to the ends. It is not here that the enclosed air is breathed out through the fine branches of the trachea and penetrates through the pores of the smallest branches of these veins. But concerning this I shall not wholly affirm my first statement until I have seen the dissection which I have in hand.

To challenge Galen at that time was to take on all of the force of the academics. It is this kind of proclamation of individual thought that probably led Leonardo to rail against the academics of the time with the following note:

> Many will think that they can with reason blame me, alleging that my proofs are contrary to the authority of certain men held in great reverence by their inexperienced judgment, not considering that my works are the issue of simple and plain experience which is the true mistress . . . I am fully aware that the fact of my not being a man of letters may cause certain presumptuous persons to think that they may with reason blame me, alleging that I am a man without learning. Foolish folk![27]

As discussed earlier, Leonardo's discovery of the second system of blood vessels, the bronchial arteries, was probably enhanced by the fact that he was dissecting the heart and lung block of an ox, in whom these structures are naturally larger than in a human specimen. Nevertheless, having reproduced the dissections of Leonardo, I have found that even in this setting they are not easy to demonstrate and require a high level of dissection skill. Leonardo's discovery is even more exceptional because no one knew of their existence beforehand. His handwritten notes unmistakably point up the separateness of the vascular systems and the need for them: "You have to consider the second order of veins and arteries which cover the first [i.e., bronchial arteries and veins] minute veins and arteries which nourish and vivify the trachea the substance of which is interposed between the first and second [order] of veins and arteries; and why Nature duplicated artery and vein in such an instrument, one above the other, for the nourishment of one and the same

organ." He went on to suggest that the reason for this may be that the main pulmonary artery could not be the source of blood for these airways rather than the lung tissue, as the attachment of those great vessels to the airways would impede the movement of the airways within the lungs, which is often violent extreme exercise. He concluded: "Wherefore this reason she [Nature] gave such veins and arteries to the trachea sufficient for its life and nourishment [the bronchial circulation] and the other big branches she separated somewhat from the trachea in order to nourish the substance of the lung [the parenchyma] more conveniently."[28] These vessels received no mention in Andreas Vesalius's *De humani corporis fabrica* of 1543. Leonardo's physiological reasoning and astute observation are exceptional, predicting future knowledge of the anatomical record.

RECOGNITION OF LEONARDO'S ANATOMICAL ENDEAVORS

Leonardo's anatomical observations would not be recognized for hundreds of years. In fact, the only contemporary acknowledgment of Leonardo's anatomical endeavors is cursory and does not dwell on what was achieved. Antonio de Beatis, secretary to the Cardinal Luigi of Aragon, notes his visit to Leonardo's studio in Amboise on October 10, 1517, and remarks:

> This gentleman has written of anatomy with such detail, showing with illustration the limbs, veins, tendons, intestines and whatever else there is to discuss in the bodies of men and women in a way that has never yet been done. All this we have seen with our eyes; and he said that he had dissected more than thirty bodies of men and women of all age. He has also written on the nature of water, on various machines and on other matters, which he has set down in an infinite number of volumes all in the vulgar tongue; which if they were published would be useful and very delighful.[29]

There could be other reasons why his observations on anatomy were not appreciated. Monica Azzolini points out that Leonardo's lower position in society, owing to his illegitimacy and lack of a classical education (and only rudimentary command of Latin), would put him at a disadvantage in the elite academic societies of Milan, Florence, and Rome.[30] Despite this reasonable challenge to the claim of his mental supremacy over the ages, it cannot be ignored that, aside from the utility of the musculoskeletal anatomy for the surgeon and the mapping of superficial veins for bloodletting, the functional descriptions that Leonardo made of the internal organs were of no use to physicians or surgeons of that era or for many years to come. Indeed, the derived understanding of very complex functional anatomy that Leonardo displays in his later anatomical pages does indeed place him in the stratosphere of intellect across the ages and in these areas; whereas his work might have anticipated the future, he himself was not contemplating it in terms of the future.

MATHEMATICS

The idea for this portion of the essay originated with a sentence from Martin Kemp's book *Seen/Unseen* in a chapter devoted to the art of analogy.[31] Kemp writes about how the use of analogy need not be purely qualitative when scientists apply it to understanding natural processes. He gives the example of Leonardo da Vinci's applying the law of conservation of volume, which he had deduced from his studies of river flows, to explain the way tree branches bifurcate. As Kemp puts it, Leonardo comprehended the unwritten (undiscovered in Leonardo's time) physical law that governs bifurcation of tree branches through similitude and analogy as if he could see this law unformulated before him.[32] Modern scientists rarely find opportunities to experience this process, since they are trained to see nature and the physical processes that govern it through existing equations of physics. Hence, they are limited to seeing only cases that fit as solutions to equations that we choose to use. While powerful as tools for finding solutions, these equations often limit the view of the broader connections that link natural processes. In contrast, Leonardo da Vinci observed nature not only for its naked beauty via his artistic work but also as a manifestation of related and harmonic solutions to unseen and unwritten equations of natural laws. He achieved this understanding by applying qualitative and quantitative analogies. His approach, while limited by the primitive methods of measurements of his time, allowed him to reach a much deeper level of understanding of laws of nature than that of his contemporaries.

This section will examine two examples of Leonardo's qualitative and quantitative approach to using an analogy as a tool to decipher natural laws. One deals with his study of ballistic trajectories, where he envisions a parabolic trajectory despite experimental evidence to the contrary and exact mathematical equations in support of his parabolic postulate. The second example deals with seeing the unseen equations of motion nearly two hundred years before the observations of Isaac Newton.

MOTION

Leonardo was intrigued by the trajectories of projectiles and falling objects. His fascination with mysterious forces of gravity occupied him through many studies on the nature of weight, force, and motion under different static and dynamic conditions. He was familiar with the Medieval concept of "impetus," which influenced objects to gain acceleration toward the earth. He would describe acceleration by noting that "a weight that descends freely in every degree of time acquires . . . a degree of velocity."[33] This statement indicates that Leonardo had correctly understood that the velocity of a falling object has a linear relationship with time, a

discovery that is popularly attributed to Galileo. In mathematical notation, we can translate Leonardo's statement to

$$v = gt, \tag{1}$$

where g is a constant factor to be defined by the then-modern physics/mechanics of Newton's time as the local constant of gravity. Obviously, this mathematical language and the concept of "equations" regarding functions and variables were not known to fifteenth-century Leonardo or even to Galileo, who lived 140 years later. For them, the mathematical proof was performed through Euclidean geometry. Galileo's approach was more advanced than Leonardo's, since he added proportionality and ratios of quantities to prove his postulates or describe his observations. Also, unlike Newton, Leonardo did not have access to abstract mathematical methods such as algebra and calculus.

As can be seen in equation (1), which is also considered as one of the equations of motion, the accurate measurement of time is central to any experimental studies of falling objects. In this respect, a major impediment to Leonardo's observations of falling objects was his lack of access to accurate timing instruments. This limitation had naturally forced him and all of his contemporaries to resort to the measurement of distance in representing time. By using distance to represent itself and time concurrently, it would be difficult if not impossible to develop a clear definition for velocity as "the distance traveled over a time interval"; that would as well be true for the definition of acceleration. More accurate timing devices became available only during Galileo's time; equations and calculus were tools of Newton's time.

Two hundred years later, in the seventeenth century, we begin to see equations that describe kinematics of bodies in motion (equations of motion) mainly in the published works of René Descartes, Isaac Newton, and Gottfried Leibniz. These equations can be derived from the basic definition of acceleration (Eq. 2), defined and published by Newton, as the rate of change of velocity with time (or derivative of velocity with respect to time) and velocity as the rate of change of distance with time as given in equations (2) and (3) below,

$$a = \frac{dv}{dt}. \tag{2}$$

$$v = \frac{ds}{dt}, \tag{3}$$

where s is the distance, v is the velocity, a is the acceleration, and t is time. Note that ds, dv, and dt are infinitesimal intervals of space, velocity, and time respectively. Here, we see that to measure velocity, one needs to have accurate measurements of small intervals of space and time.

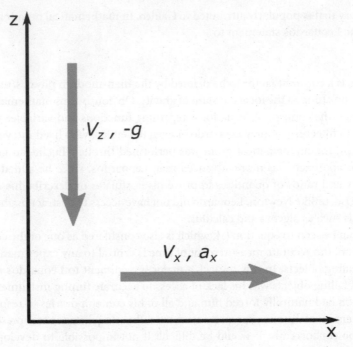

FIGURE 5.4. Leonardo da Vinci, Coordinate system and convention used in deriving equations of motion. a_x, a_y, and g are components of acceleration in x, y, and z directions, respectively. Similarly, v_z is the z-component of falling velocity vector in equation.

For constant acceleration and for objects that start to move from rest, equations of motion for distance traveled by an object under constant acceleration can be derived from equations (2) and (3) as

$$s = \frac{1}{2}at^2.$$ (4)

For falling objects, gravitational acceleration commonly denoted as "g" will replace "a" in equation (4). However, as a vector quantity, acceleration and velocity can be expressed in terms of their vertical (z) and horizontal (x) components. Conventionally, gravitational acceleration is aligned with (–z), which means that it is oriented toward the earth (see figure 5.4)

Also, we can write equation (1) as

$$\upsilon_x = \upsilon_{x0} + a_x t(a), \upsilon_z = \upsilon_{z0} - gt(b),$$ (5)

where v_{zo} and v_{xo} are initial velocities.

Finally, one can break down equation (4) into two components along the x and z directions as follows,

$$x = \upsilon_{x0}t + \frac{1}{2}a_x t^2(a), z = \upsilon_{z0}t - \frac{1}{2}gt^2(b).$$ (6)

Equation (5b) reveals that a falling object's velocity has a linear relationship with time and is changing by a factor of "g" (approximately 9.8 m/s) with each consecutive second. For falling objects, equation (6b) says that these objects increase their falling distance as the square of time weighted by the gravitational factor "g." For projectiles, the ratio of initial launch velocities will define the launch angle, Θ. The equations of motion mentioned above can be combined to eliminate the time parameter to obtain an equation of motion (Eq. 7) that would represent the trajectory of any falling objects or projectiles in the absence of air resistance.

$$y = xtan(\theta) - \frac{gx^2}{2v^2cos^2\theta} \tag{7}$$

Depending on the initial velocity and launch angle (Θ), this equation (which belongs to the family of parabolic equations) would represent parabolas of different heights and widths.

DILEMMA OF LEONARDO'S PARABOLAS

Leonardo was fascinated by the nature of gravity. Almost two hundred years before Newton, he postulated that "every weight tends to fall towards the center [of the earth] by the shortest possible way."[34] He tried to decipher the secrets of gravitational law by conducting a series of simple but ingenious experiments, imagined and real. For example, he predicted parabolic trajectories for projectiles launched with various angles and initial velocities. In a plot (figure 5.5) in *Codex Madrid I*, folio 147 recto,[35] Leonardo suggested parabolic trajectories for a range of launch angles from 90 to near zero degrees.

This depiction by Leonardo is perhaps the first documented conjecture on the parabolic nature of ballistic trajectories, a discovery that is also commonly attributed to Galileo. To better understand the importance of the information presented in this drawing, we should compare them to trajectories that the equations of motion (Eq. 7) predict for the same set of conditions. As we have mentioned before, equation (7) belongs to a family of equations known as parabolic equations for which their solutions represent parabolas of different heights and widths. Figure 5.6 shows such trajectories calculated from equation (7) for projectiles launched with fixed initial velocity of v and for a wide range of launch angles under conditions close to those that Leonardo presents in his drawing (fig. 5.6). The reader may appreciate the striking similarities for trajectories launched at high and low angles. His parabolas fall short of the maximum ranges that exact parabolic curves reach for mid-launch angles. It is remarkable that he comes this close to drawing perfect parabolic shapes without having a quantitative knowledge of parabolic equations. •

One may conclude that Leonardo had used his photographic memory in registering trajectories of these projectiles during an actual experiment. The dilemma

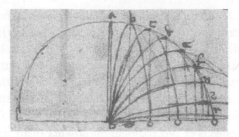

FIGURE 5.5. Leonardo da Vinci, Prediction of parabolic ballistic trajectories, Codex Madrid I, folio 147r, National Library of Spain. *(Note that we have transformed the image from its original mirror-imaged version to make it easier to read.)*

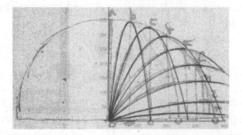

FIGURE 5.6. A direct-overlay comparison of trajectories calculated from equation (7) with those depicted by Leonardo for ballistic trajectories for various launch angles. Calculations are based on the author's best angles that could be estimated from Leonardo's drawings.

here is that, as we have indicated before, equation (7) is valid only when air resistance is not considered, and thus trajectories obtained through this equation are valid only when projectiles are launched under vacuum conditions or when resistance caused by airflow is small and of frictional nature. For almost all of the ballistic projectiles in Leonardo's time, the main airflow resistance must have been of the pressure type. Such projectiles do not follow a parabolic trajectory. As a matter of fact, equation (7) loses its parabolic characteristics when air-pressure resistance known as "form drag" is considered in deriving ballistic trajectories. Bertoloni-Meli notes that ballistic trajectories observed and reported by Galileo and others do not show parabolic behavior.[36] Some authors have suggested that Leonardo, raised under the influence of the classical approach of Aristotelian mechanics, might have used trajectories of issuing water jets to draw an analogy for the trajectory of ballistic projectiles. In Ms. C, folio 7 recto[37] (figure 5.5), Leonardo presents his observations of water jets issuing into the air from a water bag. While impressively accurate, trajectories depicted in Ms. C, folio 7 recto cannot be considered parabolic in general to justify Leonardo's nearly perfect rendering of ballistic trajectories in Codex Madrid I, folio 147 recto. This contradiction

is intriguing and prompts us to question methods that Leonardo had used to deduce the parabolic trajectory concept. Did he comprehend and understand the nature of equations of motion well enough to draw nearly perfect parabolas as their solutions?

It would be intriguing to question whether Leonardo had the equations of motion unformulated in front of him (as Martin Kemp puts it) and whether he had the power of insight or feeling for these equations. We had to wait an additional two hundred years to see the power of differential calculus that allowed Newton and Leibnitz to formulate equations of motion as we know them today in order to correctly predict parabolic trajectories of ballistic projectiles. For Leonardo, waiting for the future of mathematics to arrive was not an option; that is why he refers to his observations of motion of objects as "equation di moti" or equations of motion.[38] In the history of physics and mechanics, the next time that we see the use of this phrase is by Sir Isaac Newton (1688) in his seventeenth-century book *Philosophiae naturalis principia mathematica*.[39]

LEONARDO AND FUTURISM

Was Leonardo a futurist? Do his unparalleled observations and deductions in the areas of cardiac anatomy and mathematics indicate that he was predicting the future? A gifted polymath and artist, Leonardo was not a science-fiction writer; nor was he intent on predicting the future. On the contrary, Leonardo believed in his ideas and hoped that his inventions might change lives in their own day. What is the difference then between an inventor from the fifteenth century and a science-fiction writer? The inventor is present, while the science-fiction creator projects and imagines a distant world. While Leonardo da Vinci anticipated many of the great scientific discoveries ahead of his time, nowhere did Leonardo discuss futurity. Instead, he embraced his present; he believed in the now. He so believed in the power of creating in the present that he took his ideas, ideas that would be enhanced later by individuals such as Copernicus, Galileo, and Newton, and turned his principles into first attempts at real applications, from calculators to helicopters, hydrodynamics to solar power. Leonardo was not waiting for the future to unfold and bring his creations to fruition; he was intent on attempting to create them during his own lifetime. In other words, he was more in line with Renaissance philosophers such as Michel de Montaigne, who warned against the "folly of gaping Mankind always after futurity . . . ," advising "us to lay hold of good which is present." He described "the most universal of human error": "For we are never present with, but always beyond ourselves."[40] Curiously, had Leonardo's ideas been published in his day, perhaps some of these modern advances in cardiology, mathematics, or physics would have been discovered centuries earlier. If there is one thing to which Leonardo's incredible array of notebooks attests, it is his very real presence as a man of the Early Modern era.

Medicine as a Hunt

Searching for the Secrets of the New World

William Eamon

King Philip II, who ruled Spain from 1556 until 1598, was the first monarch in history to govern an empire, in the words of a contemporary, "over which the sun never set" (*el imperio en el que nunca se pone el sol*).[1] Administering such vast territory required immense effort and entirely new ways of managing the mountains of information that poured in from all parts of the world. So diligent was Philip about managing the daily details of government that he earned the sobriquet "paper prince." Yet even while drowning in a sea of paperwork, Philip managed to devote his personal attention to the important affairs of state. Measured by his assiduous attention to the details of running his empire, Philip was a thoroughly modern monarch. Although one contemporary marveled that the king must have "the biggest brain in the world," in reality it was the bureaucratic agencies Philip created to gather and sift empirical information that enabled him to rule his empire.[2] To the extent that, in the modern West, science serves to advance the well-being of society and the state, King Philip of Spain embodied the future of science. Coincidentally, this essay will argue, building Early Modern empires produced a revolutionary new model for the advancement of science and medicine: the idea of medicine as a hunt for the secrets of nature.

In January 1560, King Philip inaugurated one of his most ambitious imperial projects ever, ordering his *médico de cámera* (court physician), Francisco Hernández, to cross the Atlantic and search for new medicinal herbs in America—launching the first organized scientific expedition of the Early Modern era, and until then the most ambitious search for new medicinal plants ever attempted. In his instructions, Philip commanded Hernández in these words:

You shall consult, wherever you go, all the doctors, medicine men, herbalists, Indians, and other persons with knowledge in such matters, . . . and thus you will gather information about herbs, trees, and medicinal plants in whichever province you are at the time. . . . You shall test at first hand all the above-mentioned if you can, but otherwise, you are to obtain information from the said persons, and . . . you shall describe their nature, virtue, and temperament.[3]

After months of preparation, Hernández, a doctor from Toledo and a landlubber if ever there was one, embarked for America in September 1560. The passage took a little over a month, plenty of time for Hernández to ponder what wonders lay ahead and how to catalog them. Graced with the title of "*protomédico general* of our Indies," he spent seven years in Mexico, compiling a massive anthology of New World plants. Besides illustrations, he provided details about their medicinal uses, which he based on his own observations and reports from indigenous sources.

About all Hernández was able to realize of King Philip's lofty goal of cataloging the natural history of his empire was an undigested mountain of notes and drawings loosely arranged into sixteen volumes. Sadly, Hernández died without seeing his book in print. Yet, even before the work was eventually published, copies of Hernández's text and images circulated, appearing in natural history treatises throughout Europe. Some of the images appeared in the Pomar Codex, a collection of 218 hand-colored illustrations of plants from the New World commissioned by Philip II and presented as a gift to the distinguished Valencia medical professor Jaume Honorat Pomar in an effort to lure Pomar to Madrid.[4] So enchanted was Philip by Hernández's illustrations that he hung many in the antechamber of his private suite at El Escorial—no doubt accounting for the eventual disappearance of many of the pictures.

Eventually Hernández's efforts did pay off, but only by way of a skin-of-the-teeth scenario that strains the imagination. Hernández's original manuscripts went up in flames in a fire that destroyed the Library of the Escorial, where they were stored.[5] Fortunately, before that happened one of Philip's court physicians had made copies, which he took with him when he returned home to Naples. A few years later, a young nobleman named Federico Cesi obtained the rights to publish the material under the auspices of the newly formed Academy of Lynxes, the private society he had founded in Rome for conducting scientific experiments and natural history investigations.[6] In 1651, an edition of woodblock prints of Hernández's illustrations and accompanying descriptions came off the presses under the title *Mexican Treasury* (figure 6.1).[7]

The pursuit of nature's secrets in the New World bore fruit in the work of later explorers as well. Reports of plants and drugs brought back from America had already begun circulating in Spain as early as 1526, when Gonzalo Fernández de Oviedo published his *Sumario de la natural historia de las Indias* (Natural History of the Indies).[8] Information about new medicinal plants also came into Spain from

FIGURE 6.1. Title page, Francisco Hernández, *Nova plantarum, animalium et mineralium mexicanorum historia* (1651). John Carter Brown Library, Providence, RI.

Jesuit missionaries in Peru, including José de Acosta and Bernabé Cobo.[9] With a knowledge network extending from South America to India to the Philippines, Jesuit missionaries participated in a massive, organized search for medicinal plants that vastly expanded the European pharmacopoeia.[10] Whereas the ancient Greek botanist Dioscorides had described around 600 herbs, the seventeenth-century French naturalist Caspar Bauhin could list 6,000 different plants.

THE HUNT FOR THE SECRETS OF NATURE

In this essay I want to explore the implications imbedded in the metaphor that I have just described—the metaphor of medicine as a hunt.[11] I begin with a comment made more than fifty years ago by the late Paolo Rossi, one of the greatest Renaissance historians of our era. Rossi observed that during the Early Modern period "there was continuous discussion, with an insistence that bordered on monotony, about a logic of discovery conceived as a *venatio,* a hunt—as an attempt to penetrate territories never known or explored before."[12]

Rossi's insightful clue is worth following because the hunt metaphor occurs repeatedly in the scientific literature of the period. To take just one example, the sixteenth-century Neapolitan savant Giambattista Della Porta, author of a bestsell-

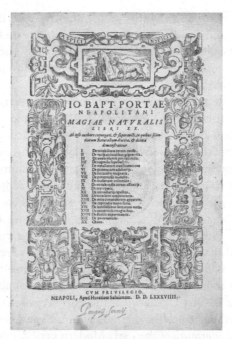

FIGURE 6.2. Title page, Giambattista Della Porta, *Magiae naturalis* (Naples, 1589). Huntington Library, San Marino, CA.

ing treatise on natural magic, organized one of Europe's first scientific societies, one whose members, he explained, were not content merely to gaze upon nature's exterior but instead aimed to discover secrets "locked up in the bosom of nature."[13] Della Porta adopted the lynx, the keen-sighted hunter, as the emblem for his book, explaining that the investigator of nature must "examine with lynx-like eyes those things which manifest themselves." A lynx, wary and alert, appears at the top of Della Porta's title page beneath the motto *Aspicit et Inspicit* (Examine and Inspect). Della Porta's "Academy of Secrets" has, of course, been overshadowed by other scientific societies, such as the Royal Society of London, but the aims of the two organizations—and for that matter all of the Early Modern scientific societies— were the same: to institutionalize curiosity (figure 6.2).

Other Renaissance academies emulated the style of science advanced by Della Porta and his comrades. In fact, Della Porta's use of the lynx as an emblem for his book inspired the name of the more famous *Accademia dei Lincei*, or "Academy of Lynxes" founded in 1603 by the enthusiastic young Roman prince Federico Cesi. Explaining the choice of the lynx as the society's emblem, one of the academy's original members said that the academy's purpose was to "penetrate into the inside of things in order to know their causes and the operations of nature that work internally, just as it is said of the lynx that it sees not just what is in front of

it but what is hidden inside."[14] In other words, they believed that the workings of nature were occult, and that the investigator needed to tease them out with skill, cunning, and keen-sightedness—an ability to "see beyond" the obvious. It was the hidden *secrets of nature*, not merely nature as it appears outwardly, that fascinated Early Modern naturalists.

Since antiquity, the metaphor of the hunt provided a literary structure for all kinds of quests. In Ancient and Medieval literature the hunt was a metaphor for the seeking of spiritual and intellectual truth, the hero's journey into the unknown, and the lover's attempt to win a woman's heart. Plato used the metaphor to describe geometers and astronomers, who are "hunters" after the nature of being, while for Cicero the scientist was a "seeker and hunter of nature." Although the metaphor of the hunt for knowledge is ancient, I believe Rossi was correct in stressing its novelty in the late Renaissance. Whereas images of the chase abound in Medieval literature, they were rarely used to describe the search for secular knowledge. The Scholastics believed that the essential qualities of nature were directly accessible. One did not have to "hunt" them out because they were evident to the senses.[15] What is significant about the examples I have cited is that all were premised on the idea of scientific inquiry conceived as the discovery of *new* things rather than a demonstration of the known. The themes of newness and novelty appear repeatedly in the scientific literature of the Early Modern period.

In the Renaissance the *Ne plus ultra* ("Do not go beyond") inscribed on the ancient Pillars of Hercules became a favorite device to illustrate the tyranny of ancient philosophy over creative thought. The growing awareness that reverence for antiquity hampered progress in learning aroused a sense of the importance of new discoveries and of the value of novelty for its own sake. The frontispiece of Sir Francis Bacon's *Great Instauration* pictures a ship passing through and beyond the Pillars of Hercules, symbolizing his age's passing beyond the traditional limits of ancient learning. The book's motto confidently proclaims, *Multi pertransibunt et augebitur scientia* ("Many shall pass through and knowledge shall increase") (figure 6.3).[16]

Certainly the most important event contributing to Europe's heightened consciousness of novelty was the discovery of the American continent—the New World, as Europeans called it. News of the discovery, which revealed regions and peoples completely unknown to the ancients, raised Europe's awareness of the sheer immensity of the world. The explorers brought back specimens of exotic plants and animals, hair-raising tales of adventure, and relations of completely new peoples and cultures. Above all, the new geographical discoveries demonstrated that ancient philosophy and science were not eternal verities. The news that voyagers to America sent home seemed to confirm, in the words of the Spanish historian Francisco López de Gómara, that "experience is contrary to philosophy." The New World itself became a metaphor for all of which the ancients were ignorant. As Sir Thomas Browne declared, ancient philoso-

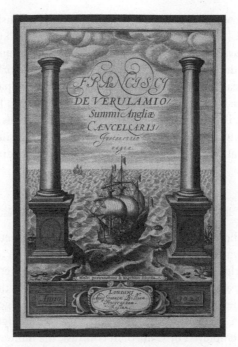

FIGURE 6.3. Title page, Francis Bacon, *Instauratio magna* (London, 1620). British Museum Images, © Trustees of the British Museum.

phy was so fraught with error that "the America and untraveled parts of Truth" still awaited discovery.[17] In the mid-seventeenth century the English virtuoso Joseph Glanvill still envisioned the opening up of an "America of secrets and an unknown Peru of nature."[18] Like the New World, nature stood before investigators as uncharted territory.

Spaniards were awash in medical and botanical information from the New World. Nicolás Monardes (ca. 1508–1588), the foremost European authority on New World *materia medica*, never set foot in America. A physician involved in the New World trade, he lived in Seville, the peninsular hub of the Spanish Empire, a place buzzing with information and rumor about American *materia medica*. Monardes collected plants, seeds, and stories from travelers returning from the New World. He grew American plants in his garden and tested drugs in his home laboratory. He learned the Indian names and uses of the plants and listened to the stories of soldiers, sailors, and New World settlers.[19]

Monardes wove his experiments and travelers' tales into a bestseller, *Historia medicinal* (Seville, 1565), describing hundreds of New World plants and their uses. Monardes was a fanatical promoter of New World drugs.[20] He was convinced that remedies originating in the Americas were worthy substitutes for any found in the classical pharmacopoeia. What need have Spaniards of exotic drugs from the Spice

Islands, he asked, when "our Indies yield them spontaneously in untilled fields and mountains?"[21]

The *Historia medicinal* was a dazzling success. To its English translator John Frampton, it was the "Joyful News from the New-Found World."[22] When Monardes died in 1588, his work had been published in seventeen Spanish, Italian, Latin, French, and English editions. Fourteen more came out the following century.[23] The Latin edition by the Flemish naturalist Carolus Clusius (1526–1609) introduced Monardes to the European academic world.[24] Clusius's edition became the most authoritative scholarly work on botanical and medical discovery in the Age of the New.[25]

THE EPISTEMOLOGY OF THE HUNT

What is the paradigm of knowledge implied in the hunt metaphor? What did it mean, and what was its appeal to Renaissance people? In an important but little-noticed essay, Carlo Ginzburg discovered in the hunter's methodology the roots of an "evidential paradigm," which Ginzburg contrasted to the more prestigious (and socially higher) Platonic model, a model of knowledge based on abstraction and deductive certainty.[26] The latter model of knowledge was, for example, the methodology employed by Galileo. In contrast, the hunter's methodology has two essential features: It is *evidential*, and it is *conjectural*. The hunter, who follows clues that lead to an unseen quarry, uses a conjectural methodology. His lore is characterized by the ability to make the leap from apparently insignificant facts, which can be observed, to a complex reality that cannot be experienced directly. "In the course of countless chases [the hunter] learned to reconstruct the shapes and movements of his invisible prey from tracks on the ground, broken branches, excrement, tufts of hair, entangled feathers, stagnating odors. He learned to sniff out, record, interpret, and classify such infinitesimal traces as trails of spittle." This "venatic methodology" was similar to that of the ancient diviner, who used clues found in the guts of animals, in the heavens, or in the flight of birds to look into the future, and was the forerunner of the psychoanalytic method, which Freud said "is accustomed to divine secret and concealed things from unconsidered or unnoticed details, from the rubbish heap, as it were, of our observations."[27]

The Greeks called this type of knowledge *mêtis*. It refers to practical intelligence based on acquired skill and experience—in other words, cunning. *Mêtis*, or practical knowledge, was entirely different from philosophical knowledge. It applied in transient, shifting, and ambiguous situations that did not lend themselves to precise measurement or logic. Its stratagems were especially applicable to situations requiring foresight: hunting, navigation, and medicine, for example, all of which were guided not by a fixed method but by the circumstances themselves, and by signs in the stars or forest. Just as the navigator conjectures his route through the raging seas by following signs in the stars and winds, so the physician looks for

signs in the fluctuating sea of symptoms to make a diagnosis of the illness he must treat. Primed with knowledge acquired through long experience, like a pilot at the tiller the physician makes his way by conjecture and seizes the right moment to apply his art. Wholly oriented toward the world of becoming, *mêtis* applied in situations demanding action rather than reflection, where intuition and quick judgment were more useful intellectual traits than facility with logic.

The venatic paradigm contrasted sharply with conventional philosophical knowledge. Classical Greek philosophy posed a radical dichotomy between the worlds of being and becoming. To the Greeks, the sphere of being—the unchanging world—was the domain of true and certain knowledge. The sphere of becoming—of the sensible and the unstable—was the world of changing opinion. *Mêtis* or conjectural knowledge, which is oriented toward the sensible world of becoming rather than the intelligible world of being, can have no place in the realm of philosophy understood this way. Hence the conjectural paradigm was pushed into the background, erased from the realm of knowledge and relegated to speculation and mere opinion.

Whereas the classical concept of truth framed Medieval science, the venatic paradigm re-emerged in the Renaissance. In fact, the paradigm of the hunt turns up repeatedly in Renaissance discussions of scientific method. For reasons I shall try to explain, the hunt metaphor was particularly prominent in two closely related Renaissance traditions: medicine and natural magic. In listening to the new voices booming from the printing presses in popular medical and natural magic tracts, Europeans of the day had good reason to hope that the future held great promise.

THE PROFESSORS OF SECRETS HUNT FOR
SECRETS OF MEDICINE

In the therapeutic domain, the venatic paradigm undermined and ultimately subverted orthodox Renaissance medicine. Traditional Galenic medicine, which defined sickness as an imbalance of bodily humors and therapy as aiding nature's inherent power to heal (*vis medicatrix naturae*), came under attack from empirics and charlatans. They adopted a radically activist stance, insisting they had remedies that targeted specific diseases—a claim that gave them an edge in a competitive marketplace. Quick cures and quick gains were the empiric's ends. Panaceas abounded and coin purses jingled.

A major influence on the shifting medical marketplace was the threat of new and threatening contagious diseases. The Renaissance was an age of new diseases. Besides syphilis, there was plague, which first struck Europe in the form of the Black Death of 1348–50; typhus, a disease of urbanism, mobility, and warfare; and the English Sweat, a mysterious and lethal disease that struck Europe in a succession of epidemics beginning in 1485 and lasting until 1551, after which the dis-

ease mysteriously vanished, leaving in its wake memories of husbands, wives, and friends coming down with the sickness in the morning and dying by dusk.

In the age of new infectious diseases, the old rules began to show their wear. A devastating plague in Venice in 1576 tested the physicians' performance, and the results were not impressive. By 1577 tens of thousands had succumbed to the epidemic. More than just testing Galenism's competence, syphilis and plague raised skepticism, opening a crack in the medical marketplace for alternative healers who competed with the regular doctors. Unsurprisingly, the idea of disease agents appealed to irregular healers and charlatans. Panaceas were their bread and butter.

In 1555, the Venetian humanist Girolamo Ruscelli published a book that influenced vernacular culture for decades to come. The book was called *The Secrets of Alessio Piemontese*—Alessio being a pseudonym Ruscelli made up as part of an elaborate ruse. The book became a phenomenal bestseller, largely because it promised to reveal the jealously guarded "secrets" (recipes) the author had assembled over a lifetime of collecting "not just from very learned men and noblemen, but also from poor women, artisans, peasants, and all sorts of people."[28] His secrets included remedies unknown to ordinary doctors, exotic perfumes, techniques for making artificial gemstones and valuable dyestuffs, and rare alchemical secrets tried out by Alessio himself. With Alessio's *Secrets,* the power of the recipe became manifest, and an age of how-to opened.

Alessio's *Secrets* touched off a torrent of books of secrets. The genre was so popular that their authors became known as the "professors of secrets."[29] Characters like Alessio roved all over Early Modern Europe, part of a network of experimenters making up an underworld of sixteenth-century science. The professors of secrets affirmed the superiority of experience over reason in the search for scientific knowledge. They believed that nature was permeated with occult forces that lay hidden underneath the exterior appearances of things. Neither reason nor authority nor any of the traditional instruments of inquiry, they insisted, were capable of gaining access to the occult interior of nature. Some new way had to be found to penetrate nature and capture its secrets.[30]

The new scientific epistemology advanced by the professors of secrets was in fact one of the most ancient epistemologies of all: that of the hunter. The hunter of nature's secrets experiences nature not as a text but as a dense woods in which theory offers a poor guide. Just as the hunter tracks his hidden prey by following its spoor, the hunter of secrets looks for traces, signs, and clues that will lead to the discovery of nature's deeply hidden causes. A sharp eye, intuition, and sagacity—not theoretical knowledge or cleverness at parsing a text—were the marks of the scientist as hunter.

The writings of the Bologna surgeon Leonardo Fioravanti, one of Europe's most famous professors of secrets, capture this way of thinking. Dissatisfied with traditional medical learning and determined to recover the primitive, pristine medicine of "the first physicians," he resolved to take the road of experience to learn the

secrets of true medicine. In his autobiography, he recalled the day in October 1548, when at the age of thirty, he embarked on his quest:

> Many years have passed since I left my sweet home, Bologna, solely with the intention of traveling around the world in order to gain knowledge of natural philosophy, so that I might be able to practice medicine and surgery better than I could in those days when I began my work. And thus I have traveled to various and diverse provinces, always practicing the art wherever I found myself. I never ceased studying but always went looking for precious experiments, whether from learned physicians or simple empirics, yea from all kinds of people, whether peasants, shepherds, soldiers, clerics, old women, and people of all different qualities.[31]

Thus began a thirty-year pilgrimage that took him to Sicily, which he took to be the original font of empirical medicine, and from there all over Italy and finally to Spain, where he plied his trade—and when necessary pleaded his case—in Philip II's court, where he met alchemists, navigators, American Indians, and naturalists returning from the New World.[32] Fioravanti said he was following in the footsteps of the ancient philosopher Apollonius of Tyana, who traveled to distant parts of the world to learn the secrets of nature. Rejecting official medicine, Fioravanti offered this advice to those who wished to be philosophers:

> If you want to be called a philosopher, you must go walking the world and live among all sorts of people and understand their nature and the medicines they use. Once you've done that, you have to discover the great variety of things in nature, the diversity of people in the world, and their many different medicines. And when you've seen all these things, only then will you have acquired the name of philosopher.[33]

The professors of secrets put little faith in theory. They rarely asked why particular recipes worked. Nor did they use experiments to test theories. They were guided by the conjectural methodology of the hunter rather than by the theoretical approach of the experimental scientist. Yet, for all their talk about the hollowness of theory, the professors of secrets carried out their investigations within an intellectual framework that most of their readers shared; otherwise, their books would not have sold so well. The philosophical expression of this outlook was natural magic, the science that attempted to give naturalistic explanations of occult forces. The basic assumption of natural magic was that nature teemed with hidden forces and powers that could be imitated, improved on, and exploited for human gain.

SIGNS AND SIGNATURES IN THE
LABYRINTH OF NATURE

To the natural magicians, the universe was an immense network of correspondences and hidden analogies. The Neapolitan savant Giambattista Della Porta, Europe's most famous magus, envisioned an encrypted world in which nature's

secrets were locked away in a dense forest of symbols. Della Porta wrote at a time when geographical discoveries had expanded the known world and had completely altered the landscape of nature. Nature became more abundant, an almost infinite reservoir of secrets waiting to be discovered. The decoding of nature could not be accomplished using the usual tools of Scholastic natural philosophy, Della Porta insisted. Some new way of making the secrets of nature visible had to be found. Della Porta was convinced that experience was the way.

But how can experience alone weave its way through the labyrinthine network of correspondences that defines the universe of natural magic? Can nature's secrets ever be discovered? The answer, according to Della Porta, is that nature puts a mark on things. The outward appearances of objects provide clues indicating the secret properties hidden within. These "signatures," or visual likenesses, are the signs that God implanted in nature, enabling us to conjecture that certain objects have influences on other objects. Signatures are the clues leading one to see the inner workings of nature.

Signatures enable us to discern, for example, that the herb *Scorpius,* which is shaped like a scorpion, is a good remedy against insect bites and that the amethyst, the color of wine, can be used as an amulet to prevent drunkenness. Such signatures are not merely coincidences but are divinely ordained. Nor are they separable from the objects they mark. They are woven into the fabric of nature, giving it meaning and intelligibility. Without signatures, nature would be opaque and impenetrable.

Sixteenth-century intellectuals thought the doctrine of signatures was especially useful in medicine, which, driven by a competitive capitalist marketplace, increasingly aspired to identify specific drugs to treat specific ailments. Followers of the Swiss medical reformer Paracelsus were particularly enthusiastic.[34] One of Paracelsus's disciples, the Marburg medical professor Oswald Croll, wrote a treatise advancing the idea that signatures offer clues to discovering the specific healing powers of plants. *Basilica Chymica* (1609), Croll's treatise on the doctrine of signatures, opens with a violent attack on the physicians and herbalists who, "like plebeians without eyes," occupy themselves solely with the external face of things, neglecting to investigate their internal forms. Croll, on the other hand, hewed to "the footsteps of the invisible God in creatures," thereby seeking out the power enclosed within. These tracks, or signatures, he said, would lead the investigator to the secret virtues in things, which finally must be extracted alchemically. Croll gave this advice to the researcher:

> In things occult consider the manifest footsteps of nature divinely impressed in things, and diligently enquire after the hidden dowries of herbs by inspecting their external form, and by taste perceiving the difference between the shell and the kernel, between the house and the inhabitant. . . . In all external things the exterior case is only the receptacle of innate and inherent virtues infused by God, as the soul into the human body.[35]

These interior virtues are not easily accessed. They are revealed only by long study and careful observation. They can be extracted only with "the industrious help of Vulcan or anatomic knife," in other words by alchemy, anatomy, and experiment. We can acquire this knowledge, Croll asserts, only by experience guided by clues in the form of the "hieroglyphic characters of things." Signs in nature are not like those in a book. They appeal to more than the visual. They engage all the senses, as well as the emotions—in short, they embrace all experience. Thus the rough feel of the callused pedicles of ivy root signifies its virtue to heal scrofula, while the sweet smell of orchid roots indicates its power as an aphrodisiac. Rhubarb, its color indicates, expels yellow bile, while lily-of-the-valley, which droops its head, is a cure for apoplexy.

Croll compares this methodology to that of the treasure-hunter, who follows clues on the surface to discern what lies beneath:

> For as men who in digging find a treasure are wont to note the place by a certain sign, so God himself has placed signs in many things in nature, which He has not manifested, that we can only discover through the signature. . . . It pleased the Almighty furtively to create metals in the lowest places so we might know that in them are concealed occult virtues of nature.[36]

In the labyrinthine cosmos of spagyrical physicians, nature was as opaque as the densest forest. Only by following the signs and clues that God implanted in things might the investigator be led, like the hunter, to his quarry, the secrets of nature.

THE QUEST FOR SIGNATURES IN THE NEW WORLD

It has been argued that the European encounter with the New World struck an irreparable blow to the doctrine of signatures. The plants and animals of America were entirely new. Anteaters and sloths, tobacco and chocolate, are all missing from the writings of antiquity. They had no known similitudes. As one historian observes, "They come to the Old World naked, without emblematic significance." Thus, the argument holds that naturalists could not approach this new flora and fauna in the manner of earlier humanists. Instead, they were forced to limit their descriptions to discussions of appearance, habitat, and the reports of native peoples.[37]

If the New World flora and fauna came to the Old World naked, they were soon clothed with layer upon layer of correspondences and signatures. Few works better illustrate this than the compendious natural history of the Americas published by the Spanish Jesuit Juan Eusebio Nieremberg. Of all people, Nieremberg might be expected to have viewed natural history objectively. The Spanish explorers had far greater firsthand knowledge of American natural history than had other Europeans, and Nieremberg had access to their writings.[38] Yet this zealous Jesuit was obsessed with signatures. For Nieremberg, signatures were signs of Spain's divinely ordained destiny in the Americas.

Nieremberg was born in Madrid of German parents. He entered the Society of Jesus at an early age and studied at the universities of Salamanca and Alcalá, one a renowned center of Renaissance humanism and the other Spain's greatest medical school. His best-known Spanish works were deeply spiritualist tracts exploring the relation between the temporal and eternal. So it is somewhat surprising to encounter two massive works dedicated to natural philosophy and, in particular, to the natural history of the New World. Nieremberg, who had never been to America, confidently expounded on the subject in two massive, densely documented works dedicated to the natural history of the New World: *Historia naturae* (1635) and *Curiosa y oculta filosofía* (1649).

Confronting these works, one cannot help but ask: How could such a deeply religious author—one who disdained earthly affairs—be so interested in nature? For one who sought eternal truths, what was the point of studying things that were apparent and ephemeral? The answer is that, to the Jesuits, observing natural phenomena was a means of coming closer to God. To decipher facts of nature was to unveil the mysteries of the Creator. As Nieremberg put it, "all nature is something of an image, or better, an enigma of the divinity."[39] The task of the natural philosopher, therefore, was to read and interpret the universe, which by definition is apparent and deceptive. "If all contemplation of nature is quiet and pleasing even at first sight," Nieremberg wrote, "how much more enjoyable and pleasant will it be when one penetrates its secrets and enters the depths of its mysteries."[40]

Here the metaphor of *theatrum mundi* came into play; that is, the view that nothing was as it seemed and everything acquired another meaning, a sense going *beyond* the apparent. The idea permeates Spanish Golden Age poetry, painting, and philosophy.[41] The natural world, like human existence, was a representation, the result of a divine plan, a code to be deciphered, a labyrinth to negotiate and resolve. Nature's manifestations, in Nieremberg's words, were a copy of God: "By them we make Him out and by them we venerate Him, and thus they had to have much that is admirable, much that is incredible, and of which we are ignorant."[42]

Time and again Nieremberg deploys the hunt metaphor to describe his prescribed methodology for discovering the divine in nature. It is a method guided by clues, enigmas, and signs. "In all the works of nature there are proofs of the Godhead," Nieremberg writes. "There are also evident riddles [*aenigmata*] of the Divine Intelligence from the plan of nature." Therefore, while hunting—that is, inquiring into—wild beasts, "one hunts for God (*per feras venari Deum*)."[43]

This is a cosmos governed by analogy, sympathies, and correspondences— similitudes, as Renaissance scholars called them. For Nieremberg, celestial movements are to be found in animals, and animals are inscribed on the stars.

Stones take organic forms, and the vegetable pharmacopoeia announces through its physical features the illness or organ it is designed to cure. It is a universe similar to the one expounded by Nieremberg's Jesuit contemporary Athanasius Kircher, who believed that nature was God's poetical labyrinth and a reflection of the supernatural. Kircher, one of the greatest polymaths and most learned men of the Early Modern period, wrote voluminously on virtually every imaginable aspect of ancient and modern knowledge. In every work, he demonstrated the motto that guided his work and his view of the world: "The world is bound by secret knots."[44]

The Spanish historian Juan Pimentel characterizes Nieremberg's work as an exemplar of "Baroque science."[45] It is an apt description. By the time Nieremberg wrote in the 1630s, the Baroque was in full swing. Among the peculiarities of the Baroque was an obsession with reading signs in nature that pointed to higher meanings, such as the Passion of Christ, redemption, and so on. The Baroque was also characterized by a fascination with change and novelty. To Nieremberg, the emergence of novelties was explained by the unfurling of the principle of plenitude. What was sought out and appreciated was in fact the strange rather than the new, and the stranger the better. Few cases seemed as promising for revealing the strange and novel as the New World. America was a black hole to one, like Nieremberg, who saw all of nature as a labyrinth, a code to be cracked.

Nieremberg had never visited America; in fact, he never left Spain. But that did not prevent him from reading into the natural history of those distant regions the signs of God's plan for the world, nor from deciphering the American signs to confirm Spain's divinely ordained imperial destiny in the New World. In dealing with America, Nieremberg relies entirely on the testimony of others, drawing information from the works of José de Acosta, Peter Martyr, Fernández de Oviedo, and the great chroniclers of the Americas. Above all, he quotes extensively from Francisco Hernández, one of the most astute sixteenth-century observers of the New World. All these empirical reports Nieremberg enveloped in the rhetoric of novelty and wonder.

In approaching the gigantic wonderland called America, Nieremberg saw signs everywhere, and he read many of them in a distinctly imperial fashion. Thus, the *manucodiata* (bird of paradise) to him augured a new paradise to come, a promised land of the future, not the biblical paradise of the past. America, of course, would be that new paradise. In another American plant, the *granadilla* (Passionflower), he was able to locate the chalice, nails, and other signs of the death of Jesus Christ—emblems of the Eucharist, the sacramental motif brandished by the Counter-Reformation as the emblem of the true faith.[46] Nieremberg's main concern, of course, was to give meaning to a world that was to Europeans entirely new, to tell a story of America that aligned it with Holy Scripture—and with Spain's imperial destiny (figure 6.4).

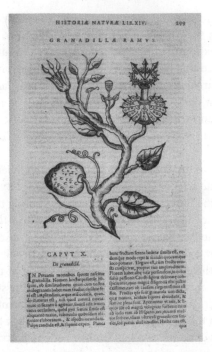

FIGURE 6.4. Granadilla (Passionflower), Juan Eusebio Nieremberg, *Historia naturae maxime peregrinae* (Antwerp, 1635). John Carter Brown Library, Providence, RI.

BACON AND PAN'S HUNT

The Spanish works on New World natural history and medicine circulated widely in Europe. Beyond Iberia, they had particular appeal in England. Despite the searing anti-Spanish propaganda that streamed from the popular press, Englishmen were clearly envious of the Iberian accomplishments, and advocated for similar colonial ventures in their own country.[47] Among the avid readers of the Spanish colonial literature was the English Lord Chancellor Sir Francis Bacon. The expansion of the geographical limits of the known world by recent overseas explorations riveted Bacon's imagination. In the *Novum Organum,* he warned, "Surely it would be a disgrace to mankind if, while the expanses of the material globe—of lands, seas, and stars—have in our times been opened up and illuminated, the limits of the intellectual globe were confined to the discoveries and narrow limits of the ancients."[48] In a brilliant tour de force, Bacon described his methodology by reference to an ancient myth, the myth of Pan, the god of hunting. Bacon compared his method—an inductive and conjectural method— to Pan's hunt for the hidden goddess Ceres. According to the legend, Pan, while hunting, accidentally discovered Ceres after all the other gods had failed in their quest for her.

Bacon interpreted the Pan myth to mean that "the discovery of things useful to life . . . is not to be looked for from the abstract philosophies, as it were the greater gods, . . . but only from Pan; that is, from sagacious experience, which will often by a kind of accident, and as if while engaged in hunting, stumble upon such discoveries."[49] As a scientific methodology, Pan's hunt proceeds from one experiment to another in the same way a hunter tracks his prey step by step, guided by footprints and signs. Bacon called this method "a kind of hunting by scent, rather than a science." Serendipity is what scientists nowadays call discovery by such means.[50]

In comparing his scientific method to Pan's hunt, Bacon provided the most detailed elaboration of the hunt metaphor. Bacon saw himself as an intellectual Christopher Columbus, the discoverer of a new world of natural science just as Columbus had discovered a New World across the Atlantic. Columbus had "conjectured" his way across the ocean, said Bacon; similarly, Bacon's new scientific methodology would be founded, like that of the Great Discoverer, on conjecture from evident clues. At the same time, Bacon acknowledged the difficulty of understanding nature. In the *Novum Organum,* he wrote:

> The universe to the eye of the human understanding is framed like a labyrinth, presenting as it does on every side so many ambiguities of way, such deceitful resemblances of objects and signs, natures too irregular in their lines and so knotted and entangled. And then the way is still to be made by the uncertain light of the sense, sometimes shining out, sometimes clouded over, through the woods of experience and particulars; while those who offer themselves for guides are themselves also puzzled, and increase the number of errors and wanderers.[51]

Nature's opaqueness was a source of profound discouragement to natural philosophers, thought Bacon. Whenever they try to weave their way through the labyrinth of nature, philosophers "complain about the subtlety of nature, the hiding places of truth, the obscurity of things, and the weakness of the mind." Too easily investigators bow to authorities instead of striking out on their own, as Columbus did. To Bacon, natural philosophy was in the same situation as navigation before the invention of the compass:

> As in former ages, when men sailed only by observation of the stars, they could indeed coast along the shores of the old continent or cross a few small and Mediterranean seas; but before the ocean could be traversed and the new world discovered, the use of the mariner's needle had to be found out; in like manner the discoveries which have been hitherto made in the arts and sciences . . . lay near to the senses and immediately beneath common notions; but before we can reach the remoter and more hidden parts of nature, it is necessary that a more perfect use and application of the human mind and intellect be introduced.[52]

Bacon devoted the bulk of *The Advancement of Learning* to elaborating such a methodology of discovery. He called his method "learned experience." The

method was meant to give order and direction to experimentation, so that scientists would not have to waste time "groping in the dark."[53] According to Bacon's method, "new knowledge is discovered by ingenious adaptation of existing knowledge, rather than by formal inference from fundamental principles."[54] Baconian induction was, in a sense, an attempt to translate *mêtis* —whether the artisan's cunning or the hunter's intuition—into a method. As I indicated earlier, *mêtis* was a kind of knowledge for which no recognized method existed in the philosophical tradition. For the ancient philosophers, *mêtis* was little more than guesswork and could not possibly lead to certainty. Bacon's learned experience, by contrast, was essentially an attempt to define a rigorous methodology for conjecturing from the seen to the unseen parts of nature, from effects to causes—or, in sixteenth-century parlance, from the manifest to the occult.

Bacon condemned natural magic, which supposedly conjectured by a sort of cunning that was beyond ordinary intelligence. He wanted to reduce cunning to a rule and to provide an orderly and systematic way of proceeding from particulars to axioms. This required extensive experience with nature, which could only be gained through the combined efforts of many researchers working together. Such efforts, Bacon believed, would enable investigators to discover in experiments clues that would lead them to nature's interior, just as Pan, having long experience in the ways of nature, fell upon Ceres apparently by accident, but in reality by a kind of "sagacity." Only, in Bacon's scheme Pan's sagacity would be replaced by learned experience, an orderly method that began with the compilation of experiments and observations, and ended with the education of laws of nature.

The hunt metaphor was extremely resilient and versatile. Because it described a method of investigation rather than a philosophical worldview, it traveled easily among different theoretical positions, from the raw empiricism of the post-Columbus explorers and the professors of secrets to the carefully regulated experimentalism of the seventeenth-century mechanical philosophers. The hunter's methodology was both empirical and conjectural, and therefore neatly coincided with the ambitions of empirical healers such as Leonardo Fioravanti, who was suspicious of conventional medicine. To empirics, medicine itself was a hunt for secrets. "I've spent forty years roaming the world, searching for the *Magna Medicina*," Fioravanti said toward the end of his life.[55] Although he never found the "Great Medicine" he was looking for, his quest, like that of Alessio Piemontese, was legendary, inspiring generations of empirics and professors of secrets.

The Renaissance naturalists and the professors of secrets advanced a radically new vision of the future of medicine. It was one in which the tyranny of ancient authority was forever abolished; a future in which newly discovered herbs from distant parts of the world promised new cures; and most of all a future in which exploration—the hunt—would always be the way to new discoveries. Indeed, the

"hunt" metaphor remains a common metaphor for scientific research. Investigators "hunt" for cancer genes, chemical elements, and new cures for deadly diseases. But whereas modern scientific quests seek out phenomena whose existence is already supposed, the Baconians took a plunge into the thickets of nature to see what might be found there. For Bacon's generation, the hunt was an exploration of uncharted territory, with the goal not simply to explain what was already known but to discover new things.

It is not easy to find new knowledge, Bacon observed, since nature so jealously guards her secrets. As a result the scientist cannot simply rely on the traditional tools of logic, but must instead be a wary and cunning hunter, like a lynx alert to every sign of his prey. As Bacon assured his readers: "There are still laid up in the womb of nature many secrets." To discover them, "you have to hound nature in her wanderings."

When in the mid-seventeenth century Joseph Glanvill envisioned the opening up of "an America of secrets and an unknown Peru of nature," he had in mind the New World explorers, as well as armchair travelers like Monardes. The navigator and the explorer provided the virtuosi with a heroic self-image as the model empiricist, unpretentious in his learning and skeptical of the opinions of the schoolmen. "The simple sailors of today have learned the opposite of the opinion of the philosophers by true experience," asserted Jacques Cartier.[56] Such pronouncements turn up again and again in the relations of the explorers. The brilliant achievements of the modern navigators brought into sharp relief the limited intellectual horizons of the ancients, and demonstrated the superiority of empirical observation over bookish knowledge. From the standpoint of *materia medica*, Glanvill and his contemporaries had every reason to turn their backs on antiquity and look toward an "America of secrets." The hunt for "new worlds of secrets" was not a mere hackneyed metaphor; it literally described a new vision of the future of science.

The Half-Life of Blue

Charlene Villaseñor Black

From the vantage point of the Renaissance, blue was the color of the future. Infrequent in Ancient and early Medieval art, blue, between the eleventh and fourteenth centuries, slowly became more prominent in European material culture, eventually emerging as Europe's favorite color by the eighteenth century, according to French historian Michel Pastoureau.[1] During this transition, and particularly between the fourteenth and seventeenth centuries, blue's semiotic value was in flux. In the late Middle Ages, for example, theologians associated blue with the Virgin Mary. By the seventeenth century, "chromophobic" Protestants, who connected rich and vibrant colors to Catholicism's excesses, accepted blue as a sober and moral hue, in line with black, gray, brown, and white.[2] Pastoureau supports his thesis with significant material, textual, and documentary evidence. For example, by the eighteenth century, the number of words for "blue" increased markedly in European languages.[3] Most extant eighteenth-century dyers' manuals demonstrate a preoccupation with blues, as evidenced by numerous recipes for creating it, in contrast to Medieval dyers' interest in reds.[4] Between 1704 and 1707 in Berlin, German chemist Heinrich Diesbach invented Prussian blue, and the natural dye indigo, derived from a plant native to Central America, became more widely available, giving artists and artisans easier access to blue hues. Westerners' taste for blue intensified in the nineteenth and twentieth centuries. By the 1900s, blue was the favorite color overall in the West, and the preferred color of most clothing.[5]

During the Renaissance, in the middle of the cultural shift described by Pastoureau and the focus of this essay, painters and patrons alike prized blue pigments, in their various forms—ultramarine, azurite, indigo, smalt, and "Santo Domingo blue," a New World pigment described in archival documents.[6] Blue pigments, though, were notorious among artists because of their expense, rarity, and instability. An early study of blues in the Renaissance suggested that artists

and treatise writers viewed the color as "feminine," thanks to its difficulty of use and capriciousness.[7] In addition to being difficult to use, many blue pigments were known to degrade, turning a muddy brown or green, gray, or even black, usually within decades of their use. Why would artists and patrons choose pigments with such a short half-life? Was it only cost that affected their decisions? How did notions of temporality, fame, and ingenuity influence their artistic choices?

I center my investigations of blue pigments in the Spanish Empire, because of the importance of its vast trade networks and Spain's unique history. In the fifteenth through eighteenth centuries, Spain was the heart of a global empire and the center of worldwide commerce. Spanish conquerors, explorers, and traders traversed the globe in search of new lands and natural resources, including new artists' materials.[8] Additionally, Spain's unique past as al-Andalus, with parts of the Peninsula under Islamic control from 711 to 1492, produced a distinctive material history, one conditioned by advanced developments in technology and science, legacies of Arabic culture. These, in turn, influenced attitudes toward, and the creation of, blue colorants in the Early Modern era. How did Spain's "Moorish" background affect the semiotics of blues at this cultural moment? How did its position as center of the largest global empire in the world influence the creation and acquisition of blue pigments in Europe and beyond?

THE HUNT FOR BLUES IN THE SPANISH EMPIRE

Documents from Spanish archives reveal tales of eager adventurers searching out new sources of blue pigments and dyes. Rocío Bruquetas, Spanish conservator, curator, and art historian, has uncovered a document dating from 1417 referring to mining "blue stones" in Talavera, Arenas de San Pedro, and San Martín de Valdeiglesias, all in Castile, in which King Juan II ordered inspections of these mines. In 1498 three inhabitants of the Spanish city of Córdoba were granted a license to search the nearby mountains (sierra) for mines of "cobre y azul," copper and blue, presumably copper and azurite, the two minerals often found together.[9] A bit earlier, in 1476, other Spanish entrepreneurs received licenses to hunt in Sigüenza and Cuenca. In 1498, explorers received a license to search for "piedra azul muy fino para pintores" ("blue stone very fine for painters") in Cabrales (Asturias); another license dated 1627 authorized exploration along "las riberas del río Óribo," the banks of the Oribo River, in León.[10] Other kinds of records in the Spanish archives point to the preciousness of blue pigments and colorants—such as court cases involving vendors trying to sell "fake blues" and artisans meeting to establish quality control of blue and green pigments.[11]

The quest for coveted blue stones, or "piedra azul," can also be documented in the Americas. Bruquetas was the first to signal the importance of trade in "Santo Domingo blue," a form of azurite, mined in the Dominican Republic, transported

via galleon back to Spain, and sold throughout Europe.[12] As she has noted, Christopher Columbus, during his second voyage (1493–96), recorded the existence of blue minerals on the island of Hispaniola in his second letter of 1495, written to the Catholic monarchs Ferdinand and Isabella. One of the most productive mines for copper blue minerals was in Cotuy, in what is now the Dominican Republic.

Such cargo was frequent on the galleons returning to Seville in the sixteenth and seventeenth centuries.[13] A royal order of 1609 asks the governor and captain general of Hispaniola to report on the quality of a certain mine containing blue stone and demands that the royal fifth, or "*quinto*," be paid to the Crown.[14] Other records, including one from 1579, record shipments of this "blue mineral" (*mineral azul*) to officials in Seville's House of Trade, on one of the first boats to return to Spain with cargo.[15] It transported "two loads of blue mineral of the best quality that is to be found on the island" ("*dos cargas de mineral azul de la mejor calidad que se encuentre en la isla*"). Another document from 1563 speaks of the discovery of silver on the island of Hispaniola, but also mentions "*cobre azul*," or blue copper, possibly copper sulphate, also used as a pigment.[16]

Other blue pigments used in Spain were acquired in Europe. During the reign of King Philip II, copious amounts of pigments were purchased for decorating his ambitious building projects, such as El Escorial, as well as the palaces in Madrid, Toledo, El Pardo, and Valsaín. Archival documents record purchases of smalt and ultramarine, in addition to azurite, previously discussed. Because most of the artists at El Escorial were Italian painters working in fresco, they purchased pigments from Italy.[17] Sixteenth-century documents reveal that much of the smalt acquired by Spanish painters came from Venice, despite the fact that most smalt was produced in Germany, the Low Countries, and Bohemia, from cobalt mined in nearby Saxony. Other pigments were acquired from Antwerp.[18]

The archival record reveals the global nature of the trade in blue pigments. Artists in the Americas often employed pigments manufactured in Europe instead of local ones. A study of 106 colonial Andean paintings, dating from 1610 to 1780, employed chemical and art historical analysis to reveal the use of a number of European blue pigments, including azurite, smalt, and ultramarine.[19] In the sixteenth and seventeenth centuries, artists working in New Spain requested pigments and other artist supplies from Europe. Similar shipments were sent to Panama and Honduras from Spain.[20] Smalt, for example, appears on the registries of ships arriving in the Americas from Spain, not surprising since smalt was not manufactured in the Americas until the second half of the nineteenth century, according to some scholars.[21]

As these documents indicate, the hunt was on in Spain and the Americas for new mineral blues. The best known of these blues is, of course, ultramarine, derived from *lapis lazuli*. The precious stone was mined in Afghanistan and imported to Europe via the Silk Road in the Middle Ages and Renaissance. Ultramarine, or powdered *lapis*, had been used for millennia by the ancient Egyptians

and Babylonians and in ancient Asia. Recipes for its use in the West date back to late Antiquity, as revealed by the Stockholm and Leiden Papyri, probably dating from the late fourth century, and the *Mappae Clavicula,* dated to the eighth to twelfth centuries, with parts probably based on earlier texts.[22] During the Early Modern era, *lapis lazuli* was mined in northeastern Afghanistan, in remote areas, including the Sar-e-Sang Valley and Badakhshan Mountains. It is a stable pigment. Europeans' reverence of it has been clearly documented, most notably by social art historian Michael Baxandall, whose groundbreaking 1972 study, *Painting and Experience in Fifteenth-Century Italy,* carefully analyzed its use in Domenico Ghirlandaio's *Adoration of the Magi* of 1488, a panel painted for the *Spedale degli Innocenti* in Florence. In the painting's contract, the artist and Fra Bernardo, the Hospital's prior, agree that the finished panel will conform to a preliminary drawing and be completed within the stipulated time frame. Most significantly, Ghirlandaio was directed to use certain blue pigments and gold. The blue is explicitly specified: "and the blue must be ultramarine of the value about four florins the ounce."[23] More precious than gold, ultramarine set the standard for blues in the Early Modern period.

The precious ultramarine was rarely used in Spain, however, as artists and treatise writers of the period testify. This has been confirmed by art historians and conservators in technical examination of Spanish paintings.[24] These writers include the painters Francisco Pacheco, author of *El arte de la pintura,* written in the first third of the seventeenth century and published in 1649, and Antonio Palomino, author of *El museo pictórico y escala óptica,* written in 1723. The pigment has been identified, though, in the painting of *The Coronation of the Virgin* (Madrid, Museo del Prado, 1641–44) by Diego Velázquez, student and son-in-law of Pacheco, and in several of Bartolomé Esteban Murillo's Immaculate Conception paintings, as well as his *Virgin of the Rosary* (Dulwich, ca. 1675–80), in which ultramarine was applied over smalt, a pigment to be discussed shortly.[25] In Spain, preliminary research seems to indicate that ultramarine was specially reserved for depictions of the Virgin Mary, as similarly noted by some art historians about Italy.[26]

Spanish artists more commonly used "Santo Domingo blue," discussed earlier, and European azurite, mined in Spain, a copper mineral or copper carbonate that was much more readily available. The former was more common in the sixteenth century, and the latter in the seventeenth. Azurite is not as stable as ultramarine, but it is much cheaper. Unfortunately, however, with time it can turn greenish, or even brown or black. It had been used for centuries in fresco and tempera painting. Sometime after the early 1400s, artists began to add the ground-up ore to linseed oil. Both Pacheco and Palomino discuss the use of Santo Domingo blue and azurite, using varied terminology.[27] Their terms for these mineral-based pigments include "Santo Domingo blue," fine blue, as well as "fine, thin blues of ashes" ("*azules de cenizas finas y delgadas*"). Vicente Carducho, a third painter

and treatise writer, mentions azurite in his 1633 text, *Dialogues of Painting*, calling it "Seville blue ashes" or simply "blue ashes" ("*cenizas azules*"). Both Pacheco and Palomino indicate that Spanish painters used azurite instead of ultramarine.[28] Whether Santo Domingo blue or azurite, the color is not the same as ultramarine, as can be seen in *Holy Family*, a painting from around 1604–06 by Antonio de Mohedano (1561–1625) that hangs in the Museo de Bellas Artes in Seville. The azurite employed for Mary's garment is quite well preserved, giving us an idea of its original greenish-blue color.[29]

The most common blue used by Spanish painters was smalt, the most unstable blue of all.[30] "*Esmalte*" or smalt was a pigment made by human hands and ingenuity, not by nature. It derived from potassium glass, made blue through the addition of small, varying amounts of cobalt ore. Cobalt was mined in the mountains of Saxony, in what is now eastern Germany, the major European source of the ore. The process of creating smalt was difficult and labor intensive. The mined ore was heated repeatedly to create cobalt oxide, called zaffer or zaffre, then ground, and poured into molten glass, turning it blue. The glass was quickly cooled by plunging it into cold water, causing the glass to fragment into granules, which were then ground finely to make smalt. The ground smalt was added to linseed oil, a process that Pacheco described in detail. To offset this complicated description of the technique, I offer this simpler explanation from Stuart Fleming, former archaeologist at the University of Pennsylvania: "The artists' pigment—smalt—is simply powdered blue glass."[31] A team of conservators, chemists, and art historians studying blues offers this description: "Smalt is an inorganic pigment of complex manufacture."[32] Venetian glassmaker Antonio Neri, author of the first known treatise on colored glass in Europe, *L'arte vetraria* (*The Art of Glass*), published in Venice in 1612, expressed bewilderment at how smalt was created. In chapter 72, on blue smalt, he wrote: "I cannot find the composition hereof in any writer, but I have been informed by an honest workman in Glass, that 'tis made of Zaffer, and Pot-ashes calcin'd together in a furnace, made like that for Glass."[33] Pacheco offered an even simpler account: Smalt was, in his estimation, "created by God," a bold statement of admiration for how difficult it was to manufacture.[34]

In addition to being challenging to make, smalt was also problematic to use in painting, if one is to believe artists' treatises of the times. Smalt was lumpy, since the intensity of the shade of blue depended on the amount of cobalt in the glass as well as the size of the glass particles; larger particles created a more intense hue. Large cobalt particles settled in the oil; smalt also dripped from canvases, prompting artists to devise various tricks to prevent it from sliding off. They attempted to drain off the excess linseed oil to make the cobalt particles more visible and to prevent them from sinking, sometimes pricking small holes in the canvas to eliminate some of the oil, according to Fleming.[35] On the other hand, the presence of cobalt in smalt sped up the slow drying process of oils, and Pacheco and others recommended using smalt to speed drying time.[36] The glass particles also gave

the pigment sparkle and made it appear rather transparent. The sparkle of glass particles combined with the transparency would have been particularly delightful when seen by candlelight. Both Pacheco and Palomino recommended that painters mix smalt with other colors,[37] probably to add luminescence and radiance to other hues.

On the downside, cobalt can fade or even turn gray over time, particularly in damp environments; moisture causes the cobalt suspended in linseed oil to oxidize. To complicate matters, potassium also attracts moisture, hastening the oxidation and fading. Pacheco and others documented such changes in treatises of the time.[38] A recent scientific study of sixteenth-century paintings employing smalt provides new information on the conditions under which smalt loses its blue color.[39] This research team demonstrated that the ratio of potassium to cobalt plays an important role. When the ratio was 1:1, the smalt preserved its intense blue hue.

The loss of color in smalt can be clearly detected in Spanish paintings from the sixteenth and seventeenth centuries, including a work attributed to Pedro Campaña (1503–1586), a Flemish painter working in Spain. His *Conversion of the Magdalen*, closely studied by Marika Spring and others,[40] provides an insightful case study for two reasons: (1) A copy of the painting exists, with its blues intact; and (2) Spring and her researchers created a digital version of the painting, restoring the discolored passages. Color loss can also be detected in a later work by Sevillian master Bartolomé Esteban Murillo, his *St. Justa* from 1665 (Dallas, The Meadows Museum). Note the passage in the middle of the canvas, in the center and to the right, where the saint holds drab gray draperies in her arms. Formerly a beautiful blue, they originally provided a vivid complement to the saint's yellow dress.[41]

Why would painters employ a pigment that oxidized and became dull in color, often within decades of its use? Was it only because it was less expensive?[42] If low cost was the only reason that artists in Spain used smalt, why would Pacheco describe smalt as "created by God"? Why would court artist Diego Velázquez, or highly successful and wealthy painters such as Murillo or El Greco, use a seemingly inferior pigment? They and their wealthy patrons could surely afford something more expensive and long-lasting.

BLUES IN *AL-ANDALUS*

As we ponder these questions, the history of smalt in the Iberian Peninsula is also important to consider. While cobalt was used in the ancient world, by the Egyptians, Babylonians, and others, it does not seem to have been used in Europe until the late Middle Ages, the thirteenth century, to be exact, when the technology arrived from the Middle East. Cobalt blue can be documented as being manufactured and used in ninth-century Iraq. By the thirteenth century, it had spread from the east to North Africa, southern Spain (Málaga), and eastern Spain (Valencia), as documented by its presence in Hispano-Moresque pottery.[43] The use of cobalt blue

can be seen in pottery produced in southeast Spain, *al-Andalus,* under Muslim control at that time. Cobalt-colored blue and white wares then spread throughout the Iberian Peninsula via *mudéjar,* or Muslim, craftsmen, working in the various Christian kingdoms.[44] In the fourteenth century, ceramic craftsmen began to move north to other parts of the peninsula, including Valencia and Barcelona, from the Nasrid kingdom in Granada, as the Nasrid dynasty began to weaken, eventually falling to Spanish control in 1492.[45]

Numerous extant ceramics from various areas of Spain, done in Hispano-Moresque style and dating from the thirteenth, fourteenth, and fifteenth centuries, use cobalt. The use of cobalt-derived blue in these ceramics was the basis of the creation of smalt for painting. Two examples, a deep dish and a basin, both in museum collections, exemplify these ceramics.[46] Both were produced in Valencia during the fifteenth century (figures 7.1 and 7.2) and are examples of tin-glazed lusterware that uses cobalt-derived blues. The first example, dating from about 1430, features cobalt blue in a bold design of Arabic script, contrasting with fine decorative patterns in yellow against a white background. The second basin, while employing the same color pattern of cobalt blue with golden accents against a white background, is a vessel used by Christians, given its central prominent "IHS," the abbreviation for "Jesus." Similar ceramics can be found in collections throughout Europe, Latin America, and the United States.[47]

In addition to their use in ceramic containers and tiles, cobalt-derived blues also appeared in Islamic architectural decoration and manuscripts in Medieval Iberia. For example, a recent technical analysis by a team of Spanish scientists of the fourteenth-century Madrasah palace in Granada, the first Islamic university in Spain, revealed the presence of cobalt in the blues employed in the stucco decoration in the Oratory, which dates from the Nasrid period (1232–1492).[48] Tiles produced in Seville in the sixteenth century also reveal the presence of cobalt blue. Spain was home to major tile-making centers in the Islamic world, in addition to Syria and North Africa. Islamic-influenced tile making later spread to Venice from Spain by about 1500.[49]

What is significant here is that the technology to create blue pigments from cobalt, the basis of smalt, was introduced into Spain by Muslim craftsmen from the Middle East and was associated with objects created in Hispano-Moresque style in the fifteenth through seventeenth centuries. The production of cobalt ceramics, in fact, continued to be closely linked to populations descended from former Muslims into the seventeenth century. After the expulsion of the *"moriscos,"* or Spanish-Muslims, in 1609 under Philip III, the production of this type of ceramic declined dramatically.

My hypothesis is that cobalt blue retained an association with the splendor, luxury, sophistication, and advanced technology of Arabic culture well into the Early Modern period. To put it another way, blue smalt, derived from cobalt, produced a number of associations for period viewers in Early Modern Spain. Color is

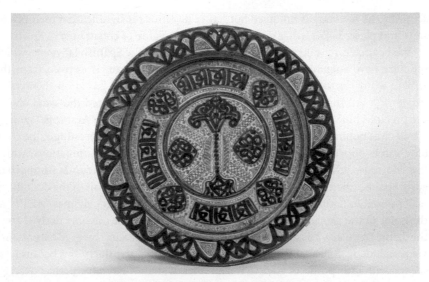

FIGURE 7.1. Hispano-Moresque Deep Dish, ca. 1430, tin-glazed earthenware, 45.72 cm (17 ⅞"), Accession 56.171.162. The Cloisters, Metropolitan Museum of Art, New York.

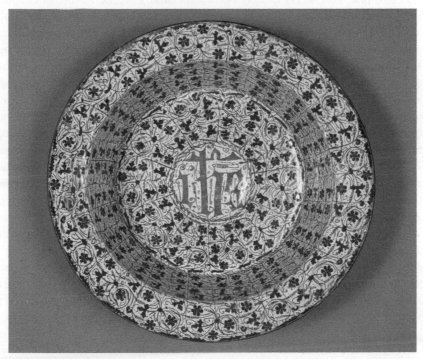

FIGURE 7.2. Hispano-Moresque Basin, mid-15th century, tin-glazed earthenware with copper luster, 49.5 cm (19 ½"). The J. Paul Getty Museum, Los Angeles, CA.

semiotic. Its meaning is not fixed but rather depends on signification in a specific time and place. Let's further explore the semiotic value of cobalt blue in Spain.

We begin with the etymology of the word "*azul*" in the Spanish language, which scholars have suggested originated in Arabic and Persian. It derived from the Arabic word "*lazaward*," or perhaps the Latin "*lazurium*," based on the Persian "*lajoard*."[50] All three of these possible source words designated the same object, the precious blue stone *lapis lazuli*. (Today the word for blue in Arabic is "*azraq*.") "*Azul*" was not in use in Spain until the High Middle Ages.[51] Interestingly, the color blue rarely appears in early Medieval Spanish manuscript illuminations, which favored reds, yellows, browns, and blacks.[52] Sebastián Covarrubias's important early Spanish dictionary of 1611, the first to employ only Spanish in the definitions (as opposed to Latin), *Tesoro de la lengua castellana o española*, defines "*AZVL*" as the color of the sky and notes that "the name is Arabic," or possibly derived from the Latin "*ceruleus*," based on the stone called "*lapis lazuli*" by the "barbarians." He concluded: "It has said color of the sky, and even of the starry sky, because it is seeded with little points of gold, in the manner of stars."[53] No more perfect description for the look of ultramarine or blue smalt could be found.

Not only was "*azul*," the word for blue, etymologically related to Arabic, but the color blue also seems to have been associated with the culture of *al-Andalus*, as evidenced by the ceramics discussed previously. An early account of the sixteenth-century Morisco Revolt against the Spanish monarchy and the detailed inventories dating from 1550 to 1580 of the confiscated belongings of participants in the Granada uprisings give a thorough picture of Muslim material life in mid-sixteenth-century Spain. The inventories are particularly useful, documenting the possessions of the forcibly converted *moriscos*, which were seized and publicly auctioned off when their owners were found guilty of rebellion.[54] The first revolts against Spanish rule ran from 1499 to 1501, soon after the fall of the Nasrid kingdom in 1492. A series of other revolts occurred throughout the century, culminating in the Alpujarras Rebellion of 1568–71. During this time, numerous inhabitants of Granada were forcibly resettled in other parts of Spain.[55] The inventories, housed in the *Archivo de la Alhambra*, reveal numerous references to blue fabrics, livery, and articles of fine clothing, including tunics and silk shirts. The presence of blue clothing and textiles is striking, since research on other areas of Europe has suggested that blue was not a common color for fine clothing during the Renaissance, but rather was worn mainly by the peasantry.[56] Additional evidence associating blue with the Arabic world comes from Italy. Once Italian artisans began using cobalt blue in the early fifteenth century, the cobalt, processed in the form of zaffer or zaffre imported from Syria, became known as "*colore damaschino*,"[57] "damask color," or "color of/from Damascus."

Material and textual evidence thus suggests that the color of cobalt blue was associated with the culture of *al-Andalus* in Early Modern Spain. The real consequences of the uprising in the Alpujarras notwithstanding, significant evidence

points to the valorization of Moorish culture in sixteenth-century Spain. A recent study of references to Islamic culture in literature, architecture, fashion, and equestrianship in Spain demonstrated that Early Modern Spaniards regarded "Moorishness" as princely, refined, luxurious, and sophisticated.[58] Art historians Cynthia Robinson, María Judith Feliciano, and Pamela Patton, among others, have teased out the various meanings associated with what has been called "*mudéjar*" style, the label given Islamic-style objects produced under Christian rule in the Iberian Peninsula, especially their aura of luxury and technological sophistication.[59]

While the Spanish monarchs and the Catholic Church might reject and fight back against Muslim "heretics" in their midst, the great scientific and technological advancements of the Arabic world were greatly appreciated, indeed, coveted by European scholars. It was because of Arabic culture that the knowledge of the ancient Greeks had been preserved, to be translated later to Latin and made available to Europeans. *Al-Andalus* was, in fact, the most important center for translation to Latin from Arabic in the eleventh and twelfth centuries, the height of Arabic culture, with important sites at Santa María de Ripoll Monastery in Girona, Barcelona, Toledo, Salamanca, and other cities.[60] Texts and treatises on science and technology, of particular interest, were tirelessly translated, preserving the Arabic world's knowledge of mathematics, medicine, astronomy, physics, chemistry, alchemy, and astrology, as well as architecture, mining, hydraulics, irrigation, agriculture, and commerce.[61] In 1085, after the fall of Toledo to Christian forces, that city became a magnet for European scholars, who traveled there to consult and translate the numerous Arabic manuscripts housed in its libraries.[62] Arguably, Western science had its origins in the Arabic world, a line of argumentation that could potentially lead to a new sense of what the Renaissance means.[63]

This scientific knowledge was central to the creation of Spain's future empire. Indeed, it was the Arabic world's advanced knowledge of mathematics, astronomy, and navigation, as well as its preservation of Greek achievements, that led to the creation of the astrolabe, sextant, and quadrant, critical tools that enabled Spanish galleons to sail to the Americas. Without the scientific and technological knowledge preserved by scholars in *al-Andalus*, later translated into Latin and made available to the West, there would have been no future Spanish Empire.

And there would have been no cobalt blue or smalt, either, since it was Arabic technology that created the prized blue color.[64] A treatise on ceramics by historian Abu'l-Qasim, dating from 1304 to 1316, describes the use of cobalt for ceramics and mentions Kashan, in central Iran, as its source.[65] Qamsar, outside of Kashan in central Iran, was the site of a major cobalt mine, in use from ancient times until the early 1900s. Recent scientific analysis of cobalt in thirteenth- and fourteenth-century blue and white ceramic pieces from Teruel revealed that they were colored with cobalt from the Middle East.[66] From where did Early Modern Spanish artists obtain smalt? Did they get it from the cobalt mines in Iran? Art historians have long assumed that as elsewhere in Europe, smalt in Spain came from Saxony,

which had large cobalt mines and factories to manufacture smalt for export.[67] The source of the cobalt used in Renaissance Spain merits further investigation, however, as the intriguing clues presented above suggest.

A document from 1613 indicates the possibility that Syria exported cobalt to Spain, although further study and corroboration are needed.[68] This document, the record of a lawsuit brought by dyers in Barcelona, describes "Damascus Blue" (*Damasco azul*), reminiscent of the Italian "*colore damaschino*" referenced earlier. Damascus, Syria, had been home to the illustrious Umayyad dynasty, the group that conquered the Iberian Peninsula in the seventh century and built the Great Mosque at Córdoba. Is it possible that this document refers to the import of zaffer made from cobalt in the Middle East? The current word "*cobalto*," or cobalt, derived from the German word "*Kobald*," meaning "sprite" or "spirit," did not enter the Spanish language until much later, well after the Early Modern era. Great care must be taken not to read too much into this document, since "*Damasco azul*" could also refer to damask, a fabric. Additional corroborating evidence is necessary.

THE TEMPORALITY OF BLUES

In conclusion, the goal of this essay was to rethink blue pigments in Spain and its empire and to reconsider our notions of temporality. I was intrigued by why Spanish artists knowingly used pigments that degraded and, furthermore, by Pacheco's estimation of one of these pigments, smalt, as "created by God." Were there reasons beside low cost to employ smalt? How did concepts of temporality and ingenuity influence artists' and patrons' artistic choices?

My investigation was also deeply concerned with constructs of temporality. The Renaissance is typically thought of as a period concerned with the future, with legacies, with posterity and fame. The use of smalt by Spanish artists, however, unsettles this assumption. Documents and other primary sources, combined with scientific analysis of ceramics made with cobalt blue, suggested another path— that during Spain's Renaissance blue was associated with the splendor and innovation of Iberia's illustrious Arabic past—and that the scientific achievements of *al-Andalus* were critical for the development of Spain's future empire. This led me to consider temporality and the possibility of multiple European histories,[69] an idea with particular importance for Spain, with its unique Islamic past. To quote art historian Keith Moxey, in his recent book *Visual Time:* "[H]istorical time is heterochronous rather than monochronous."[70] Alexander Nagel and Christopher S. Wood, authors of *Anachronic Renaissance,* have even suggested that Renaissance artworks were expected to encode references to Europe's multiple pasts, an example of what they call time "folding" over on itself.[71] Such artworks, which reflect temporal instability, are "anachronic." Paintings that use smalt perfectly embody this notion of anachronic works, since they refer back to the illustrious history

of *al-Andalus,* as they simultaneously predicted Europe's future taste for blue. In fact, fading smalt is a literal witness to, a performative mechanism for, such temporal instability.

Finally, my reconsideration of blues in the Spanish Empire was conditioned by discourses drawn from ethnic and decolonial studies, especially recent theorizing of Afro and Chicanx futurisms.[72] Futurist scholars, writers, activists, and artists in ethnic studies posit new, more just futures for people of color, alternative futurisms inspired by non-Western notions of temporality, as they simultaneously question Eurocentric constructions of history. This has taken off in the realm of speculative fiction, what was once called "science fiction," in response to the fact that people of color were never expected to be part of the history of science or technology. My interest in ethnic studies led me to question Western histories of science and art, both marred by assumptions of European superiority. Similarly, decolonial theorists, including Walter Mignolo and Nelson Maldonado-Torres, have questioned the discursive formation of history in ways that resonate with Chicanx futurism.[73] Which histories are authorized, and who is empowered to narrate them?

Encouraged by these theorists' reconsiderations of Eurocentric strategies in the humanities, I ventured that Spain's interest in blue during the Renaissance was a prediction of what would transpire in the rest of Europe. From the vantage point of the Renaissance, blue was the color of the future, and Spain was ahead of other European countries in its use of and taste for blues, both conditioned by Spain's unique Islamic past, including and especially its technological advances. In the Renaissance mind, these scientific developments became associated with futurity, a futurity built on the sophisticated culture and advanced learning of *al-Andalus.*

Allow me to conclude with contemporary New Mexico, where many homes have front doors painted cobalt blue, described as "a requisite for doors and windows"[74] in New Mexican villages, a carryover from Spanish colonial practice, according to common wisdom, and a distant echo of the cobalt blue of Islamic Iberia. The blue doors still visible in New Mexico today act as a fulcrum between past and present. They suggest why knowledge of the past matters, and they materialize its power to carry over into the future.

8

'Ingenuity' and Artists' Ways of Knowing

Claire Farago

CONTRETEMPS

The editors of this volume called upon its contributors to write the history of the Renaissance differently by suspending the conventional operations of time and place, two of the most cherished and seemingly neutral epistemological categories in the humanities. Villaseñor Black and Álvarez invited discussion of the broader historical effects of our precisely honed investigations into primary sources in the following terms. First, they asked us to think intersectionally about the "rise [of] the scientific revolution" and "European imperialism." No mean task, this first requirement involves breaching geographical and disciplinary boundaries designated by long-established specializations. "Art" and "science" were more fluid categories that overlapped in ways that our modern disciplinary formations do not recognize, while "imperialism" involves studying European behavior outside Europe in the same breath (and breadth) as within, not divvying up the world into "Latin American," "Asian," "European," "Italian," and other subdisciplinary fabrications of nineteenth-century origin. Second, the editors asked us to consider the "futurities" that emerge at the intersection of "interest in fame and posterity" frequently expressed in our sources and the "recent theorizing of temporality." This second requirement asks us to breach conventional period boundaries by thinking critically—historically, strategically—about what "time" denotes. Since "time" is itself a culturally and historically specific construction, it too invites historical inquiry.

Our editors claim that writing history at these underexplored intersections with such heightened self-awareness of our own projections is desirable because "[i]nstead of blindly accepting fixed ideas about Renaissance futures, we try to rethink these developmental teleologies." How might the "future" of the "Renais-

sance" be treated other than as part of a teleological trajectory, Hegelian or otherwise? In the overlapping worlds of science, technology, and art that served European imperialistic ambitions with great ingenuity, to summarize very briefly our editors' framing focus, the challenge of how to account for the event demands new tools, new subjects of investigation. I will leave aside (until the end) the question that arises of what justifies focusing solely on "European imperialism" if the goal is to revise, not re-instantiate, the Eurocentric approaches of our inherited histories.

As an Early Modern Europeanist art historian, my response to the invitation—what became the essay you are invited to read here—has been to offer reflections on the rich and complex history of the concept "ingenuity" itself. Although the present discussion is focused on painting and the artist's design process, a much broader study could inquire after the understanding of *ingegno* in other texts involving other techno-sciences that require theoretical knowledge combined with embodied practice.[1] The Italian word "*ingegno*," often translated as "inborn talent," is a category historically associated with the individual. All the terms we use have histories and no matter how critical (and self-aware) we are of our inherited categories, we can never escape their effects any more than our subjects of study can, however "they" or "we" or "it" is construed. As far as the "futurities" of the Renaissance are concerned, ingenuity offers a significant opportunity to revisit well-known literature on the visual arts with different interpretive goals. Instead of looking for the origins of the modern concept of the artist as "genius" in the European literature from the fourteenth to the eighteenth centuries, when the modern notion of "genius" made its debut, we can ask how the artist's status and knowledge were understood in our primary sources, what activities were involved in the fabrication of works of human artifice, how the same criteria were applied to extra-European artisans and their products, how the manufacture of images and material things by Europeans were exported and actively received outside of Europe, and many other new questions that arise when the framework for discussion is transcultural and politically engaged in the ways that our editors ask. This essay takes what one might call a transverse path through the prehistory of "genius" since the first appearance of the term "*ingegno*" and its synonyms and alternatives in the literature on the visual and spatial arts around 1400. By the mid-seventeenth century the European empire was established across the globe through its various colonial outposts and trading networks. What does the visual artist's ingenuity have to do with it?

INGENIUM AND THE HUMANIST LEGACY OF ARTISTIC PRACTICE

Genius is a talent for producing something for which no determinate rule can be given, not a predisposition consisting of a skill for something that can be learned by following some rule or other.

—IMMANUEL KANT, *CRITIQUE OF JUDGMENT*, 1790, § 46[2]

There is no shortage of writings on the modern idea of "genius" that emerged in the late eighteenth century, most famously defined by Kant in his treatise on aesthetic judgment. According to the standard encyclopedia articles, "genius" designates "superior mental powers" closely linked with individualism and typically associated with some type of performance.[3] Cicero and Aristotle provide two anchor points for modern discussions. Cicero wrote about innate capacity as distinct from learned skill and, in doing so, brought skill (in Greek, techne [τέχνη]; in Latin, arte) and innate capacity (ingenium) into close alignment. With the pairing of ingegno and mano (hand), to use the Medieval/Early Modern terms often encountered in the vernacular literature, the ear and the eye become the final arbiters. According to Cicero, these are exceptionally skillful human organs of discrimination (iudicium) for judging differences of tone, pitch, and key in, for example, music and rhetoric.[4] Aristotle wrote about the faculty of "quick wittedness" (Poetics 1459a), that is, the "faculty of hitting upon the middle term instantaneously" (Posterior Analytics 89b34), a principle of inherited individual difference that achieves its highest form in the phantasia of the prophet. Aristotle's influential eleventh-century Arabic commentator Avicenna (who was translated into Latin and served as an important source of Aristotelian ideas for St. Thomas Aquinas and other Scholastic writers) considered ingenium to be the agent intellect associated with Aristotle's "faculty of discovering the middle term," perceiving what is right immediately by a kind of illumination.[5]

Ancient discussions of ingenium are concerned with sensate judgment, what we still call "discrimination" in the strictly quantifiable sense of the word. David Summers, who has studied the history of aesthetic judgment in Medieval and Early Modern European texts, and their ancient sources, argues that imagining ingenium or "quick wittedness" on a sliding scale running from mere cleverness to prophetic vision also explains why some writers thought that it could be taught.[6] If it is possible to teach quick-wittedness, Summers observes, then human nature can be corrected by art. It follows that, based on this philosophical heritage, the Christian justification for using images to acquire religious understanding—that is, its core defense against charges of idolatry since St. Augustine of Hippo (354–430 CE) and Pope Gregory the Great (ca. 540–604 CE)—has been expressed as the need to address human modes of cognition proceeding from sense experience.

With this very brief introduction to the history of ingenium in mind, I would like to consider the new practical literature on art emerging at the end of the fourteenth century through one of the earliest and most famous vernacular texts on painting, Cennino Cennini's Libro dell'arte (ca. 1390–1410). Cennini's text cannot be considered a transparent record of late Quattrocento Florentine artisanal practices, however, as it is still often taken to be in the nonspecialist literature. Cennini was a painter at the court of Francesco Novello da Carrara, near Padua, in the 1390s when he most likely composed his manual, judging from the language and contents of the text.[7] After the Carrara library in Padua was largely destroyed by

invading Milanese forces in 1388, the ruler's son, Francesco Novello, rebuilt it with a new focus on practical wisdom, that is, on what were then known as the mechanical arts or productive sciences.[8] Painting technology was included in this library in the form of Cennini's compilation. Far from being a simple guide to current workshop practices, Cennini's text includes recipes and materials dating from late antiquity that were no longer in common use. Ancient pigment names and other peculiarities of his text indicate that he compiled an encyclopedic sourcebook on the productive science of painting, probably at the request of his patron.

Regardless of whether Cennini recorded theory that guided practices for his own profession or compiled his treatise for a humanistic patron with an interest in technology, his discussion of the formation of a personal artistic style is unprecedented. Cennini's remarkable text begins with *scientia* and *fantasia* as the two theoretical components of the artist's expertise.[9] The text assumes familiarity with classical theories of literary imitation defined as patterning one's work on the accomplishments of another. His account can best be understood within the context of court culture, particularly discussions of Petrarchan formulas for literary prose composition popular at the court of Carrara during the time he was there. Cennini adapted concepts and terminology for composing a literary text into the terms used to discuss the role of imitation in artistic apprenticeship, whereby the student learns by copying visual models of progressively increasing difficulty. At the same time, as Andrea Bolland has shown, Cennini's text remained notably similar to the advice given by the humanist educator at Carrara, Pier Paolo Vergerio (1370–1444), on the appropriate use of literary models.[10]

Since antiquity, the most significant correspondences between writers and painters in the Western tradition have revolved around their shared ability to fabricate an ideal kind of reality perfected by art. Cennini, writing in terms he could have derived from Vergerio, strongly advises following one master, "the best one with the greatest fame," to avoid becoming fickle. "*Fantastichetto*" is the vernacular term Cennini uses to mean becoming distracted by trying out each artist's manner in turn without perfecting one's skills or acquiring a manner proper to oneself.[11] Whether one combines many models into one style (as the bee gathers honey from many flowers) or follows a single master (these were the two choices in the literary tradition), the issue was how to develop "right judgment" to exercise hand and mind together. Cennini uses the word *fantasia*, a term so closely associated with *ingegno* that they are often considered synonyms, to describe an active mental power of discernment, which he insists must be internalized through imitating only one good model.[12] Through imitating good models, the artist exercises his *ingegno* until he develops good judgment.

Unfortunately, it remains unclear whether Cennini's remarkable theoretical advice was directly known to fifteenth-century painters. The earliest historical citation of his manuscript took place in another courtly context, when Vincenzo Borghini, who worked for Cosimo I de' Medici in Florence, acquired a copy from a

Sienese goldsmith in 1564, just one year after the founding of the Florentine *Accademia del Disegno*, where Borghini was appointed its first *luogotenante* in 1563.[13] Cennini's manuscript was first published only in the nineteenth century, although Vincenzo's fellow Florentine *letterato* Raffaello Borghini copied sections from it in *Il riposo* (Florence, 1584), an art treatise intended for an educated public.[14] And in the early 1460s, the Milanese architect Antonio Averlino, known as Filarete, apparently made extensive use of a manuscript of Cennini's compilation, and Filarete was also the likely source for Leonardo da Vinci's access to another key text in the early vernacular literature on art, Leon Battista Alberti's humanist treatise on painting (1435). From this evidence, and other documentation (such as Lorenzo Ghiberti's commentaries), it is known that theoretical texts were already circulating among artists in central and northern Italy by the mid-fifteenth century.[15]

There can be no doubt that workshop knowledge was not entirely tacit. In the Aristotelian sense in which Cennini, Leonardo, and their sixteenth-century successors understood *scienza*, it is the equivalent of *theoria* and means knowledge of the causes of effects observed in nature on the basis of two components: first principles, which Leonardo treated as knowledge of the geometrical principles of optics, and the experience of phenomena.[16] This is exactly how Leonardo defined painting as an investigative science requiring great *ingegno*, grounded in both theory and experience:

> Nature's aid, free of deception, is *chiaroscuro*, which painters call light and shadow. The painter generates it by himself with the greatest speculation, helping himself with the same quantities and qualities and proportions with which nature helps sculpture without the sculptor's *ingegno*. And the same nature helps such artificers with the proper diminutions which produce perspective naturally, by itself, without the discourse of the sculptor. The painter has to acquire this science by his *ingegno*.[17]

In numerous passages, Leonardo described the scientific knowledge the painter acquires by his *ingegno* (his mental, as opposed to physical, effort) in terms of the kind of judgments exercised in producing a work of art. His description of *ingegno* as a discursive process of reasoning ultimately derives from Aristotle's ten properties or "predicaments," expressions used to talk about any subject (*Categories* 4a10–30).[18] These are the "accidents" (from *accidere*, to happen) or properties that the physicist studies in natural bodies. In his polemical defense of painting, Leonardo argued that painted images are closer to the "truth" of nature than words because they reproduce the appearance of natural effects based on the artist's knowledge of their causes. Deriving his Aristotelian terms from optical theory, Leonardo also referred to these as the "functions (*ofiti*) of the eye," "visual discourses," and "the ornaments of nature" with which the painter embellishes his images.[19]

At the same time that Leonardo recorded his ideas on painting, *ingegno* also appears in contexts associated with engineering, a word that derives from the same

Latin root.[20] Instead of maintaining categorical differences between the fine and applied arts that emerged in eighteenth-century Europe, some Early Modern historians of art, science, and technology are taking a more holistic approach, pursuing connections in a wide range of sources among new forms of artisanal and industrial knowledge production requiring mechanical knowledge.[21] Ancient sources shared by Early Modern practitioners in these fields include Vitruvius and Lucretius, who assigned prominent roles to *ingenium* in the development of technology.[22] Vitruvius devoted extensive discussions to engineering practices based on knowledge of geometry and mechanics, reflected in Roberto Valturio's fifteenth-century treatise on the military arts that Leonardo and his associates studied extensively. Artists like Leonardo who practiced as engineers and technical consultants are evidence of the increasing stature awarded to the mechanical arts and emerging technology requiring theoretical knowledge in the fifteenth century.[23] In 1642, one of the earliest histories of Urbino, a duchy long renowned for its support of mathematics and its practical applications as studied recently by Alexander Marr, observed that this land "has in every age produced men of sublime *ingegno*."[24] Globalization, industrialization, capitalism—the driving forces of modernity—encouraged innovation put to practical purposes. By the mid-eighteenth century, mechanical knowledge and Newtonian science ushered in what Margaret Jacob calls "the first knowledge economy" by supplying the theoretical underpinnings to technological innovation in mining, manufacturing, and the application of steam power more generally.[25] The role of ingenuity in technological fields is an important line of inquiry for future studies in a global framework that avoid developmental teleologies and inquire after the processes of European imperialism.

INGEGNO AND THE NEW PRACTICE OF COMPOSITIONAL SKETCHING

Focusing my analysis on the visual and spatial arts, I turn to Vasari, who first came to know Cennini's *Libro dell'arte* through Borghini at the time they were working together on the revised edition of the *Le vite de' più eccellenti pittori, scultori ed architettori*.[26] In his introduction to painting (chapter 16 of the Introduction to the *Lives*), Vasari described the process of developing the design of a painting from the initial compositional sketch to the transfer of the *disegno* to the surface to be painted. He might have derived his terms from any number of sources, including Scholastic theology. Vasari's formulation is also reminiscent of Cennini's account of the apprentice's program of study, where the student learns in a predetermined sequence of steps how to create a three-dimensional illusion through modeling in *chiaro* and *scuro*: first the student draws with silverpoint, then on paper using ink wash, leadpoint, and pen, until he is capable of rendering the "*disegno*: inside his head" (chapters 1–14).

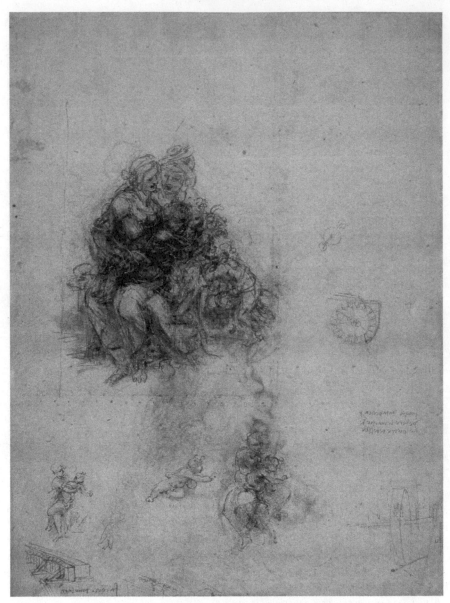

FIGURE 8.1. Leonardo da Vinci, Sketches for the Virgin and Child with Saint Anne; Wheels; a Weir, Dam, or Bridge, ca. 1500, pen and brown ink and wash over black chalk, 26.5 × 20 cm (10 7/16" × 7 7/8"). London, The British Museum 1875–6–12–17.

The many correspondences between Cennini's and Vasari's descriptions of the process of *disegno* from mental conception to physical drawing actually predate Vasari's knowledge of Cennini's text.[27] The description Vasari published in the 1550 and 1568 editions of the *Lives* is also essentially the same procedure that Leonardo described in his unpublished writings beginning with MS A (1490–92), which, as far as any surviving evidence is concerned, Vasari also did not know firsthand.[28] Yet Vasari's definition of a sketch as taking the form of a blot (*macchia*) is particularly reminiscent of Leonardo's advice on sketching a new composition. Leonardo's most mature surviving description is the paragraph famously discussed by E. H. Gombrich in his study of the artist's methods for working out compositions, in which Leonardo refers to the preliminary sketch as a *componimento inculto* (an unrefined or "wild" composition) (see figure 8.1 for a well-known example):

> Therefore, painter, compose roughly (*componi grossamente*) the limbs of your figures. For you will understand that if such an uncultivated composition (*componimento inculto*) is appropriate to its invention, so much the more will it satisfy when it is adorned with the perfection appropriate to its parts. I have seen in clouds and walls, splotches (*macchie*) that have roused me to fine inventions of various things, which, though they were wholly lacking in the perfection of any one member, did not lack perfection in their movements or other actions.[29]

Here is Vasari's very similar account of compositional sketching, combined with a description of the rest of the process of developing the design for a painting:

> On sketches, drawings, cartoons, and schemes of perspective: how they are made and how painters use them
>
> Sketches [*schizzi*, literally splashes], mentioned above, are what we [artists] call the first sort of drawing [*disegno*] that is made to establish the poses [of the figures] and the initial composition of the work. They take the form of a blot [*macchia*] and establish only a rough draft of the whole [work]. Gripped by [divine] furor, the artificer makes them in a short time with pen or other drawing instrument or with charcoal, just to indicate his intentions using whatever occurs to him. And this is why we call them sketches. Afterwards, drawings executed in a more finished manner come from these, in which the artificer tries to copy from life, with all due diligence, whatever he does not understand completely in such a way that he could rely solely on himself. Later on, measuring with a compass or by eye, he enlarges [the drawing] by turning the little measurements into larger ones, according to the work in hand.[30]

It is worth noting that when his student Francesco Melzi compiled Leonardo's scattered notes on painting, he included the passages from MS A alongside others on the same topic of various dates, which he grouped together in a subsection of the *Libro di pittura*.[31] However, the passage cited by Gombrich was omitted when an unidentified editor, about 1570, combined what are passages 186 through 189

in the *Libro di pittura* to form what became chapter 98 of the printed edition, titled the *Trattato della pittura*.[32] The abridged version of Melzi's compilation is the only form in which the text circulated until the nineteenth century, when Melzi's original codex was discovered in the Vatican Library and published soon thereafter (ed. G. Manzi, Rome, 1817). Thus, Leonardo's crucial advice on compositional sketching would have been known only through the shorter version retained in the abridged *Libro*.

If Vasari did not know the Cennini passage at the time he wrote about the design process in similar terms and did not know the Leonardo passage about the *componimento inculto* preserved only in the *Libro di pittura*, then how are we to account for these intergenerational similarities? Cennini, Leonardo, and Vasari all drew on the living language and procedures of the workshop.[33] The literary authority of the language of artistic practice was largely established by Vasari, who could call on his own experience as an artist as well as other artists' largely unpublished writings.[34] While he was preparing the second edition of the *Lives*, Vasari was advised by his literary friends, including Borghini, who had a well-documented interest in enriching the written Tuscan language with vernacular terms derived from artisanal texts.[35] Cennini's text was specifically of interest to them because it provided a solid textual foundation for long-standing (and widespread) workshop procedures. Borghini described Cennini's *Libro dell'arte* to Vasari as containing "good old advice and such beautiful ancient things."[36] The portion of Cennini's text that might have impressed modern readers the most was its extensive discussion of *disegno*, which is the part that Vasari expanded in the 1568 edition.

The greatest historical significance of Vasari's introductions to the three arts of *disegno*, which he called "*Theoriche*," is their rich lexicon of artistic terminology—a glossary of terms and recurring problems in the *Lives* themselves that were mined by the Florentine academician Filippo Baldinucci for his famous dictionary of artistic terminology published by the Accademia della Crusca in 1681.[37] In seeking continuities between verbal and visual accounts of the creative process, such correlations between literary audiences and artistic ones are significant because they show in concrete terms how a shared language for discussing the creative process and aesthetic response developed out of humanist interest in the techno-science of painting and workshop knowledge. This contributed to the artist's rising intellectual status as new demands were placed on him, such as knowledge of perspective theory, anatomy, proportion theory, and the close observation of natural phenomena.

A different account of *ingegno* derives from the classical idea of divine inspiration originating in the philosophy of Plato. It was a commonplace of the Platonic tradition that *furor poeticus* refers to the inspiration of the poet as it took form in the language of poetry.[38] Applied to the visual register, *furia* refers to the spontaneous quality of works of art resulting from the excited state of the artist. Sixteenth-century writers such as Vasari, Gianpaolo Lomazzo, Federico Zuccaro,

Vincenzo Danti, and others close to Michelangelo understood *furore* as a hallmark of divine inspiration linked closely to both the artist's initial idea or *concetto,* and his inspired execution. One of the major ancient statements of this ideal known to Early Modern writers was the *De Demosthene* of the Greek historian and teacher of rhetoric, Dionysius of Halicarnassus (ca. 60 BCE–7 BCE), who described the highest form of furor in the following terms:

> I am swept this way and that, one emotion follows another . . . a succession of all the passions that can sway the human heart. I think that at such times I am in exactly the same state as the initiates at the mystery of the Mother of Corybantes, or the like (whether it be smell, or sound or the actual breath of the divinity that arouses in these persons such a galaxy of varied visions).[39]

The arousal of *furore* by sensation that Dionysius describes (as the equivalent of an initiation rite) is closely aligned with Vasari's description of the artist as "gripped by furor" and also calls to mind Leonardo's discussion of the excited *ingegno* working with the *imaginativa* as the motivating force for the rapid-fire first sketch of the composition. Like Dionysius, Leonardo associated the onset of the artist's heightened state with certain sense impressions: "I have seen in clouds and walls, splotches that have roused me to fine inventions." Vasari and Leonardo need not have known *De Demosthene* directly, because the Platonic idea of *furore* was widely disseminated in Christian and secular sources, and must have been familiar in the oral culture of the workshop. To cite a significant example dating from the mid-sixteenth century, the Portuguese writer and artist Francisco de Hollanda (1517–1587), who lived in Rome from 1538 to 1547 and published a dialogue in which Michelangelo was one of his interlocutors, describes how the artist has first "in his imagination an idea and immediately he will conceive in the mind [*entendimento*] the invention that the work will have"; then, having fixed the invention in his *fantasia* with "great care and forethought," when his hand is placed to paper, "the idea or concept must be placed most quickly in execution" so that the artist does not lose "that divine furor and image that it bears in the *fantasia.*"[40]

In De Hollanda's description of the creative process, the passage excerpted above continues by discussing different media used in the successive stages of developing the composition: the initial use of red and black chalk, followed by pen to make the outlines and contours, and wash to make a "sweet tint" (*tinta dolce*) that veils and shades it; then using "a fine brush tipped in white heightening with gum for the highlights of the drawing" to establish the *rilievo,* all of which he calls "the order of coloring." Using only pen, De Hollanda specifies, is difficult but more masterful than other media—surely because it allows for fluid execution unparalleled in other media and cannot be erased.

At the end of the century, Lomazzo and Zuccaro both published treatises on painting titled *Idea* (in 1590 and 1607, respectively), in which they described the artist's mental process of invention in similar terms.[41] Lomazzo was directly famil-

iar with Leonardo's writings, and Zuccaro, who probably owned a manuscript copy of Leonardo's abridged *Libro di pittura*, was informed by Florentine ideas of *disegno*. Yet the presence of so many similar accounts of the creative process in so many sources is difficult to explain as the transmission of texts alone. Rather, it indicates the existence of a shared oral tradition of workshop practice with a theoretical component—artisanal knowledge orally transmitted through the workshop found its way into the new sub-philosophical literature on art, some of which was also circulating in workshops.[42]

The relationship between Leonardo's text in the unpublished MS A and Vasari's famous chapter in the introduction to his *Lives* has been treated as an important point of confluence by modern scholars. Carmen Bambach considers these two famous texts along with Leonardo's procedures to "represent essentially the legacy of High Renaissance practice."[43] Bambach develops an account of Leonardo's design process, building on Gombrich's classic study of Leonardo's method for working out compositions, in which the rapid sketching of figures and Leonardo's extensive use of small notebooks to sketch figures from life and write about the physical expression of *moti mentali* play an important role.[44]

Despite their detail, unlike Leonardo's notes, neither De Hollanda's nor Vasari's text was meant to serve as technical information for professional artists; rather, De Hollanda's account was a fictional dialogue, a popular humanist genre, whereas Vasari's essay on artistic techniques was meant as an introduction to his biographies for the educated reader interested in practical knowledge.[45] Bringing these intertextual relationships involving *ingegno* to light helps explain how workshop knowledge was transmitted and shared with a humanist audience. The sources point to a complex interplay between written and oral transmission of artisanal knowledge. Verbal descriptions apparently changed little between Cennini and Vasari, even though the appearance of works of art did. The considerable gap between the written legacy and actual artmaking practices must relate in part to the fact that the transmission of sensitive practical knowledge was not normally entrusted to written texts. The crucial details of fabrication were privileged information. Very little technical information exists in the *Libro di pittura* that Melzi compiled from Leonardo's autograph notes, and even less resides in the abridged version that circulated, perhaps partly to safeguard workshop secrets and partly because the skills and procedures involved were passed down orally and through demonstrations.

THE PURPOSE OF ILLUSION IN SACRED PAINTING

Leonardo's legacy comprised writings and visual material that enable us to trace connections between his ideas and his artistic production unmatched by any other artist. But why did he and his contemporaries put so much time and effort into acquiring the knowledge and producing spectacular effects of illusionism and movement in the first place? Beyond the scientific and practical information needed

to produce these effects is the still more fundamental question of what purpose they were meant to serve in the *Virgin of the Rocks,* the *Salvator Mundi,* the *Last Supper,* the *Madonna of the Yarnwinder,* the *Virgin and Child with St. Anne and the Lamb,* and other sacred images that constitute most of Leonardo's paintings.

The question of "why" the artist puts his intellectual effort and manual skills to certain uses and not others is actually broad enough to encompass a wide range of artistic practices. Herbert Kessler, Cynthia Hahn, Caroline Walker Bynum, and many other Medievalists now emphasize that Medieval sacred images manifest, evoke, and conjure up the sacred—that is, they *show* significance without recourse to representation.[46] Certain precious materials, such as rubies, rock crystal, mother of pearl, gold, and ivory, and imitations of them ranging from expensive enamels to cheap paste jewels have become the subject of study by Medievalists interested in understanding what properties ranked these above others as suitable containers for relics.[47] This is the "materiality" of materials—the significance attached to certain kinds of matter, especially when transformed by inspired artists who translate their mental images using their skilled human hands into works of art praising God, the Divine Artificer.[48] Instead of the mimetic, illusionistic modes that try to trick the senses, as in Pliny's stories, Kessler writes, Medieval artisans call attention to the stuff their reliquaries and other sacred objects are made of. They call attention to the signifying properties of the fashioned materials themselves.[49]

In the case of reliquaries, how artisans understood their process of conception and fabrication must be recovered from the material object, technical manuals, and theological writings. The issue I want to pursue now concerns the transition from a "Medieval" sense of the materiality of art to the "Modern" sense of an illusionistic visual image. What are we to make of the changed mode of presentation signaled by Medievalists such as Hans Belting, Kessler, Bynum, and others? We are accustomed to thinking about "virtual images" as a modern if not exclusively contemporary phenomenon, yet the optical naturalism we still associate with the label of Renaissance art is also a regime of virtual images. In fact, the standard definition of a virtual image derives from Medieval optical theory.[50]

How are the Medieval sense of materiality and the virtual reality of illusionistic art mutually related; how are they entangled with each other? The presence of the eternal and immutable in the transient and corruptible is a paradox central to all Christianity—and is not limited to the "Medieval" period. Discussions pertaining to the productive arts that were first formulated by theologians in the eleventh and twelfth centuries were widely diffused in courtly poetry, vernacular literature, scientific writings on mechanics, optics, and anatomy, and other sources that artists and humanists who wrote about the arts read in the "Early Modern" period as well. Does the era of illusionism we associate with "Renaissance" art divest sacred images of their time-honored power to manifest the significance of that which is understood to be immaterial? Put another way, were the virtual images that Leonardo and his contemporaries so skillfully fashioned related in any way to long-standing preferences for using certain precious materials, such as gold, crystal, and

gems, to convey Christian themes and theological ideas? Will the answer help us more fully understand *ingegno* in historical terms?

One set of clues resides in certain passages from MS A and elsewhere that Melzi included in the first, theoretical section of the *Libro di pittura* that were eliminated from the 1651 *Trattato*, where Leonardo describes the painter's *ingegno* as an active power for gathering and exercising knowledge. Deriving his terms from Dante (who in turn derived his language from St. Thomas Aquinas, who was dependent upon Aristotle via Arabic sources available in Latin since the early thirteenth century), Leonardo conceives of painters as being able to "transmute" themselves into the mind of nature.[51] By making their *ingegni* like the surface of a mirror, which contains the similitude of whatever object is placed before it, Leonardo writes, painters "discourse" about the properties of observed nature. He quotes lines from Dante's *Convivio* that the painter could not paint a thing if first his *fantasia* did not have the capacity to conceive the incorruptible form of it.[52] Such statements demonstrate that Leonardo subscribed to the widespread Augustinian view that God is perceptible everywhere in creation, as the following well-known excerpt describing the ornaments of nature from the *Parte prima* of the *Libro di pittura* attests:

> Painting considers all the qualities of forms with philosophy and subtle speculation—seas, sites, plants, animals, grasses, and flowers, which are enveloped in shadow and light. Truly this is science and the legitimate child of nature because painting is born of nature; but to be more correct, we should say it is the grandchild of nature because all perceptible things are born from nature, and painting is born from the nature of those things. So, strictly, we shall speak of it as the grandchild of nature and kin to God.[53]

"Nature" in this sense is eternal, the source rather than the sum of perceptible things and created by God *ex nihilo*. We must look further into the premodern history of accounting for the artist's creative process that is preserved in theological texts. Thomas Aquinas, like St. Bonaventure, Hugh of St. Victor, and other Medieval theologians, distinguished between the craftsman's initial free act of contemplation, in which his active intellectual powers *united with God* so that the "exemplary form" was made "alive" in him, and the subsequent menial operation of fabrication that produced a useful or delightful object. In the Scholastic theological formulation, the more closely an entity was *in contact with* God (the "first intelligible object"), the more *divine and noble* it was. Leonardo is claiming nobility for the artist by his proximity to the intelligible acts of God in nature. Commenting on Aristotle, Thomas Aquinas defined something perfectible as "*receptive of a perfection*"; material substances received likenesses ("similitudes" of the intelligible) by way of human sensory powers.

In Aristotle's account, the foundation of this epistemology, sense impressions are received by the imagination as if they were a stamp or a signet ring impressed on a wax tablet, and these mechanistic analogies are tremendously important for

the Medieval idea of the artist. Thomas Aquinas also compared "intelligible forms" to the mental images (*fantastic forms*) used by the artist in making things. Similitudes conceived from intellective things are similar to manifestations generated by art (*Comm Metaphysics*, VII.L6: C1381–1416). Aquinas characterized the artist's "quasi-idea" as analogous to the working of the divine mind, but it was important to distinguish between the divine source of the artist's idea and the human source of his manual labor of fabricating objects from materials created *ex nihilo* by God. This distinction was meant to guarantee the "truth" of the artistic representation, made by human hands, within a Christian ontology of images. The most truthful "image" was one made without human artistic intervention at all—like a contact relic or a divine apparition—because the image was made in direct contact with the divine without human intervention.

The question, again, is whether the Medieval sense of materiality was lost in the era of illusionistically rendered sacred images, in the modern secular sense that Kessler and others posit.[54] Leonardo went a step beyond Aquinas in claiming that painting "truthfully" imitates the appearances of nature because the artist has knowledge of nature's causes. Leonardo identified this knowledge with the first principles of the science of optics, concerned with explaining the action of light by combining the first principles of mathematics with direct observation of nature's appearances. The *dangerous* innovation in Leonardo's argument—from a Christian ontological standpoint—lay in granting the artist too active a role, perhaps an independent one. The artist was then no longer simply a passive recipient, the "offspring" of a Christian God who communicates His likeness in "multiplication of itself," to cite the language of optics in the neoplatonic Christian tradition of Roger Bacon that Leonardo himself used to argue for the nobility of painting.[55]

In its Christian formulation, the "truth" of the artistic representation was crucial, for it justified the use of images in religious worship. Given this theological context for the artist's production of images intended for contemplation and prayer, Leonardo's virtual treatment of charged materials arguably attests to the continued presence of signifying materialities in sacred images and objects in the era of optical naturalism as carrying significance to an informed audience through their direct presentation: Their visuality goes far beyond their visualness *per se.*[56] The newly identified painting of *Christ as Salvator Mundi* (figure 8.2), attributed to Leonardo by some leading scholars—even if it is compromised by its condition, only a beautifully restored wreck or perhaps a variant produced by a student or a follower[57]—gives us something new with which to think about the materiality of Leonardo's virtual sacred images. The exquisitely rendered rock crystal globe, the precious silk and embroidered tunic with its intricate folds, the lustrous and transparent jewels, the otherworldly face of Christ as Savior recalling miraculous Santo Volto images (figure 8.3), the complete effacement of all brushstrokes, that is, all signs that the image was made by human hands, attest to the many creative ways in which Leonardo put scientific study in service to religious ends.

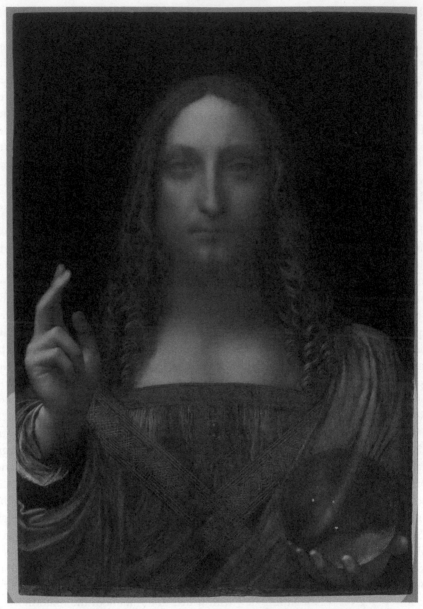

FIGURE 8.2. Leonardo da Vinci [?], *Christ as Salvator Mundi*, oil on panel, 45.4 × 65.6 cm (17 ⅞" × 25 ⅞"). Collection Prince Mohammed bin Salman. Photo by Tim Nighswander/ Imaging4Art, courtesy of Robert Simon for Salvator Mundi LLC.

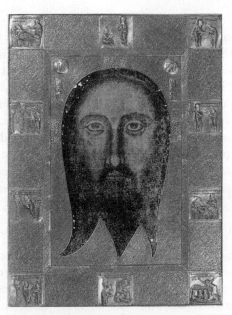

FIGURE 8.3. Santo Volto of Genoa. Church of San Bartolomeo degli Armeni, Genoa. Photo in the public domain, Creative Commons licensing.

Art historian Michael Baxandall called attention to a distinction made by Alberti in his 1435 treatise on painting, which Baxandall confirmed by studying fifteenth-century commission documents, that patrons should value the artist's scientific knowledge over the use of expensive materials. A scene illusionistically rendered with knowledge of the action of light, color, and shadow in nature, Alberti argued, is more praiseworthy than the inclusion of precious materials such as gold.[58] The combined visual and literary legacy of Leonardo and his contemporaries and successors provides extensive evidence that artists understood investigations of such optical phenomena to be operations of the *ingegno.*[59]

To recover the historical understanding of *ingegno,* however, it is necessary to refer beyond the science of artistic practice to the broader context in which artists made sacred images, virtual in their presentation of charged materials but palpable nonetheless—thanks in part to the unprecedented efforts by artists to understand the play of actual light, shadow, and color as a resource for making charged material images that seem to resonate with life. What is so significant about these connections on a broad historical scale is the manner in which theoretically grounded and technologically experimental painting practice imitates and exaggerates natural appearances with great rhetorical force, conforming to the long-standing ontological requirement that sacred Christian images be reliable and true, as artless or "perfect" as possible, to recall Savonarola's understanding of poetry's moral efficacy.[60]

Leonardo saw compositional sketching as the supreme act of the artist who makes "true" artistic images by "transmuting" himself into the mind of nature. Does it follow that he thought about artistic practice in the same terms, as dependent upon the shared understanding of the principles of light and shadow to render a "true" image? Every indication is that he—not unlike the fourteenth-century Sienese artist Lando di Pietro (died ca. 1340), who inserted strips of paper containing humble prayers offered to God inside his carved crucifix—conformed to the long-standing understanding of sacred images as infused with the embodied agency of *both* their immediate and ultimate makers, that is, the humble human artist who works through his materials and his divine artificer counterpart, who generates matter itself and is the source of the artist's *idea, concetto,* or *exemplum.*[61]

FUTURITIES BEYOND RENAISSANCE EUROPE

The brief, nontechnical discussion by Vasari about how the artist composes an image out of his imagination was known widely, but many of the other texts by artists writing at that time or earlier remained unpublished until the nineteenth or twentieth centuries. The outstanding exceptions are the many Catholic Reformation writers who redirected the discussion of ingenuity to emphasize the role of God and the acquisition of adequate representational skills for making sacred images that conform to scripture. In the institutional context of the teaching academies maintained to produce artists in service to church and state, as the structure of artistic instruction developed in the later sixteenth, seventeenth, and eighteenth centuries, artistic invention was taught as something transmissible and attainable through the acquisition of a specific skill set. That, in fact, is how Leonardo's treatise had been organized by his student Melzi: as a recursive set of exercises of increasing complexity to build a skill set. The orderly, progressive acquisition of skills and knowledge drew on long-standing workshop practices as well as a written tradition infused with humanist ideas and values already in place in the 1390s, when Cennini composed his *Libro dell'arte* probably for the library of his patron at the court of Carrara.

In the mid-sixteenth century, however, and especially after the final session of the Council of Trent in 1563, Church reformers redirected artistic license to serve religious ideals aimed at a universal audience, monitored at least in theory by ecclesiastics with the power to censure artistic production. The earlier praise of the artist's quick-wittedness and license to invent was suppressed in favor of emphasizing fidelity to nature as necessitated by human modes of cognition proceeding from sense experience, which, as noted above, had been the primary justification for religious images since Augustine. Leonardo's extensive discussions of the discursive powers of the *ingegno,* a significant case in point, were greatly reduced along these lines by an anonymous, reform-minded editor circa 1570 in the version of his compendium on painting that circulated in manuscript for eighty years before the appearance of the first printed edition in 1651.[62] In a recent

study of post-Tridentine texts on art, art historian Pamela Jones cites seventeenth-century testimony by Francesco Scannelli, 1657; Carlo Cesare Malvasia, 1678; Luigi Pellegrino Scaramuccia, 1674; and Giovanni Battista Passeri, the poet and painter, ordained a priest in 1672, who often cited theological sources. She compares their language with numerous seventeenth-century prayers and poems (including Antonio Glielmo, *Le grandezze della Santissima Trinità* [Venice, 1658]) in which the same terms are used to draw connections between the theological and visual connotations of grace, long associated with the artist's elevated *ingegno*. The artist was credited with the ability to evoke in paint on canvas the beautiful, bright, loving, charming, majestic, grand, and eternal God filled with grace, as if seen in a vision (*bellissima, vaga, gioconda, svelata, chiara, amorosa, goiosa, gaudio, felicita, lume superno; lume puro; fiamma gioconda; gioia immense; amore felice; belo vis*).[63]

As Jones notes, even in antiquity, grace was considered a gift with both stylistic and spiritual resonances.[64] However, it was not until the questioning of the academic system of institutionalized instruction beginning in the later eighteenth century and associated with the label "Romanticism" that the previous appreciation for the artist's quick-witted creative powers based on embodied knowledge resurfaced in the Modern idea of artistic genius as individual giftedness—grace endowed by a higher power, perhaps, but not subservient to the institutional controls of religion or the state.

This history is not innocent. The persuasive visual rhetoric that was manufactured by Church- and later state-run institutions of artistic instruction throughout Europe and far beyond was an effective tool of empire capable of generating enormous economic profit as well as universally imposed, but actually culturally specific, attitudes about art.[65] "Ingenuity" was a culturally specific category that was applied to extra-European artists. I cite the example of Fray Bartolomé de las Casas, the most famous sixteenth-century European apologist for Amerindians, who compared the arts of the Old and New worlds to prove the rationality of Amerindian peoples. Acutely aware of the danger of classifying outsiders as inferiors and believing that Amerindians possessed full potential for civility, Las Casas cited as evidence their skill in the mechanical arts which, he argued, were, like the liberal arts, a function of the rational soul (*habitus est intellectus operativus*).[66] His arguments echoed ideas recorded around the same time by Italian art theorists who claimed that painting, sculpture, and architecture, which had been classified as mechanical arts in Medieval texts, deserved the same status as the liberal arts.

Yet even as Las Casas defended the Amerindians' humanity, he helped to construct an inferior collective identity for the "New World." In his view, the Indians were merely capable of assimilating European culture under European guidance.[67] Moreover, his praise of Amerindians for their skill in the mechanical arts positioned their capabilities at a level inferior to the liberal arts status argued for painters, sculptors, and architects in contemporary European debates on the visual and spatial arts.[68]

Many new research questions are vying for attention. The compositional proce-
dures and representational skills that we still associate with individual Renaissance
artists were disseminated around the globe, above all through printed texts and
images. Engravings more than paintings provided the necessary spectacle because
prints could be multiplied inexpensively and quickly and disseminated broadly.[69]
The technical innovations of the print media also speak to the continuing impor-
tance of ingenuity in the Early Modern state. The great age of French printmaking
during the reign of Louis XIV is a testament to the artistic and economic success
of his policies; today we might call it branding. In France, prime ministers Riche-
lieu and Colbert were pointedly emulating the Plantin-Moretus Press in Antwerp,
publisher for the Spanish Habsburg Empire. The art book—illustrated compila-
tions of natural history specimens, and equally lavishly illustrated, large-format
cultural geographies of the world or of specific extra-European peoples—also
attracted a considerable market share by the late sixteenth century, and sales were
booming in the 1600s.[70]

What became the institutional authority of European art, media, and technology
deserves to be told differently if the aim is to create more inclusive understandings
of how the past reverberates in the present. Broader arguments about the work of
art in the age of its mechanical reproducibility can easily apply to the sixteenth cen-
tury.[71] Accelerating the process of global connectedness, printed images and texts
alongside manuscript sources and other mobile objects made a multi-forked trek
across Europe and the Mediterranean, the Americas, Asia, and the entire planet
beginning in the sixteenth century.[72] The material texts, images, objects, and human
agents that established the authority of Western representation and technology for
hundreds of years are a magnificent but also troubling and contested legacy entan-
gled with European imperialism. Our present challenge is to find ways to write
history anew from many previously unexplored angles. This short essay has defined
themes and arguments about ingenuity at the initiation of these complex trajecto-
ries in some important Italian sources with the aim of encouraging the investiga-
tion of artisanal epistemologies in a transcultural context.

NOTES

INTRODUCTION

1. Miguel de Cervantes, *The History of the Ingenious Gentleman Don Quixote de la Mancha*, trans. P. A. Motteux (Edinburgh: William Paterson, 1879), 385.

2. Two symposia resulted in key publications on the topic: *The Natural Sciences and the Arts: Aspects of Interaction from the Renaissance to the 20th Century: An International Symposium* (convened in Uppsala; proceedings published in Stockholm: Almqvist and Wiksell International, 1985); and B. Castel, J. Leith, and A. Riley, eds., *Muse and Reason: The Relation of Arts and Sciences 1650–1850: A Royal Society Symposium* (Kingston, Ontario: Queen's University, 1994). The latter symposium and publication focused mostly on the Enlightenment.

3. David Topper and John H. Holloway, "Interrelationships between the Visual Arts, Science, and Technology: A Bibliography," *Leonardo* 13, no. 1 (1980): 29–33; Topper, "Interrelationships of the Arts, Sciences, and Technology: A Bibliographic Up-Date," *Leonardo* 18, no. 3 (1985): 197–200; and Topper, "On a Ghost of Historiography Past," *Leonardo* 21, no. 1 (1988): 76–78. *Leonardo* was founded in 1968 by aeronautical engineer and painter Frank Malina and was later taken over by his son, astrophysicist Roger Malina.

4. Ken Arnold and Martin Kemp, *Materia Medica: A New Cabinet of Art and Medicine*, exh. cat. (London: Wellcome Institute for the History of Medicine, 1995).

5. Martin Kemp, *The Science of Art: Optical Themes in Western Art from Brunelleschi to Seurat* (New Haven, CT: Yale University Press, 1990).

6. Martin Kemp, *Seen/Unseen, Art, Science, and Intuition from Leonardo to the Hubble Telescope* (Oxford: Oxford University Press, 2006).

7. Assimina Kaniari and Marina Wallace, eds., with Martin Kemp, *Acts of Seeing: Artists, Scientists and the History of the Visual* (London: Artakt and Zidane Press, 2009).

8. The scholarship on the Renaissance, in particular, is important to note, such as Paula Findlen, *Possessing Nature: Museums, Collecting and Scientific Culture in Early Modern Italy* (Berkeley: University of California Press, 1994); Paula Findlen and Pamela Smith, eds., *Merchants and Marvels: Commerce, Science, and Art in Early Modern Europe* (New York: Routledge, 2001); and Pamela Smith, Christy Anderson, and Anne Dunlop, eds., *The Matter of Art: Materials, Practices, Cultural Logics, c. 1250–1750* (Manchester: Manchester University Press, 2015); and Pamela Smith, "Historians in the Laboratory: Reconstruction of Renaissance Art and Technology in the Making and Knowing Project," *Art History*, special issue, *Art and Technology in Early Modern Europe*, 39, no. 2 (2016): 210–33.

9. Edgar Zilsel, *The Social Origins of Modern Science* (Dordrecht: Kluwer Academic, 2003), especially Part I, "The Social Origins of Modern Science," 1–170; and Paolo Rossi Monti, *Philosophy, Technology and the Arts in the Early Modern Era, 1470–1700*, trans. Salvator Attanasio (New York: Harper and Row, 1970), based on *I filosofi e le macchine, 1400–1700* (Milan: Feltrinelli, 1962).

10. Katharine Park, *Doctors and Medicine in Early Renaissance Florence* (Princeton, NJ: Princeton University Press, 1985).

11. William Eamon, *Science and the Secrets of Nature: Books of Secrets in Medieval and Early Modern Cultures* (Princeton, NJ: Princeton University Press, 1994).

12. Pamela H. Smith, *The Body of the Artisan: Art and Experience in the Scientific Revolution* (Chicago: University of Chicago Press, 2004).

13. Pamela H. Smith, Amy R. W. Meyers, and Harold J. Cook, eds., *Ways of Making and Knowing: The Material Culture of Empirical Knowledge* (Ann Arbor: University of Michigan Press, 2014).

14. Dupré and Marr are currently involved in a five-year research project led by Maar, "Genius before Romanticism: Ingenuity in Early Modern Art and Science," University of Cambridge, www.crassh.cam.ac.uk/programmes/genius-before-romanticism.

15. See the editors' discussion of the topic in "Introduction: Art and Trade in the Age of Global Encounters, 1492–1800," *Journal of Interdisciplinary History* 45, no. 3 (Winter 2015): 5–8.

16. William Eamon and Víctor Navarro Brotóns, eds., *Beyond the Black Legend: Spain and the Scientific Revolution* (Valencia: Instituto de Historia de la Ciencia y Documentación, 2007). A fundamental article is Richard L. Kagan, "Prescott's Paradigm: American Historical Scholarship and the Decline of Spain," *American Historical Review* 101, no. 2 (April 1996): 423–46.

17. Key works by De Vos include her dissertation (currently being turned into a book), "The Art of Pharmacy in Seventeenth- and Eighteenth-Century Mexico," (PhD diss., University of California, Berkeley, 2001); "Natural History and the Pursuit of Empire in Eighteenth-Century Spain," *Eighteenth-Century Studies*, 40, no. 2 (January 2007): 209–39; and "The Science of Spices: Empiricism and Economic Botany in the Early Spanish Empire," *Journal of World History*, 17, no. 4 (December 2006): 399–427. Jorge Cañizares-Esguerra is the author of *Nature, Empire, and Nation: Explorations in the History of Science* (Stanford, CA: Stanford University Press, 2007); "Iberian Colonial Science," *Isis* 96, no. 1 (March 2005): 64–70. Daniela Bleichmar was editor, along with Paula De Vos, Kristin Huffine, and Kevin Sheehan, of *Science in the Spanish and Portuguese Empires, 1500–1800* (Stanford, CA: Stanford University Press, 2009).

18. Alexander Nagel and Christopher S. Wood, *Anachronic Renaissance* (New York: Zone Books, 2010), 10.

19. Jonathan Goldberg, "The History That Will Be," *GLQ: A Journal of Lesbian and Gay Studies* 1, no. 4 (1995): 385–403; and his edited anthology, *Queering the Renaissance* (Durham, NC: Duke University Press, 1994). Queer theorists such as Jack Halberstam introduced the notion of "strange temporalities" to challenge heteronormative constructs of "family, heterosexuality, and reproduction": Halberstam, "What's That Smell?: Queer Temporalities and Subcultural Lives," *Scholar and Feminist Online* 2.1 (Summer 2003), http://sfonline.barnard.edu/ps/printjha.htm; Halberstam, *In a Queer Time and Place: Transgender Bodies, Subcultural Lives* (New York: New York University Press, 2005).

20. Keith Moxey, *Visual Time: The Image in History* (Durham, NC: Duke University Press, 2013), 33.

21. Aníbal Quijano, "Coloniality of Power, Eurocentrism, and Latin America," *Nepantla: Views from the South,* 1, no. 3 (2000): 533–80; Walter Mignolo, "Epistemic Disobedience and the Decolonial Option: A Manifesto," *Transmodernity: Journal of Peripheral Cultural Production of the Luso-Hispanic World* 1, no. 2 (2011): 44–66; and Walter Mignolo, "Delinking," *Cultural Studies* 21, nos. 2/3 (2007): 452–54.

22. Michel Foucault, *Power/Knowledge: Selected Interviews and Other Writings 1972–1977,* ed. Colin Gordon (New York: Pantheon, 1977), 127; Mignolo, "Epistemic Disobedience."

23. Gayatri Chakravorty Spivak, "Can the Subaltern Speak?," in *Colonial Discourse and Post-Colonial Theory: A Reader,* ed. Patrick Williams and Laura Chrisman (New York: Columbia University Press, 2010), 66–111.

24. See Mignolo, "Epistemic Disobedience"; Nelson Maldonado-Torres, "On the Coloniality of Being: Contributions on the Development of a Concept," *Cultural Studies* 21, nos. 2/3 (2007): 240–70.

25. Jacques Derrida, *Who's Afraid of Philosophy? Right to Philosophy,* vol. 1 (Stanford, CA: Stanford University Press, 2002), 22.

26. Amir Eshel, *Futurity: Contemporary Literature and the Quest for the Past* (Chicago: University of Chicago Press, 2012), 5.

27. Our understanding of people of color futurisms is indebted to Catherine S. Ramírez, "*Deus ex Machina*: Tradition, Technology, and the Chicanafuturist Art of Marion C. Martínez," *Aztlán: A Journal of Chicano Studies* 29, no. 2 (2004): 55–92; and her edited dossier, "The Time Machine, from Afrofuturism to Chicanafuturism and Beyond," *Aztlán: A Journal of Chicano Studies* 40, no. 2 (Fall 2015): 127–257.

28. Matthew D. O'Hara, *The History of the Future in Colonial Mexico* (New Haven, CT: Yale University Press, 2018).

29. Cervantes, *History of the Ingenious Gentleman Don Quixote,* 385.

CHAPTER 1

1. The first known use of "futurity" appears in William Shakespeare's *Othello* (1603) in Act 3, Scene 4, where Cassio states: "That nor my service past, nor present sorrows, / Nor purposed merit in futurity, / Can ransom me into his love again, / But to know so must be my benefit"; *The Tragedy of Othello, the Moor of Venice,* ed. Russ McDonald (New York: Penguin Books, 2001), 6. The full definition of "futurity" can be found in *The Oxford English*

Dictionary, s.v. "futurity, n." OED Online, Oxford University Press, June 2017, www.oed. com/view/Entry/75863?redirectedFrom = futurity.

2. For Derrida, "futurity," distinct from "future," is intertwined with "The self, the autos of legitimating and legitimated self-foundation, is still to come, not as a future reality but as that which will always retain the essential structure of a promise and as that which can only arrive as such, as to come." Jacques Derrida, *Who's Afraid of Philosophy? Right to Philosophy,* vol. 1 (Stanford, CA: Stanford University Press, 2002), 22.

3. On the history of *"Plus Ultra"* see Earl Rosenthal, *"Plus Ultra, Non Plus Ultra* and the Device of Emperor Charles V," *Journal of the Warburg and Courtauld Institute* 34 (1971): 204–28; H. J. König, *"Plus Ultra:* ¿Emblema de conquista e imperio universal? América y Europa en el pensamiento político de la España de Carlos V," in *Carlos V / Karl V: 1500–2000,* ed. A. Kholer (Madrid: Sociedad Estatal para la Conmemoración de los Centenarios de Felipe II y Carlos V, 2001), 577–99. For Earl Rosenthal, author of *The Palace of Charles V in Granada* (Princeton, NJ: Princeton University Press, 1985), the adage was closely linked to the Pillars of Hercules of Greek mythology, which according to legend marked the edge of the then-known world, the strait of Gibraltar. According to the legend, the pillars, complete with the admonishment *"Ne plus ultra"* ("nothing further beyond"), served as a caution to sailors not to venture past them.

4. For Francis Bacon's literary description of this new utopian island, see Francis Bacon, *The New Atlantis,* vol. III, part 2, Harvard Classics (New York: P.F. Collier & Son, 1909–14); also available at Bartleby.com, 2001.

5. Roger D. Aus, "Paul's Travel Plans to Spain and the 'Full Number of the Gentiles' of Rom. XI 25," *Novum Testamentum* 21, fasc. 3 (1979): 232–62.

6. Lino Camprubí, "Traveling around the Empire: Iberian Voyages, the Sphere, and the Atlantic Origins of the Scientific Revolution," *Eä-Journal of Medical Humanities & Social Studies of Science and Technology* 2, no. 1 (2009): 1–24.

7. The Spanish were certainly challenging accepted wisdom from the Medieval period, which had conceived of the known world as an area surrounded by water. In fact, Isidore de Séville (d. 630) describes the map of the physical world this way: "The [inhabited] mass of solid land is called round after the roundness of a circle, because it is like a wheel . . . Because of this, the Ocean flowing around it is contained in a circular limit, and it is divided in three parts, one part being called Asia, the second Europe, and the third Africa." See Isidore of Seville, "Etymologiae XIV" (1911).

8. Even today, some five centuries later, it remains the national motto of Spain.

9. For further information on Philip II's imperial reach, see Mari-Tere Álvarez and Charlene Villaseñor Black, "Introduction: Art and Trade in the Age of Global Encounters, 1492–1800," *Journal of Interdisciplinary History* 45, no. 3 (winter 2015): 267–75.

10. For further information on the Crisis of Portuguese Succession, see James C. Boyajian, *Portuguese Trade in Asia under the Habsburgs, 1580–1640* (Baltimore: Johns Hopkins University Press, 2008); and Anthony R. Disney, *A History of Portugal and the Portuguese Empire* (Cambridge: Cambridge University Press, 2009).

11. Mauricio Drelichman and Hans-Joachim Voth, *Lending to the Borrower from Hell: Debt, Taxes, and Default in the Age of Philip II* (Princeton, NJ: Princeton University Press, 2014), 244.

12. According to a famous apocryphal story, when Sir Francis Drake arrived at the governor's palace in Santo Domingo in 1586, the English found a map of the world com-

plete with a rearing horse crowned with the motto, *The world is not enough*. See also Pamela Bekka, "Picturing the 'Living' Tabernacle in the Antwerp Polyglot Bible," in *The Anthropomorphic Lens: Anthropomorphism, Microcosm and Analogy in Early Modern Thought and Visual Arts*, ed. Walter Melion, Michel Weeman, and Bret Rothstein (Leiden: Brill, 2013), 227.

13. Of course, it is critical to note that there were travelers before the sixteenth century who imagined worlds beyond. For further information, see Lorraine Daston and Katharine Park, *Wonders and the Order of Nature, 1150–1750* (New York: Zone Books, 1998); Stephen Greenblatt, *Marvelous Possessions: The Wonder of the New World* (Oxford: Oxford University Press, 1991); Arthur Newton, *Travel and Travellers of the Middle Ages* (London: Routledge, 2013); Rosamund Allen, ed., *Eastward Bound: Travel and Travellers, 1050–1550* (Manchester: Manchester University Press, 2004).

14. Meg Twycross and Sarah Carpenter, *Masks and Masking in Medieval and Early Tudor England*, Studies in Performance and Early Modern Drama (Abingdon: Routledge, 2016), 231.

15. In 1516, Ariosto's *Orlando furioso* recounts the melodramatic love story of Orlando, who is driven to madness. Orlando's insanity can be cured only by a remedy found on the moon, so a knight is sent there to obtain it. Ariosto added an encomium to Holy Roman Emperor and King of Spain Charles V to this story, a famous prophesy, about his being the universal king; it alludes to Charles V's heraldic device "even further," for truly the world was not enough.

16. Guy J. Consolmagno, "Astronomy, Science Fiction and Popular Culture: 1277 to 2001 (and Beyond)," *Leonardo* 29, no. 2 (1996): 127.

17. Consolmagno, "Astronomy," 129.

18. Before closing the treaty, the Portuguese Crown requested an amendment, moving the original line dividing the globe several hundred miles to the west. (Curiously, the then-"undiscovered" Brazil would now be included as part of the Portuguese territories.) In one fell swoop, an artificial line across the Atlantic Ocean effectively divided the world in half. Unclaimed territories to the east of the division could be claimed by Portugal, whereas unclaimed territories to the west could be claimed by Spain. Portugal, which at the time was perceived to have gotten the better deal, was the envy of all of Europe, but it would soon become apparent with further explorations into the Western Hemisphere that Spain had gained far more territory than anyone could have imagined.

19. There is an extensive bibliography dealing with Anglo-Spaniard history. See J. H. Elliott, *Imperial Spain 1469–1716*, 2nd ed. (New York: Penguin, 2002); John Lynch, *Spain under the Habsburgs*, 2 vols., 2nd ed. (New York: New York University Press, 1981); J. H. Elliott, *Spain, Europe and the Wider World 1500–1800* (New Haven, CT: Yale University Press, 2009); R. B. Wernham, *The Return of the Armadas: The Last Years of the Elizabethan Wars against Spain 1595–1603* (Oxford: Clarendon Press, 1994); Stephen Hornsby and Michael Hermann, *British Atlantic, American Frontier: Spaces of Power in Early Modern British America* (Lebanon, NH: University Press of New England, 2005); Charles Beem, ed., *The Foreign Relations of Elizabeth I* (New York: Palgrave Macmillan, 2011).

20. By 1634, astronomer Johannes Kepler published *Somnium (The Dream)*, in which the protagonist Duractos, son of a witch, is transported to the moon via a lunar bridge. One critical note here: In his text Kepler recommends Spaniards as the most suitable moon voyagers.

21. Richard L. Kagan, "La luna de España: mapas, ciencia y poder en la época de los Austrias," *Pedralbes: Revista d'història moderna* 25 (2005): 171–90.

22. For the entire text see Juan Maldonado, *Ioannis Maldonati geniale iudicium siue bacchanalia,* vol. 24, ed. Warren S. Smith and Clark Andrews Colahan (Leuven: Leuven University Press, 2009).

23. Maldonado, *Ioannis Maldonati,* 6; Kagan, "La luna de España," points out that the Maldonado text identifies the "New Islands," meaning the Americas, as "the trophies of Spaniards," implying ideas of property.

24. Kagan, "La luna de España," 171–90.

25. John Lyly, *Endimion, The Man in the Moon: Play'd Before the Queene's Majestie at Greenwich on Candlemas day, at night, by the Children of Paule's* (London: H. Holt, 1894).

26. Gillian Knoll, "How to Make Love to the Moon: Intimacy and Erotic Distance in John Lyly's Endymion," *Shakespeare Quarterly* 65, no. 2 (2014): 164–79.

27. This moon fiction would continue with Cyrano de Bergerac's *Voyage dans la lune* (1657), in which the writer himself is the protagonist traveling to the moon in a firework-powered vehicle. Daniel Defoe's *Consolidator* (1705) has a machine that flies the author to the moon, where he discovers a religiously intolerant world ruled by a dictator, the "lunar prince." Jules Verne's *From Earth to the Moon* (1865) features the first cannon that would shoot men to the men and served as a visual prototype for the modern space rocket. H. G. Wells's *The First Men in the Moon* (1900–1901) introduces readers to the moon's insect-like inhabitants, the Selenites. Hugh Lofting's 1928 *Doctor Dolittle in the Moon* features a huge moth that carries Dr. Dolittle to the moon, where his skill for speaking with animals allows him to speak to moon plants. By the 1940s, Arthur Clarke's *Prelude to Space* takes us to the moon via the spacecraft Prometheus. And, of course, there are many others, including Hergé's Tin Tin adventure *Explorers on the Moon,* in which even Snowy, the canine sidekick, is outfitted in a space suit.

28. R. Chris Hassel Jr., "Donne's 'Ignatius, His Conclave' and the New Astronomy," *Modern Philology* 68, no. 4 (1971): 329–37.

29. John Donne, *Ignatius His Conclave,* ed. Timothy Stafford Healy (Oxford: Clarendon Press, 1969).

30. Charles Morton, Theodore Hornberger, and Samuel Eliot Morison, *Compendium physicae ex authoribus extractum . . . ,* Publications of the Colonial Society of Massachusetts, vol. 33 (Boston: The Society, 1940).

31. Morton et al., *Compendium physicae;* Thomas P. Harrison, "Birds in the Moon," *Isis* 45, no. 4 (1954): 323–30, especially 325. Harrison does point out that Morton correctly understands that birds notice both "changes of the air where they are," as well as the "alteration of abatement of their daily food," but, unfortunately, his next conclusion—that since no one sees where the birds go they must leaving Earth for space—is of course completely erroneous. To counter the argument regarding how the birds cross between atmosphere and stratosphere, Morton explains that in space birds "encounter no air resistance and are unaffected by gravitation." Many scholars believe that Morton based these theories on science, Scripture, and Wilkins's *Man on the Moone,* in which Gonsales traveled to the moon via the birds. Relying on the *Compendium physicae,* scholars believe that indeed Morton's inspiration likely came directly from Wilkins's books.

32. Francis Godwin, *The Man in the Moone,* 2nd ed. (London: John Norton, 1657).

33. Many other books followed, including Cyrano de Bergerac's *The Other World: Comical History of the States and Empires of the Moon*, published after the author's death, in 1657. In de Bergerac's fictional vision of the future, a traveler journeys to the moon and meets "a little man . . . European, native of Old Castile," who had uncovered the "means by Birds to arrive at the Moon." This little man, former earthling turned lunar resident, was viewed by the lunar natives as something equivalent to a domestic pet. Most important, Cyrano proposed a new method for reaching the moon, a rocket ship. The English Royalist Margaret Cavendish published the novella *Blazing World* in 1666 to accompany a treatise she had written on experimental philosophy, in which she writes: "Some said the moon was another world like their terrestrial globe, and the spots therein were hills and valleys; but others would have the spots to be the terrestrial parts and the smooth and glossy parts the sea." There are many, many other works of literature on moon travel. What is most striking about all of these examples is that, regardless of the nationality of the writer, all the books feature a Spaniard as moon explorer and as the natural first colonizer.

34. It was imagination, not hard science, that allowed English readers to become fascinated with the moon. It was during this period that moon gazing grew in popularity. In Stuart England, the almanac, which identified eclipses, was the most popular book, after the Bible.

35. See David Turnbull, *Maps Are Territories: Science Is an Atlas* (Chicago: University of Chicago Press, 1987), 3; David N. Livingstone, *The Geographical Tradition: Episodes in the History of a Contested Enterprise* (Oxford: Blackwell, 1992), 24–30.

36. D. J. Tacey, "Australia's Otherworld: Aboriginality, Landscape and the Imagination," *Meridian* 8, no. 1 (1989): 59.

37. For further information on the intellectual collections in the Golden Tower see Fernando J. Bouza Álvarez, *El libro y el cetro: la biblioteca de Felipe IV en la Torre Alta del Alcázar de Madrid* (Salamanca: Instituto de Historia del Libro y de la Lectura, 2005).

38. Jesús Escobar, "Map as Tapestry: Science and Art in Pedro Teixeira's 1656 Representation of Madrid," *Art Bulletin* 96, no. 1 (2014): 50–69.

39. Philip IV is the *Oceanus Philippicus*. Other names include *Mare Austria-cum* and craters and peaks called *Balthasaris, Hispa. Pri.*, and *Isabellae Reg. Hisp.*

40. René Taton, Curtis Wilson, and Michael Hoskin, eds., *Planetary Astronomy from the Renaissance to the Rise of Astrophysics, Part A, Tycho Brahe to Newton*, vol. 2 (Cambridge: Cambridge University Press, 2003), 127.

41. The historian Peter Martyr d'Anghiera (1457–1526) worked for the Spanish crown and chronicled the history of the Spanish expansion into the Americas. In 1511, his most famous chronicling of the explorations into Central and South America was published as *De orbe novo decades (Decades from the New Globe)*. By 1555, Richard Eden's translation of the book "*Novo Orbe*" was understood to mean "New World" (i.e., *Decades from the New World*). In the discipline of cosmology, "*orbis*" would refer to the sphere, in this case the whole hemisphere within the sphere, whereas "*novo mundus*" would refer to the land within the geographic area.

CHAPTER 2

1. Aquinas himself proposed that animals might be regarded as machines some four centuries before Descartes and in strikingy similar terms. Thomas Aquinas, *Summa Theologica*, Prima Secundæ Partis, Qu. 13, Art II, Reply obj. 3.

2. Charles Wriothesley, *A Chronicle of England During the Reign of the Tudors, 1485–1559*, ed. William Hamilton (London: Printed for the Camden Society, 1875), 1:74. On the Boxley Abbey Rood of Grace, see also Alfred Chapuis and Edouard Gélis, *Le monde des automates* (Paris, 1928), 1:95; and Michael Jones, "Theatrical History in the Croxton Play of the Sacrament," *ELH* 66, no. 2 (1999): 243–44.

3. William Lambarde, *A Perambulation of Kent: Conteining the Description, Hystorie, and Customes of that Shire. Written in the Yeere 1570. by William Lambarde of Lincolns Inne Gent.*, ed. Richard Church (Bath: Adams and Dart, 1970), 205–6. See also Wriothesley, *Chronicle of England*, 1:75; Edward, Lord Herbert of Cherbury, *Life and Reign of King Henry the Eighth, together with which is briefly represented A general History of the Times* (London: Mary Clark, 1683), 494. "The 24 of February being Sonday, the Rood of Boxeley in Kent, called the Rood of Grace, made with divers vices, to move the eyes and lips, was shewed at Pauls Crosse by the Preacher, which was the Bishop of Rochester, and there it was broken, and plucked in pieces." John Stow and Edmund Howes, *Annales, or, a generall chronicle of England. Begun by John Stow: continued and augmented with matters forraigne and domestique, ancient and moderne, unto the end of this present yeere, 1631* (London: [Printed by John Beale, Bernard Alsop, Thomas Fawcett, and Augustine Mathewes] impensis Richardi Meighen, 1632), 575.

4. Lambarde, *Perambulation of Kent*, 209–10.

5. Later examples of automaton Christs include an eighteenth-century one in Dachau, Germany, that has human hair. Hidden in its beard are strands that control the movements of the eyes, mouth, and head. Another, in Limpias, Spain, moves its lips, rolls its eyes, blinks, and grimaces. See Chapuis and Gélis, *Le monde des automates*, 2:95–96; 1:104. On mechanized Passions, see also Johannes Tripps, *Der Handelnde Bildwerk in der Gotik* (Berlin: Gebr. Mann, 1998), 159–73 and plates 10e and f, on 292–93; plates 42a and b, 325; plate 43a, 326.

6. Chapuis and Edmond Droz, *Automata: A Historical and Technological Study*, trans. Alec Reid (Geneva: Editions du Griffon, 1958), 119–20.

7. Some mechanical devils are depicted in drawings by the fifteenth-century engineer, Giovanni Fontana, *Bayerische Staatsbibliothek Cod.icon.* 242 (MSS. mixt. 90), 59v-50r; printed in Eugenio Battisti and Giuseppa Saccaro Battisti, *Le macchine cifrate di Giovanni Fontana* (Milan: Arcadia, 1984), 134–35. On Fontana's automaton devils, see especially Anthony Grafton, "The Devil as Automaton," in *Genesis Redux: Essays on the History and Philosophy of Artificial Life*, ed. Jessica Riskin (Chicago: University of Chicago Press, 2007), chap. 3. See also Chapuis and Gélis, *Le monde des automates*, 2:97–101.

8. I am indebted to Paula Findlen for bringing this devil to my attention.

9. Alessandro D'Ancona, *Origini del teatro* in Italia (Firenze: Successori le Monnier, 1877), 1:424; D'Ancona, *Sacre rappresentazioni dei secoli XIV, XV e XVI* (Florence: Successori le Monnier, 1872), 2:321; Philippe Monnier, *Le Quattrocento, essai sur l'histoire littéraire du XVè siècle italien* (Paris: Perrin et Cie., 1908), 2:204.

10. Giorgio Vasari, *Lives of the Most Eminent Painters, Sculptors & Architects*, trans. Gaston de Vere (London: Philip Lee Warner, 1912–14), 2:229–32. On Brunelleschi's and other *ingegni*, see Frank D. Prager and Gustina Scaglia, *Brunelleschi: Studies of His Technology and Inventions* (Cambridge, MA: MIT Press, 1970); Paolo Galluzzi, *Gli ingegneri del Rinascimento da Brunelleschi a Leonardo da Vinci* (Bologna: Istituto e Museo di storia della

scienza, 1996); and Anthony Grafton, "From New Technologies to Fine Arts," in *Leon Battista Alberti: Master Builder of the Italian Renaissance* (Cambridge, MA: Harvard University Press, 2000), chap. 3. Jacob Burkhardt was scathing on the subject of the *ingegni*: the drama, he said, "suffered from this passion for display," in Burkhardt, *The Civilization of the Renaissance in Italy* (1860; London: Penguin, 1990), 260. The moving figures in heaven that Vasari mentions were in fact little boys; nevertheless he considers them as components in an overall work of "machinery." The paradise apparatus was so heavy that it pulled down the roof of the Carmine monastery where it was installed and necessitated the monks' departure. See Vasari, *Lives of the Most Eminent Painters*, 2:229. On moving Annunciations, see also Tripps, *Der Handelnde Bildwerk*, 84–88.

11. See Vasari, *Lives of the Most Eminent Painters*, 3:194–96.

12. Bibliothèque nationale de France (hereafter cited as BNF), MS. Fr. 12536; Gustave Cohen, *Histoire de la mise en scène dans le théâtre religieux français du moyen âge* (Paris: Champion, 1926), 97; Chapuis and Droz, *Automata*, 356–57.

13. D'Ancona, *Origini del teatro*, 1:424; D'Ancona, *Sacre rappresentazioni*, 2:135, 232; Monnier, *Le Quattrocento*, 2:204. These mechanized performances were elaborations of an older tradition of religious puppet shows, or "motions." An individual puppet might also be called a "motion," and the puppeteer was known as the "motion master." William Lambarde described a motion that took place in Witney, in Oxfordshire, in which the priests used articulated figures to enact the Resurrection. These puppets might have included some mechanized features. The figure of the waking watchman who saw Christ rise made a continuous clacking noise that earned him the nickname "Jack Snacker of Wytney." See *Lambarde, Dictionarium angliæ topographicum & historicum. An alphabetical description of the chief places in England and Wales; with an account of the most memorable events which have distinguish'd them. By . . . William Lambard . . . Now first publish'd from a manuscript under the author's own hand* (London: F. Gyles, 1730), 459; and William Hone, *The Every-Day Book and Table Book* (London: William Tegg, 1825–27), entry for September 5, 1825, entitled "Visit to Bartholomew Fair."

14. *Le mistère du viel testament*, ed. James de Rothschild (Paris: Firmin-Didot, 1878–91), 4:112; Cohen, *Histoire de la mise en scène*, 147. The *Mystère du viel* testament was composed around 1450 by the brothers Arnoul et Simon Gréban and first performed in 1470.

15. Edelestand Du Méril, *Origines latines du théâtre moderne* (Paris: Franck, 1849), 253; Cohen, *Histoire de la mise en scène*, 31.

16. Arnoul and Simon Gréban, *Mystère des actes des apôtres, represente à Bourges en avril 1536, publié depuis le manuscript original*, ed. Auguste-Théodore and Baron de Girardot (Paris: Didron, 1854), 27; Cohen, *Histoire de la mise en scène*, 147. The Actes des Apôtres was an assemblage of dramatizations of stories from the Old Testament collected around 1450 and staged in Paris at the beginning of the sixteenth century.

17. Armand Gasté, *Les drames liturgiques de la cathédrale de Rouen* (Evreux: Imprimerie de l'Eure, 1893), 75; Cohen, *Histoire de la mise en scène*, 31.

18. Anonymous, *Jeu d'Adam* [c. 1150], ed. Wolfgang van Emden (Edinburgh: British Rencensvals Publications, 1996) (original is in the Bibliothèque municipale de Tours, MS 927), 23 (l. 292); Cohen, *Histoire de la mise en scène*, 54.

19. Gréban, *Mystère des actes des apôtres*, livre IV, fol. 67v, livre III, fols. 21r and 23r, livre II, fol. 9r; Cohen, *Histoire de la mise en scène*, 147.

20. Cohen, *Histoire de la mise en scène*, 143–44; Chapuis and Droz, *Automata*, 356–57.

21. Vasari described the high point of Florentine festivals as having coincided with the career of the architect Francesco d'Angelo (known as Cecca), in the second half of the fifteenth century: Cecca "was much employed in such matters at that time, when the city was greatly given to holding festivals." These took place, according to Vasari, not only in churches "but also in the private houses of gentlemen." There were also four public spectacles, one for each quarter of the city. For example, the Carmine kept the feast of the Ascension of Our Lord and the Assumption of Our Lady. See Vasari, *Lives of the Most Eminent Painters*, 3:194.

22. See M. Vidal, "Notre-Dame du Montement à Rabastens," in *Bulletin historique et philologique du Comité des travaux historiques et scientifiques* (Paris, 1908), 415ff.; Chapuis and Gélis, *Le Monde des Automates*, 1:102.

23. See Alphonse Auguste, "Gabriel de Ciron et Madame de Mondonville," in *Revue historique de Toulouse* 2 (1915–19): 26; Chapuis and Gélis, *Le monde des automates*, 1:103.

24. This practice was thriving in the mid-seventeenth century, when Madame de Mondonville (Anne-Jeanne Cassanea de Mondonville) recalls in her memoirs having built a Virgin-ascender with her brothers. She used her precious, glittering bits of quartz crystal to carve the Virgin. See Auguste, "Gabriel de Ciron et Madame de Mondonville," 26; Chapuis and Gélis, *Le monde des automates*, 1:103. On mechanical Assumptions, see also Tripps, *Der Handelnde Bildwerk*, 174–90.

25. The Dieppe mechanical figures were built for a local festival of the Virgin, celebrated on the day of the Assumption and the following day, called the "mitouries de la mi-Août." See Jean-Antoine Samson Desmarquets, *Mémoire chronologique pour servir à l'histoire de Dieppe* (Paris: Desauges, 1785), 1:36; Ernest Maindron, *Marionnettes et guignols* ([s.l.], 1897), 99–102; Ludovic Vitet, *Histoire de Dieppe* (Paris: Ch. Gosselin, 1844), 45; Chapuis and Gélis, *Le monde des automates*, 1:103. This performance, like the others discussed here, combined living and mechanical actors.

26. Lambarde, *Dictionarium angliæ topographicum*, 459; Hone, *The Every-Day Book*, entry for September 5, 1825; Chapuis and Gélis, *Le monde des automates*, 1:104.

27. See J. L. Heilbron, *The Sun in the Church: Cathedrals as Astronomical Observatories* (Cambridge, MA: Harvard University Press, 1999); and David Landes, *A Revolution in Time: Clocks and the Making of the Modern World* (Cambridge, MA: Belknap, 2000), especially chap. 3.

28. Chapuis and Gélis, *Le monde des automates*, 1:114; Chapuis and Droz, *Automata*, 53. The name may have come from St. John the Baptist. See Alphonse Wins, *L'horloge à travers les âges* (Mons: Léon Dequesne, 1924).

29. The current clock in the Piazza San Marco is the result of many modifications that have taken place over the centuries, but these central elements have remained. On the history of the clock, see *Relazione storico-critica della Torre dell'orologio di S. Marco in Venezia* (Venice, 1860); Chapuis and Gélis, *Le monde des automates*, 1:118; and Renato and Franco Zamberlan, "The St. Mark's Clock, Venice," *Horological Journal* (January 2001): 11–14.

30. For other examples, see Chapuis and Gélis, *Le monde des automates*, vol. 1, chap. 7.

31. "Le coq, qui aux temps les plus reculés était déjà symbole de fierté et vigilance, est sans contredit l'animal que les constructeurs de machines horaires à sujets animés, ont mis le plus souvent à contribution." Chapuis and Gélis, *Le monde des automates*, 1:172–73.

32. Chapuis and Gélis, *Le monde des automates*, 1:120. Cluny Abbey was the biggest church in Europe before Saint Peter's Basilica in Rome; it was almost entirely destroyed in 1790 during the French Revolution.

33. "Description d'une horloge merveilleuse," par "Jean BOUHIN," BNF, fonds français, MS no. 1744, published by Edmond Duret as "L'horloge historique de Nyort en Poitou, fabriquée on 1570 par Jean Bouhin," *Revue Poitevine et Saintongeaise* 6 (1889): 432–34.

34. Chapuis and Gélis, *Le monde des automates*, 1:120–27; Derek J. de Solla Price, "Automata and the Origins of Mechanism and Mechanistic Philosophy," *Technology and Culture* 5, no. 1 (1964): 18, 22; Silvio A. Bedini, "The Role of Automata in the History of Technology," in ibid., 29 and figs. 2 and 3.

35. Described by Joseph Gallmayr in the *Münchner Intelligenzblatt* (1779), 273; Chapuis and Gélis, *Le monde des automates*, 1:167.

36. On the connection between organs and automata in the Medieval period, see Merriam Sherwood, "Magic and Mechanics in Medieval Fiction," *Studies in Philology* 44 (October 1947): 585ff.

37. Marie Pierre Hamel, "Notice historique abrégée pour l'histoire de l'orgue," in *Nouveau manuel complet du facteur d'orgues. Nouvelle édition contenant l'orgue de dom Bédos de Celles . . . précédé d'une notice historique par M. Hamel . . .*, ed. Marie Pierre Hamel (Paris: L. Mulo, 1903), xxiv–cxxvi, see esp. l–li; Chapuis and Gélis, *Le monde des automates*, 1:106. A 1541 bill records: "A Nicolas Quesnel, ymaginier, pour faire deux ymages des anges mouvantz, pour mettre sur l'amortissement des orgues." Léon Emmanuel Simon Laborde, *Notice des emaux, bijoux et autres objets divers, exposés dans les galeries du Musée du Louvre* (Paris: Vinchon, 1853), 2è Partie, Documents et glossaire, "Images mouvantes"; Chapuis and Gélis, *Le monde des automates*, 1:105.

38. Chapuis and Gélis, *Le monde des automates*, 1:106. Joseph Gallmayr built a Saint Cecilia in Munich powered by organ pedals in the latter eighteenth century. Ibid.

39. Rohraſſen meant "roaring apes" and referred to the grotesque, bellowing figure of the *Bretzelmann*. He had help, for the vocal part of his act, from a *Münsterknecht*, a servant of the cathedral hidden in the pendentive that held the organ. But the physical motions were the *Bretzelmann*'s own and were controlled by the organ strings. See *Les orgues de la Cathédrale de Strasbourg à travers les siècles. Etude historique, ornée de gravures et de planches hors texte, à l'occasion de la bénédiction des grandes orgues Silbermann-Roethinger, le 7 juillet 1935* (Librissimo, Phénix Editions, 2002); Conseil Régional d'Alsace, Orgues Silbermann d'Alsace (Strasbourg: A.R.D.A.M., 1992); Chapuis and Gélis, *Le monde des automates*, 1:108–9; Sherwood, "Magic and Mechanics," 585–86.

40. "Item rusticanam quondam imaginem: in sublimi sub organis: in ecclesia maiori collocarunt. Qua sic abutuntur. In ipsis sacris diebus Penthecostes: quibus ex tota dyocesi populus processionaliter cum sanctorum reliquijs: deuocionis et laudandi dei gratia canens et iubilans: matricem ecclesiam subintrare consueuit, Nebulo quispiam ac post iiam imaginem occultans: incomptis motibus: voce sonora: *prophana et indecora cantica eructans: veniencium hymnis obstrepit: eosque subsannando irridet: ita ut non solum illorum deuocionem in distractionem: gemitus in cachinnos vertat: sed et ipsis clericis diuina psallentibus: sit impedimento: immo diuinis missarum solemnijs (quas non longe inde celebrare contingit) ecclesiastici immo diuini cultus gelatori longe abominandam et execrandam afferat perturbacionem*" (cited passage is italicized). Peter Schott-Emmerich Kemel (c. 1482–85),

in *Petri Schotti argentinensis patricii: juris utriusque doctoris consultissimi: oratoris et po-etae elegantissimi: graecaeque linguae probe aeruditi: lucubraciunculae ornatissimae,* ed. Jacob Wimpheling (Strassburg: Martin Schott, 1498), fols. 116a–117b. Published in both the original Latin and in English translation in Murray A. Cowie and Marian L. Cowie, "Geiler von Kayserberg and Abuses in Fifteenth Century Strassburg," *Studies in Philology* 58, no. 3 (1961): 489–90, 494.

41. Alexandre de Salies, "Lettre sur une tête automatique autrefois attachée à l'orgue des Augustins de Montoire," *Bulletin de la Société archéologique, scientifique et littéraire du Vendômois* 6, no. 2 (1867): 114. Three similar heads continue to grace the organ, built in 1557, of the church of Saint-Savin-en-Lavedan in the Hautes Pyrénées.

42. Salies, "Lettre sur une tête automatique," 99.

43. Ibid., 98. On the basis of this head's markedly Lancastrian features and its nick-name Gallima (which could mean "he who brings death to the French"), Salies suggests that the head may have been an effigy of Henry V, Henry VI, or Humphrey, Duke of Gloucester, who acted as protector during the regency of Henry VI.

44. The text was edited by Giovanni Sulpizio da Veroli, a close collaborator of the young Cardinal Raffaele Riairo, to whom the edition was dedicated, and who was a central actor in the Renaissance renovation of Rome. Most of Vitruvius's illustrations had been lost; the Veronese friar Fra Giovanni Giocondo reconstituted these in a 1511 edition printed un-der the auspices of Pope Julius II. Vitruvius's treatise continued to inform the great building projects of the Renaissance popes through the reigns of Leo X and Paul III, not least Saint Peter's Cathedral. See Ingrid D. Rowland, ed., *Introduction to Vitruvius: Ten Books on Archi-tecture, The Corsini Incunabulum with the Annotations and Drawings of Giovanni Battista da Sangallo* (Rome: Edizioni dell'Elefante, 2003), 1–31.

45. The astronomical tower clock in Bern, the Zytglogge, built in 1530, continues to play a four-minute mechanical pageant every hour: a rooster crows, a dancing jester rings the bells, Chronos turns his hourglass, and bears (the city mascot) parade around.

46. Chapuis and Gélis, *Le monde des automates,* 1:165–66. The sovereign and his seven electors reappeared on the clock of the *Marienkirche* in Lübeck where they paraded before Christ. Ibid., 1:170.

47. Vasari, *Lives of the Most Eminent Painters,* 4:99. The other (known) primary men-tions of this event are Giovanni Paolo Lomazzo, *Libro dei Sogni* (1564) and *Trattato dell'arte della pittura, scoltura et architettura* (1584), both in *Scritti sulle arti,* ed. Roberto Ciardi and Marchi e Bertolli (Florence: Marchi & Bertolli, 1973), 1:53, 2:96 (see also Lomazzo, *Idea del tempio della pittura* [1590; Hildesheim: Olms, 1965], 17, for a mention of "andari Leoni per forza di ruote"); and Michelangelo Buonarroti the Younger, *Descrizione delle felicissime nozze della Cristianissima Maestà di Madama Maria Medici Regina di Francia e di Navarra* (Florence, 1600), 10. See also Jill Burke, "Meaning and Crisis in the Early Sixteenth Century: Interpreting Leonardo's Lion," *Oxford Art Journal* 29, no. 1 (2006): 77–91. Accounts vary as to the French king in question, the occasion, the date, and the place. The currently estab-lished view, which I have adopted here, is that of Carlo Pedretti, who discovered the Buon-arroti the Younger account in 1973. See Pedretti, *Leonardo architetto* (Milan: Electa, 1973), 322. See also his "Leonardo at Lyon," *Raccolta Vinciana* 19 (1962): 267–72; and his *Leonardo: A Study in Chronology and Style* (New York: Johnson Reprint, 1982), 172. On the mechanical lion and other creations of Leonardo that might be seen as automata—flying machines, the

figure of a knight with an internal cable-and-pulley system enabling it to wave its arms and move its head and mouth, and a wheeled cart that might have been a programmable robot-platform—see also Mark Elling Rosheim, *Leonardo's Lost Robots* (New York: Springer, 2006). Even earlier instances of an automaton designed for purely secular political purposes is the iron fly purportedly presented by Johannes Müller (Regiomontanus) (1436–76) to Maximilian I and an eagle that escorted the emperor to the city gates of Nuremberg. The first account of these machines is by Peter Ramus in *Scholarum mathematicarum libri unus et triginta* (Frankfurt, 1627 [1569]), 62. John Dee then mentions Regiomontanus's automata in his "Mathematicall Praeface" to Henry Billingsley's 1570 English translation of *Euclid's Elements*. See John Dee, *The Mathematicall Praeface to the Elements of Geometrie of Euclid of Megara* (1570), ed. Allen Debus (New York: Science History, 1975).

48. Johann Gabriel Doppelmayr, *Historische nachricht von den nürnbergishcen mathematicis und künstlern* (Nürnberg: P. C. Monath, 1730), 285. See Chapuis and Gélis, *Le monde des automates*, 2:181; and Bedini, "Role of Automata," 31.

49. See Chapuis and Gélis, *Le monde des automates*, 1:179ff.

50. Bedini, "Role of Automata," 34; Chapuis and Gélis, *Le monde des automates*, 1:192–97, 2:152–53; Chapuis and Droz, *Automata*, 76–77, 242. Aristocratic dining tables were also set with automaton-embellished fountains that poured out wine and perfumed liquor. See Bedini, "Role of Automata," 33. Bedini mentions a fourteenth-century example at the Cleveland Museum of Art. See N. M. Penzer, "A Fourteenth-Century Table Fountain," *Antique Collector* (June 1957): 112–17.

51. Chapuis and Droz, *Automata*, 67. With the development of springs rather than weights as the motive force, clocks got ever smaller and more elaborate. Clocks often included carillons, as did watches, ultimately, with the addition of pinned barrels to organize the motions. Ibid., 77, 265–66.

52. The Italian architect and stage designer Nicola Sabbattini regularly included mechanized elements in his sets: crank-operated ocean waves, clouds on pulleys. See Nicola Sabbattini, *Manual for Constructing Theatrical Scenes and Machines [Pratica di fabricar scene e macchine ne 'teatri, 1638]*, ed. Barnard Hewitt (Coral Gables: University of Miami Press, 1958), 132–33, 149–50. Other principal builders of mechanical sets for secular theater include Giacomo Torelli, the seventeenth-century Italian stage designer and engineer who invented the "chariot-and-pole" system of changing sets and who directed the fêtes of Louis XIV. See Raimondo Guarino, "Torelli a Venezia: l'ingegnere teatrale tra scena e apparato," in *Teatro e storia* A. 7, n. 12, fasc. 1 (1992), 35–72; *Macchine da teatro e teatri di macchine: Branca, Sabbatini, Torelli scenotecnici e meccanici del Seicento. Catalogo della mostra a cura di Enrico Gamba e Vico Montebelli* (Urbino: QuattroVenti, 1995). Another important figure in this area was Ferdinando Galli Bibiena (1657–1743), the most illustrious of an Italian dynasty of architects and set designers. Bibieni wrote *L'architettura civile*, which exists in a modern edition with an introduction by Diane M. Kelder (New York: B. Blom, 1971).

53. Dee, *Compendious Rehearsal* (1592), in Autobiographical Tracts of John Dee, ed. James Crossley (Whitefish, MT: Kessinger, 2005), 5–6. As mentioned above, Dee discusses several legendary automata—Archytas's wooden dove, Albertus Magnus's brazen head, Regiomontanus's iron fly and artificial eagle—as examples of the mathematical art of "*thaumaturgike*" in his *Mathematicall Praeface*. On Dee's automaton, see Benjamin Woolley, *The Queen's Conjurer: The Science and Magic of Dr. John Dee, Advisor to Queen Elizabeth I* (New

York: Henry Holt, 2001), 12–15; and Deborah E. Harkness, *John Dee's Conversations with Angels: Cabala, Alchemy, and the End of Nature* (Cambridge: Cambridge University Press, 1999), 121.

54. Theodore Bowie, ed., *The Sketchbook of Villard de Honnecourt* (Bloomington: Indiana University Press, 1959), 58c and 58e [Bibl. nat. de France, MS. Fr. 19093]. Nothing is known about the artist apart from what can be inferred from his portfolio.

55. See Heilbron, *Sun in the Church;* and Landes, *Revolution in Time,* esp. chap. 3.

56. My discussion of the monk is derived from Elizabeth King's work on it. See King, "Perpetual Devotion: A Sixteenth-Century Machine that Prays," in Riskin, *Genesis Redux,* chap. 13; and King, "Clockwork Prayer: A Sixteenth-Century Mechanical Monk," *Blackbird: An Online Journal of Literature and the Arts* 1, no. 1 (2002). The monk now resides in storage at the Smithsonian Institution's National Museum of American History; it has a twin at the Deutsches Museum in Munich.

57. On Turriano, see José A. García-Diego, *Los relojes y autómatas de Juanelo Turriano* (Madrid: Tempvs Fvgit, Monografías Españolas de Relojería, 1982); Garcia-Diego, *Juanelo Turriano, Charles V's Clockmaker* (Madrid: Editorial Castalia, 1986); King, "Clockwork Prayer"; Bedini and Francis R. Maddison, *Mechanical Universe: The Astrarium of Giovanni de' Dondi* (Philadelphia: American Philosophical Society, 1966), 56–58; Bedini, "Role of Automata," 32; and Chapuis and Gélis, *Le monde des automates,* 1:90–91. Originally from Cremona, Turriano was also known as Giovanni Torriani and as Gianello della Torre.

58. Famiano Strada, *De bello belgico. The history of the Low-Countrey warres,* trans. Sr. Rob. Stapylton (Rome, 1632–47; London: H. Moseley, 1650), 7. See also William Sterling-Maxwell, *The Cloister Life of Charles V* (London: John C. Nimmo, 1891), 116, 178–80, 499; Luis Montañes Fonteñla, "Los Relojes del Emperador" and "Los relojes de la exposición 'Carlos V y su Ambiente,'" *Cuadernos de relojería* 18 (September 1958): 3–22; Bedini, "Role of Automata," 32. One of Turriano's automata, a woman playing a lute, remains in existence. It is in the collection of the Kunsthistorisches Museum in Vienna.

59. King, "Perpetual Devotion," 264–66.

60. King writes: "Everyone who sees the monk in action agrees that it is intimidating . . . The character of the image, together with its head-on motion, makes an object that is impossible to regard with objective remove." King, "Perpetual Devotion," 274–75.

61. The art historian David Freedberg has described a certain kind of viewing that occurs in response to powerful religious representations. The devout beholder "reconstitutes" the thing being represented, turning its representation into a presence: "The slip from representation to presentation is crucial . . . from seeing a token of the Virgin to seeing her there." David Freedberg, *The Power of Images: Studies in the History and Theory of Response* (Chicago: University of Chicago Press, 1989), 28. I am indebted here to King's discussion of Freedberg's observation about religious images as viewed by the monk, in "Perpetual Devotion."

62. Leaders of the Reformed movement, notably Ulrich Zwingli, denounced the use of organs and other musical instruments in church. See Charles Garside: *Zwingli and the Arts* (New Haven, CT: Yale University Press, 1966); Quentin Faulkner, *Wiser than Despair: The Evolution of Ideas in the Relation of Music and the Christian Church* (Westport, CT: Greenwood Press, 1996), chap. 9; Diarmaid MacCulloch, *The Reformation: A History* (New York: Penguin, 2003), 146, 590.

63. Chapuis and Gélis, *Le monde des automates,* 1:104–1.

64. Chamber to Cromwell, 7 February 1538, in *Letters and Papers, Foreign and Domestic, of the Reign of Henry VIII,* ed. J. S. Brewer (London: Longman, 1862–1910), vol. 13, pt. I, no. 231, 79.

65. Lambarde, *Perambulation of Kent,* 210.

66. For synoptic discussions of this vast and complex subject, see Alain Besançon, *The Forbidden Image: An Intellectual History of Iconoclasm* (Chicago: University of Chicago Press, 2001), chaps. 5, 6; Carlos N. M. Eire, *The War Against Idols: The Reformation of Worship from Erasmus to Calvin* (Cambridge: Cambridge University Press, 1989), chaps. 3, 4, 6, 8; Freedberg, *The Power of Images,* chap. 8; Sergiusz Michalski, *The Reformation and the Visual Arts: The Protestant Image Question in Western and Eastern Europe* (New York: Routledge, 1993); and Edward Muir, *Ritual in Early Modern Europe* (Cambridge: Cambridge University Press, 1997), chaps. 5, 6. For a study of the relations of Reformation art to iconoclasm, see Joseph Leo Koerner, *The Reformation of the Image* (Chicago: University of Chicago Press, 2004).

67. William Page, ed., *The Victoria History of the County of Kent* (Rochester, NY: Boydell and Brewer, 1974), 2:154.

68. On the popularity of the Rood of Grace as a tourist attraction, see William Warham, Archbishop of Canterbury to Thomas Wolsey, 3 May 1524. [R.O.] Extract in Brewer, *Letters and Papers,* vol. 4, pt. 1, no. 299, 127.

69. Page, *History of Kent,* 2:154.

70. Wriothesley, *Chronicle of England,* 1:74.

71. Page, *History of Kent,* 2:153–55.

72. Wriothesley, *Chronicle of England* 1:75.

73. Lambarde, *Perambulation of Kent,* 207, 206, 210, 208.

74. Chapuis and Gélis, *Le monde des automates,* 1:104.

75. Auguste, "Gabriel de Ciron et Madame de Mondonville"; Chapuis and Gélis, *Le monde des automates,* 1:103.

76. James Waterworth, ed. and trans., *The Canons and Decrees of the Sacred and Ecumenical Council of Trent* (London: Dolman, 1848), Session the Twenty-Fifth, 235–36.

77. On the history of the *presepio,* see Pietro Gargano, *Il presepio: otto secoli di storia, arte, tradizione* (Milan: Fenice 2000, 1995); Nesta de Robeck, *The Christmas Crib* (Milwaukee: Bruce, 1956), chap. 10. and fig. 39. On mechanical nativity scenes, see also Chapuis and Gélis, *Le monde des automates,* 2:200–202.

78. Athanasius Kircher, *Ars Magnesia* (Würzburg, 1631), cited in translation in Michael John Gorman, "Between the Demonic and the Miraculous: Athanasius Kircher and the Baroque Culture of Machines," in *The Great Art of Knowing: The Baroque Encyclopedia of Athanasius Kircher,* ed. Daniel Stolzenberg (Stanford: Stanford University Libraries, 2001), 68. On Kircher's automata, see Bedini, "Role of Automata," 35; Jan Jaap Haspels, *Automatic Musical Instruments, Their Mechanics and Their Music, 1580–1820* (Niroth: Muiziekdruk C. V. Koedijk, 1987); Paula Findlen, "Scientific Spectacle in Baroque Rome: Athanasius Kircher and the Roman College Museum," *Roma moderna e contemporanea* 3 (1995): 635–65; Findlen, "Introduction: The Last Man Who Knew Everything . . . or Did He? Athanasius Kircher, S.J. (1602–80) and His World," in *Athanasius Kircher: The Last Man Who Knew Everything,* ed. Paula Findlen (New York: Routledge, 2004), 34–35; Thomas L. Hankins and

Robert J. Silverman, *Instruments and the Imagination* (Princeton, NJ: Princeton University Press, 1995), chaps. 2–4; Gorman, "Between the Demonic and the Miraculous"; and Penelope Gouk, "Making Music, Making Knowledge: The Harmonious Universe of Athanasius Kircher," in Stolzenberg, *The Great Art of Knowing*, 71–84.

79. The mechanical nativity scene had been donated by Ferdinand of Bavaria, the elector of Cologne. It and the other automata that Trigault shipped in 1618 did not arrive directly at their destination since the Emperor Wan-Li was even then expelling the Jesuits from China. But a couple of decades later, after the Ming dynasty gave way to the Manchurian T'sing dynasty, many of the automata arrived belatedly as the Jesuits returned under Emperor Shun-che and set up clockmaking workshops. See Edmond Lamalle, "La propagande du P. Nicolas Trigault en faveur des missions de Chine (1616)," *Archivum Historicum Societatis Jesu* 9, no. 1 (1940): 49–120; Chapuis and Droz, *Automata*, 77–84; and Jonathan D. Spence, *The Memory Palace of Matteo Ricci* (New York: Penguin, 1985), 180–84. On the Jesuits' clockwork gifts in China, see also *China in the Sixteenth Century: The Journals of Matthew Ricci*, ed. Nicholas Trigault, trans. Louis J. Gallagher (1615; New York: Random House, 1953), bk. 1, chap. 4 and bk. 4, chap. 12.

80. Louis Pfister, *Notices biographiques et bibliographiques sur les Jésuites de l'ancienne mission de Chine (1552–1773)* (Shanghai: Imprimerie de la Mission Catholique, 1932, 1934), notice 88; Chapuis and Droz, *Automata*, 315.

81. Chapuis and Gélis, *Le monde des automates*, 1:192; 2:141–43, 152–53; Chapuis and Droz, *Automata*, 242.

82. Principal builders of animated paintings during the last decades of the seventeenth century included the clockmakers Abraham and Christian-Théodore Danbeck and Christophe Leo of Augsburg, and during the early eighteenth century Jean Truchet (le père Sébastien). See Chapuis and Gélis, *Le monde des automates*, 1:319.

83. Late Medieval and Early Modern palace waterworks were informed by translations of ancient texts, notably the works of Hero of Alexandria, and made virtually no changes to the ancient mechanisms. See Bedini, "Role of Automata," 26.

84. Jules-Marie Richard, *Une petite-nièce de saint Louis. Mahaut, comtesse d'Artois et de Bourgogne (1302–1329). Etude sur la vie privée, les arts et l'industrie, en Artois et à Paris au commencement du XIVe siècle* (Paris: Champion, 1887) (a study of the comtesse Mahaut's account books), 333; Sherwood, "Magic and Mechanics," 589–90.

85. Archives nationales de France (hereafter cited as Arch. nat., Fr.), KK 393; Richard, *Une petite-nièce de saint Louis*, 308.

86. Archives départementales du Pas-de-Calais (hereafter cited as A.D. P.d.C.), A 297; Richard, *Une petite-nièce de saint Louis*, 336.

87. A.D. P.d.C., A 548; Richard, *Une petite-nièce de saint Louis*, 341.

88. A.D. P.d.C., A 648; Richard, *Une petite-nièce de saint Louis*, 342.

89. *Ve compte de Jehan Abonnel dit Legros, conseilleur et receveur général de toutes les finances de monseigneur le duc de Bourgoingne . . . in the Recette générale des finances*, Chambre des comptes de Lille, Archives departementales du Nord, série B no. 1948 (Registre); Laborde, *Les Ducs de Bourgogne: études sur les lettres, les arts et l'industrie pendant le XVe siècle, et plus particulièrement dans les Pays-Bas et le duché de Bourgogne* (Paris: Plon frères, 1849–52), Seconde Partie, Tome 1:268–71; Sherwood, "Magic and Mechanics," 587–90 (the quoted passage is taken from the excerpt cited in translation in Sherwood); Price, "Automata and the Origins of Mechanism," 20–21; Chapuis and Gélis, *Le monde des automates*, 1:72.

90. On the fame and influence of the Hesdin engines, see Sherwood, "Magic and Mechanics," 590; and Price, "Automata and the Origins of Mechanism," 21.

91. Michel de Montaigne, *Travel Journal*, ed. and trans. Donald M. Frame (San Francisco: North Point, 1983), 37.

92. Chapuis and Gélis, *Le monde des automates*, 1:74.

93. Montaigne, *Travel Journal*, 64. See also Salomon de Caus, *Les Raisons des forces mouvantes avec diverses machines tant utiles que plaisantes, auxquelles sont adjoints plusieurs dessings de grotes & fontaines* (Francfort: J. Norton, 1615), 1:29 (owl and birds), 2:13 (Pratolino).

94. Christian Hülsen, "Ein deutscher Architekt in Florenz (1600)," with drawing of the grotto in question by Henri Schickhardt, in *Mitteilungen des Kunsthistorischen Instituts in Florenz (1912–1917)*, 2:152–93; Chapuis and Gélis, *Le monde des automates*, 1:75. On hydraulic entertainments in Italy, see also Philippe Morel, *Les Grottes maniéristes en Italie au XVIe siècle: théâtre et alchimie de la nature* (Paris: Macula, 1998).

95. Montaigne, *Travel Journal*, 143.

96. Ibid., 99. The owl-and-birds arrangement was taken from a much-imitated design by Hero of Alexandria. See *The Pneumatics of Hero of Alexandria*, ed. and trans. Bennett Woodcroft (London: Taylor Walton and Maberly, 1851), #15. On Hero's automaton, see Sylvia Berryman, "The Imitation of Life in Ancient Greek Philosophy," in Riskin, *Genesis Redux*, chap. 2.

97. The primary source of information about the Francini fountains at Saint-Germain-en-Laye is a collection of engravings by Abraham Bosse, done from Francini's own designs. Tommaso Francini's brother, Alessandro, who collaborated with him on the fountains at Fontainebleau, is listed as the author of the collection: Alessandro Francini, Recueil. *Modèles de grottes et de fontaines. Dessins lavés. BNF Estampes et photographie*, Réserve Hd-100(A)-Pet Fol; also in the Archives nationales, O1 1598. There is also John Evelyn's description in his diary: Evelyn, *Diary and Correspondence*, ed. William Bray (London: George Bell and Sons, 1883), 1, entry for 27 February 1644. See also Evelyn, Elysium *Britannicum, or the Royal Gardens*, ed. John E. Ingram (Philadelphia: University of Pennsylvania Press, 2000), bk. 2, chap. 9, "Of Fountains, Cascades, Rivulets, Piscenas, Canales, and Water-works"; bk. 2, chap. 12, "Of Artificial Echoe[']s, Automats, and Hydraulic motions"; bk. 3, chap. 9, "Of the most famous Gardens in the World, Ancient and Modern." For other primary accounts of the hydraulic automata at Saint-Germain-en-Laye, see Georges Houdard, *Les châteaux royaux de Saint-Germain-en-Laye, 1124–1789: étude historique d'après des documents inédits recueillis aux Archives Nationales et à la Bibliothèque Nationale* (Saint-Germain-en-Laye: Maurice Mirvault, 1910–11), vol. 2. For secondary descriptions, see Albert Mousset, *Les Francine, créateurs des eaux de Versailles, intendants des eaux et fontaines de France de 1623–1784* (Paris: E. Champion, 1930), chap. 1 and plates 2, 3, 4; Lionel du Sorbiers de la Tourrasse, *Le Château-neuf de Saint-Germain-en-Laye, ses terrasses et ses grottes* (Paris: édition de la Gazette des beaux-arts, 1924), Alfred Marie, *Jardins français créés à la Renaissance* (Paris: Vincent Fréal & Cie., 1955); Chapuis and Droz, *Automata*, 43–47. The fountains were abandoned after Louis XIV moved his court to Versailles in 1682, and virtually no trace of them remains. On the fountains at Versailles as emblems of material power, see Chandra Mukerji, *Territorial Ambitions and the Gardens of Versailles* (Cambridge: Cambridge University Press, 1997), esp. 181–97.

98. Evelyn, *Diary*, entry for 27 February 1644.

99. André du Chesne, *Les antiquités et recherches des villes, chasteaux, et places plus remarquables de toute la France* (Paris: Pierre Rocolet, 1637), 221–24.

100. Evelyn, *Diary*, entry for 27 February 1644; Mousset, Les Francine, 35–41.

101. Du Chesne, *Les antiquités*, 222; Evelyn, *Diary*, entry for 27 February 1644.

102. Evelyn, *Diary*, entry for 27 February 1644; Mousset, *Les Francine*, 38.

103. "a dix heures et demie et demy quart selon ma monstre faicte a Abbeville par M. Plantard." Jean Hérouard, *Journal de Jean Héroard*, ed. Madeleine Foisil (Paris: Fayard, 1989), 1:370 (entry for 27 September 1601).

104. See, e.g., the entry for 6 June 1605, Hérouard, *Journal*, 1:676.

105. In April and May 1605 alone, visits to the grottoes are recorded on 11, 13, 14, 17, and 29 April; 2, 8, 9, 15, 27, and 29 May. Hérouard, *Journal*, 1:638, 639, 643, 653, 655, 657, 658, 660, 666, 668.

106. "Faite semblan que je sui Ophée (Orphée) e vous le fontenié (-er), dite chante le (les) canarie." Hérouard, *Journal*, 1:633 (entry for 20 March 1605).

107. See entries for 13, 14, and 17 April 1605, Hérouard, *Journal*, 1:638, 639, 643.

108. See entries for 25 May, 2 June, 3 July, 30 July, 20 August, 28 August, and 25 October 1605; 9 May, 15 June, and 8 July 1606, Hérouard, *Journal*, 1:664–65, 672, 703, 722, 741, 759, 809, 943, 987, 1000.

109. See entries for 16 April, 18 April, 1 June, 2 June, 6 June, 10 June, 13 June, 15 June, 22 June, 26 June, 30 June, and 3 August 1605, Hérouard, *Journal*, 1:640, 643, 671, 672, 673, 676, 681, 684, 686, 692, 696, 698, 725.

110. See entries for 12 February, 13 March, and 27 September 1605, Hérouard, *Journal*, 1:596, 614, 767.

111. "Maman ga, allon voir ma fontaine ché Francino." M. "Mr, je n'ay point de carrosse." D. "Nous iron bien a pié." Madame luy dict: "Mousieu i a bien loin." D. "Madame, nou passerons pa le jadin nou i seron incontinent." Entry for 25 May 1605, Hérouard, *Journal*, 1:664–65. "Maman ga" was Madame de Montglat (Françoise de Longuejoue), the Dauphin's governess. See also the entries for 30 May and 7 June 1605, Hérouard, *Journal*, 1:669, 678.

112. See entries for 29 April and 2 June 1605, Hérouard, *Journal*, 1:653, 672.

113. "Dict qu'il y a ung robinet a son cul et ung autre sa guillery: 'fs fs.'" Entry for 18 April 1605, Hérouard, *Journal*, 1:643. For some repetitions of the joke, see entries for 2 April, 1 June, 10 June 1605, Hérouard, *Journal*, 1:638, 671, 681. The eroticism that pervades Hérouard's journal has occasioned a good deal of analysis. See, for example, Philippe Ariès, *L'enfant et la vie familiale sous l'Ancien Régime* (Paris: Plon, 1960).

114. Hérouard, *Journal*, 1:1502 (entry for 12 September 1608).

115. See entries for 31 July 1611 and 27 October 1612, Hérouard, *Journal*, 2:1939, 2066.

116. "Maman ga, je sone les heure, dan, dan, i (il) sone come le jaquemar qui frape su l'enclume." Hérouard, *Journal*, 1:699 (entry for 30 June 1605). The prince referred to the clock at Fontainebleau.

117. Hérouard, *Journal*, 1:1396 (entry for 5 March 1608).

118. Ibid., 1:1434 (entry for 16 May 1608).

119. Antoine Morand's clock with automata, made in 1706 to honor Louis XIV, is currently in the Musée de Versailles. Chapuis and Gélis, *Le monde des automates*, 1:233–37. François-Joseph de Camus built a mechanical carriage for the future Louis XIV, then still the dauphin, with moving figures of soldiers and a lady. The carriage may have been melted

down along with all other objects of precious metal, by order of the king, in 1709, when war had depleted the royal treasury. See Charles-Étienne-Louis de Camus, *Traité des forces mouvantes pour la pratique des arts et des métiers* (Paris: C. Jombert, 1722), 521–33; Chapuis and Gélis, *Le monde des automates,* 2:13–18. Jean Truchet (*le père Sébastien*) built the mechanical opera. It is described in Bernard le Bouvier de Fontenelle, *Suite des éloges des académiciens* (Paris: Osmont, 1733), 170; and in Louis Abel de Fontenay, *Dictionnaire des artistes* (Paris, 1772), s.v. "Notice sur le P. Truchet." See Chapuis and Gélis, *Le monde des automates,* 1:337.

120. The automaton army was built by Gottfried Hautsch in Nuremberg for Louis, *le Dauphin du Viennois* (*le Grand Dauphin*), born in 1661. See Doppelmayr, *Historische nachricht,* 304; Chapuis and Gélis, *Le monde des automates,* 2:12–13.

121. The engineers were Orazio Olivieri and Giovanni Guglielmi. Edith Wharton, *Italian Villas and Their Gardens* (1904; New York: Da Capo, 1977), 154. Other spouts of water and water-powered jets of air played organ and fife music and produced eerie sounds— thunder, wind, rain, whistles, shrieks—while wooden globes danced magico-mechanically across the floor. On the Villa Aldobrandini (originally named the Villa Belvedere), see Carla Benocci, *Villa Aldobrandini a Roma* (Rome: Argos, 1992). Giovanni Battista Falda's engraving of the Stanza dei Venti is in *Le fontane di Roma,* pt. 2, *Le fontane delle ville di Frascati* (Rome: Giovanni Giacomo de' Rossi, 1691), plate 7.

122. See Giovanni Battista Falda's engraving of the Stanza dei Venti in *Le fontane delle ville di Frascati,* plate 7.

123. On Sittikus and the Schloss Hellbrunn, see Chapuis and Gélis, *Le monde des automates,* 1:76–77; Chapuis, "The Amazing Automata at Hellbrunn," *Horological Journal* 96, no. 6 (June 1954): 388–89; Bedini, "Role of Automata," 27; Wilfried Schaber, *Hellbrunn: Schloss, Park und Wasserspiele* (Salzburg: Schlossverwaltung Hellbrunn, 2004).

124. See Falda's engraving of the Semicircular Water Theater of the Villa Mondragone in *Le fontane della ville di Frascati,* plate 18.

125. The story of the wedding and De Caus's work in Heidelberg is told in Frances Yates, *The Rosicrucian Enlightenment* (London: Routledge, 1972), chap. 1. Yates suggests that De Caus invented the mechanical use of steam power (19).

126. De Caus, *Les Raisons des forces mouvantes* (1615) and *Hortus Palatinus* (Frankfurt, 1620).

127. De Caus, *Les Raisons des forces mouvantes,* 2:n. pg., 2: 6v, 1:34v; see also Chapuis and Gélis, *Le monde des automates,* 1:78–82.

128. Giorgio Valla, *Georgii Vallae Placentini viri clari de expetendis, et fugiendis rebus opus* (Venetiis: In aedibvs Aldi Romani, 1501); Federigo Commandino, *Aristarchi de Magnitudinus, et distantiis sollis, et lunae, liber* (Pisa: apud Camillum Francischinum, 1572); Giovanni Battisti Aleotti, *Gli artificiosi et curiosi moti spirituali di Herrone* (Ferrara: Vittorio Baldini, 1589). Subsequent editions included Alessandro Giorgi da Urbino, *Spirituali di herone alessandrino* (Urbino: Press, 1592, 1595). See also Bedini, "Role of Automata," 25.

129. Agostino Ramelli, *The Various and Ingenious Machines of Agostino Ramelli (1588),* ed. Eugene S. Ferguson, trans. Martha Teach Gnudi (Baltimore: Johns Hopkins University Press, 1976), chap. 186; see also chap. 187, which describes an essentially similar arrangement in which the effects are produced by a concealed person blowing through a pipe rather than by the flow of water. Another example is Giambattista della Porta, *Pneumaticorum libri tres: quibus accesserunt curvilineorum elementorum libri duo* (Naples: J. J. Carlinus, 1601).

130. De Caus, *Les Raisons des forces mouvantes,* 1:30: "Pour faire representer plusieurs oiseaux lesquels chanteront diversement quand une choüette se tournera vers iceux, & quand ladite choüette se retournera, ils cesseront de chanter."

131. De Caus, *Les Raisons des forces mouvantes,* 1:34: "Machine par laquelle l'on representera une Galatee qui sera trainee sur l'eau par deux daufins, allant en ligne droite, & se retournant d'elle mesme, cependant qu'un ciclope Joüe dessus un flajollet."

132. Evelyn, *Elysium britannicum,* 231, 242, 191. (The markings indicate Evelyn's amendments in the manuscript.)

133. Kircher, *Musurgia universalis* (Rome: Francisi Corbelletti, 1650), 2:347; Bedini, "Role of Automata," 35.

134. Price writes that in automaton clocks, "For the first time [around 1550], wheelwork is used instead of levers, gears instead of strings, organ-barrel programming instead of sequential delay devised hydraulically." Price, "Automata and the Origins of Mechanism," 22.

135. This was a collaborative work. The goldsmith Randolph Bull, clockmaker to the queen, built the clock part of the device while the organ maker Thomas Dallam built the organ part and supervised installation in the sultan's palace. See C. B. Drover, "Thomas Dallam's Organ Clock," *Antiquarian Horology* 1, no. 10 (1956): 150–52; Bedini, "Role of Automata," 35.

136. De Caus, *Les Raisons des forces mouvantes,* 1:29.

137. Price, "Automata and the Origins of Mechanism," 20. Langenbucher's Pomeranian Chest, presented to Duke Philip of Pomerania in 1617, held an automatic organ of twenty-one pipes that played four pieces of music.

138. Evelyn, *Elysium britannicum,* 232–42.

139. Ibid., 241.

140. Ibid., 232.

141. Ibid., 244.

142. Ibid., 249–50. Evelyn cites Pliny, Philostratus, Pausanius, Lucian, Tacitus, Strabo, and Kircher as authorities on the legendary statue. See also Kircher, *Oedipus aegyptiacus, hoc est, vniuersalis hieroglyphicae veterum doctrinae temporum iniuria abolitae instauratio* (Romae: Ex typographia Vitalis Mascardi, 1652–54), 3:488.

143. On Martin Löhner and his automata, see Doppelmayr, *Historische nachricht,* 306; Chapuis and Gélis, *Le monde des automates,* 1:76.

144. Evelyn, *Diary and Correspondence,* 1 (entry for 27 February 1644).

145. Evelyn, *Elysium britannicum,* 184, 439.

146. Anne-Louise d'Orléans, *duchesse de Montpensier, Mémoires de Mlle. de Montpensier,* ed. Bernard Quilliet (Paris: Mercure de France, 2005), chap. 23 (July–September, 1656). The owner of the estate, whom the writer identifies as "Esselin," was Louis Cauchon d'Hesselin, who served as *Maître de la chambre aux deniers de la maison du roi.* Madame de Lixein was Henriette de Lorraine, daughter of François de Lorraine, who had married the Prince of Lixen.

147. Robert Darnton, *The Great Cat Massacre and Other Episodes in French Cultural History* (New York: Vintage, 1985), 78.

148. Henri Bergson, *Laughter: An Essay on the Meaning of the Comic,* trans. Cloudesley Brereton and Fred Rothwell (Whitefish, MT: Kessinger, 2004), 16, 81 (first published

in French as *Le Rire: essai sur la significance du comique* [Paris: Editions Alcan, 1900]). For Freud's use of Bergson's theory of humor in his own very different account, see Sigmund Freud, *Jokes and Their Relation to the Unconscious*, trans. James Strachey (New York: W. W. Norton, 1963, chap. 7, esp. 259–60 (first published in German as *Der Witz und Seine Beziehung zum Unbewussten* [Leibzig: Deuticke, 1905]).

149. For an anthology of recent treatments of this subject, see Jan M. Bremmer and Herman Roodenburg, eds., *A Cultural History of Humour: From Antiquity to the Present Day* (Cambridge: Polity Press, 1997). Peter Burke, in chap. 5 of the volume, "Frontiers of the Comic in Early Modern Italy, c. 1350–1750," mentions Renaissance palace waterworks in passing (65). The history of humor is an integral part of the discussion in Norbert Elias's classic work, *The Civilizing Process: Sociogenetic and Psychogenetic Investigations* (London: Blackwell, 1994) (first published in German as *Über den Prozess der Zivilisation* [Basel: Haus zum Falken, 1939]).

CHAPTER 3

1. Giulio Camillo, *L'idea del theatro* (Florence: Lorenzo Torrentino, 1550). Page numbers in parentheses refer to this edition, which is reprinted and translated in Lu Beery Wenneker, "An Examination of *L'idea del theatro* of Giulio Camillo, Including an Annotated Translation, with Special Attention to His Influence on Emblem Literature and Iconography," PhD diss., University of Pittsburgh, 1970 (Ann Arbor, MI: University Microfilms International), 187–355.

2. Joseph Burney Trapp, "Frances Amelia Yates 1899–1981," in *Biographical Memoirs of Fellows*, vol. 2, ed. British Academy (Oxford: Oxford University Press 2004), 527–54, 545.

3. See www.modernlibrary.com/top-100/100-best-nonfiction/.

4. She merely assumes that the general interest of the later sixteenth century in "Lullism with its moving figures and letters" might be "comparable to the popular interest in the mind machines of today." Frances A. Yates, *The Art of Memory* (London: Routledge, 1966), 206.

5. Lina Bolzoni, "Introduzione," in Giulio Camillo, *L'idea del theatro: con 'L'idea dell'eloquenza', il 'De transmutatione' e altri testi inediti a cura di Lina Bolzoni* (Milan: Adelphi, 2015), 7–138, 94.

6. Achille Neri, ed., "Una lettera inedita di G. Muzio," *Giornale Storico della Letteratura Italiana* 4 (1884): 229–40.

7. E.g., Giulio Camillo, *Il secondo tomo dell'opere di M. Giulio Camillo Delminio . . .* (Venice: Gabriel Giolito de' Ferrari, 1574), 3.

8. Titian even seems to have fully illustrated an edition of *L'idea del theatro* on 201 parchment pages. The book that is mentioned in the library catalogue of the Spanish royal site *El Escorial* was tragically lost during the great palace fire of 1671, Bolzoni, "Introduzione," 30.

9. P. S. Allen, H. M. Allen, and H. W. Garrod, eds., *Opus epistolarum Des. Erasmi Roterdami*, vol. 9, *1530–1532* (Oxford: Oxford University Press, 1938), 479.

10. Loira J. Patino, "Camillo Delminio, Giulio," in *Encyclopedia of Renaissance Philosophy*, ed. Marco Sgarbi (Berlin: Springer, 2017), 2.

11. Erasmus became aware of a 1528 anonymously published pamphlet that was critical of his *Ciceronianus* and erroneously attributed the critique to Camillo (Patino, "Camillo

Delminio, Guilio," 2). Camillo did, in fact, author a book that rejected the *Ciceronianus* and was published posthumously in Giulio Camillo, *Due trattati . . . l'uno delle materie, che possono uenir sotto lo stile dell'eloquente: l'altro della imitatione* (Venice: Stamperia de Farri, 1544).

12. Viglius Zuichemus, "Letter to Erasmus, Padua, 8 June 1532," in *Opus epistolarum Des. Erasmi Roterodami,* vol. 10, *1532–1534,* ed. P. S. Allen, H. M. Allen, and H. W. Garrod (Oxford: Oxford University Press, 1941), 29. Translation taken from Yates, *Art of Memory,* 131ff.

13. Ibid.

14. Girolamo Muzio, *Lettere, a cura di A. M. Negri,* vol. 2 (Alessandria: Edizioni dell'Orso, 2000), 135.

15. I refer to the 1550 edition (see note 1).

16. "imaginibus autem agentibus, acribus, insignitis, quae occurere celeriterque percutere animum possint" in Marcus Tullius Cicero, *Libros de oratore tres continens,* ed. August Samuel Wilkins (Oxford: Clarendon Press, 1988), Liber Secundus, 358.

17. See *Titelliste,* ed. Nikola Rossbach. Website, DFG-Projekt "Welt und Wissen auf der Bühne. Die Theatrum-Literatur der Frühen Neuzeit," Universität Kassel / HAB Wolfenbüttel 2009–2012: www.theatra.de/index.php?searchRes = 0&cPage = 2&sPage = 2.

18. See Hole Rössler, "Weltbeschauung: Epistemologische Implikationen der Theatrum-Metapher in der Frühen Neuzeit," in *Theatralität von Wissen in der Frühen Neuzeit,* ed. Costanze Baum and Nikola Rossbach (Wolfenbüttel: Herzog August Bibliothek, 2013): diglib.hab.de/ebooks/ed000156/id/ebooks_ed000156_article02.

19. Peter Matussek, "Literature as a Technique of Recollection," in *Memory, History and Critique: European Identity at the Millenium,* Proceedings of the Fifth Conference of the International Society for the Study of European Ideas, ed. Frank Brinkhus and Sascha Talmor (Utrecht: ISSEI/University of Humanist Studies, 1998) [CD-ROM].

20. "hic ne deficeret metuens avidusque videndi": Ovid, *Metamorphoses X,* ed. Lee Fratantuono (London: Bloomsbury, 2014), 21.

21. The psychological term "episodic memory" seems to me appropriate here, because this memory system is defined by its opposition to that of the "semantic memory," which serves as a nonvolatile storage. Thus, the attempt to hypostatize what is envisioned in the episodic memory must lead to the vanishing of its performative essence. See Endel Tulving, "Episodic and Semantic Memory," in *Organization of Memory,* ed. Endel Tulving and Wayne Donaldson (New York: Academic Press,1972), 381–403.

22. Constanze Baum, "Theatrale Inszenierungen auf den Titelbildern der Theatrum-Literatur," in Baum and Rossbach, *Theatralität von Wissen;* diglib.hab.de/ebooks/ed000156/start.htm (accessed 10 January 2019).

23. Yates, *Art of Memory,* 140.

24. Eighty-one of them are identified by Lina Bolzoni in collaboration with Angelo Maria Monaco and Massimiliano Rossi. Lina Bolzoni, "Per immaginare le immagini del teatro," in Camillo, *L'idea del theatro: con 'L'idea dell'eloquenza',* 311–24.

25. Erwin Panofsky and Fritz Saxl, "A Late-Antique Religious Symbol in Works by Holbein and Titian," *Burlington Magazine for Connoisseurs* 49 (1926): 177–81, 177. Erwin Panofsky, "Titian's *Allegory of Prudence:* A Postscript," in *Meaning in the Visual Arts: Papers in and on Art History* (Garden City, NY: Doubleday Anchor Books, 1955), 149–51.

26. Ambrosius Aurelius Theodosius Macrobius, *Saturnalia (ca. 420)*, ed. Robert A. Kaster (Oxford: Oxford University Press, 2011).

27. Among others Eugenio Garin, *Testi umanistici sulla retorica* (Rome: Fratelli Bocca, 1953); Paolo Rossi, *Clavis universalis: arte mnemoniche e logica combinatoria da Lullo a Leibniz* (Naples: Ricciardi, 1960).

28. Yates, *Art of Memory*, 11 and after 439.

29. Ibid., xi.

30. Ibid., xii.

31. Frances A. Yates, *Giordano Bruno and the Hermetic Tradition* (London: Routledge, 1964).

32. Yates, *Art of Memory*, 161.

33. Giovanni Pico della Mirandola, *De hominis dignitate* (1496), ed. E. Garin (Florence: Vallecchi, 1942).

34. Ibid., 102.

35. Yates, *Art of Memory*, 161.

36. Ibid., 158.

37. Joseph Burney Trapp, "Frances Amelia Yates 1899–1981," in *Biographical Memoirs of Fellows*, vol. 2, ed. British Academy (Oxford: Oxford University Press, 2004), 527–54, 527.

38. Lynn White, cited in Marjorie G. Jones, *Frances Yates and the Hermetic Tradition* (Lake Worth, FL: IBIS Press/Nicolas Hays, 2008), 193.

39. Cited in ibid., 196.

40. Ibid., 195.

41. Cf. Brian Vickers, *Occult and Scientific Mentalities in the Renaissance* (Cambridge, MA: Cambridge University Press, 1984), 5–6.

42. Trapp, "Frances Amelia Yates 1899–1981," 528.

43. She used the term consistently throughout the book and thus made it canonical. Cf. Lina Bolzoni, *Il teatro della memoria: studi su Giulio Camillo* (Padua: Liviana, 1984).

44. Giulio Camillo, *Il theatro della sapientia*, MS, ca. 1530 (Manchester, John Rylands Library: Christie MS 3 f 8).

45. Camillo's "mastery with regard to new invention techniques" as the outstanding characteristic of his theater is treated extensively under consideration of the *Theatro della sapientia* in Barbara Keller-Dall'Asta, *Heilsplan und Gedächtnis. Zur Mnemologie des 16. Jahrhundert in Italien* (Heidelberg: Carl Winter, 2001), 185–279; quote from 213 (my translation, P.M.).

46. Harald Szeemann, "Das Museum der Obsessionen: Vorschläge für eine künftige documenta," in Harald Szeemann, *Museum der Obsessionen: Von/über/zu/mit Harald Szeemann* (Berlin: Merve Verlag, 1981), 154–65, 162ff.

47. www.surfacemag.com/events/jean-dubuffet-theatres-de-memoire/.

48. Mikael Thejll, *Anatomisches Theater und Memoriatheater* (Ausstellungsinstallation Nationalmuseet Kopenhagen, 1993) at Kunst- und Ausstellungshalle der Bundesrepublik Deutschland. See *Wunderkammer des Abendlandes: Museum und Sammlung im Spiegel der Zeit* (Bonn: Bundeskunsthalle, 1994), 27.

49. Heidi Ellis Overhill, "THE MUSEUM OF ME (MoMe): An Exhibition of Conceptual Art," MFA thesis, University of Waterloo, Ontario, 2009, https://uwspace.uwaterloo.ca/bitstream/handle/10012/4337/Overhill_Heidi.pdf?sequence=1.

50. www.marcfeustel.com/eyecurious/eikoh-hosoe-theatre-of-memory-agnsw/.

51. See Corrado Bologna, *El teatro de la mente: de Giulio Camillo a Aby Warburg* (Madrid: Siruela, 2017).

52. Carlos Fuentes, *Terra nostra* (Madrid: Espasa-Calpe, 1991).

53. Kerstin Oloff, "*Terra Nostra* and the Rewriting of the Modern Subject: Archetypes, Myth, and Selfhood," *Latin American Research Review* 46, no. 3 (2011): 3–20, 5.

54. John Buller, *The Theatre of Memory,* CD-Booklet (London: Unicorn-Kanchana 1985), 13.

55. Ibid., 11.

56. Ibid., 12.

57. Another attempt to enhance the listening process through spatialization of the sound sources in analogy to Camillo's *L'idea del theatro* has been made with regard to the sound installations of the New York artist James Rouvelle: Christa Brüstle and Peter Matussek, *Just Here Therefore Now: Ein elektroakustisches Gedächtnistheater* (Berlin, 2001), peter-matussek.de/Pro/MuMe/EAGT/index.html.

58. Laura Karrman, "Camillo '93. Rieks Swarte's Memory Theatre," *Performance Research* 17, no. 3 (2012): 39–45, 39.

59. Carlota Caulfield, *The Book of Giulio Camillo: A Model for a Theater of Memory* (USA: Eboli Poetry, 2003), 24.

60. Simon Critchley, *Memory Theatre* (London: Fitzcarraldo Editions, 2014).

61. Obviously, Critchley refers here implicitly to a passage in Georg Wilhelm Friedrich Hegel, *Vorlesungen über die Geschichte der Philosophie*, where Hegel circumscribes "Erinnerung" as "Sich-innerlich-machen." In *Werke in zwanzig Bänden,* ed. Eva Moldenhauer and Karl Markus Michel, vol. 19 (Frankfurt am Main: Suhrkamp, 1995) 44. Thus, Hegel's term "*Erinnerung*" is strictly opposed to "*Gedächtnis*," which he circumscribes as "the storage container of the dead." Ibid., vol. 1, 432 (my translation, P.M.).

62. Critchley, *Memory Theatre*, Kindle, Pos. 270.

63. Ibid., Pos. 592.

64. Ibid., Pos. 667.

65. Ibid.

66. Ibid., Pos. 697.

67. Ibid., Pos. 349.

68. Frances A. Yates, "Autobiographical Fragments," *Collected Essays III* (London: Routledge, 1984), 290.

69. Keller-Dall'Asta, *Heilsplan und Gedächtnis*, 217.

70. Marshall McLuhan, *The Gutenberg Galaxy* (Toronto: University of Toronto Press, 1962).

71. Yates, *Art of Memory,* 251.

72. Steve Harrison, Phoebe Sengers, and Deborah Tatar, "The Three Paradigms of HCI," Conference Paper, *CHI 2007,* San Jose, 28 April 2007, http://people.cs.vt.edu/~srh/Downloads/TheThreeParadigmsofHCI.pdf.

73. Vannevar Bush, "As We May Think," *The Atlantic* (1945): 101–8.

74. Verbal communication with the author, P.M.

75. Richard A. Bolt, *Spatial Data Management* (Cambridge, MA: MIT Press, 1979), 8.

76. Ibid.

77. In a later book, Bolt refers explicitly to Yates: Richard A. Bolt, *The Human Interface: Where People and Computers Meet* (London: Wadsworth, 1984), 6 (footnote).

78. Edgar has captured the original images and animations from the 1985 Apple II *Memory Theatre One* and reprogrammed them for exploring the web. Edgar's work may be accessed using a standard web browser at www.robertedgar.com.

79. www.youtube.com/watch?v = b4a9i58IdIY.

80. Bill Viola, "Will There Be Condominiums in Data Space?" *Video 80*, no. 5 (1982): 36–41. Reprinted in Bill Viola, *Reasons for Knocking at an Empty House: Writings 1973–1994* (London: Thames & Hudson, 1995), 98–111.

81. Harrison et al., "Three Paradigms of HCI."

82. Michael Barrett and Eivor Oborn, "Boundary Object Use in Cross-Cultural Software Development Teams," *Human Relations* 63, no. 8 (2010): 1199–221.

83. Apple Computer Inc., *Human Interface Guidelines: The Apple Desktop Interface* (Reading, MA: Addison-Wesley, 1987).

84. Lina Bolzoni, "The Play of Images. The Art of Memory from Its Origins to the Seventeenth Century," in *The Enchanted Loom: Chapters in the History of Neuroscience*, ed. Pietro Corsi (Oxford: Oxford University Press, 1991), 16–65, 23.

85. *Shakespeare's Twelfth Night*, CD-ROM, © Exploratorium 1991.

·86. Leah S. Marcus, "The Silence of the Archive and the Noise of Cyberspace," in *The Renaissance Computer: Knowledge Technology in the First Age of Print*, ed. Neil Rhodes and Jonathan Sawday (London: Routledge, 2000), 18–28, 18.

87. Ibid.

88. Ibid.

89. Brenda Laurel, *Computers as Theatre* (Reading, MA: Addison-Wesley, 1991).

90. See Bernard J. Baars, *In the Theater of Consciousness: The Workspace of the Mind* (Oxford: Oxford University Press, 1997).

91. Mark A. Schneider, "Culture-as-Text in the Work of Clifford Geertz," *Theory and Society* 16, no. 6 (1987): 809–39.

92. See the Berlin Centre of Excellence, established in 1999, *Performing Culture* (http://gepris.dfg.de/gepris/projekt/5482988?language = en), in which the author participated with the research project *Computers as Theaters of Memory*, conducted at the Humboldt-University of Berlin (1999–2002). Results of this research have been presented at various venues, including the World Congress FIRT/IFTR *Theatre and Cultural Memory* (Amsterdam, 2002) and the Performance Studies international conference *Camillo 2.0* (Utrecht 2011), published in *Performance Research* 17, no. 3 (2012): 8–16.

93. Agnes Hegedüs, "Memory Theater VR: An Installation in and about Virtual Reality," (unpublished thesis, Karlsruhe, 1 December 1998), 3 (archive of the author, P.M.)

94. Konstantina Georgelou and Janez Janša, "Janez Janša's Camillo 4," *Performance Research* 17, no. 3 (2012): 83–89, 86ff.

95 Arnd Wesemann, "A Drive-in Ballet in Ljubljana," *ballett international/tanz aktuell* 68 (2000): 8–9.

96. The URL is still active (www.theaterofmemory.com), but the project has been removed. A copy can be viewed on www.peter-matussek.de/Pro/F_05_Synopse/GT_Dateien/Simon_2000_203.html.

97. www.seedbed.net/WhirlpoolFrame91.html.

98. See Kate Robinson, *A Search for the Source of the Whirlpool of Artifice: The Cosmology of Giulio Camillo* (Edinburgh: Dunedin Academic Press, 2006).

99. Harrison et al., "Three Paradigms of HCI," 9.

100. www.youtube.com/watch?v = baO7p3yVYFY. See Mario Fallini and Enrico Ferraris, *Concettissimo and Giulio Camillo's Theatre of Memory* (Alessandria: LineLab.edizioni, 2009).

101. Peter Oldfield, *World Memory Theater,* website, 2009: www.worldmemorytheatre.org.

102. www.fabula.org/actualites/camillo-20-technology-memory-experience-performance-studies-international-17_39203.php.

103. William Uricchio, "A Palimpsest of Place and Past," *Performance Research* 17, no. 3 (2012), 45–49, 45.

104. Ibid., 49.

105. Ibid.

106. Yates, *Art of Memory,* 206.

107. Ibid., 173ff.

118. See Bill Buxton, *Sketching User Experiences: Getting the Design Right and the Right Design* (San Francisco: Morgan Kaufmann, 2007).

109. See Stephanie Riggs, Justin Berry, Johannes DeYoung, Lance Chantiles-Wertz, and Jack Wesson, *Evaluating Embodied Navigation in Virtual Reality Environments* (Blended Reality: Applied Research Project at Yale). 4 April 2018, https://blendedreality.yale.edu/news/evaluating-embodied-navigation-virtual-reality-environments (accessed 2 February 2019).

110. Eric Krokos, Catherine Plaisant, and Amitabh Varshney, "Virtual Memory Palaces: Immersion Aids Recall," *Virtual Reality* (16 May 2018): 1–15, 1.

111. Ibid., 2.

112. Ibid., 13.

113. George A. Miller, "The Magical Number Seven Plus or Minus Two: Some Limits on Our Capacity for Processing Information," *Psychological Review* 63 (1956): 81–97.

114. Krokos et al., "Virtual Memory Palaces," 7. Cf. Sven Fuchs, *HCI 450—Foundations of Usability Research Review: How Magical Is Miller's Famous Seven for HCI Issues?* (2004), https://pdfs.semanticscholar.org/0301/9e34c8c625de5c571074972145e01ebe991c.pdf (3 February 2019). See Robert W. Proctor and Kim-Phuong L. Vu, "Human Information Processing: An Overview for Human-Computer Interaction," in *The Human-Computer Interaction Handbook: Fundamentals, Evolving Technologies, and Emerging Applications*, ed. Andrew Sears and Julie A. Jacko (Boca Raton, FL: CRC Press, 2007), 43–62.

CHAPTER 4

1. Henry James, "The Autumn of Florence," in *Italian Hours* (Boston: Houghton Mifflin, 1909), 385.

2. Jeremy Norman Melius, "Art History and the Invention of Botticelli" (PhD diss., University of California, Berkeley, 2010), 2.

3. "Whether he abolishes it periodically, whether he devaluates it by perpetually finding transhistorical models and archetypes for it, whether, finally, he gives it a metahistorical

meaning (cyclical theory, eschatological significations, and so on), the man of the traditional civilizations accorded the historical event no value in itself; in other words, he did not regard it as a specific category of his own mode of existence." Mircea Eliade, *Cosmos and History: The Myth of the Eternal Return*, trans. Willard R. Trask (New York: Harper & Brothers, 1959), 139.

4. "The chief difference between the man of the archaic and traditional societies and the man of the modern societies with their strong imprint of Judaeo-Christianity lies in the fact that the former feels himself indissolubly connected with the Cosmos and the cosmic rhythms, whereas the latter insists that he is connected only with History." Eliade, *Cosmos and History*, vii.

5. See, for example, Peter V. Turchin, *Historical Dynamics: Why States Rise and Fall* (Princeton, NJ: Princeton University Press, 2003).

6. Virgil, *Eclogues, Georgics, Aeneid*, trans. H. R. Fairclough (Cambridge, MA: Harvard University Press, 1916), 1:374–75.

7. Turning to this passage, Frances Yates affirms: "The world will be put under a universal monarchy beneath the wisest and most just emperor since Roman times." Frances Yates, *Astraea: The Imperial Theme in the Sixteenth Century* (London: Routledge and Kegan Paul, 1975), 53. This notion is corroborated and placed as part of the Spanish Empire by Marie Tanner, *The Last Descendant of Aeneas: The Hapsburgs and the Mythic Image of the Emperor* (New Haven, CT: Yale University Press, 1993), 289. For a different view see Julia Farmer, who argues that "Ariosto's narrative interlace juxtaposes Charles with the net-wielding monster Caligorante." Julia L. Farmer, *Imperial Tapestries: Narrative Form and the Question of Spanish Hapsburg Power 1530–1647* (Lewisburg, PA: Bucknell University Press, 2016), 16.

8. "If we trusted the panegyrics of the courtly poets, we should have little doubt that the golden age had been reborn in the Renaissance. There would be some disagreement among them, however, as to whether that rebirth had taken place under the Medici or the Valois or the Tudors or the dynasty of Spain and Austria. Whoever happened to ascend the throne at the moment, of course, was always the new Saturn or Astraea." Harry Levin, *The Myth of the Golden Age in the Renaissance* (Oxford: Oxford University Press, 1969), 112.

9. See Frederick A. de Armas, *The Return of Astraea: An Astral-Imperial Myth in Calderón* (Lexington: University of Kentucky Press, 1986).

10. On the unstable calendar in the novel, see Frederick A. de Armas, "Sancho as a Thief of Time and Art: Ovid's *Fasti* and Cervantes' *Don Quixote*, II," *Renaissance Quarterly* 61, no. 1 (2008): 1–25.

11. "There is never one geography of authority and there is never one geography of resistance. Further, the map of resistance is not simply the underside of the map of domination—if only because each is a lie to the other, and each gives the lie to the other." Steve Pile, "Introduction: Opposition, Political Identities and Spaces of Resistance," in *Geographies of Resistance*, ed. Steve Pile and Michael Keith (London: Routledge, 1997), 32.

12. "Heteronormative common sense leads to the equation of success with advancement, capital accumulation, family ethical conduct, and hope." Jack Halberstam, *The Queer Art of Failure* (Durham, NC: Duke University Press, 2011), 89.

13. Ibid., 83.

14. De Armas, "Sancho as a Thief of Time and Art," 1–25.

15. It is curious that Lord Carteret turned to Cervantes, since he was one of the main figures in the Opposition at the time and was advocating war with Spain. He stood against Robert Walpole, who was close to the Queen. Indeed, he was part of the group that ridiculed the Queen's "cave," where her "wizard" Walpole must abide. At the same time, the Opposition and Carteret were in favor of reviving England's mythical past. Judith Colton, "Merlin's Cave and Queen Caroline: Garden Art as Political Propaganda," *Eighteenth Century Studies* 10 (1976): 1–20.

16. "The architectural structure was not really a cave at all but rather a thatched Gothic cottage that consisted of a circular room with openings on three sides that contained collections of English books." Amanda S. Meixell, "Queen Caroline's Merlin Grotto and the 1738 Lord Carteret Edition of *Don Quixote:* The Matter of Britain and Spain's Arthurian Tradition," *Cervantes: Bulletin of the Cervantes Society of America,* 25, no. 2 (2005): 62.

17. Carteret's volume was the first Spanish version of Don Quixote published in England. *Vida y Hechos del Ingenioso Hidalgo Don Quixote de la Mancha. Compuesta por Miguel de Cervantes Saavedra. En quatro tomos* (London: J. and R. Tonson, 1738). Vanderbank (1694–1739) also included a portrait of Cervantes in this edition. He was known not just for his book illustrations, but also as a portrait painter. He painted a portrait of Sir Isaac Newton and included his portrait as frontispiece in his *Principia* (1729).

18. Wayne C. Booth, *The Rhetoric of Fiction* (Chicago: University of Chicago Press, 1961).

19. Anthony J. Cascardi, "Don Quijote and the Invention of the Novel," in *The Cambridge Companion to Cervantes,* ed. Anthony J. Cascardi (Cambridge: Cambridge University Press, 2002), 59; Frederick A. de Armas, *Don Quixote among the Saracens: A Clash of Civilizations and Literary Genres* (Toronto: University of Toronto Press, 2011), 1–24.

20. Empire was said to begin in the Middle East first with the Assyrians, then the Medes, and later the Persians. Alexander's victory over Darius would then move the succession of empires further east, to Greece.

21. Ignacio Navarrete, *Orphans of Petrarch: Poetry and Theory in the Spanish Renaissance* (Berkeley: University of California Press, 1994), 20; Antonio de Nebrija, *Gramática castellana,* ed. Pascual Galindo Romero and Luis Ortiz Muñoz (Madrid: Edición de la Junta Centenario, 1946), 4.

22. This notion is contrary to that of the Four Monarchies, a prophecy of biblical origin: "Through a vision, the prophet Daniel interpreted Nebuchadnezzar's dream of a man with a head of gold, back of silver, chest of copper and feet of clay as an image of the world's Four Monarchies. After these will come the realm of God, which will be eternal . . . it was expected that Christ's return would occur under the imperial rule of Rome—the Fourth Monarchy." Tanner, *Last Descendant of Aeneas,* 24.

23. Navarrete, *Orphans of Petrarch,* 21–22.

24. Nebrija claims that the grammar of a language fixes it for eternity, and he thus wants to make Castilian a new Greek or Latin that can be read forever. Nebrija, *Gramática castellana,* 6.

25. Andrew J. Bacevich, *American Empire: The Realities and Consequences of U.S. Diplomacy* (Cambridge, MA: Harvard University Press, 2002), 243.

26. Niall Ferguson, *Colossus: The Rise and Fall of the American Empire* (London: Penguin Books, 2004), 34.

27. Ibid., viii. Ferguson explains that the United States is engaged in a "kind of universal civilizing mission that has been a feature of all great empires" (ibid., ix), since the "freedom" we seek for others is not very different from the ideal of "civilization" sought by the Victorians. Freedom becomes a concept for "self-replicating;" and once imposed, it is subverted.

28. Peter Turchin, *War and Peace and War: The Rise and Fall of Empires* (New York: Plume Books and Penguin Group, 2006), 6.

29. Jason von Ehrenkrook, "Effeminacy in the Shadow of Empire: The Politics of Transgressive Gender in Josephs' *Bellum Judaicum*," *Jewish Quarterly Review* 101, no. 2 (2011): 159.

30. Numerous controversies arose out of the 2010 Census conducted in the United States as mandated by the Constitution. Some argued that "illegal aliens" (or undocumented immigrants) were counted and thus it "will unconstitutionally increase the number of representatives in some states and deprive some other states of their rightful political representation." John Baker and Elliott Stonecipher, "Our Unconstitutional Census," *Wall Street Journal*, August 9, 2009, www.wsj.com/articles/SB10001424052970204908604574332950796281832. Others argued that the census failed to fairly count minorities; still others considered some of the form's questions to be an invasion of privacy. In the United Kingdom, the census has aroused similar suspicions. It is said to have been started by Louis Moss, an eastern European immigrant who had worked at the Ministry of Information during the Second World War. There, he worked for Minister Alfred Duff-Cooper as a "Cooper-snooper," gathering as much information as he could on his countrymen. Some have argued that Cooper was the model for Big Brother in Orwell's *Nineteen Eighty-Four* (1949), where the author reimagined the Ministry of Information into the infamous Ministry of Truth.

31. The office of the censor was abolished by Augustus. After that, the emperors fulfilled these duties under the name of "prefect of the morals."

32. Plutarch, *Life of Cato the Elder*, 17; cf. Cicero, *de Re Publica*, iv.6; Dionys. xx.3. If the fictional character of Don Quixote had existed and had been a Roman citizen, he would certainly have suffered ignominious marks from these magistrates; he should have been married long before age fifty, and he should have been cultivating his fields instead of selling land to buy his books.

33. Since ancient times, books were often censored and burned. In response to St. Paul's preaching at Ephesus, for example, the converted burned a number of "superstitious" books. Joseph Hilgers, "Censorship of Books," in *The Catholic Encyclopedia* (New York: Robert Appleton, 1908), 2, www.newadvent.org/cathen/03519d.htm. During the Middle Ages, professors at the University of Paris "were not allowed to hand any lecture over to booksellers before it had been examined by the chancellors and the professors of theology." Ibid., 3. In England this use of the term is first found, as far as I know, in Milton's *Areopagitica* (1644). Orwell's essay on "The Prevention of Literature" was motivated by his attendance to the commemoration of the third anniversary of the *Areopagitica* at the PEN Club in 1946. Recalling Milton's admonition against the "sin" of killing books, Orwell laments that none of the speakers discusses freedom of the press, in particular the ability to express political opinions. George Orwell, *All Art Is Propaganda*, ed. George Packer (New York: First Mariner Books, 2009), 253.

34. Hilgers, "Censorship of Books," 1. In Spain, Sebastián de Covarrubias in his famous *Diccionario de la lengua* (1611) does not include the new meaning. Under the term "Censores" he explains the Roman custom and then adds that "Este oficio, tan necessario, falta en nuestras repúblicas" [This office, so necessary, is lacking in our republics]; Sebastián de Covarrubias y Horozco, *Tesoro de la lengua castellana o española,* ed. Martín de Riquer (Barcelona: Horta, 1943), 323. In the seventeenth century, the term also meant to criticize as when Mendoza claims of Lope's *Circe:* "Y todas hallarán más presto quien las alabe, que quien las censure" [And they will all find more quickly who will praise them than who will criticize them] (RAE, 269). The RAE of 1729 defines *Censurador* as "el que aprueba o reprueba alguna cosa. Comúnmente se toma por el que mormura o vitupera" [He who approves or disapproves of something. Often it means the one who criticizes or vituperates] (ibid., 269).

35. For example, Quevedo's *Las tres musas últimas castellanas* (1670), instead of republishing the approvals found in what the editor considered to be the first part, *El parnaso español* (1648), simply lists the *Censores deste libro.* Francisco de Quevedo, *Las tres musas últimas castellanas, segunda cumbre del Parnaso español,* ed. Felipe B. Pedraza Jiménez and Melquíades Prieto Santiago (Madrid: Universidad de Castilla-La Mancha, 1999), n.p.

36. Let us recall some of the many steps that a manuscript had to go through to be approved for publication, following the law promulgated in Valladolid on September 7, 1558. José García Oro, *Los reyes y los libros: la política libraria de la corona en el Siglo de Oro (1475–1598)* (Madrid: Cisneros, 1995), 76–83; Jaime Moll, "Problemas bibliográficos del libro del Siglo de Oro," *Boletín de la Real Academia Española* 59 (1979): 49–107. First, all manuscripts had to be sent to the Council of Castile and/or other Councils in other regions of the kingdom. They, in turn, sent it to two or more censors to evaluate. If approved, the manuscript was given a license to be published by the king for a specific amount of time. Even when the work was approved and sent to the printer a second level of censorship ensued. As Roger Chartier reminds us: "First the corrector must identify the compositors' errors by following the printed text while the original is read aloud . . . In addition, he also acts as censor, charged with rejecting any book in which he finds anything prohibited by the Inquisition or contrary to the faith, the king or the republic . . . even if the work has been approved and authorized." Roger Chartier, *Inscription and Erasure: Literature and Culture from the Eleventh to the Eighteenth Century,* trans. Arthur Goldhammer (Philadelphia: University of Pennsylvania Press, 2007), 29.

37. There were two main Spanish indexes from the sixteenth century: one by Fernando de Valdés (1559) and a second by Gaspar de Quiroga (1583). There were three main indexes in seventeenth-century Spain, overseen by three Grand Inquisitors. The first was published under the leadership of Bernardo de Sandoval y Rojas (1612), followed by an appendix in 1614. The second was overseen by Antonio de Zapata Cisneros in 1632; an appendix was published under him even earlier, in 1628. A third index came out in 1640 under Antonio de Sotomayor.

38. "Steganography" refers to concealed writing only meant to be seen by its recipient, and derives from the Greek words *steganos* (covered or protected) and *graphei* (writing). Johannes Trithemius (1462–1516) was an early Renaissance theoretician of this art. His *Steganographia* was published in 1606 but placed on the index in 1609. Augustus the Younger, Duke of Brunswick-Wolfenbüttel (1579–1666), under the pseudonym of Gustavus Selenus, wrote a book of cryptography. His first name is a cryptic reference to his name while his

last name plays with the goddess of the moon (Selene). Although he borrows much from Trithemius, he goes on to outline the history of the art of cryptography.

39. See Frederick A. de Armas, *Quixotic Frescoes: Cervantes and Italian Renaissance Art* (Toronto: University of Toronto Press, 2006), 89–92; and de Armas, *Don Quixote among the Saracens*, 54, 146–61.

40. Cervantes, *El ingenioso hidalgo Don Quijote de la Mancha*, ed. Luis Andrés Murillo (Madrid: Castalia, 1978), 1:54–56. The first two derive from Horace, whereas the third and fourth are from the Gospel of Matthew. De Armas, *Quixotic Frescoes*, 41.

41. Although his *sententiae* were widely known in the Middle Ages, many were probably not penned by him. The friend, by falsely attributing a maxim to Cato, provides an added element of satire on those who revel in a show of erudition, while knowing little.

42. Cervantes, *Don Quijote*, 55; Ovid, *Tristia: Ex Ponto*, trans. A. L. Wheeler (Cambridge, MA: Harvard University Press, 1996), 1.9, 5–6. A section of *Tristia* was first translated into Spanish in 1692 by Antonio de Solís y Rivadeneyra. He only includes 5.1. Theodore S. Beardsley, *Hispano-Classical Translations Printed between 1482 and 1699* (Pittsburgh: Duquesne University Press, 1970), 98.

43. Indeed, within the novel, Sancho cites a maxim claiming that it is by Cato, whereas this is not the case; and he calls the writer *Cato Nonsensor*. Cervantes, *Don Quijote*, 144–45. Thus, he comically mispronounces *Censorino* the Censor as *Nonsensor,* a term that refers to a fool. The priest twice refers to Cato as an authority in the 1605 novel. Ibid., 371, 413.

44. Ovid, *Tristia*, 2.207.

45. Ovid, *Metamorphoses*, trans. Frank Justus Miller (Cambridge, MA: Harvard University Press, 1976), 1.64.

46. The decree came directly from the emperor, and was not examined by the senate or by a judge. As Gareth William explains, his "relegation" to Tomis was less severe a punishment than *exilium*, "which would have deprived him of Roman citizenship and property." Gareth William, "Ovid's Exile Poetry: *Tristia, epistolae ex Ponto* and *Ibis*," in *The Cambridge Companion to Ovid*, ed. Philip Hardie (Cambridge: Cambridge University Press, 2002), 233. In a terse remark he points to the reasons for his exile (*Carmen et error* [ibid., 3.5.49–52, 3.6.29–36; *Epistolae ex Pontus* 1.6.21–6]). In other words, one of his works and a mistake were the cause of his banishment. During the last decade of Augustus's life, Tiberius was a de facto coregent, and he would become famous for his trials of historians and writers. Peter E. Knox, "The Poet and the Second Prince: Ovid in the Age of Tiberius," *Memoirs of the American Academy in Rome* 49 (2004): 3–4. Knox asserts: "In contrast to the traditional portrait of the tolerance of Augustus, Tiberius's zeal in prosecuting individuals who spoke ill of the emperor had to be restrained from an early age" (5). Ovid could well have been banished by a weakened Augustus and his chances of forgiveness decreased as Tiberius's power increased.

47. Ovid imagines the emperor as a new Jupiter striking him down with his thunderbolt, relegating him to Pontus. There are many references to Jupiter as Augustus in *Tristia*. See, for example Ovid, *Tristia*, 1.4.26, 2.34, 2.69–70, 2.216, 2.333, 3.1.38, 3.5.7.

48. George Orwell, *Nineteen Eighty-Four* (New York: Plume/Harcourt Brace, 2003), 12–14.

49. "Goldstein's book, of course, turns out to be a contrivance worked up by the Party to trap lapsed Party members and rebels like Winston Smith. Winston's arrest, torture, and reeducation thus reinforce Orwell's bleak view of revolution, whether by slaves of the mod-

ern state or those of ancient ones." Paul Burton, "George Orwell and the Classics," *Classical and Modern Literature* 25, no. 1 (2005): 73.

50. Pen American Center, *Chilling Effects: NSA Surveillance Drives U.S. Writers to Self-Censor,* November 12, 2013, https://pen.org/sites/default/files/Chilling%20Effects_PEN%20American.pdf.

51. Cervantes, *Don Quijote,* 1.56; *Don Quixote,* trans. Tom Lathrop (Delaware: European Masterpieces, 2005), 6.

52. Carolyn Nadeau, the only critic to discuss this at length, explains that in *Metamorphoses* Medea is a complex character who represents overwhelming passion and thus comes close to the figures of Dorotea and Zoraida in Cervantes's novel. Carolyn Nadeau, *Women of the Prologue: Imitation, Myth and Magic in Don Quixote I* (Lewisburg, PA: Bucknell University Press, 2002), 87.

53. The tragedy of *Medea* is lost; *Metamorphoses* moves from innocence to guilt, whereas *Heroides* focuses on Medea's lamentations. Of the latter, Russell argues: "The dark and hostile witch into whom Medea is turning is present, this is true, but we see this through the juxtaposition with the innocent figure that she tries to show herself to be." Stephen C. Russell, "Reading Ovid's Medea: Complexity, Unity, and Humor" (PhD diss., McMaster's University, 2011), 100.

54. Ovid, *Tristia,* 3.9.2.

55. Ibid.

56. Ibid., 3.9.16.

57. Russell, "Reading Ovid's Medea," 340.

58. Ovid, *Tristia,* 3.9.30–31.

59. Eric C. Graf, *Cervantes and Modernity: Four Essays on Don Quijote* (Lewisburg, PA: Bucknell University Press, 2007), 112. Graf goes even further, adding that the pomegranate becomes a "a moral symbol of social harmony through sacrifice as a kind of transcultural solution to the long history of violence between Basques, Castilians, Jews, Christians, Arabs and Moriscos" (113).

60. Orwell, *Nineteen Eighty-Four,* 218–19.

61. Ovid writes: "Poetry comes fine spun from a soul at peace; my mind is clouded with unexpected woes. Poetry requires the writer to be in privacy and ease; I am harassed by the sea, by gales, by wintry storms. Poetry is injured by fear; I in my ruin am ever and ever expecting a sword to pierce my throat." Ovid, *Tristia,* 1.1.39.

62. Cervantes, *Don Quijote,* 1.50.

63. Ibid.; Ovid, *Tristia* 1.1, 39–44.

64. Gareth William explains that the "shabby appearance of Ovid's personified book of exile poetry reflects not only its author's reduced circumstances but also the quality of the poem that it contains. Disheveled and unpolished." Gareth William, "Ovid's Exile Poetry," 74. Cervantes also argues that his book is dry, meager, and wild because of the writer's own circumstances.

65. Cited in John Rodden, *George Orwell: The Politics of Literary Reputation* (New Brunswick, NJ: Transaction, 2002), 122. It has been ascertained that: "In numerous memoirs in the 50's and 60's . . . he was nothing less than 'the English Don Quixote'" (221).

66. Orwell, *Nineteen Eighty-Four,* 28.

67. Marsyas was considered a wise satyr whose statue at the Roman Forum, with an arm raised, signified, according to Elaine Fantham, telling truth to power, and affirming the

desire for freedom. Elaine Fantham, "Liberty and the Roman People," *Transactions of the American Philological Association* 135, no. 2 (2005): 221.

68. In Book 6 of *Metamorphoses*, Ovid tells what happens when a satyr thinks that his rustic pipe is sweeter than Apollo's lyre. Ovid does not focus on his cruel punishment (being flayed alive) but on the river Marsyas that is created by all those nymphs, satyrs, gods, and goddesses who wept at his punishment and death. Ovid, *Metamorphoses*, 6.383–400.

69. Cervantes, *Don Quijote*, 4.97. This transformation of myth into hagiography is quite common in Cervantes. As Américo Castro reminds us, "Los santos recuerdan a los dioses, la Virgen a Venus" [The saints recall the ancient gods, while the Virgin recalls Venus]; Américo Castro, *El pensamiento de Cervantes* (Barcelona and Madrid: Moguer, 1972), 272. As is customary throughout the novel, Cervantes once again brings up images from classical mythology and from Christianity (Marsyas and Bartholomew), fusing them to create a brilliant and unsettling image. For his uses of classical and Christian images and allusions, see de Armas, *Quixotic Frescoes*, 30, 45, 75–76, etc.

70. Cervantes's novel is replete with images from Italian Renaissance art. See de Armas, *Quixotic Frescoes* and "Don Quixote as Ovidian Text," in *A Handbook to the Reception of Ovid*, ed. John F. Miller and Carole Newlands (New York: Wiley-Blackwell, 2014), 277–90.

71. Cervantes, *Don Quijote*, 4.95; *Don Quixote*, 35.

72. Timothy Hampton, *Writing from History: The Rhetoric of Exemplarity in Renaissance Literature* (Ithaca, NY: Cornell University Press, 1990), 252.

73. Orwell, *Nineteen Eighty-Four*, 253, 267.

74. Oliver Laughland, "How the CIA Tortured Its Detainees," *The Guardian* (December 9, 2014), www.theguardian.com/us-news/2014/dec/09/cia-torture-methods-waterboarding-sleep-deprivation.

75. Anthony Close asserts: "This image of an Inquisition-bullied society which fiddled while Spain burnt was a stereotype among nineteenth-century Quixote critics from Simonde de Sismondi onwards." Anthony Close, *The Romantic Approach to Don Quixote* (Cambridge: Cambridge University Press, 1978), 110. In recent times, P. E. Russell has worked on the relation between the prohibitions at the Council of Trent and its effects on fiction. P. E. Russell, "El Concilio de Trento y la literatura profana," in *Temas de la Celestina y otros estudios: del Cid al Quijote* (Barcelona: Ariel, 1978), 443–78.

76. Prendergast asserts that "the novel's representation of the desire to control the circulation of texts, [is] seen vividly in the attempted control and manipulation of the character of Don Quixote." Ryan Prendergast, *Reading, Writing and Errant Subjects in Inquisitorial Spain* (Burlington, VT: Ashgate, 2011), 9. This critic argues against Salvador Muñoz Iglesias, who claims that there is no serious critique of the Inquisition in the novel. Salvador Muñoz Iglesias, *Lo religioso en El Quijote* (Toledo: Estudio Teológico de San Idelfonso, 1989).

77. Prendergast, *Reading, Writing and Errant Subjects*, 14.

78. Erich Fromm compares Inquisitional attitudes to the Ministry of Love. Orwell, *Nineteen Eighty-Four*, 335.

79. In spite of the comic nature of the initial passage, Cervantes's chapter is quite to the point: Books that do not conform to the priest's or the barber's view of what should be in print will be burned. In addition, those that do not receive a definite judgment are sent to a dry well to wait for further scrutiny, a site also reminiscent of Orwell's memory hole. We learn that certain elements in some of the books must be expunged, whereas the book itself

can be saved. This censorship, as stated, is capricious—the priest finds different reasons to save certain texts and gets tired of looking at so many books.

80. Cervantes, *Don Quijote*, 6.110–11; Cervantes, *Don Quixote*, 45.

81. Orwell, *Nineteen Eighty-Four*, 249.

82. Ibid., 27.

83. Ibid., xi.

84. Prendergast asserts: "What is more challenging to decipher, however, is how writers incorporated responses to the socio-cultural control exerted by royal and ecclesiastical policies and practices in their work." Prendergast, *Reading, Writing and Errant Subjects*, 2.

85. De Armas, *Don Quixote among the Saracens*, 146, 158–59, 167–68; and Anthony J. Cascardi, *Cervantes, Literature, and the Discourse of Politics* (Toronto: University of Toronto Press, 2011), 240.

86. Leo Strauss, *Persecution and the Art of Writing* (Chicago: University of Chicago Press, 1988), 24–25.

87. Cascardi, *Cervantes, Literature, and the Discourse of Politics*, 240.

88. The image comes from Sebastian Münster's *Cosmographiae universalis* (Basel: Heinrich Petri, 1550). The volume is preserved in the Biblioteca Nacional, Madrid (R/33638). A very popular tome, it describes many of the cities in the world.

89. Cervantes, *Don Quijote*, 1.17.209.

90. Ibid., 17.210.

91. Pedro Ciruelo, *Reprouacion de las supersticiones y hechizerias*, ed. Alva V. Ebersole (Valencia: Albatros-Hispanófila, 1978), 80.

92. Armando Maggi, who has carefully studied *De incantantionibus seu ensalmis* (1620), provides and translates De Maura's definition: "Ensalmi are benedictions or evil invocations (*imprecationes*) composed of a certain formula of words, primarily holy ones, and sometimes also of some material things like wine or cloth . . . Many individuals, first of all, Spaniards, make use of these [*ensalmi*] to heal wounds and different diseases and to remove various forms of injuries . . ." Armando Maggi, *Satan's Rhetoric: A Study of Renaissance Demonology* (Chicago: University of Chicago Press, 2001), 55–56. This is precisely what Don Quixote does in the text.

93. Maggi, *Satan's Rhetoric*, 51.

94. Cervantes, *Don Quijote*, 17.210; *Don Quixote*, 115.

95. Summer Harlow, "It Was a "Facebook Revolution": Exploring the Meme-Like Spread of Narratives during the Egyptian Protests," *Revista de comunicación* 12 (2013): 59–82. In a recent short story, Roberto González Echevarría has imagined a meeting between Don Quixote and Cide Hamete Benengeli. The latter, riding an immense camel, carries a computer and records the story as it happens, while behind him, his translator, riding a dromedary, immediately translates on his computer what has been written. "Don Quijote II, 11bis. Epílogo a las Cortes de la Muerte" in *Doce cuentos ejemplares y otros documentos cervantinos*, ed. Frederick A. de Armas and Antonio Sánchez Jiménez (Madrid: Ediciones del Orto / Ediciones Clásicas, 2016), 19–20.

96. In addition to many European wars (England, the Netherlands and even the Electorate at Cologne), there were wars with the Ottoman Empire and the continued conquests in America.

97. Goldstein's forbidden book reveals that war is no longer a way to win, but a way to keep the status quo: "In one way or another, these three superstates are permanently at war

and have been so for the past twenty-five years The primary aim of modern warfare . . . is to use up the products of the machine." Orwell, *Nineteen Eighty-Four*, 190, 193.

98. Ibid., 198.

99. Even lectures by scholars started to be censored, as books and lecture notes were incinerated. Labeinus, Cassius Severus, and many others suffered this fate. Frederick H. Cramer, "Bookburning and Censorship in Ancient Rome: A Chapter from the History of Freedom of Speech," *Journal of the History of Ideas* 6, no. 2 (1945): 170–73.

100. In today's world, embedded journalism, that is, journalists accompanying an army and cheering their victories, has been considered a form of censorship (avoiding the voice of the enemy) and a type of imperial propaganda. Stephen Farrell, "Embedistan," *New York Times*, June 25, 2010, https://atwar.blogs.nytimes.com/2010/06/25/embedistan-2/.

101. Ovid, *Tristia*, 2.103–6.

102. Walter Marx, "Motivos reiterados o la estructura simétrica del *Quijote* de 1605," in *Cervantes y su mundo*, ed. Eva Reichenberger and Kurt Reichenberger (Kassel: Editio Reichenberger, 2004), 146.

103. Some can also believe a mainstream media claim that a particular camera shot is of a rebellion in a country where it did not happen. *Pravda* reported on December 8, 2011, that *Fox News* had just misled the viewers: "The report about the election riots in Moscow came along with the footage of the clashes between protesters and police officers in Athens, the capital of Greece." Antón Kulikov, "Fox News Is Going Bananas," *Pravda*, August 12, 2011, http://english.pravda.ru/russia/politics/08–12–2011/119886-fox_news-o/.

104. Rodden, *George Orwell*, 128.

CHAPTER 5

Coauthor Morteza Gharib would like to thank David Kremers for his encouragement and support with respect to the mathematical portion of the essay. Dr. Chris Roh generously helped in the preparation of plots. Raimondo Pictet and Professor Flavio Noca have been crucial in the translation of legends of figures from Ms. Arundel, f143 and f217.

1. William Harvey's hypothesis of continuous circulation is based on prior work by the Italian anatomist Hieronymus Fabricius (+1619), who demonstrated the venous valves.

2. Rheumatic heart-valve disease is damage to the valves as a result of rheumatic fever.

3. The only reference to a physician is to an entry in his notes, in which he writes to remind himself to return the book on the waters to the anatomist/physician Marcantonio della Torre. This, of course, could be related to hydrology, another of his serious interests, and not urology.

4. Although there were possible suggestions that Leonardo would have liked to have published the material, the fact remains it was not a priority and the work was not published. Consequently, it is not until the twentieth century that Leonardo's cardiac anatomy and physiology drawings were examined in the literature: *I manoscritti di Leonardo da Vinci della Reale Biblioteca di Windsor: dell'anatomia Fedor Vasil'evich Sabashnikov*. The publications of Sabachnikov and the *Quaderni* are reproductions of the Windsor sheets accompanied by transliteration and translation of the text (*Quaderni d'anatomia di Leonardo da Vinci : . . . fogli della Royal Library di Windsor*, pubblicati da O. C. L.Vangensten, A. Fonahn, e H. Hopstock). Kenneth Clarke, Carlo Pedretti, and Kenneth Keele are responsible for the early in-depth reviews of the anatomy sheets; Kenneth D. Keele and Carlo Pedretti,

Leonardo da Vinci. Corpus of the Anatomical Studies in the Collection of Her Majesty the Queen at Windsor Castle (New York: Harcourt, Brace, Jovanovich, 1978–1980). Perhaps the most in-depth examination of the cardiac anatomy was carried out by Kenneth Keele and presented in two important publications: *Leonardo da Vinci's Elements of the Science of Man* (New York: Academic Press, 1983) and *Leonardo da Vinci on Movement of the Heart and Blood* (London: Harvey and Blythe, 1952). Whereas both publications provide an in-depth consideration of the cardiac pages, in the introduction to the 1952 publication, *Movement of the Heart and Blood*, Keele recognized the shortcomings of cardiological knowledge to interpret some of Leonardo's findings.

5. In fact, within the field of science-fiction literature, there is a subgenre devoted to Leonardo da Vinci known as Vinciad; John Clute, Peter Nicholls, Brian Stableford, and John Grant, eds., *The Encyclopedia of Science Fiction* (London: Orbit, 1993), 332.

6. Leonardo da Vinci, Royal Library, Windsor Castle, UK. Royal Collection, HM Queen Elizabeth II, RL 19027v, circa 1504–6. For further information on the history of dissection in the Early Modern period, see Katharine Park, *Secrets of Women: Gender, Generation, and the Origins of Human Dissection* (New York: Zone Books, 2006).

7. Codex Magliabechiano XVII 17, folios 881–91v and 121v–122r; Anonimo Gaddiano, Biblioteca Nazionale, MS Magliabechiano, Florence, XVII, 17, fol. 91v. Also see Cornelius von Fabriczy, "Il codice dell'Anonimo Gaddiano nella Bibliotheca Nationale di Firenze," *Archivo storico italiano* 12, nos. 3–4 (1891): 15ff.; and Monica Azzolini, "Leonardo da Vinci's Anatomical Studies in Milan: A Re-Examination of Sites and Sources," in *Visualising Medicine and Natural History, 1200–1550*, ed. J. A. Givens, K. M. Reeds, and A. Touwaide (Aldershot, Eng.: Ashgate, 2006), chap. 6, 153.

8. Von Fabriczy, "Il codice dell'Anonimo Gaddiano," 15ff. There is documentary evidence that drawings of the dissections were a requirement of the authorities of at least the hospital Ca'Granda in Milan. Perhaps Leonardo's unique skills in draftsmanship enhanced his presence at such dissections.

9. Leonardo da Vinci, Royal Library, Windsor Castle, UK, Royal Collection, HM Queen Elizabeth II, RL 19051r.

10. Florentine physician Antonio Benivieni pioneered the use of autopsy. He published the treatise *De abditis morborum causis* (The Hidden Causes of Death).

11. Antonio Costa and Giorgio Weber, *L'inizio dell'anatomia patologica nel quattrocento fiorentino sui testi di Antonio Benivieni, Bernardo Torni, Leonardo da Vinci* (Florence: Edizioni riviste mediche, 1963), 564–65.

12. Francis Wells, *The Heart of Leonardo* (London: Springer, 2016), 184–85.

13. Leonardo da Vinci, Royal Library, Windsor Castle, UK, Royal Collection, HM Queen Elizabeth II, 19078v: "Cut out these 3 muscles with their cords and valves and then join them in the manner in which they exist when the right ventricle closes itself and then you will see the true shape of the valves [and] what they do with their cords when they shut themselves."

14. C. D. O'Malley and J. B. de C. M. Saunders, *Leonardo da Vinci on the Human Body: The Anatomical, Physiological and Embryological Drawings of Leonardo da Vinci* (New York: Gramercy, 2006; orig. publ. New York: H. Schuman, 1952), 254.

15. Had Leonardo published this work the phrase undoubtedly would be "the sinuses of Leonardo," since his extensive investigation of this was unrivaled until the twentieth century.

16. Leonardo da Vinci, Royal Library, Windsor Castle, UK. Royal Collection, HM Queen Elizabeth II, 19082r [III]. "How the blood which turns back when the heart reopens is not that which closes the gates of the heart. This would be impossible because if the blood percussed back on to the valve cusps of the heart which stay curled, wrinkled and snatched up, the blood which pressed on them from above would weigh on them and press the surface of each membrane down on its origin as shown by the valve cusp *ro* which being weighed down from above its folds would shut up in solid contact. And Nature intended to stretch it out in height, breadth and width."

17. Leonardo da Vinci, Royal Library, Windsor Castle, UK. Royal Collection, HM Queen Elizabeth II, 19116r. This factor will also add to peripheral vorticeal formation. Here Leonardo can be seen to introduce knowledge from other disciplines, in this case hydrodynamics and fluid engineering, another specialist area of his knowledge and experience. Leonardo's next action was to devise an experiment to demonstrate the accuracy of his deductions in what must be one of the earliest if not the earliest example of experimental design in the very modern sense. There were several steps to this experiment. First, he needed to make an accurate model of the aortic root. This he did by injecting the aortic root of the bull with hot wax to form a cast; da Vinci, Royal Library, Windsor Castle, UK, Royal Collection, HM Queen Elizabeth II, 19082r. From this he cast a glass aortic root and placed it in a closed circuit. Water was then pumped through the circuit into which he reported injecting grass seeds from which he could observe the vortices forming in the artificial sinuses. This model has been faithfully reproduced by Professor Morteza Gharib of the California Institute of Technology; M. Gharib, D. Kremers, M. Koochesfahani, and M. Kemp, "Leonardo's Vision of Flow Visualization," *Experiments in Fluids* 33, no. 1 (2002): 219–23. Alongside Leonardo's notes describing this apparatus are drawings that seem to represent the making of an artificial aortic valve, which he seemed to have planned to place within the aortic root for complete simulation; da Vinci, Royal Library, Windsor Castle, UK. Royal Collection, HM Queen Elizabeth II, RL19082. This work was reproduced by Bellhouse and Bellhouse, engineer brothers in Oxford, and was published in *Nature* with only one reference, and that reference was five hundred years old and is to the work of Leonardo da Vinci; B. J. Bellhouse and F. H. Bellhouse, "Mechanism of Closure of the Aortic Valve," *Nature* 217, no. 5123 (1968): 66–67. The fact that we can discuss his observations today speaks volumes about the quality of his work. The details of the structure of the aortic root in his descriptions reveal a correctly observed complex geometrical product of evolution, perfectly designed to ensure reproducible valve closure.

18. Leonardo da Vinci, Royal Library, Windsor Castle, UK. Royal Collection, HM Queen Elizabeth II, RL19118r.

19. Virginia M. Walley, Claudia A. Keon, Mandana Khalili, David Moher, Martine Campagna, and Wilbert J. Keon, "Ionescu-Shiley Valve Failure I: Experience with 125 Standard-Profile Explants," *Annals of Thoracic Surgery* 54, no. 1 (1992): 111–16.

20. Leonardo da Vinci, Royal Library, Windsor Castle, UK, Royal Collection, HM Queen Elizabeth II, RL19117v. See the illustrations and note the top right-hand corner of the page.

21. See Leonardo da Vinci, detail of atrio-ventricular valve leaflets, ca. 1513, pen and ink on blue paper, Windsor, Royal Library, MS 119074r.

22. Leonardo da Vinci, Royal Library, Windsor Castle, UK, Royal Collection, HM Queen Elizabeth II, RL 19070v: ". . . or perhaps you will lack patience so that you will not

be diligent. Whether all these things were found in me or not, the 120 books composed by me will give their verdict yes or no. In these I have been impeded neither by avarice or negligence but only time. Farewell."

23. Leonardo da Vinci, *Paris Manuscript, G,* Bibliothèque National, Paris, 1510–1516.

24. Leonardo da Vinci, Royal Library, Windsor Castle, UK, Royal Collection, HM Queen Elizabeth II, RL19062r.

25. Leonardo da Vinci, Royal Library, Windsor Castle, UK, Royal Collection, HM Queen Elizabeth II, RL19062r [II, III and IV].

26. Leonardo da Vinci, Royal Library, Windsor Castle, UK, Royal Collection, HM Queen Elizabeth II, RL19065r [I].

27. Leonardo da Vinci, *Codex Arundel,* British Library, London, MS 263, 119v, and Jane Roberts, *Anatomical Drawings from the Royal Library Windsor Castle* (New York: Metropolitan Museum of Art, 1983), 11.

28. Leonardo da Vinci, Royal Library, Windsor Castle, UK. Royal Collection, HM Queen Elizabeth II, RL19071r.

29. The note by Antonio de Beatis comes from his travel journal. There were five original manuscript versions written in Latin, four written in Beatis's hand. In 1872 Gustavo Uzielli provided a translated version in Italian, which in turn was translated into German by Ludwig Pastor in 1905, into French by Madeleine Havard de la Montagne in 1913, and finally into English by J. R. Hale and J. M. A. Lindon in 1979. The travel journal was never published.

30. Azzolini, "Leonardo da Vinci's Anatomical Studies in Milan."

31. Martin Kemp, *Seen/Unseen: Art, Science, and Intuition from Leonardo to the Hubble Telescope* (Oxford: Oxford University Press, 2006), 87–115.

32. Kemp, *Seen/Unseen,* 99.

33. Leonardo da Vinci and Irma A. Richter, *Selections from the Notebooks of Leonardo da Vinci: With Commentaries* (Oxford: Oxford University Press, 1977), 65.

34. Leonardo and Richter, *Selections from the Notebooks,* 66.

35. Leonardo da Vinci, Codex Madrid I, Biblioteca Nacional, Madrid, Spain, folio 147r.

36. Domenico Bertoloni Meli, *Thinking with Objects: The Transformation of Mechanics in the Seventeenth Century* (Baltimore: Johns Hopkins University Press, 2009).

37. Leonardo da Vinci, Paris Manuscript C, folio7r, Institut de France.

38. Leonardo da Vinci, Arundel Manuscript, folio 217r, British Museum.

39. Isaac Newton, *Philosophiae naturalis principia mathematica* (London: Jussu Societatis Regiæ ac Typis Josephi Streater, 1687). Retrieved from the Library of Congress, www.loc.gov/item/28020872/.

40. *Michel Eyquem de Montaigne, Lord of Montaigne* (1533–1592), "That Our Affections Carry Themselves Beyond Us," *Essays,* Book 1, III, 1580.

CHAPTER 6

1. Geoffrey Parker, *Imprudent King: A New Life of Philip II* (New Haven, CT: Yale University Press, 2014), 43.

2. Arndt Brendecke, *The Empirical Empire: Spanish Colonial Rule and the Politics of Knowledge* (Berlin: De Gruyter, 2016).

3. "Instructions and Letters to the King," in *The Mexican Treasury: The Writings of Dr. Francisco Hernández*, ed. Simon Varey (Stanford, CA: Stanford University Press, 2000), 46.

4. José María López Piñero, *El códice Pomar (ca. 1590), el interés de Felipe II por la historia natural y la expedición Hernández a América* (Valencia: Universades de Valencia-CSIC, 1991); and López Piñero, "The Pomar Codex (ca. 1590): Plants and Animals of the Old World and from the Hernández Expedition to America," *Nuncius* 7 (1992): 35–52.

5. Some of the manuscripts survived the conflagration. On the surviving texts, see Jesús Bustamante, "The Natural History of New Spain," in Varey, ed., *Mexican Treasury*, 26–39).

6. David Freedberg, *The Eye of the Lynx: Galileo, His Friends, and the Beginnings of Modern Natural History* (Chicago: University of Chicago Press, 2002).

7. On the fortunes of the Hernández manuscripts, see Simon Varey and Rafael Chabrán, "Medical Natural History in the Americas: The Strange Case of Francisco Hernández," *Huntington Library Quarterly* 57 (1994): 124–51. In addition, see José María López Piñero and José Pardo Tomás, *Nuevos materiales y noticias sobre la historia de las plantas de Nueva España, de Francisco Hernández*, Cuaderno Valencianos de Historia de la Medicina y de la Ciencia, 44 (Valencia: Universitat de València-CSIC, 1994).

8. Gonzalo Fernández de Oviedo, *Sumario de la natural historia de las Indias*, ed. José Miranda (México: Fondo de Cultura Economica, 1996 [1950]).

9. Andrés I. Prieto, *Missionary Scientists: Jesuit Science in Spanish South America, 1570–1810* (Nashville: Vanderbilt University Press, 2011).

10. Sabine Anagnostou, "Jesuit Missionaries in Spanish America and the Transfer of Medical-Pharmaceutical Knowledge," *Archives internationales d'histoire des science* 52 (2002): 176–97.

11. For further discussion, see William Eamon, "Science as a Hunt," *Physis* 31 (1994): 393–432.

12. Paolo Rossi, *Philosophy, Technology and the Arts in the Early Modern Era*, trans. Salvator Attanasio (New York, Harper & Row, 1970), 42.

13. Giambattista Della Porta, *De i miracoli et meravigliosi effetti dalla natura prodotti* (Venice: Lodovico Auanza, 1560), 2.

14. Francesco Stelluti, quoted in Giuseppe Gabrieli, "Spigolatura Dellaportiane," *Rendiconti della R. Accademia Nazionale dei Lince: classe di scienze morali, storiche e filologiche* 6, no. 11 (1935): 507; D. Carutti, *Breve storia della Accademia dei Lincei* (Rome: Salviucci, 1883), 8.

15. For a broad survey of Medieval Scholastic science, see David Lindberg, *The Beginnings of Western Science: The European Scientific Tradition in Philosophical, Religious, and Institutional Context, 600 B.C. to 1450* (Chicago: University of Chicago Press, 1992).

16. On the iconography of Bacon's frontispiece, see Jorge Cañizares-Esguerra, "The Colonial Iberian Roots of the Scientific Revolution," in *Nature, Empire, and Nation: Explorations of the History of Science in the Iberian World* (Stanford, CA: Stanford University Press, 2006), 14–45.

17. Sir Thomas Browne, *Pseudodoxia epidemica*, in *The Works of Sir Thomas Brown*, ed. Geoffrey Keynes (Chicago: University of Chicago Press, 1964), 2:5.

18. John Glanvill, *The Vanity of Dogmatizing* (London: E. C. Henry, 1661), 178.

19. Daniela Bleichmar, "Trajectories of Natural Knowledge in the Spanish Empire (ca. 1550–1650)," in *Más allá de la Leyenda Negra: España y la Revolución Científica,* ed. Victor Navarro Brotóns and William Eamon (Valencia: Universitat de València, 2007), 139. José María López Piñero and José Pardo Tomás, *La influencia de Francisco Hernández (1515–1587) en la constitución de la botánica y la materia médica modernas* (Valencia: Universitat de València, 1996); Teresa Huguet-Termes, "New World *Materia Medica* in Spanish Renaissance Medicine: From Scholarly Reception to Practical Impact," *Medical History* 45 (2001): 359–75.

20. Daniela Bleichmar, "Books, Bodies, and Fields: Sixteenth-Century Transatlantic Encounters with New World Materia Medica," in *Colonial Botany: Science, Commerce, and Politics in the Early Modern World,* ed. Londa Schiebinger and Claudia Swan (Philadelphia: University of Pennsylvania Press, 2005), 88–89.

21. Nicolás Monardes, *Historia medicinal de las cosas que se traen de nuestras Indias Occidentales* (Seville: Fernando Diaz, 1580), 31r-v.

22. Nicolás Monardes, *Joyfull Newes out of the Newe Founde Worlde,* trans. John Frampton (London: William Norton, 1580).

23. See José María López Pinero et al., *Bibliographia medica hispanica* (Valencia: Instituto de Estudios Documentales e Históricos sobre la Ciencia, Universidad de Valencia, 1987–1989), I:150–60; II:176–80.

24. On Clusius's importance in the history of botany, see Brian Ogilvie, *The Science of Describing: Natural History in Renaissance Europe* (Chicago: University of Chicago Press, 2006).

25. William Eamon, "Spanish Science in the Age of the New," in *A Companion to the Spanish Renaissance,* ed. Hilaire Kallendorf (Leiden: Brill, 2019), 473–507.

26. Carlo Ginzburg, "Clues: Roots of an Evidential Paradigm," in *Clues, Myths and the Historical Method,* trans. J. and A. Tedeschi (Baltimore: Johns Hopkins University Press, 1989), 96–125, on 105–6.

27. Ibid., 99–103.

28. Alessio Piemontese, *I secreti* (Venice, 1555), 1.

29. The sobriquet was invented by Tommaso Garzoni, *La piazza della tutte le professioni del mondo* (Venice, 1580).

30. On the professors of secrets, see William Eamon, *Science and the Secrets of Nature: Books of Secrets in Medieval and Early Modern Culture* (Princeton, NJ: Princeton University Press, 1994).

31. Leonardo Fioravanti, *Tesoro della vita humana* (Venice, 1570), 1.

32. William Eamon, *The Professor of Secrets: Mystery, Medicine, and Alchemy in Renaissance Italy* (Washington: National Geographic, 2010).

33. Leonardo Fioravanti, *Capricci medicinali* (Venice, 1561), 1r.

34. Bruce Moran, *Distilling Knowledge: Alchemy, Chemistry, and the Scientific Revolution* (Cambridge, MA: Harvard University Press, 2006).

35. Oswald Croll, *Basilica chymica,* quoted in Owen Hannaway, *The Chemists and the Word: The Didactic Origins of Chemistry* (Baltimore: Johns Hopkins University Press, 1975), 31.

36. Croll, *Basilica chymica,* quoted in Hannaway, *Chemists and the Word,* 31.

37. William B. Ashworth, Jr., "Natural History and the Emblematic World View," in *Reappraisals of the Scientific Revolution,* ed. David C. Lindberg and Robert S. Westman (Cambridge: Cambridge University Press, 1990), 318.

38. On Jesuit science in America, see Sabine Anagnostou, "Jesuit Missionaries in Spanish America and the Transfer of Medical-Pharmaceutical Knowledge," *Archives internationales d'histoire des sciences* 52 (2002): 176–97.

39. Juan Eusebio Nieremberg, *Historia natura, maxime peregrinae*, quoted in Miguel de Asúa and Roger French, *A New World of Animals: Early Modern Europeans on the Creatures of Iberian America* (Aldershot: Ashgate, 2005), 164.

40. Juan Eusebio Nieremberg, *Curiosa y oculta filosofia* (Alcalá: Imprenta Real, 1649), 185.

41. John Slater, *Todos son hojas: literatura e historia natural en el barroco español* (Madrid: Consejo Superior de Investigaciones Científicas, 2010).

42. Quoted in Juan Pimentel, "Baroque Natures: Juan E. Nieremberg, American Wonders, and Preterimperial Natural History," in *Science in the Spanish and Portuguese Empires, 1500–1800*, ed. Daniela Bleichmar et al. (Stanford, CA: Stanford University Press, 2009), 99.

43. Nieremberg, *Historia naturae*, 15.

44. On Kircher's scientific activity, see Paula Findlen, ed., *Athanasius Kircher: The Last Man Who Knew Everything* (New York: Routledge, 2004).

45. Pimentel, "Baroque Natures," 93–111.

46. Pimentel, "Baroque Natures," 110.

47. On Spanish exploration of America and empiricism, see Antonio Barrera-Osorio, *Experiencing Nature: The Spanish Americal Empire and the Early Scientific Revolution* (Austin: University of Texas Press, 2006).

48. Francis Bacon, *The New Organon*, ed. Fulton H. Anderson (Indianapolis: Bobbs-Merrill, 1960), Bk I, aphorism LXXXIV, 81. In addition, see Silvia Manzo, "Utopian Science and Empire: Notes on the Iberian Background of Francis Bacon's Project." *Studii de Ştiinţă şi Cultură* 6, no. 4 (2010): 111–23.

49. Francis Bacon, *De sapientia veterum*, in *The Works of Francis Bacon*, ed. James Spedding, Robert Leslie Ellis, and Douglas Denon Heath (New York: Garrett Press, 1968), 6:713.

50. On Bacon's role in the history of serendipity, see Sean Silver, "The Prehistory of Serendipity, from Bacon to Walpole," *Isis* 106 (2015): 235–56.

51. *Novum organum*, in *Works*, 4:18.

52. *Novum organum*, in *Works*, 4:18.

53. *De augmentis scientiarum*, in *Works*, 4:413.

54. For a detailed discussion of Bacon's methodology of "learned experience," see Lisa Jardine, *Francis Bacon: Discovery and the Art of Discourse* (London: Cambridge University Press, 1974), 143–49.

55. Leonardo Fioravanti, *Della fisica* (Venice: Giacomo Zattoni, 1576), 136.

56. Jacques Cartier, *Bref récit et succincte narration* (Paris, 1545), quoted in Geoffroy Atkinson, *Nouveaux horizons de la Renaissance française* (Paris: Droz, 1935), 256.

CHAPTER 7

1. This is the thesis of distinguished French historian Michel Pastoureau, *Blue: The History of a Color*, trans. Markus I. Cruse (Princeton, NJ: Princeton University Press, 2001).

2. Pastoureau, *Blue*, 49–50 (on the Virgin Mary); 110 and 124 (on Protestants and blue); and 85–86 (on change in blue's symbolic importance in Europe).

3. Pastoureau, *Blue*, 134.

4. Pastoureau, *Blue,* 79.

5. Pastoureau, *Blue,* 132 (on Prussian blue); and 169 (on the twentieth century).

6. The body of scholarship on blue pigments is growing. Specific studies are cited throughout the article. More general studies include Boston Museum of Fine Arts, *Blue: Cobalt to Cerulean in Art and Culture* (San Francisco: Chronicle Books, 2015); Dena S. Katzenberg, *Blue Traditions: Indigo Dyed Textiles and Related Cobalt Glazed Ceramics from the 17th through the 19th Century* (Baltimore: Baltimore Museum of Art, 1973); Carol Mavor, *Blue Mythologies: Reflections on a Colour* (London: Reaktion, 2013); and François Delamare, *Blue Pigments: 5000 Years of Art and Industry,* trans. Yves Rouchaleau (London: Archetype, 2013).

7. Patricia Reilly, "The Taming of the Blue: Writing Out Color in Italian Renaissance Theory," in *The Expanding Discourse: Feminism and Art History,* ed. Norma Broude and Mary D. Garrard (New York: HarperCollins, 1992), 86–99.

8. The research in this essay forms part of an ongoing project that looks at Early Modern discoveries of and trade in artists' materials during the global Renaissance. See our previous publication: Mari-Tere Álvarez and Charlene Villaseñor Black, "Art and Trade in the Age of Global Encounters, 1492–1800," 267–75, in Álvarez and Villaseñor Black, eds., *Arts, Crafts, and Materials in the Age of Global Encounters, 1492–1800,* special edition, *Journal of Interdisciplinary History* 45, no. 3 (Winter 2015): 267–406.

9. These documents were identified and published by Rocío Bruquetas, "Azul fino de pintores: obtención, comercio y uso de la azurita en la pintura española," in *In sapientia libertas: escritos en homenaje al Profesor Alfonso E. Pérez Sánchez* (Madrid and Seville: Museo Nacional del Prado and Fundación Focus Abengoa, 2007), 148–57. Several of them have been digitized (1476 Archivo General de Simancas, Cancillería, Registro del Sello de Corte, "Licencia a Esteban de Morales, a Pedro Fernández de León y a Pedro de Loranca, vecinos de Córdoba, para que puedan buscar en la sierra de Córdoba dos minerso de cobre y azul," Signatures RGS, LEG, 147611, 726): http://pares.mcu.es/ParesBusquedas/servlets/Control_ servlet?accion = 3&txt_id_desc_ud = 1597787&fromagenda = N Or, dated 1498: "Licencia por ocho años para que García de Durazno y consortes puedan buscar mineros de oro, plata, cobre, plomo y azul en cualquier localidad de los obispados de Sigüenza y Cuenca y su término, así realengos, abadengos, de señoríos, Ordenes o de behetrías, con tal de que indemnicen a los dueños de las heredades por los daños que les causaren en tales trabajos," Archivo General de Simancas, Cancillería, Registro del Sello de Corte, Signatura RGS, LEG, 149810,157 (http://pares.mcu.es/ParesBusquedas/servlets/Control_servlet?accion = 3&txt_id_desc_ud = 1650690&fromagenda = N).

10. Bruquetas, "Azul fino de pintores," 3.

11. "Justicia en Villanueva de los Infantes a Francin Col, cerero real, sobre la venta de azul falso que le hizo Alonso de Rueda," 1501, Archivo General de Simancas, RGS, LEG, 150008, 209: http://pares.mcu.es/ParesBusquedas/servlets/Control_servlet?accion = 3&txt_id_desc_ud = 6148549&fromagenda = N Archivo General de Simancas, Cancillería, Registro del Sello de Corte, 1501; "Que el corregidor de Salamanca haga comparecer a los tintoreros de dicha ciudad; Al corregidor de Salamanca, para que haga comparecer a los tintoreros de dicha ciudad, junto con sus maestros, para tomarles declaración de lo que es mejor y más perfecto con la finalidad de introducirlo o quitarlo de un capitulo de las ordenanzas hechas por la ciudad acerca de la tintura, en color azul y verde, de lanas de

mantas, reposteros, bancales y otras obras de mantería." Conde de Cabra: http://pares.mcu.
es/ParesBusquedas/servlets/Control_servlet?accion = 3&txt_id_desc_ud = 6149050&fro-
magenda = N.

12. Bruquetas, "Azul fino de pintores," 6 and 10. Also see Rocío Bruquetas, "La obten-
ción de pigmentos azules para las obras de Felipe II: comercio europeo y Americano," in *Art
Technology: Sources and Methods* (London: Archetype, 2008), 56.

13. Bruquetas, "La obtención de pigmentos azules," 59–60.

14. "Real Cédula a Diego Gómez de Sandoval, presidente de la Audiencia de Santo
Domingo y gobernador y capitán general de la isla Española, pidiéndole que informe de
la calidad de cierta mina de piedra azul que hay en la isla, explotada primero por Juan de
Ollo, difunto, y luego por sus hijos, que tienen el titulo de ella, y que explique por qué no se
ha pagado ni se paga el quinto de lo que se saca a la Hacienda Real." 1609, Madrid. Archivo
General de Indias, Cobre del quinto de Su Majestad sobre explotación de minas. signatura:
SANTO_DOMINGO, 869, L.6, F61V.: http://pares.mcu.es/ParesBusquedas/servlets/Con-
trol_servlet?accion = 3&txt_id_desc_ud = 405035&fromagenda = N.

15. Archivo General de Indias, Audiencia de Santo Domingo, "Envio de cargas de min-
eral azul a los oficiales de Seville," SANTO_DOMINGO, 868, L.3, F.91R: http://pares.mcu.
es/ParesBusquedas/servlets/Control_servlet?accion = 3&txt_id_desc_ud = 404257&froma-
genda = N.

16. Archivo General de Indias, Audiencia de Santo Domingo, Real Cédula, 1563,
ES.41091.AGI/23.14.2746/SANTO_DOMINGO, 899, L.1, F.314: http://pares.mcu.es/Pares-
Busquedas/servlets/Control_servlet?accion = 3&txt_id_desc_ud = 406485&fromagenda =
N.

17. Bruquetas, "La obtención de pigmentos azules," 55–63. "[A]zul ultramar," or ultra-
marine, obtained from Venice, is referenced in documents after 1580 related to decoration
of the Escorial.

18. Bruquetas, "La obtención de pigmentos azules," 57.

19. Alicia M. Seldes, José Emilio Burucúa, Marta S. Maier, Gonzalo Abad, Andrea
Jáuregui, Gabriela Siracusano, "Blue Pigments in South American Painting (1610–1780),"
Journal of the American Institute for Conservation 38, no. 2 (Summer 1999): 101. Also see
Rocío Bruquetas, "Técnicas y materiales en la pintura limeña de la primera mitad del siglo
XVII: Angelino Medoro y su entorno," *Goya* 327 (April–June 2009): 144–61, which similarly
demonstrates that most artists' pigments in Lima came from Europe.

20. Bruquetas, "La obtención de pigmentos azules," 46–58, 52, and 62. Also see José
María Sánchez and María Dolores Quiñones, "Materiales pictóricos enviados a América en
el siglo XVI," *Anales del Instituo de Investigaciones Estéticas* 95 (2009): 45–67.

21. Seldes et al., "Blue Pigments in South American Painting," 108, citing M. Bargalló,
La minería y la metalurgia en la América española durante la época colonial (Mexico City:
FCE, 1955).

22. William B. Jensen, ed., *The Leyden and Stockholm Papyri: Greco-Egyptian Chemical
Documents from the Early 4th Century AD*, trans. Earle Radcliffe Caley (Cincinnati, OH:
Oesper Collections in the History of Chemistry, University of Cincinnati, 2008); Jensen,
"General Introduction," 1–16; 40, 47–52, and 73–74; and Cyril Stanley Smith and John G.
Hawthorne, eds., *Mappae Clavicula: A Little Key to the World of Medieval Techniques* (Phila-
delphia: American Philosophical Society, 1974).

23. Michael Baxandall, *Painting and Experience in Fifteenth-Century Italy* (Oxford: Oxford University Press, 1972), 6. Lapis was the subject of a 2015 exhibition in the Palazzo Pitti in Florence, glowingly reviewed in the *New York Times*: Roderick Conway Morris, "Lapis Lazuli and the History of 'the Most Perfect' Color," *New York Times*, August 18, 2015, www.nytimes.com/2015/08/19/arts/international/lapis-lazuli-and-the-history-of-the-most-perfect-color.html.

24. Rocío Bruquetas Galán and Marta Pres Cuesta, "Estudio de algunos materiales pictóricos utilizados por Zuccaro en las obras de San Lorenzo de El Escorial," *Archivo Español de Arte* 278 (1997): 163. Bruquetas, "La obtención de pigmentos azules," 55–63. "[A]zul ultramar," or ultramarine, obtained from Venice, is referenced in documents after 1580 related to decoration of the Escorial.

25. http://chsopensource.org/2015/07/06/bartolome-esteban-murillo-technical-art-examination/.

26. See the discussion of how ultramarine was considered more precious than gold in Italy, so much so that it was used only for the draperies of the Virgin Mary: Maria João Durão, "Sketching the Ariadne's Thread for Alchemical Linkages to Painting," *Fabrikart: arte, tecnología, industria, sociedad* 8 (2008): 106–23. She also notes the use of azurite as an underlayer with ultramarine on top.

27. Seldes et al., "Blue Pigments in South American Painting," 100–23; Francisco Pacheco, *El arte de la pintura,* ed. Bonaventura Bassegoda i Hugas (Madrid: Cátedra, 1990), 448–65, 471, and 485–87. On re-creating historical techniques employing azurite, see Michael Price, "Separation and Preparation of Azurite for Use in Oil Painting," *Leonardo* 33, no. 4 (2000) 281–88.

28. Bruquetas, "Azul fino de pintores," 13.

29. Azurite has been identified in Mohedano's *Holy Family,* from the early Baroque. Carmen Guerrero Quintero, *Restauración de la Anunciación del Carmen de Antequera* (Seville: Junta de Andalucía, Consejería de Cultura, 2007). This is an early picture that includes St. Anne and St. Joachim. The investigators detected greenish-blue azurite in the Virgin Mary's garment.

30. Barbara H. Berrie, "Mining for Color: New Blues, Yellows, and Translucent Paint," in *Early Modern Color Worlds,* ed. Tawrin Baker, Sven Dupré, Sachiko Kusukawa and Karin Leonhard (Leiden: Brill, 2016), 20–46. Her discussion of smalt is on 33: "Smalt was used extensively in Spain in the seventeenth century."

31. Stuart Fleming, "Controversy over Smalt," *Archaeology* 38, no. 2 (March/April 1985): 68–69, 80. This quote is from 68, the opening line of his article. He is scientific director of MASCA, Museum Applied Science Center for Archaeology, University Museum, University of Pennsylvania, Philadelphia, PA. For other useful descriptions of the production of smalt, see Seldes et al., "Blue Pigments in South American Painting," 108; and Bruquetas. The following website is also helpful. It explains that potassium was added to glass to make the glass more malleable: www.tate.org.uk/about/projects/changing-properties-smalt-over-time.

32. Seldes et al., "Blue Pigments in South American Paintings," 108.

33. Antonio Neri, *The Art of Glass,* trans. Christopher Merrett (London: Octavian Pulleyn, 1662; orig. 1612 in Italian), chap. 72, "Blew Smalts for Painters."

34. Pacheco, *El arte de la pintura,* 448–65, 471, and 485–87.

35. Fleming, "Controversy over Smalt."

36. Pacheco, *El arte de la pintura*, 448–65, 471, and 485–87; and E. Simunkova, J. Brothankova-Bucifalova and J. Zelinger, "The Influence of Cobalt Blue Pigments on the Drying of Linseed Oil," *Studies in Conservation* 30, no. 4 (November 1985): 161–66.

37. On Palomino's recommendation, see Seldes et al., "Blue Pigments in South American Paintings," 109, which also references Palomino, *El museo pictório y escala óptica*, 1723 (Madrid: Aguilar, 1988), 157–58.

38. Pacheco, *El arte de la pintura*, 465.

39. www.tate.org.uk/about/projects/changing-properties-smalt-over-time. "'The Changing Properties of Smalt over Time," published in January 2007. Also Jaap J. Boon, Katrien Keune, Jaap van der Weerd, Muriel Geldof, Kees Mensch, Scott Bryan, and J. R. J. van Asperen de Boer, "Imaging Microspectroscopic, Secondary Ion Mass Spectrometric and Electron Microscopic Studies on Discoloured and Partially Discoloured Smalt in Cross-Sections of 16th Century Paintings," *Chimia* 55 (2001): 952–60.

40. Marika Spring et al., "Colour Changes in 'The Conversion of the Magdalen' Attributed to Pedro de Campaña," *National Gallery Technical Bulletin* 22 (2001): 54–63.

41. Lisa Duffy-Zeballos, "Bartolomé Esteban Murillo's Saint Justa," *JAMA Arch Facial Plastic Surgery* 8, no. 5 (2006): 354–55. Bartolomé Esteban Murillo, *Santa Justa*, 1665, oil on canvas, 36 ¾ × 26 1/9 in., Algur H. Meadows Collection, Meadows Museum, Southern Methodist University, Dallas.

42. Art historians are unanimous in agreeing that smalt was employed in Spain as a blue pigment because it was inexpensive. Other painters throughout Europe also used smalt, for similar reasons. Bruquetas notes an additional reason—that supplies of azurite were decreasing, especially in the seventeenth century: "El esmalte (vidrio azul colorado con óxido de cobalto) es el pigmeno azul más común en la pintura al óleo europea del siglo XVII ya que la azurita se fue abandonado por su tendencia a ennegrecer y por ser cada vez más escasa." Bruquetas, "Técnicas y materiales en la pintura limeña," 12; and Bruquetas, "La obtención," 58.

43. George Saliba, "The World of Islam and Renaissance Science and Technology," 55–73, on 57, in *The Arts of Fire: Islamic Influences on Glass and Ceramics of the Italian Renaissance*, ed. Catherine Hess (Los Angeles: J. Paul Getty Museum, 2004).

44. Clodoaldo Roldán, Jaume Coll, and José Ferrero, "Case Study: EDXRF Analysis of Blue Pigments Used in Valencia Ceramics from the 14th Century to Modern Times," *Journal of Cultural Heritage* 7 (2006): 134–38.

45. Catherine Hess, "Brilliant Achievements: The Journey of Islamic Glass and Ceramics to Renaissance Italy," 1–33, on 12, in Hess, *Arts of Fire*.

46. Linda Komaroff, "Color, Precious Metal, and Fire: Islamic Ceramics and Glass," 34–53, plates 19 and 20, discussed on 47, in Hess, *Arts of Fire*.

47. See, for example, other similar ceramics in the Metropolitan: accession numbers 56.171.103; 56.171. 127; 41.100.173, etc.

48. Julia Romero Pastor et al., "Elemental, Molecular and Mineralogical Characterization of Polychromes in the Oratory Room of Granada's Madrasah (Spain)," *Macla* 13 (September 2013): 185–86. They date the structure to the period of the Nasrid dynasty, 1238–1492, and identify the patron as Yusuf I. Also see Romero Pastor's dissertation, "Benefit of Applying Spectrometric Techniques and Principal Component Analysis," (PhD diss., Universidad de Granada, September 2011), chaps. 3 and 10.

49. Hess, "Brilliant Achievements," 17, and Saliba, "World of Islam," 57, in Hess, *Arts of Fire*. A number of *mudéjar*-style tiles are housed in the collection of the Metropolitan Museum of Art, New York. See, as examples, the following accession numbers: 94.4.443a-1; 94.4.445a-c; 94.4.449a-b; 94.4.445. On tile making, also see Saliba, "World of Islam," 57, in Hess, *Arts of Fire*.

50. Pastoureau, *Blue*, 28; Bruquetas, "Azul fino de pintores," 2.

51. Bruquetas, "Azul fino de pintores," 2.

52. Pastoureau, *Blue*, 40–41. Blue is rare in Spanish Medieval manuscript illumination or other art until the tenth and eleventh centuries.

53. Sebastián de Covarrubias Orozco, *Tesoro de la lengva castellana, o española* (Madrid: Luis Sanchez, 1611), folio 109r: "AZVL, es la color que llamamos de cielo: esta es vna clara y otra escura, y la que media entre estos dos estremos: el nombre es Arabigo, y segun Vrrea Turquesco. Algunos creen ser Latino del nombre ceruleus, abreuiado Lazul . . . los barbaros la llaman lapis lazuli. Tiene la dicha color de cielo, y aun de cielo estrellado, porque esta sembrada de vnos punticos de oro, a manera de estrellas."

54. Juan Martínez Ruiz, "La indumentaria de los moriscos según Pérez de Hita y los documentos de la Alhambra," *Cuadernos de la Alhambra* 3 (1967): 55–124. See, for example, the discussion of livery (66), Moorish tunics (*marlotas*, 67), and *camisas* (shirts) of blue silk (77).

55. Sources include L. P. Harvey, *Muslims in Spain, 1500 to 1614* (Chicago: University of Chicago Press, 2005); and Henry Charles Lea, *The Moriscos of Spain* (London: Bernard Quaritch, 1901). Primary sources include Diego Hurtado de Mendoza, *Guerra de Granada, hecha por el Rey D. Felipe II. contra los moriscos de aquel reino, sus rebeldes* (Valencia: Librería de Mallén y Berard, 1830; orig. 1627).

56. Pastoureau, *Blue*, 134. In fact, blue was mainly worn by the peasantry. Elsewhere in Europe, the color was attained by dying fabrics with woad, a plant of the cabbage family, which resulted in a light blue.

57. Ahmad Y. al-Hassan, "History of Science and Technology in Islam: Lazaward (Lajvard) and Zaffer Cobalt Oxide in Islamic and Western Lustre Glass and Ceramics," www.history-science-technology.com/notes/notes9.html.

58. Barbara Fuchs, *Exotic Nation: Maurophilia and the Construction of Early Modern Spain* (Philadelphia: University of Pennsylvania Press, 2009), 8 ("aristocratic"), 10 ("princely"), and 13 ("luxury"). On 75 see the association with "aristocratic, chivalric culture."

59. Cynthia Robinson and Leyla Rouhi, eds., *Under the Influence: Questioning the Comparative in Medieval Iberia* (Leiden: Brill, 2005); Cynthia Robinson, *In Praise of Song: The Making of Courtly Culture in al-Andalus and Provence, 1065–1135 A.D.* (College Park: Pennsylvania State University Press, 2002); Cynthia Robinson, *Imagining the Passion in a Multi-Confessional Castile: The Virgin, Christ, Devotions, and Images in the Fourteenth and Fifteenth Centuries* (College Park: Pennsylvania State University Press, 2013); Pamela Patton, "Arts," *Journal of Medieval Iberian Studies*, special issue, *Shards of Memory: Reflections on the Legacy of María Rosa Menocal* 5, no. 2 (2013): 111–17; and María Judith Feliciano Chaves, "Mudejarismo in Its Colonial Context: Iberian Cultural Display, Viceregal Luxury Consumption, and the Negotiation of Identities in Sixteenth-Century New Spain," (PhD diss., University of Pennsylvania, 2004).

60. A. Y. al-Hassan, Maqbul Ahmed, and A. Z. Iskandar, eds., *The Different Aspects of Islamic Culture*, vol. 4, *Science and Technology in Islam* (Paris: UNESCO, 2001), chap. 1.5;

Ahmad Y. al-Hassan, "Transmission of Islamic Science to the West," 136–43; and Saliba, "World of Islam," in Hess, *Arts of Fire*, 55–73.

61. J. M. Roberts and Odd Arne Westad, *The Penguin History of the World*, 6th ed. (London: Penguin, 2013), 349–54; and Donald Hill Routledge, *Islamic Science and Engineering* (Edinburgh: Edinburgh University Press, 1993).

62. al-Hassan, "Transmission of Islamic Science to the West," 136–38.

63. See the following scholars: George Saliba, *Islamic Science and the Making of the European Renaissance* (Cambridge, MA: MIT Press, 2007); Routledge, *Islamic Science and Engineering*; and David C. Lindberg, *The Beginnings of Western Science: The European Scientific Tradition in Philosophical, Religious, and Institutional Context, 600 B.C. to A.D. 1450* (Chicago: University of Chicago Press, 1992). One of the anonymous peer reviewers pointed to an important article that asserts the importance of Arabic science for the European Renaissance: Peter E. Pormann, "The Dispute between the Philarabic and Philhellenic Physicians and the Forgotten Heritage of Arabic Medicine," in *Islamic Medical and Scientific Tradition: Critical Concepts in Islamic Studies*, vol. II (London: Routledge, 2010), 283–316.

64. Hess, *Arts of Fire*, 10.

65. Hess, 10–13 and Saliba, "World of Islam, 57, in Hess, *Arts of Fire*; and J. W. Allan, "Abu'l-Qasim's Treatise on Ceramics," *Iran* 11 (1973): 111–20, and especially 116–17 (on cobalt). Abu'l-Qasim was from a family of potters.

66. J. Pérez-Arantegui et al., "Materials and Technological Evolution of Ancient Cobalt-Blue-Decorated Ceramics: Pigments and Work Patterns in Tin-Glazed Objects from Aragon (Spain) from the 15th to the 18th Century AD," *Journal of the European Ceramic Society* 29, no. 12 (September 2009): 2499–509. Also see Moujan Matin and Mark Pollard, "Historical Accounts of Cobalt Ore Processing from the Kashan Mine, Iran," *British Institute of Persian Studies* 53 (2015): 171–84.

67. See, for examples, Seldes et al., "Blue Pigments in South American Painting," 109: "In effect, during the 18th century, Saxony held a monopoly on the pigment, and it is highly probable that its mines and manufactures produced the smalt that Spanish and South American painters used from the late 17th century." On 110 Seldes et al. note that the smalt used in the Americas was brought from Europe.

68. "Causa de Pau Plau, pasamanero de Barcelona, contra Francesc Mauri y Jaume Magrinyà, tenderos de Barcelona," Archivo de la Corona de Aragón, within Real Audiencia de Cataluña, Pleitos civiles, 29694. "Causa de apelación a sentencia en el consulado de la Llotja de Mar de Barcelona, sobre la reclamación a Pau Palau del pago del damasco azul que se llevó de la tienda de los demandados por cuenta de Bernardino de Marimon." (Approximately 20 folios, in Catalan and Latin.)

69. See Jonathan Goldberg, "The History That Will Be," *GLQ: A Journal of Lesbian and Gay Studies* 1, no. 4 (1995): 385–403. The other important text on queer temporality is Jack Halberstam, *In a Queer Time and Place: Transgender Bodies, Subcultural Lives* (New York: New York University Press, 2005).

70. Keith Moxey, *Visual Time: The Image in History* (Durham, NC: Duke University Press, 2013), 33.

71. Alexander Nagel and Christopher S. Wood, *Anachronic Renaissance* (New York: Zone Books, 2010), 10.

72. My window onto people of color futurisms was Catherine S. Ramírez, "*Deus ex Machina*: Tradition, Technology, and the Chicanafuturist Art of Marion C. Martínez," *Azt-*

lán: A Journal of Chicano Studies 29, no. 2 (2004): 55–92; and her edited dossier, "The Time Machine, from Afrofuturism to Chicanafuturism and Beyond," *Aztlán: A Journal of Chicano Studies* 40, no. 2 (Fall 2015): 127–257.

73. Walter Mignolo, "Epistemic Disobedience and the Decolonial Option: A Manifesto," *Transmodernity: Journal of Peripheral Cultural Production of the Luso-Hispanic World* 1, no. 2 (2011): 44–66; and Nelson Maldonado-Torres, "On the Coloniality of Being: Contributions on the Development of a Concept," *Cultural Studies* 21, nos. 2–3 (2007): 240–70.

74. Roland F. Dickey, *New Mexico Village Arts* (Albuquerque: University of New Mexico Press, 1949), 62: "Blue became a requisite for doors and windows; it was the Virgin's color, and would keep out witches." The author, Roland F. Dickey (1913–2000), was a museum director in New Mexico. Thank you to Felipe Mirabal for directing me to this source. The Smithsonian, Archives of American Art, houses an oral interview of Dickey, available online: "Oral history interview with Roland F. Dickey, 1964 January 16," www.aaa.si.edu/collections/interviews/oral-history-interview-roland-f-dickey-12840.

CHAPTER 8

1. By analyzing printed dictionaries and other lexical works: Alexander Marr, Raphaële Garrod, José Marcaida, and Richard Oosterhoff, *Logodaedalus: Word Histories of Early Modern Ingenuity* (Pittsburgh: Pittsburgh University Press, 2018), provides the first systematic history of the language of ingenuity (in Latin, Italian, Spanish, French, Dutch, German, and English) from the fifteenth to the eighteenth century. Unfortunately, this study appeared too late to incorporate fully in my essay, but see discussion below at note 20. Also appearing after this essay was submitted for publication but relevant to the discussion are *LexArt: Words for Painting (France, Germany, England, the Netherlands, 1600–1750)*, ed. Michèle-Caroline Heck (Montpellier: Presses universitaires de la Méditerranée, 2018); and *Lexicographie artistique: formes, usages et enjeux dans l'Europe moderne*, ed. Michèle-Caroline Heck with Marianne Freyssinet and Stéphanie Trouvé (Montpellier: Presses universitaires de la Méditerranée, 2018).

2. Immanuel Kant, *Critique of Judgment, Including the First Introduction*, trans. and intro. Werner S. Pluhar, foreword Mary J. Gregor (Indianapolis: Hackett, 1987), 174–75.

3. Giorgio Tonelli, "Genius from the Renaissance to 1770," in *Dictionary of the History of Ideas*, ed. Philip P. Weiner, 5 vols. (New York: Charles Scribner's Sons, 1973), II:293; Rudolf Wittkower, "Genius, Individualism in Art and Artists," same volume, 297–312.

4. David Summers, *Michelangelo and the Language of Art* (Princeton, NJ: Princeton University Press, 1981), 355–58, citing key texts by Cicero: *Oratore*, 51, 173; 58, 198; 44, 151; *De natura deorum*, 2, 58. On individual judgment more generally, see Robert Klein, "'Giudizio' et 'Gusto,'" in *Le Forme et l'intelligible: écrits sur la Renaissance et l'art moderne*, ed. André Chastel (Paris: Gallimard, 1970); Howard Caygill, *Art of Judgement* (Oxford: B. Blackwell, 1989); and David Summers, *The Judgment of Sense: Renaissance Naturalism and the Rise of Aesthetics* (Cambridge: Cambridge University Press, 1987).

5. On Avicenna and Scholastic thought, see Summers, *Judgment of Sense*.

6. Summers, *Judgment of Sense*, 97–101.

7. In 1398, Cennini was described as "Familiaris magnifici domini paduan" in the household of Francesco Novello da Carrara; see N. Gramaccini, "Cennini e il suo 'Trattato

della pittura,'" *Res publica litterarum* 10 (1987): 143–51. Close examination of the *Libro*'s language and techniques places it in a north Italian and perhaps a Venetian milieu, while Cennini's techniques for making panel paintings are relevant to practices throughout Western Europe, before and well beyond his lifetime; see Thea Burns, "Cennino Cennini's *Il Libro dell'Arte*: A Historiographical Review," *Studies in Conservation* 56 (2011): 1–13; for the best current edition, see Cennino Cennini, *Il libro dell'arte*, ed. F. Frezzato (Vicenza: Neri Pozza, 2003).

8. Martin Kemp, *Behind the Picture: Art and Evidence in the Italian Renaissance* (New Haven, CT: Yale University Press, 1997), 116.

9. In the opening chapter of *Libro dell'arte*, Cennini writes that "painting . . . calls for imagination, and skill of hand, in order to discover things not seen, hiding themselves under the shadow of natural objects, and to fix them (*formarle*) with the hand, presenting to plain sight what does not actually exist. And it justly deserves to be enthroned next to theory (*scienza*), and to be crowned with poetry" (*Il libro dell'arte*, chap. 1, translated by Daniel V. Thompson, Jr., *The Craftsman's Handbook: The Italian "Il Libro dell'Arte"* [New York: Dover, 1960], 1–2). Cennini defines painting as dependent on the artist's theory (*scientia*), imagination, and skill of hand, granting the painter license to invent things out of his imagination, just as the poet exercises his *fantasia* (echoing the opening lines of Horace's *ars poetica*). The coupling of hand and intellect, *maniera* and *buon giudizio*, is for Cennini the cause of personal style.

10. In a letter of 1396 to Ludovico Bazzacarini, cousin of the ruler of Carrara, cited by Andrea Bolland, "Art and Humanism in Early Renaissance Padua: Cennini, Vergerio, and Petrarch on Imitation," *Renaissance Quarterly* 49, no. 3 (1996): 469–87.

11. Bolland, "Art and Humanism" and Summers, *Michelangelo*, 191–94, discussing Cennini in the context of the classical idea of imitation that Petrarch revived (on the basis of the ancient rhetorical writings of Quintilian).

12. Bolland, "Art and Humanism," explores a further connection to Petrarch in Cennini's use of the word *aria* to describe what is sought in poetic or artistic imitation—not the surface appearance of the model, but qualities that seem to render a portrait a living thing, a "resemblance felt rather than expressed," according to Petrarch in his famous letter of 1366 to Boccaccio.

13. The earliest citation of Cennini's text comes from Vincenzo Borghini, who acquired a manuscript copy in February 1564; see Angela Cerasuolo, *Diligenza e prestezza: la tecnica nella pittura e nella letteratura artistica del Cinquecento* (Florence: Edifir, 2014), 23, citing Borghini's letter to Vasari, published in Carl Frey, *Das literarische Nachlass Giorgio Vasaris: Fortsetzung des Briefwechsels*, ed. and expanded by Hermann-Walther Frey, 2 vols. (Munich: Müller, 1930), 1:26–28 (Florence ASA, AV, 14 [XLVIII], cc. 26, 37): 24 February 1564. Cerasuolo's identification of the manuscript as a copy owned by the Sienese goldsmith "maestro Giuliano" is based on Giorgio Vasari, *Le vite de' più eccellenti pittori, scultori ed architettori nelle redazioni del 1550 e 1568*, ed. Rosanna Bettarini and Paola Barocchi, 6 vols. (Florence: Sansoni, 1966–87), 1:248–49, in the 1568 "Life of Agnolo Gaddi."

14. Burns, "Cennini's *Libro*," 3, citing Raffaello Borghini, *Il riposo* (1584), ed. M. Rosci (Milan: Edizione Labor, 1967), 27, notes that Borghini's unacknowledged incorporation of Cennini's text was first noted in 1821, when the text appeared in print for the first time, edited by the historian Giuseppe Tamborini.

15. Ludwig Heydenreich, "Introduction," in Leonardo da Vinci, *Treatise on Painting [Codex Urbinas Latinus 1270]*, trans. A. Philip McMahon, 2 vols. (Princeton, NJ: Princeton University Press, 1956), 1:xxv, citing books 22–24 of Filarete's *Treatise on Architecture* dedicated to the art of drawing and painting "with many technical remarks taken from Cennini." Filarete also quoted Alberti frequently, as Heydenreich notes; see also Lucia Bertolini, "Ancora su Alberti e Filarete: per la fortuna del *De pictura* volgare," in *Gli antichi e i moderni: studi in onore di Roberto Cardini*, ed. Lucia Bertolini and Donatella Coppini (Florence: Polistampa, 2010), 125–66. There was a rich tradition of perspective studies by artists in north Italy, including Jacopo Bellini (ca. 1400–ca. 1470), Andrea Mantegna (d. 1506), Vincenzo Foppa (d. 1515), Bernardo Zenale (d. 1536), Bramantino (d. 1536). For an introduction, see Martin Kemp, *The Science of Art: Optical Themes in Western Art from Brunelleschi to Seurat* (New Haven, CT: Yale University Press, 1990), 42–44; Barbara Tramelli, "The Art of Writing / The Writing of Art: Giovanni Paolo Lomazzo's Context, Connections, and Influences in His *Trattato dell'Arte della Pittura*," (PhD diss., Free University of Berlin, 2015), 166 and *passim*.

16. Carlo Pedretti and Carlo Vecce, *Libro di pittura: Codice Urbinate lat. 1270 nella Biblioteca apostolica Vaticana* (Florence: Giunti, 1995), n. 1 [hereafter cited as LdP], which begins Melzi's original compilation, is a mature statement of this definition of painting as a *scientia media*, a mixture of principles and experience, to use the Scholastic terminology; see Claire Farago, *Leonardo da Vinci's 'Paragone': A Critical Interpretation with a New Edition of the Text in the Codex Urbinas* (Leiden: E. J. Brill, 1992), 289–99, for discussion of dating, sources, and previous scholarship. Its striking precedent is the first chapter of Cennini's *Il libro dell'arte;* see note 9.

17. LdP, n. 43, translation by Farago, *Paragone,* 280–81.

18. See discussion in Farago, *Paragone,* 338 and *passim*.

19. Leonardo's language suggests numerous connections with late fifteenth-century humanist discussions of rhetorical invention, beyond the scope of discussion here, but see Farago, *Paragone,* 79–91.

20. See Marr et al., *Logodaedalus,* a study described by the authors "as a prehistory of genius which explores the various ways this language of ingenuity was defined, used, and manipulated between 1470 and 1750."

21. In addition to the seminal work of Marr and his associates cited in the adjacent notes see, for example, Evelyn Lincoln, *Brilliant Discourse: Pictures and Readers in Early Modern Rome* (New Haven, CT: Yale University Press, 2014); Camilla Skovjerg and Jacob Wamberg, eds., *Art, Technology and Nature: Renaissance to Postmodernity* (Farnham: Ashgate, 2015); and the work of Pamela H. Smith, whose essay "Science on the Move: Recent Trends in the History of Early Modern Science," *Renaissance Quarterly* 62 (2009): 345–75, provides an excellent historiographical introduction to Early Modern studies of art and technology in a broader framework.

22. Thomas Cole, *Democritus and the Sources of Greek Anthropology* (Cleveland: Western Reserve University Press, 1967), 35.

23. See further, Farago, *Paragone,* 331–32.

24. Vincenzo Maria Cimarelli, *Istorie dello stato d'Urbino,* 1642, cited by Alexander Marr, *Between Raphael and Galileo: Mutio Oddi and the Mathematical Culture of Late Renaissance Italy* (Chicago: University of Chicago Press, 2011), 28.

25. See Margaret C. Jacob, *The First Knowledge Economy: Human Capital and the European Economy, 1750–1850* (Cambridge: Cambridge University Press, 2014). The organized body of mechanical knowledge documented in lectures, textbooks, and curricula is the subject of Jacob's book. She follows the lead of economic historians who advanced the thesis that England led the industrial revolution through the efforts of a "small creative community" of engineers, mechanics, chemists, physicians, and natural philosophers who formed circles in which access to knowledge was the primary objective. See Joel Mokyr, *The Gifts of Athena: Historical Origins of the Knowledge Economy* (Princeton, NJ: Princeton University Press, 2002), 66, cited by Jacob, 7. Jacob, on 10–11, pushes back against charges of Eurocentrism as misplaced because this is not a reductive claim that Western science makes Europe superior, nor does it disregard the inventiveness of non-Western science, but it does invite further study of the use of the new "general purpose technologies" in a global context.

26. The first edition was published in Florence by Torrentino Press (1550), and the second edition was published by Giunti (1568). The standard critical edition now is Vasari, *Vite*, ed. Bettarini and Barocchi.

27. On descriptions of the artist's procedures by Cennini, Leonardo, and Vasari, see further, Claire Farago, "Leonardo's Workshop Procedures and the *Trattato della pittura*," in Claire Farago, Janis Bell, and Carlo Vecce, *The Fabrication of Leonardo da Vinci's Trattato della pittura with a Scholarly Edition of the Italian edition princeps (1651) and an Annotated English Translation*, 2 vols. (Leiden: Brill Press, 2018), especially 1:122–27. Invention is a term widely used in the Early Modern literature that derives from ancient rhetorical theory where it designates the first stage of composing a text or image (usually on an assigned subject), followed by the disposition or arrangement of the parts, and concluding with the embellishment of the text with "ornaments" such as figured language, known as *elocutio* (translated as style). When Alberti, *Della pittura / De pictura*, 1435–36, first adapted rhetorical theory to discuss the design process of composing a narrative painting, *elocutio* referred to the modeling of figures and details of representation. See Michael Baxandall, *Giotto and the Orators: Humanist Observers of Painting in Italy and the Discovery of Pictorial Composition* (Oxford: Oxford University Press, 1971).

28. Leonardo first described his process for inventing the figurative composition in MS A of 1490–92, in two different passages separated by 14 folios. He recommended contemplating suggestive shapes in nature and establishing emotional and gestural narrative coherence through the sketching of entwined figures.

29. LdP, n. 189, ff. 61v–62r (dated ca. 1490–92 or 1500–1505 by Pedretti and Vecce, LdP, 1, 222; 1492 by Pedretti, *Libro A*, 185). See Farago, Bell, and Vecce, *Fabrication*, 2, chap. 98, n. 15, of the critical apparatus for the text deleted from the 1651 editions. Alberti advised the painter to represent emotions through the movements of limbs. Leonardo interpreted this advice as a method for inventing new pictorial compositions. In doing so, as some of his most famous compositional sketches demonstrate, he appears not to heed Alberti's critical advice to observe moderation, warning the painter not to display "too fervid and furious *ingegno*" (*De pictura / Della pittura*, 2.44). E. H. Gombrich, "Leonardo's Method for Working Out Compositions," in *Norm and Form: Studies in the Art of the Renaissance* (London: Phaidon, 1976), 58–63.

30. Vasari, *Vite*, 1:117–21. My translation modified from Giorgio Vasari, *Vasari on Technique*, ed. and intro. G. Baldwin Brown, trans. Louisa S. Machelose (1907; New York: Dover, 1960), 213.

31. It begins on folio 58 verso (LdP, n. 173) and ends on 61 verso (LdP, n. 189).

32. The same editor omitted all of chapter 188 and a large portion of chapter 189, the only place where the term "*componimento inculto*" appears. See Farago, "On the Origins of the *Trattato* and the Earliest Reception of the *Libro di pittura*," in *Fabrication*, 213–40. The concordance, *Fabrication*, 2:1129–35, provides a chart of all the passages excerpted from MS A to LdP to the *Trattato*, including those omitted along the way.

33. Burns, "Cennini's *Libro*," notes that Cennini's compendium transmits a long tradition of practice in that it includes some ancient recipes and some pigments no longer used.

34. On Vasari's authority, see Cerasuolo, *Diligenza e Prestezza*, 32–33; citing Paola Barocchi, "Storiografia artistica: Lessico tecnico e lessico letterario," in *Convegno nationale sui lessici tecnici del Sei e Settecento*, Pisa, Scuola Normale Superiore, 1–3 December 1980, 2 vols. (Florence: [publisher not identified], 1981), 1:135–36.

35. See Brian Richardson, *Print Culture in Renaissance Italy: The Editor and the Vernacular Text, 1470–1600* (Cambridge: Cambridge University Press, 1994), 130, and chap. 11, 155–81, for the leading role that Borghini played in Florentine editing in the second half of the sixteenth century. Richardson discusses Borghini's special interest in Tuscan texts of the thirteenth and fourteenth centuries. Borghini favored preserving archaic forms that survived in speech in communities outside the dominant Florentine middle and upper classes.

36. Frey, *Nachlass*, 26–28, citing Florence, ASA, AV, 14 (XLVIII), cc.26.37; cited by Cerasuolo, *Diligenza e Prestezza*, 32, along with a letter dated 9 October 1563, written by Vasari to the governor of Siena a few months earlier. The exact manuscript they read cannot be identified with certainty; see discussion by Cerasuolo.

37. Filippo Baldinucci, *Vocabolario toscano dell'arte del disegno* (Florence, 1681), http://baldinucci.sns.it. See discussion in Cerasuolo, *Diligenza e prestazza*, 33–35.

38. The following analysis draws upon the primary sources assembled and discussed by Summers, "Furia," *Michelangelo*, 60–71. My purpose in treating Summers's nuanced analysis as my touchstone is to entangle the Platonic tradition of artistic inspiration discussed by Summers with the Aristotelian one of inferential analysis. Leonardo draws upon both strands of accounts of *ingegno* without apparent discomfort at their incommensurability. The effort to synthesize divine inspiration with scientific analysis provides the framework for one of the most productive debates in sixteenth-century artistic literature.

39. *De Demosthene*, 22, in D. A. Russell and M. Winterbottom, *Ancient Literary Criticism* (Oxford: Oxford University Press, 1972), 319; cited by Summers, *Michelangelo*, 238.

40. Francisco de Hollanda's *Diálogos de Roma* (Lisbon, 1548) in the edition *De la pintura antigua por Francisco de Hollanda, versión castellana de Manuel Denis* (1563), ed. E. Tormo (Madrid, 1921), 59. This understanding of furor in relation to the artist's initial compositional idea, is, according to Summers, *Michelangelo*, 68, fully consistent with the ideas of Vasari and Condivi on Michelangelo's process of invention—and, we might add, also in line with Leonardo's compositional sketches and writings about the process of compositional sketching as early as 1490 to 1492.

41. Giovanni Paolo Lomazzo, *Idea del tempio della pittura* (Milan: Paolo Gottardo Pontio, 1590); Federico Zuccaro, *Idea de' pittori, scultori, e architetti* (Turin, 1607). See Farago, "Leonardo's Workshop Procedures and the *Trattato della pittura*, Part Three," in *Fabrication*, 1:135–82, on how these late sixteenth-century writings were inflected by Catholic Reformation ideals of religious decorum.

42. See, for example, Matthew Landrus, "Leonardo's Lost Book on Painting and Human Movements," in Farago, Bell, and Vecce, *Fabrication*, 1:183–212.

43. Carmen Bambach, *Drawing and Painting in the Italian Renaissance Workshop: Theory and Practice 1300–1600* (New York: Cambridge University Press, 1999), 271, nn. 128–29 (citing MS A, 88v, 102v), writing about the design process for the large-scale *"ben finiti cartoon"* emerging circa 1500.

44. Carmen Bambach, "Introduction to Leonardo and His Drawings," in *Leonardo da Vinci: Master Draftsman*, exh. cat. (New York: Metropolitan Museum of Art, 2003), especially 20–22; and Bambach, *Un'eredità difficile: i disegni ed i manoscritti di Leonardo tra mito e documento*, Lettura Vinciana 47, Vinci, Biblioteca Leonardiana (Florence: Giunti, 2009), where she discusses Leonardo's procedures at length, especially his use of notebooks, in the context of his training in Verrocchio's shop and the long-standing use of model books as *exempla*.

45. Brown, "Introductory Essay," in Vasari, *Vasari on Technique*, 5, citing the end of the general *"Proemio"* that precedes the technical chapters as serving primarily to instruct "every gracious spirit in the most noble matters that appertain to the artistic professions . . . for his delight and service . . . to enable any one that wills to gain advantage from the labour and cunning of those who in times past have excelled in the arts."

46. Herbert L. Kessler, *Seeing Medieval Art* (Peterboro, Ontario: Broadview Press, 2004); Caroline Walker Bynum, *Christian Materiality: An Essay on Religion in Late Medieval Europe* (New York: Zone Books, 2011); Cynthia J. Hahn, *Strange Beauty: Issues in the Making and Meaning of Reliquaries, 400–circa 1204* (University Park: Pennsylvania State University Press, 2012); and *"'Res et significatio'*: The Material Sense of Things in the Middle Ages," ed. Lisa Reilly with Libby Parker, Aden Kumler, and Christopher R. Lakey, special issue of *Gesta* 51, no. 1 (2012).

47. See in particular Hahn, "First Things," in *Strange Beauty*, 2–29; and Beate Fricke, "Matter and Meaning of Mother of-Pearl: The Origins of Allegory in the Spheres of Things," *Gesta* 51, no. 1 (2012): 35–53, for two sustained case studies that link materials with sacred and truthful images.

48. See Martin Kemp, "'Wrought by No Artist's Hand': The Natural, the Artificial, the Exotic and the Scientific in Some Artifacts from the Renaissance," in *Reframing the Renaissance: Visual Culture in Europe and Latin America 1450–1650*, ed. Claire Farago (New Haven, CT: Yale University Press, 1995), 177–96.

49. Bynum, *Christian Materiality*, 53, citing Kessler, *Seeing Medieval Art*, 19.

50. A plane mirror forms a virtual image positioned behind the mirror, although light from a source exists only in front of the mirror (www.thefreedictionary.com/virtual+image, consulted 5 November 2015).

51. MS A, f. 113v (similar to Fabrication, 2: chap. 6, derived from LdP, n. 53). On the widely discussed passage in MS A, see recently Robert Zwijnenberg, "*St. John the Baptist* and the Essence of Painting," in *Leonardo da Vinci und the Ethics of Style*, ed. Claire Farago (Manchester: Manchester University Press, 2008), 96–118, with further references.

52. Leonardo means that the eye receives the image (*similitude*) of a solid object (*corpo ombroso*), which the sensate power of sight (*virtu visiva*) passes to the mirror-like *impressiva*, where the *imaginatione* "sees" it. The source of Dante's text where the word *discorrimento* occurs is Aquinas, *Summa contra gentiles*, 1.cap. 1, where Aquinas writes that the

desire for wisdom is the first principle of medicine and other examinations (*disserrere*). Dante, *Convivio,* 2:66–68, states that the Peripatetics perfected the Socratic mode of disputation "by their *ingegno* and almost divine nature" because they valued "*deambulatori.*" Dante's use of the word *ingegno* and his discussion of modes of discourse is an early and perhaps direct precedent for the way in which Leonardo used the word *ingegno* to mean an inborn faculty that can learn to discourse (LdP, n. 38). Dante described the passage of images through the optic nerve as a *discorso* in which the images are constantly transmuted according to the properties of vision. His arguments hinge on the important distinction between the transmutable, sensitive mind and the immutable intellective mind: one is concerned with particular visible images, and the other with principles, essence. In MS A, ff. 112v–113r, where Leonardo quotes part of the *Convivio* (Book 4, third canzone, lines 52–53 of the third stanza), Dante's own text includes a commentary that distinguishes between "vile" and "noble" with reference to the degeneration of corruptible matter; see Farago, *Paragone,* 75–76, 300. Among Leonardo's earliest discussions of the inner senses are Paris MS B, ff. 31e–33v, ca. 1486–90, and the related C.A. 181v.

53. Excerpted from LdP, n. 12. On Leonardo's debt to Augustine with respect to the passages under discussion here on how the painter transmutes himself into the mind of nature and how the world—and, by extension, painting as Leonardo understood it—is a book written by God for man to read, see Steven F. H. Stowell, *The Spiritual Language of Art: Medieval Christian Themes in Writings on Art of the Italian Renaissance* (Leiden: Brill, 2015), 130–60.

54. These period designations seem to be lingering echoes of Hans Belting's influential (but problematic) distinction between the Medieval "era of cult images" and the Modern "cult of art images," most famously set out in *Likeness and Presence: A History of the Image before the Era of Art,* trans. Edmund Jephcott (Chicago: University of Chicago Press, 1994); originally published in German as *Bild und Kult* (1990).

55. LdP, n. 8; translation cited from Farago, *Paragone,* 305–6.

56. The charged materials of sixteenth-century works of art have been receiving attention from art historians; one of the earliest studies is Michael W. Cole, *Cellini and the Principles of Sculpture* (New York: Cambridge University Press, 2002). Projecting allegorical content into materials in their sacred setting is a long-standing tradition in Byzantine art. On the implications of these viewing practices for both virtual and aniconic images in the Early Modern era, deserving of further study, see Alexander Nagel, *The Controversy of Renaissance Art* (Chicago: University of Chicago Press, 2011); Maria Evangelatou, "Between East and West: The Symbolism of Space in the Art of Domenikos Theotokopoulos (El Greco)," in *Renaissance Encounters: Greek East and Latin West,* ed. Marina S. Brownlee and Dimitri H. Gondicas (Leiden: Brill, 2013), 147–88; Claire Farago, "Die Ästhetik der Bewegung in Leonardos Kunsttheorie," in *Leonardo da Vinci: Natur im ¨Ubergang,* ed. F. Fehrenbach (Munich: Wilhelm Fink, 2002), 137–68, and "Aesthetics before Art: Leonardo through the Looking Glass," in *Compelling Visuality: The Work of Art in and out of History,* ed. Claire Farago and Robert Zwijnenberg (Minneapolis: University of Minnesota Press, 2003), 45–65.

57. The painting has been the subject of debate since it was sold at auction in 2017 (Christie's, New York) as an autograph work by Leonardo, backed by leading experts including Martin Kemp. Based on a lost design by Leonardo and known in numerous copies, the execution of this panel has been convincingly attributed to Bernardino Luini, with

Leonardo's participation, by Matthew Landrus, "Salvator Mundi: Why Bernardino Luini Should Be Back in the Frame," *Art Newspaper,* 3 September 2018, at www.theartnewspaper. com/feature/salvator-mundi-why-bernardino-luini-should-be-back-in-the-frame. On the history of the sale, see Ben Lewis, *The Last Leonardo: The Secret Lives of the World's Most Expensive Painting* (New York: Penguin Random House, 2019).

58. Michael Baxandall, *Painting and Experience in Fifteenth-Century Italy: A Primer in the Social History of Pictorial Style* (Oxford: Clarendon Press, 1972).

59. See further Summers, *Judgment of Sense,* 97–101, on the roots of Leonardo's understanding of *ingegno* in Avicenna read through Augustine on common sense and "spiritual vision."

60. In 1490, the Dominican preacher Girolamo Savonarola delivered sermons on the abuses of poetry in which he followed Thomas Aquinas by associating poetry with the exemplum, a form of induction that induces virtue by delighting the individual soul through a concrete image; see Concetta Carestia Greenfield, *Humanist and Scholastic Poetics, 1250–1500* (Lewisburg, PA: Bucknell University Press, 1981), 251.

61. Pamela H. Smith, *The Body of the Artisan: Art and Experience in the Scientific Revolution* (Chicago: University of Chicago Press, 2004), 9–12, cites the example of a wooden Crucifixion by the Sienese artist Lando di Pietro (died ca. 1340), who placed two inscriptions inside the head of Christ: a prayer asking the saints to recommend him to God that ends with an admonition to beholders to adore Christ and "not this wood" and a second inscription inserted into Christ's nostril to "let the soul of Lando be recommended" through Christ's mercy.

62. See Claire Farago, "On the Origins of the *Trattato* and the Earliest Reception of the *Libro di pittura,*" in *Fabrication,* 213–40, which includes a concordance of all the chapters eliminated by the editor who reduced the size of Melzi's compilation by 60 percent.

63. Pamela M. Jones, "Leading Pilgrims to Paradise: Guido Reni's Holy Trinity (1625–26) for the Church of SS. Trinità dei Pellegrini e Convalescenti and the Care of Bodies and Souls," in *Altarpieces and Their Viewers in the Churches of Rome from Caravaggio to Guido Reni* (Aldershot: Ashgate, 2008), 261–324.

64. Jones, "Leading Pilgrims," 306, associated above all with Apelles by writers such as Quintilian, Pliny the Elder, and Plutarch.

65. See further discussion in Farago, "Leonardo's Workshop Procedures and the *Trattato della pittura,*" in *Fabrication,* 1:152–83.

66. The operative intellect (*intellectus operativus*) corresponds to Averroes's "particular intellect" or *vis cogitativa,* the activity that Thomas Aquinas described as bringing together and comparing individual forms, just as human reason performs analogous operations with universal forms. See Summers, *Judgment of Sense,* 27–28. In the Latin tradition of Scholastic thought, these operations at the level of the individual are equivalent to the operations associated with *ingegno* in the vernacular tradition.

67. Las Casas, *Argumentum apologiae adversus Genesium Sepulvedam theologum cordubensem,* 24r–25r, cited in Anthony Pagden, *The Fall of Natural Man: The Amerindian and the Origins of Comparative Ethnology,* 2nd ed. (Cambridge: Cambridge University Press, 1986), 136. Las Casas also cited the products manufactured by Amerindian laborers and artisans as proof of their rationality (*Apológetica historia sumaria,* ca. 1555–59, chaps. 61–65). See further, Farago, "Mediating Ethnicity and Culture: Framing New Mexico as a Case

Study," in Claire Farago and Donna Pierce, *Transforming Images: New Mexican Santos in-between Worlds* (University Park: Pennsylvania State University Press, 2006), 19–20.

68. See further, Claire Farago, "The Classification of the Visual Arts during the Renaissance," in *The Shapes of Knowledge from the Renaissance to the Enlightenment*, ed. R. D. Kelley and R. H. Popkin (Netherlands: Kluwer Press, 1991), 25–47.

69. During the reign of Louis XIV, his chief minister Jean-Baptiste Colbert (1619–1683) developed a strategy that appears to be a direct continuation of Cardinal Richelieu's under Louis XIII, for stabilizing the French economy focused on selling in foreign markets, regulating the guilds, founding new academies, raising tariffs, and encouraging public works projects. Cultural production under Louis XIV became an enormous economic driver. Colbert, the main figure of France's finances and cultural affairs, who acquired the *Manufacture royale des Gobelins* in 1662 to boost the manufacture of furniture and tapestries, established the *Manufacture royale de glaces de miroirs* in 1665 and became the patron of the *Académie royale*. For an introduction with further references, see W. Gaehtgens, "The Arts in the Service of the King's Glory," in *A Kingdom of Images: French Prints in the Age of Louis XIV, 1660–1715*, ed. Peter Fuhring, Louis Marchesano, Rémi Mathis, and Vanessa Selbach, exh. cat. (Los Angeles: Getty Research Institute, 2015), 1–8; the entire catalogue is a testament to the success of Colbert's policies.

70. Among recent studies, see Benjamin Schmidt, *Inventing Exoticism: Geography, Globalism, and Europe's Early Modern World* (Philadelphia: University of Pennsylvania Press, 2015); Stephanie Leitch, *Mapping Ethnography in Early Modern Germany: New Worlds in Print Culture* (Basingstoke [NY]: Palgrave Macmillan, 2010); Michael Gaudio, *Engraving the Savage: The New World and Techniques of Civilization* (Minneapolis: University of Minnesota Press, 2008); and Bronwen Wilson, *The World in Venice: Print, the City, and Early Modern Identity* (Toronto: University of Toronto Press, 2005).

71. Walter Benjamin, "The Work of Art in the Age of Its Mechanical Reproducibility," in *Selected Writings 1935–1938*, ed. Howard Eiland and Michael W. Jennings, trans. Edmund Jephcott and Henry Zohn, 4 vols. (Cambridge, MA: Belknap Press of Harvard University Press, 2002), 3:101–33.

72. Simon Ditchfield, "The 'Making' of Roman Catholicism as a 'World Religion,'" in *Multiple Modernities?: Confessional Cultures and the Many Legacies of the Reformation Age*, ed. Jan Stievermann and Randall Zachmann (Tubingen: Mohr Siebeck, 2018), 189–203. My thanks to the author for sharing his work in manuscript and discussing the issues with me.

BIBLIOGRAPHY

Aleotti, Giovanni Battisti. *Gli artificiosi et curiosi moti spirituali di Herrone*. Ferrara: Vittorio Baldini, 1589.

al-Hassan, Ahmad Y. "History of Science and Technology in Islam: Lazaward (Lajvard) and Zaffer Cobalt Oxide in Islamic and Western Lustre Glass and Ceramics." www.history-science-technology.com/notes/notes9.html.

———. "Transmission of Islamic Science to the West." In *The Different Aspects of Islamic Culture*, edited by Abdelwahab Bouhdiba, Ahmad Y. al-Hassan, and Ekmeleddin İhsanoğlu. Paris: UNESCO Publishing, 1998.

Allan, J. W. "Abu'l-Qasim's Treatise on Ceramics." *Iran* 11 (1973): 111–20.

Allen, P. S., H. M. Allen, and H. W. Garrod, eds. *Opus epistolarum Des. Erasmi Roterdami*, vol. 9, *1530–1532*. Oxford: Oxford University Press, 1938.

———, eds. *Opus epistolarum Des. Erasmi Roterodami*, vol. 10, *1532–1534*. Oxford: Oxford University Press, 1941.

Allen, Rosamund, ed. *Eastward Bound: Travel and Travellers, 1050–1550*. Manchester: Manchester University Press, 2004.

Álvarez, Mari-Tere, and Charlene Villaseñor Black. "Art and Trade in the Age of Global Encounters, 1492–1800," 267–75. Edited by Álvarez and Villaseñor Black, *Arts, Crafts, and Materials in the Age of Global Encounters, 1492–1800*, special edition, *Journal of Interdisciplinary History* 45, no. 3 (Winter 2015): 267–406.

Ambrosius Aurelius Theodosius Macrobius. *Saturnalia (ca. 420)*. Edited by Robert A. Kaster. Oxford: Oxford University Press, 2011.

Anagnostou, Sabine. "Jesuit Missionaries in Spanish America and the Transfer of Medical-Pharmaceutical Knowledge." *Archives internationales d'histoire des sciences* 52 (2002): 176–97.

D'Ancona, Alessandro. *Sacre rappresentazioni dei secoli XIV, XV e XVI*. Florence: Successori le Monnier, 1872.

———. *Origini del teatro in Italia*. Florence: Successori le Monnier, 1877.

Anonimo Gaddiano. *Codex Magliabechiano*. MS Florence, Biblioteca Nazionale.

Anonymous. *Jeu d'Adam* [ca. 1150]. Edited by Wolfgang van Emden. Edinburgh: British Rencensvals Publications, 1996 [original is in the Bibliothèque municipale de Tours, MS 927), 23 (l. 292)].

Apple Computer Inc. *Human Interface Guidelines: The Apple Desktop Interface.* Reading, MA: Addison-Wesley, 1987.

Aquinas, Thomas. *Summa theologica.* Bibliothèque nationale de France. MS Fr. 12536.

Ariès, Philippe. *L'enfant et la vie familiale sous l'Ancien Régime.* Paris: Plon, 1960.

Armas, Frederick de. *The Return of Astraea: An Astral-Imperial Myth in Calderón.* Lexington: University of Kentucky Press, 1986.

———. *Quixotic Frescoes: Cervantes and Italian Renaissance Art.* Toronto: University of Toronto Press, 2006.

———. "Sancho as a Thief of Time and Art: Ovid's *Fasti* and Cervantes' *Don Quixote,* II." *Renaissance Quarterly* 61, no. 1 (2008): 1–25.

———. "Preface." In *Ovid in the Age of Cervantes.* Edited by Frederick A. de Armas. Toronto: University of Toronto Press, 2010.

———. *Don Quixote among the Saracens: A Clash of Civilizations and Literary Genres.* Toronto: University of Toronto Press, 2011.

———. "Don Quixote as Ovidian Text." In *A Handbook to the Reception of Ovid.* Edited by John F. Miller and Carole Newlands, 277–90. New York: Wiley-Blackwell, 2014.

Arnold, K. *Materia Medica: A New Cabinet of Art and Medicine.* Exhibition catalog. London: Wellcome Institute for the History of Medicine, 1995.

Ashworth, Jr., William B. "Natural History and the Emblematic World View." In *Reappraisals of the Scientific Revolution,* edited by David C. Lindberg and Robert S. Westman. Cambridge: Cambridge University Press, 1990.

Asúa, Miguel de, and Roger French. *A New World of Animals: Early Modern Europeans on the Creatures of Iberian America.* Aldershot: Ashgate, 2005.

Atkinson, Geoffroy. *Nouveaux horizons de la Renaissance française.* Paris: Droz, 1935.

Auguste, Alphonse. "Gabriel de Ciron et Madame de Mondonville." *Revue historique de Toulouse* 2 (1915–19): 20–69.

Aus, Roger D. "Paul's Travel Plans to Spain and the 'Full Number of the Gentiles' of Rom. XI 25." *Novum Testamentum* 21, fasc. 3 (1979): 232–62.

Azzolini, Monica. "Leonardo da Vinci's Anatomical Studies in Milan: A Re-Examination of Sites and Sources." In *Visualizing Medicine and Natural History, 1200–1550,* edited by J. A. Givens, K. M. Reeds, and A. Touwaide, Aldershot, 147–76. England and Burlington, VT: Ashgate, 2006.

Baars, Bernard J. *In the Theater of Consciousness: The Workspace of the Mind.* Oxford: Oxford University Press, 1997.

Bacevich, Andrew J. *American Empire: The Realities and Consequences of U.S. Diplomacy.* Cambridge, MA: Harvard University Press, 2002.

Bacon, Francis. *The New Atlantis,* vol. III, part 2. Harvard Classics. New York: P.F. Collier & Son, 1909–14.

———. *The New Organon.* Edited by Fulton H. Anderson. Indianapolis: Bobbs-Merrill, 1960.

———. *The Works of Francis Bacon.* Edited by James Spedding, Robert Leslie Ellis, and Douglas Denon Heath. New York: Garrett Press, 1968.

Baker, John, and Elliott Stonecipher. "Our Unconstitutional Census." *Wall Street Journal*, August 9, 2009. www.wsj.com/articles/SB10001424052970204908604574332950796281832.

Bambach, Carmen. *Drawing and Painting in the Italian Renaissance Workshop: Theory and Practice 1300–1600*. New York: Cambridge University Press, 1999.

——— and Leonardo da Vinci. *Un'eredità difficile: i disegni ed il manoscritti di Leonardo tra mito e documento*. Florence: Giunti, 2009.

———. "Introduction to Leonardo and His Drawings." In *Leonardo da Vinci: Master Draftsman*, exhibition catalog. New York: Metropolitan Museum of Art, 2003.

Bargalló, Modesto. *La minería y la metalurgía en la América española durante la época colonial: con un apéndice sobre la industria del hierro en México desde la iniciación de la independencia hasta el presente*. Mexico City: Fondo de Cultura Económica, 1955.

Barocchi, Paola. "Storiografia artistica: lessico tecnico e lessico letterario." In *Convegno nationale sui lessici tecnici del Sei e Settecento*. 2 vols. Pisa, Scuola Normale Superiore, 1–3 December 1980. Florence: np, 1981.

Barrera-Osorio, Antonio. *Experiencing Nature: The Spanish American Empire and the Early Scientific Revolution*. Austin: University of Texas Press, 2006.

Barrett, Michael, and Eivor Oborn. "Boundary Object Use in Cross-Cultural Software Development Teams." *Human Relations* 63, no. 8 (2010): 1199–221.

Baum, Constanze. "Theatrale Inszenierungen auf den Titelbildern der Theatrum-Literatur." In Baum and Nikola Rossbach, *Theatralität von Wissen*, diglib.hab.de/ebooks/ed000156/start.htm.

Baxandall, Michael. *Giotto and the Orators: Humanist Observers of Painting in Italy and the Discovery of Pictorial Composition*. Oxford: Oxford University Press, 1971.

———. *Painting and Experience in Fifteenth-Century Italy*. Oxford: Oxford University Press, 1972.

Beardsley, Theodore S. *Hispano-Classical Translations Printed between 1482 and 1699*. Pittsburgh: Duquesne University Press, 1970.

Becker, Howard. *Über den Prozess der Zivilisation: Soziogenetische und psychogenetische Untersuchungen*. Basel: Verlag Haus zum Falken, 1939.

Bedini, Silvio A. "The Role of Automata in the History of Technology." *Technology and Culture* 5, no. 1 (1964): 9–42.

——— and Francis R. Maddison. *Mechanical Universe: The Astrarium of Giovanni de' Dondi*. Philadelphia: American Philosophical Society, 1966.

Beem, Charles, ed. *The Foreign Relations of Elizabeth I*. New York: Palgrave Macmillan, 2011.

Bekka, Pamela. "Picturing the 'Living' Tabernacle in the Antwerp Polyglot Bible." In *The Anthropomorphic Lens: Anthropomorphism, Microcosm and Analogy in Early Modern Thought and Visual Arts*, edited by Walter Melion, Michel Weemans, and Bret Rothstein. Leiden: Brill, 2013.

Bellhouse, B. J., and F. H. Bellhouse. "Mechanism of Closure of the Aortic Valve." *Nature* 217, no. 5123 (1968): 86–87.

Belting, Hans. *Likeness and Presence: A History of the Image before the Era of Art*. Translated by Edmund Jephcott. Chicago: University of Chicago Press, 1994; originally published in German as *Bild und Kult* (1990).

Benjamin, Walter. "The Work of Art in the Age of Its Mechanical Reproducibility." In *Select-ed Writings 1935–1938*, edited by Howard Eiland and Michael W. Jennings, translated by Edmund Jephcott and Henry Zohn, 4 vols. Cambridge, MA: Belknap Press of Harvard University Press, 2002.

Benocci, Carla. *Villa Aldobrandini a Roma*. Rome: Argos, 1992.

Bergson, Henri. *Laughter: An Essay on the Meaning of the Comic*. Translated by Cloudesley Brereton and Fred Rothwell. Whitefish, MT: Kessinger, 2004 [1900].

———. *Le rire. Essai sur la signification du comique [1900]. Paris: Éditions Alcan*, 1924.

Berrie, Barbara H. "Mining for Color: New Blues, Yellows, and Translucent Paint." In *Early Modern Color Worlds*, edited by Tawrin Baker, Sven Dupré, Sachiko Kusukawa, and Karin Leonhard, 20–46. Leiden: Brill, 2016.

Berryman, Sylvia. "The Imitation of Life in Ancient Greek Philosophy." In *Genesis Redux: Essays in the History and Philosophy of Artificial Life*, edited by Jessica Riskin. Chicago: University of Chicago Press, 2007.

Bertolini, Lucia. "Ancora su Alberti e Filarete: per la fortuna del *De pictura* volgare." In *Gli antichi e i moderni: studi in onore di Roberto Cardini*, edited by Lucia Bertolini and Do-natella Coppini. Florence: Polistampa, 2010.

Bertoloni Meli, Domenico. *Thinking with Objects: The Transformation of Mechanics in the Seventeenth Century*. Baltimore: Johns Hopkins University Press, 2009.

Besançon, Alain. *The Forbidden Image: An Intellectual History of Iconoclasm*. Chicago: University of Chicago Press, 2001.

Bettarini, Rosanna, Paola Barocchi, and Giorgio Vasari. *Le vite de' più eccellenti pittori, scultori e architettori: nelle redazioni del 1550 e 1568*. Florence: Sansoni, 1966.

Bleichmar, Daniela. "Books, Bodies, and Fields: Sixteenth-Century Transatlantic Encoun-ters with New World Materia Medica." In *Colonial Botany: Science, Commerce, and Poli-tics in the Early Modern World*, edited by Londa Schiebinger and Claudia Swan, 83–99. Philadelphia: University of Pennsylvania Press, 2005.

———. "Trajectories of Natural Knowledge in the Spanish Empire (ca. 1550–1650)." In *Más allá de la Leyenda Negra: España y la revolución científica*, edited by Victor Navarro Brotóns and William Eamon, 137–46. Valencia: Universitat de València, 2007.

———, Paula S. De Vos, Kristin Huffine, and Kevin Sheehan, eds. *Science in the Spanish and Portuguese Empires, 1500–1800*. Stanford, CA: Stanford University Press, 2009.

Bolland, Andrea. "Art and Humanism in Early Renaissance Padua: Cennini, Vergerio, and Petrarch on Imitation." *Renaissance Quarterly* 49, no. 3 (1996): 469–87.

Bologna, Corrado. *El teatro de la mente: de Giulio Camillo a Aby Warburg*. Madrid: Siruela, 2017.

Bolt, Richard A. *Spatial Data Management*. Cambridge, MA: MIT Press, 1979.

———. *The Human Interface: Where People and Computers Meet*. London: Wadsworth, 1984.

Bolzoni, Lina. *Il Teatro della Memoria: studi su Giulio Camillo*. Padova: Liviana, 1984.

———. "The Play of Images: The Art of Memory from Its Origins to the Seventeenth Cen-tury." In *The Enchanted Loom: Chapters in the History of Neuroscience*, edited by Pietro Corsi, 16–65. Oxford: Oxford University Press, 1991.

———. "Introduzione." In Giulio Camillo, *L'idea del theatro: con L'idea dell'eloquenza'*, 7–138. Milan: Adelphi, 2015.

———. "Per immaginare le immagini del teatro," in Guilio Camillo, *L'idea del theatro: con 'L'idea dell'eloquenza'*, 311–24. Milan: Adelphi, 2015

Boon, Jaap, J. Katrien Keune, Jaap van der Weerd, Muriel Geldof, Kees Mensch, Scott Bryan, and J. R. J. van Asperen de Boer. "Imaging Microspectroscopic, Secondary Ion Mass Spectrometric and Electron Microscopic Studies on Discoloured and Partially Discoloured Smalt in Cross-Sections of 16th Century Paintings." *Chimia* 55 (2001): 952–60.

Booth, Wayne C. *The Rhetoric of Fiction.* Chicago: University of Chicago Press, 1961.

Borghini, Raffaello and Mario Rosci. *Il riposo.* Milan: Labor, 1967.

Bouhin, Jean. "Description d'une horloge merveilleuse." Bibliothèque Nationale de France. Fonds français, MS no. 1744.

Bouvier de Fontenelle, Bernard le. *Suite des éloges des académiciens.* Paris: Osmont, 1733.

Bouza Álvarez, Fernando J. *El libro y el cetro: la biblioteca de Felipe IV en la Torre Alta del Alcázar de Madrid.* Salamanca: Instituto de Historia del Libro y de la Lectura, 2005.

Bowie, Theodore, ed. *The Sketchbook of Villard de Honnecourt.* Bloomington: Indiana University Press, 1959.

Boyajian, James C. *Portuguese Trade in Asia under the Habsburgs, 1580–1640.* Baltimore: Johns Hopkins University Press, 2008.

Bremmer, Jan M., and Herman Roodenburg, eds. *A Cultural History of Humour: From Antiquity to the Present Day.* Cambridge: Polity Press, 1997.

Brendecke, Arndt. *The Empirical Empire: Spanish Colonial Rule and the Politics of Knowledge.* Berlin: De Gruyter, 2016.

Brewer, J. S., ed. *Letters and Papers, Foreign and Domestic, of the Reign of Henry VIII.* London: Longman, 1862–1910.

Browne, Sir Thomas. *The Works of Sir Thomas Brown.* Edited by Geoffrey Keynes. Chicago: University of Chicago Press, 1964.

Bruquetas, Rocío. "Azul fino de pintores: obtención, comercio y uso de la azurita en la pintura español." In *In sapientia libertas: escritos en homenaje al Profesor Alfonso E. Pérez Sánchez,* 148–57. Madrid and Seville: Museo Nacional del Prado and Fundación Focus Abengoa, 2007.

———. "La obtención de pigmentos azules para las obras de Felipe II: comercio europeo y Americano." In *Art Technology: Sources and Methods.* London: Archetype, 2008.

———. "Técnicas y materiales en la pintura limeña de la primera mitad del siglo XVII: Angelino Medoro y su entorno." *Goya* 327 (April–June 2009): 144–61.

Bruquetas Galán, Rocío, and Marta Pres Cuesta. "Estudio de algunos materiales pictóricos utilizados por Zuccaro en las obras de San Lorenzo de El Escorial." *Archivo Español de Arte* 278 (1997): 163–76.

Brüstle, Christa, and Peter Matussek. *Just Here Therefore Now: Ein elektroakustisches Gedächtnistheater.* Berlin, 2001. peter-matussek.de/Pro/MuMe/EAGT/index.html.

Buller, John. *The Theatre of Memory.* CD-Booklet. London: Unicorn-Kanchana 1985.

Buonarroti the Younger, Michelangelo. *Descrizione delle felicissime nozze della cristianissima maestà di Madama Maria Medici Regina di Francia e di Navarra.* Florence, 1600.

Burke, Jill. "Meaning and Crisis in the Early Sixteenth Century: Interpreting Leonardo's Lion." *Oxford Art Journal* 29, no. 1 (2006): 77–91.

Burke, Peter. "Frontiers of the Comic in Early Modern Italy, c. 1350–1750." In *A Cultural History of Humour: From Antiquity to the Present Day,* edited by Jan Bremmer and Herman Roodenburg, 61–75. Malden, MA: Polity Press 1997.

Burkhardt, Jacob. *The Civilization of the Renaissance in Italy.* 1860; London: Penguin, 1990.

Burns, Thea. "Cennino Cennini's *Il Libro dell'Arte*: A Historiographical Review." *Studies in Conservation* 56 (2011): 1–13.

Burton, Paul. "George Orwell and the Classics." *Classical and Modern Literature* 25, no. 1 (2005): 53–75.

Bush, Vannevar. "As We May Think." *Atlantic* (1945): 101–8.

Buxton, Bill. *Sketching User Experiences: Getting the Design Right and the Right Design.* San Francisco: Morgan Kaufmann, 2007.

Bynum, Caroline Walker. *Christian Materiality: An Essay on Religion in Late Medieval Europe.* New York: Zone Books, 2011.

Camillo, Giulio. *Il theatro della sapientia,* MS, ca. 1530. Manchester, John Rylands Library: Christie MS 3 f 8.

———. *Due trattati l'uno delle materie, che possono uenir sotto lo stile dell'eloquente: l'altro della imitatione.* Venice: Stamperia de Farri, 1544.

———. *L'idea del theatro dell'eccellen. M. Giulio Camillo.* Florence: Lorenzo Torrentino, 1550.

———. *Il secondo tomo dell'opere di M. Giulio Camillo Delminio . . .* Venice: Gabriel Giolito de' Ferrari, 1574.

———. *L'idea del theatro: English Translation.* In Lu Beery Wenneker, "An Examination of *L'idea del theatro* of Giulio Camillo, Including an Annotated Translation, with Special Attention to His Influence on Emblem Literature and Iconography," PhD diss., University of Pittsburgh, 1970. Ann Arbor, MI: University Microfilms International, 187–355.

———. *L'idea del theatro: con 'L'idea dell'eloquenza', Il 'De transmutatione' e altri testi inediti a cura di Lina Bolzoni.* Milan: Adelphi, 2015.

Camprubí, Lino. "Traveling around the Empire: Iberian Voyages, the Sphere, and the Atlantic Origins of the Scientific Revolution." *Eä: Journal of Medical Humanities & Social Studies of Science and Technology* 2, no. 1 (2009): 1–24.

Camus, Charles-Etienne-Louis de. *Traité des forces mouvantes pour la pratique des arts et des métiers.* Paris: C. Jombert, 1722.

Cañizares-Esguerra, Jorge. "Iberian Colonial Science." *Isis* 96, no. 1 (March 2005): 64–70.

———. *Nature, Empire, and Nation: Explorations in the History of Science.* Stanford, CA: Stanford University Press, 2007.

Carducho, Vicente. *Diálogos de la pintura: su defensa, origen, essencia, definicion, modos y diferencias.* Madrid: Friar Martínez, 1633.

Carutti, D. *Breve storia della Accademia dei Lincei.* Rome: Salviucci, 1883.

Cascardi, Anthony J. "Don Quijote and the Invention of the Novel." *The Cambridge Companion to Cervantes,* edited by Anthony J. Cascardi, 58–79. Cambridge: Cambridge University Press, 2002.

———. *Cervantes, Literature, and the Discourse of Politics.* Toronto: University of Toronto Press, 2011.

Castel, B., J. Leith, and A. Riley, eds. *Muse and Reason: The Relation of Arts and Sciences 1650–1850: A Royal Society Symposium.* Kingston, Ontario: Queen's University, 1994.

Castro, Américo. *El pensamiento de Cervantes.* Barcelona and Madrid: Moguer, 1972.

Caulfield, Carlota. *The Book of Giulio Camillo: A Model for a Theater of Memory.* USA: Eboli Poetry, 2003.

Caus, Salomon de. *Raisons des forces mouvantes.* Frankfurt am Main: Jan Norton, 1615.

———. *Hortus palatinus.* Frankfurt: Johann Theodor de Bry, 1620.

Caygill, Howard. *Art of Judgement.* Oxford: B. Blackwell, 1989.

Cennini, Cennino. *Il libro dell'arte.* Edited by F. Frezzato. Vicenza: Neri Pozza, 2003.

———— and Daniel V. Thompson. *The Craftsman's Handbook: The Italian "Il Libro dell' Arte."* New York: Dover Publications, 1960.

Cerasuolo, Angela. *Diligenza e prestezza: la tecnica nella pittura e nella letteratura artistica del Cinquecento.* Florence: Edifir, 2014.

Cervantes, Miguel de. *Vida y Hechos del Ingenioso Hidalgo Don Quixote de la Mancha. Compuesta por Miguel de Cervantes Saavedra.* 4 vols. London: J and R. Tonson, 1738.

————. *The History of the Ingenious Gentleman Don Quixote de la Mancha.* Translated by P. A. Motteux. Edinburgh: William Paterson, 1879.

————. *El ingenioso hidalgo Don Quijote de la Mancha.* Edited by Luis Andrés Murillo. Vol. 1. Madrid: Castalia, 1978.

————. *Don Quijote de la Mancha.* Edited by Martín de Riquer. Barcelona: Planeta, 1980.

————. *Don Quixote.* Translated by Tom Lathrop. Newark, DE: European Masterpieces, 2005.

Chapuis, S. Alfred. "The Amazing Automata at Hellbrunn." *Horological Journal* 96, no. 6 (June 1954): 388–89.

Chapuis, Alfred, and Edmond Droz. *Automata: A Historical and Technological Study.* Translated by Alec Reid. Geneva: Éditions du Griffon, 1958.

————. *Le monde des automates.* Paris: n.p., 1928.

Chartier, Roger. *Inscription and Erasure: Literature and Culture from the Eleventh to the Eighteenth Century.* Translated by Arthur Goldhammer. Philadelphia: University of Pennsylvania Press, 2007.

Chesne, André du. *Les antiquités et recherches des villes, chasteaux, et places plus remarquables de toute la France.* Paris: Pierre Rocolet, 1637.

Ciardi, Roberto, and Marchi e Bertolli, eds. *Scritti sulle arti.* Florence: Marchi & Bertolli, 1973.

Cicero. *De Re Publica: De Legibus.* London: Loeb, 1970.

————. *Libros de oratore tres continens.* Edited by August Samuel Wilkins. Oxford: Clarendon Press, 1988.

Ciruelo, Pedro. *Reprouación de las supersticiones y hechizerias.* Edited by Alva V. Ebersole. Valencia: Albatros-Hispanófila, 1978.

Close, Anthony. *The Romantic Approach to Don Quixote.* Cambridge: Cambridge University Press, 1978.

Clute, John, Peter Nicholls, Brian Stableford, and John Grant, eds. *The Encyclopedia of Science Fiction.* London: Orbit, 1993.

Cohen, Gustave. *Histoire de la mise en scène dans le théâtre religieux français du moyen âge.* Paris: Champion, 1926.

Cole, Michael W. *Cellini and the Principles of Sculpture.* New York: Cambridge University Press, 2002.

Cole, Thomas. *Democritus and the Sources of Greek Anthropology.* Cleveland: Western Reserve University Press, 1967.

Colton, Judith. "Merlin's Cave and Queen Caroline: Garden Art as Political Propaganda." *Eighteenth-Century Studies* 10 (1976): 1–20.

Commandino, Federigo. *Aristarchi de magnitudinus, et distantiis sollis, et lunae, liber.* Pisa: Camillum Francischinum, 1572.

Conseil Régional d'Alsace. *Orgues silbermann d'Alsace.* Strasbourg: A.R.D.A.M., 1992.

Consolmagno, Guy J. "Astronomy, Science Fiction and Popular Culture: 1277 to 2001 (and Beyond)." *Leonardo* 29, no. 2 (1996): 127–32.

Costa, Antonio, and Giorgio Weber. *L'inizio dell'anatomia patologica nel Quattrocento fiorentino sui testi di Antonio Benivieni, Bernardo Torni, Leonardo da Vinci.* Florence: Edizioni riviste mediche, 1963.

Covarrubias Orozco, Sebastián de. *Tesoro de la lengua castellana, o española.* Madrid: Luis Sanchez, 1611.

Covarrubias y Horozco, Sebastián de. *Tesoro de la lengua castellana o española.* Edited by Martín de Riquer. Barcelona: Horta, 1943.

Cowie, Murray A., and Marian L. Cowie. "Geiler von Kayserberg and Abuses in Fifteenth-Century Strassburg." *Studies in Philology* 58, no. 3 (1961): 489–94.

Cramer, Frederick H. "Bookburning and Censorship in Ancient Rome: A Chapter from the History of Freedom of Speech." *Journal of the History of Ideas* 6, no. 2 (1945): 157–96.

Critchley, Simon. *Memory Theatre.* London: Fitzcarraldo Editions, 2014.

Crossley, James, ed. *Autobiographical Tracts of John Dee.* Whitefish, MT: Kessinger, 2005.

Darnton, Robert. *The Great Cat Massacre and Other Episodes in French Cultural History.* New York: Vintage, 1985.

Daston, Lorraine, and Katharine Park. *Wonders and the Order of Nature, 1150–1750.* New York: Zone Books, 1998.

Dee, John. *The Mathematicall Praeface to the Elements of Geometrie of Euclid of Megara.* Edited by Allen Debus. 1570; New York: Science History, 1975.

Delamare, François. *Blue Pigments: 5000 Years of Art and Industry.* Translated by Yves Rouchaleau. London: Archetype, 2013.

Della Porta, Giambattista. *De i miracoli et maravigliosi effetti dalla natura prodotti.* Venice: Lodovico Auanza, 1560.

———. *Pneumaticorum libri tres: quibus accesserunt curvilineorum elementorum libri duo.* Naples: J. J. Carlinus, 1601.

Derrida, Jacques. *Who's Afraid of Philosophy? Right to Philosophy.* Stanford, CA: Stanford University Press, 2002.

Desmarquets, Jean-Antoine Samson. *Mémoire chronologique pour servir à l'histoire de Dieppe.* Paris: Desauges, 1785.

De Vos, Paula S. "The Art of Pharmacy in Seventeenth- and Eighteenth-Century Mexico." PhD diss., University of California, Berkeley, 2001.

———. "The Science of Spices: Empiricism and Economic Botany in the Early Spanish Empire." *Journal of World History* 17, no. 4 (December 2006): 399–427.

———. "Natural History and the Pursuit of Empire in Eighteenth-Century Spain." *Eighteenth-Century Studies* 40, no. 2 (January 2007): 209–39.

Diccionario de la Real Academia Española. Madrid: Real Academia Española, 1829.

Dickey, Roland F. *New Mexico Village Arts.* Albuquerque: University of New Mexico Press, 1949.

———. "Oral History Interview with Roland F. Dickey, 1964 January 16." The Smithsonian, Archives of American Art. www.aaa.si.edu/collections/interviews/oral-history-interview-roland-f-dickey-12840.

Disney, Anthony R. *A History of Portugal and the Portuguese Empire.* Cambridge: Cambridge University Press, 2009.

Ditchfield, Simon. "The 'Making' of Roman Catholicism as a 'World Religion.'" In *Multiple Modernities?: Confessional Cultures and the Many Legacies of the Reformation Age,* edited by Jan Stievermann and Randall Zachmann, 189–203. Tubingen: Mohr Siebeck Company, 2018.

Donne, John. *Ignatius His Conclave.* Edited by Timothy Stafford Healy. Oxford: Clarendon Press, 1969.

Doppelmayr, Johann Gabriel. *Historische nachricht von den nürnbergischen mathematicis und künstlern.* Nürnberg: P. C. Monath, 1730.

Drelichman, Mauricio, and Hans-Joachim Voth. *Lending to the Borrower from Hell: Debt, Taxes, and Default in the Age of Philip II.* Princeton, NJ: Princeton University Press, 2014.

Drover, C. B. "Thomas Dallam's Organ Clock." *Antiquarian Horology* 1, no. 10 (1956): 150–54.

Duffy-Zeballos, Lisa. "Bartolomé Esteban Murillo's Saint Justa." *JAMA Archives of Facial Plastic Surgery* 8, no. 5 (2006): 354–55.

Durão, Maria João. "Sketching the Ariadne's Thread for Alchemical Linkages to Painting." *Fabrikart: Arte, Tecnología, Industria, Sociedad* 8 (2008): 106–23.

Duret, Edmond. "L'horloge historique de Nyort en Poitou, fabriquée on 1570 par Jean Bouhin." *Revue Poitevine et Saintongeaise* 6 (1889): 432–34.

Eamon, William. *Science and the Secrets of Nature: Books of Secrets in Medieval and Early Modern Culture.* Princeton, NJ: Princeton University Press, 1994.

———. "Science as a Hunt." *Physis* 31 (1994): 393–432.

———. *The Professor of Secrets: Mystery, Medicine, and Alchemy in Renaissance Italy.* Washington, DC: National Geographic, 2010.

———. "Spanish Science in the Age of the New." In *A Companion to the Spanish Renaissance,* edited by Hilaire Kallendorf, 473–507. Leiden: Brill, 2019.

——— and Víctor Navarro Brotóns, eds. *Beyond the Black Legend: Spain and the Scientific Revolution.* Valencia: Instituto de Historia de la Ciencia y Documentación, 2007.

Edward, Lord Herbert of Cherbury. *Life and Reign of King Henry the Eighth, together with which is briefly represented A general History of the Times.* London: Mary Clark, 1683.

Ehrenkrook, Jason von. "Effeminacy in the Shadow of Empire: The Politics of Transgressive Gender in Josephs' *Bellum Judaicum.*" *Jewish Quarterly Review* 101, no. 2 (2011): 145–63.

Eire, Carlos N. M. *The War against Idols: The Reformation of Worship from Erasmus to Calvin.* Cambridge: Cambridge University Press, 1989.

Eliade, Mircea. *Cosmos and History. The Myth of the Eternal Return.* Translated by Willard R. Trask. Harper Torchbooks. New York: Harper & Brothers, 1959.

Elias, Norbert. *The Civilizing Process: Sociogenetic and Psychogenetic Investigations.* Basel: Haus zum Falken, 1939; London: Blackwell, 1994.

Elliott, J. H. *Imperial Spain 1469–1716,* 2nd ed. New York: Penguin, 2002.

———. *Spain, Europe and the Wider World 1500–1800.* New Haven, CT: Yale University Press, 2009.

Erizzo, N. *Relazione storico-critica della torre dell'orologio di S. Marco in Venezia.* Venice: Commercio, 1860.

Escobar, Jesús. "Map as Tapestry: Science and Art in Pedro Teixeira's 1656 Representation of Madrid." *Art Bulletin* 96, no. 1 (2014): 50–69.

Eshel, Amir. *Futurity: Contemporary Literature and the Quest for the Past.* Chicago: University of Chicago Press, 2012.

Evangelatou, Maria. "Between East and West: The Symbolism of Space in the Art of Domenikos Theotokopoulos (El Greco)." In *Renaissance Encounters: Greek East and Latin West,* edited by Marina S. Brownlee and Dimitri H. Gondicas, 147–88. Leiden: Brill, 2013.

Evelyn, John. *Diary and Correspondence.* Edited by William Bray. London: George Bell and Sons, 1883.

———. *Elysium Britannicum, or the Royal Gardens.* Edited by John E. Ingram. Philadelphia: University of Pennsylvania Press, 2000.

Fabriczy, Cornelius von. "Il codice dell'Anonimo Gaddiano nella Bibliotheca Nationale di Firenze." *Archivo storico italiano* 12, nos. 3–4 (1893): 299–368.

Falda, Giovanni Battista. *Le fontane di Roma.* Rome: Giovanni Giacomo de' Rossi, 1691.

Fallini, Mario, and Enrico Ferraris. *Concettissimo and Giulio Camillo's Theatre of Memory.* Alessandria: LineLab.edizioni, 2009.

Fantham, Elaine. "Liberty and the Roman People." *Transactions of the American Philological Association* 135, no. 2 (2005): 209–29.

Farago, Claire. "The Classification of the Visual Arts during the Renaissance." In *The Shapes of Knowledge from the Renaissance to the Enlightenment,* edited by R. D. Kelley and R. H. Popkin.Netherlands: Kluwer Press, 1991.

———. *Leonardo da Vinci's "Paragone": A Critical Interpretation with a New Edition of the Text in the Codex Urbinas.* Leiden-Cologne: E. J. Brill, 1992.

———. "Die Ästhetik der Bewegung in Leonardos Kunsttheorie." In *Leonardo da Vinci: Natur im "Ubergang,* edited by F. Fehrenbach, 137–678. Munich: Wilhelm Fink, 2002.

———. "Aesthetics before Art: Leonardo through the Looking Glass." In *Compelling Visuality: The Work of Art in and out of History,* edited by Claire Farago and Robert Zwijnenberg, 45–65. Minneapolis: University of Minnesota Press, 2003.

———. "Mediating Ethnicity and Culture: Framing New Mexico as a Case Study." In Claire Farago and Donna Pierce, *Transforming Images: New Mexican Santos in-between Worlds.* University Park: Pennsylvania State University Press, 2006.

———, Janis Bell, and Carlo Vecce. *The Fabrication of Leonardo da Vinci's Trattato della pittura with a Scholarly Edition of the Italian* Editio princeps *(1651) and an Annotated English Translation,* 2 vols. Leiden: Brill Press, 2018.

Farmer, Julia L. *Imperial Tapestries: Narrative Form and the Question of Spanish Hapsburg Power 1530–1647.* Lewisburg, PA: Bucknell University Press, 2016.

Farrell, Stephen. "Embedistan." *New York Times.* June 25, 2010. https://atwar.blogs.nytimes.com/2010/06/25/embedistan-2/.

Faulkner, Quentin. *Wiser Than Despair: The Evolution of Ideas in the Relation of Music and the Christian Church.* Westport, CT: Greenwood Press, 1996.

Feliciano Chaves, María Judith. "Mudejarismo in Its Colonial Context: Iberian Cultural Display, Viceregal Luxury Consumption, and the Negotiation of Identities in Sixteenth-Century New Spain." PhD diss., University of Pennsylvania, 2004.

Ferguson, Niall. *Colossus: The Rise and Fall of the American Empire.* London: Penguin Books, 2004.

Fernández de Oviedo, Gonzalo. *Sumario de la natural historia de las Indias* [1950]. Edited by José Miranda. Mexico City: Fondo de Cultura Económica, 1996.

Findlen, Paula. *Possessing Nature: Museums, Collecting and Scientific Culture in Early Modern Italy.* Berkeley: University of California Press, 1994.

———. "Scientific Spectacle in Baroque Rome: Athanasius Kircher and the Roman College Museum." *Roma Moderna e Comtemporanea* 3 (1995): 635–65.

———, ed. *Athanasius Kircher: The Last Man Who Knew Everything.* New York: Routledge, 2004.

———. "Introduction: The Last Man Who Knew Everything . . . or Did He? Athanasius Kircher, S.J. (1602–80) and His World." In *Athanasius Kircher: The Last Man Who Knew Everything,* edited by Paula Findlen. New York: Routledge, 2004.

——— and Pamela Smith, eds. *Merchants and Marvels: Commerce, Science, and Art in Early Modern Europe.* New York: Routledge, 2001.

Fiorani, Francesca. "Abraham Bosse e le prime critiche al Trattato della Pittura di Leonardo." *Achademia Leonardi Vinci* 5 (1992): 78–95.

Fioravanti, Leonardo. *Della fisica.* Venice: Giacomo Zattoni, 1576.

Fioravanti, Leonardo and John Henryson. *Il tesoro della vita humana. Dell'eccellente dottore & caualiere M. Leonardo Fiorauanti Bolognese. Diuiso in Libri Quattro. Nel primo, si tratta delle qualita, & cause di diuerse infermita ... Nel secondo, si descriuono molti esperimenti fatti da lui in diuerse parti del mondo. Nel terzo, vi sono diuerse lettere dell'autore, con le sue riposte ... Nel quarto ... son riuelati i secreti piu importanti di esso autore. Di nuouo posto in luce. Et con la sua tauola.* Venice: Heredi di Melchior Sessa, 1570.

Fleming, Stuart. "Controversy over Smalt." *Archaeology* 38, no. 2 (March/April 1985): 68–80.

Fontana, Giovanni. *Bayerische Staatsbibliothek Cod. Icon.* 242. MS mixt. 90. 59v–50r. Printed in Eugenio Battisti and Giuseppa Saccaro Battisti, 134–35. *Le macchine cifrate di Giovanni Fontana.* Milan: Arcadia, 1984.

Fontenay, Louis Abel de. *Dictionnaire des artistes.* Paris: Vincent, 1772.

Foucault, Michel. *Power/Knowledge: Selected Interviews and Other Writings 1972–1977.* Edited by Colin Gordon. New York: Pantheon, 1977.

———. *The Archaeology of Knowledge.* Translated by A.M. Sheridan Smith [1971]. London: Routledge, 2002.

Francini, Alessandro. *Modèles de grottes et de fontaines: Dessins lavés.* Bibliothèque Nationale de France. Estampes et photographie, Réserve Hd-100(A)-Pet Fol, 1598.

Frangenberg, Thomas. "Abraham Bosse in Context: French Responses to Leonardo's Treatise on Painting in the Seventeenth Century." *Journal of the Warburg and Courtauld Institutes* 75 (2012): 223–60.

Freedberg, David. *The Power of Images: Studies in the History and Theory of Response.* Chicago: University of Chicago Press, 1989.

———. *The Eye of the Lynx: Galileo, His Friends, and the Beginnings of Modern Natural History.* Chicago: University of Chicago Press, 2002.

Freud, Sigmund. *Der Witz und Seine Beziehung zum Unbewussten.* Leipzig: Deuticke, 1905.

———. *Jokes and Their Relation to the Unconscious.* Translated by James Strachey. New York: W.W. Norton, 1963 [Leipzig: Deuticke, 1905].

Frey, Carl. *Das literarische Nachlass Giorgio Vasaris. Fortsetzung des Briefwechsels.* Edited and expanded by Hermann-Walther Frey, 2 vols. Munich: Müller, 1930.

Fricke, Beate. "Matter and Meaning of Mother-of-Pearl: The Origins of Allegory in the Spheres of Things." *Gesta* 51, no. 1 (2012): 35–53.

Frosini, Fabio. "Pittura come filosofia: note su 'spirito' e 'spirituale' in Leonardo." *Achademia Leonardi Vinci* 10 (1997): 35–59.

Fuchs, Barbara. *Exotic Nation: Maurophilia and the Construction of Early Modern Spain.* Philadelphia: University of Pennsylvania Press, 2009.

Fuchs, Sven. *HCI 450—Foundations of Usability Research Review: How Magical Is Miller's Famous Seven for HCI Issues?*. 2004. pdfs.semanticscholar.org/0301/9e34c8c625de5c571 074972145e01ebe991c.pdf.

Fuentes, Carlos. *Terra nostra*. Madrid: Espasa-Calpe, 1991.

Gabrieli, Giuseppe. "Spigolatura Dellaportiane." *Rendiconti della R. Accademia Nazionale dei Lincei: classe di scienze morali, storiche e filologiche* 6, no. 11, (1935): 491–517.

Gaehtgens, W. "The Arts in the Service of the King's Glory." In *A Kingdom of Images: French Prints in the Age of Louis XIV, 1660–1715,* edited by Peter Fuhring, Louis Marchesano, Rémi Mathis, and Vanessa Selbach, exhibition catalog, 1–8. Los Angeles: Getty Research Institute, 2015.

Galli da Bibiena, Ferdinando. *L'architettura civile*. Introduction by Diane M. Kelder. New York: B. Blom, 1971.

Gallmayr, Joseph. *Münchner Intelligenzblätter*. Munich: Churfürstl, Intelligenz und Address Comtoir, 1779.

Galluzzi, Paolo. *Gli ingegneri del Rinascimento da Brunelleschi a Leonardo da Vinci*. Bolognia: Istituto e Museo di Storia della Scienza, 1996.

García Oro, José. *Los reyes y los libros: la política libraría de la corona en el Siglo de Oro (1475–1598)*. Madrid: Cisneros, 1995.

García-Diego, José A. *Los relojes y autómatas de Juanelo Turriano*. Madrid: Tempvs Fvgit, Monografías Españolas de Relojería, 1982.

———. *Juanelo Turriano, Charles V's Clockmaker*. Madrid: Editorial Castalia, 1986.

Gargano, Pietro. *Il presepio: otto secoli di storia, arte, tradizione*. Milan: Fenice 1995, 2000.

Garin, Eugenio. *Testi umanistici sulla retorica*. Roma: Fratelli Bocca, 1953.

Garside, Charles. *Zwingli and the Arts*. New Haven, CT: Yale University Press, 1966.

Garzoni, Tommaso. *La piazza della tutte le profesioni del mondo*. Venice: np, 1580.

Gass, Joseph. *Les orgues de la Cathédrale de Strasbourg à travers les siècles: étude historique, ornée de gravures et de planches hors texte, à l'occasion de la bénédiction des grandes orgues Silbermann-Roethinger, le 7 juillet 1935*. Reprint. [n.p.]: Librissimo-Phénix Éditions, 2002.

Gasté, Armand. *Les drames liturgiques de la Cathédrale de Rouen*. Evreux: Imprimerie de l'Eure, 1893.

Gaudio, Michael. *Engraving the Savage: The New World and Techniques of Civilization*. Minneapolis: University of Minnesota Press, 2008.

Georgelou, Konstantina, and Janez Janša. "Janez Janša's Camillo 4." *Performance Research* 17, no. 3 (2012): 83–89.

Gharib, M., D. Kremers, M. Koochesfahani, and M. Kemp. "Leonardo's Vision of Flow Visualization." *Experiments in Fluids* 33, no. 1 (2002): 219–23.

Ginzburg, Carlo. "Clues: Roots of an Evidential Paradigm." In *Clues, Myths and the Historical Method,* translated by J. and A. Tedeschi, 96–125. Baltimore: Johns Hopkins University Press, 1989.

Glanvill, John. *The Vanity of Dogmatizing*. London: E. C. Henry, 1661.

Goldberg, Jonathan. "The History That Will Be." *GLQ: A Journal of Lesbian and Gay Studies* 1, no. 4 (1995): 385–403.

———, ed. *Queering the Renaissance*. Durham, NC: Duke University Press, 1994.

Gombrich, E. H. *Norm and Form: Studies in the Art of the Renaissance*. London: Phaidon, 1976.

González Echevarría, Roberto. "Don Quijote II, 11bis. Epílogo a las Cortes de la Muerte." In *Doce cuentos ejemplares y otros documentos cervantinos,* edited by Frederick A. de Armas and Antonio Sánchez Jiménez. Madrid: Ediciones del Orto/Ediciones Clásicas, 2016.

Goodwin, Francis. *The Man in the Moone,* 2nd ed. London: John Norton, 1657.

Gorman, Michael John. "Between the Demonic and the Miraculous: Athanasius Kircher and the Baroque Culture of Machines." In *The Great Art of Knowing: The Baroque Encyclopedia of Athanasius Kircher,* edited by Daniel Stolzenberg. Stanford, CA: Stanford University Libraries, 2001.

Graf, Eric C. *Cervantes and Modernity: Four Essays on Don Quijote.* Lewisburg, PA: Bucknell University Press, 2007.

Grafton, Anthony. "From New Technologies to Fine Arts." In *Leon Battista Alberti: Master Builder of the Italian Renaissance.* Cambridge, MA: Harvard University Press, 2000.

———. "The Devil as Automaton." In *Genesis Redux: Essays on the History and Philosophy of Artificial Life,* edited by Jessica Riskin, chap. 3. Chicago: University of Chicago Press, 2007.

Gramaccini, N. "Cennini e il suo 'Trattato della pittura.'" *Res publica litterarum* 10 (1987): 143–51.

Gréban, Arnoul and Simon. *Mystère des actes des apôtres, representé à Bourges en avril 1536, publié depuis le manuscript original.* Edited by Auguste-Théodore and Baron de Girardot. Paris: Didron, 1854.

Greenblatt, Stephen. *Marvelous Possessions: The Wonder of the New World.* Oxford: Oxford University Press, 1991.

Greenfield, Concetta Carestia. *Humanist and Scholastic Poetics, 1250–1500.* Lewisburg, PA: Bucknell University Press, 1981.

Guarino, Raimondo. "Torelli a Venezia: l'ingegnere teatrale tra scena e apparato." In *Teatro e storia* A. 7, n. 12, fasc. 1 (1992): 35–72.

Guerrero Quintero, Carmen. *Restauración de la Anunciación del Carmen de Antequera.* Seville: Junta de Andalucía, Consejería de Cultura, 2007.

Hahn, Cynthia J. *Strange Beauty: Issues in the Making and Meaning of Reliquaries, 400–circa 1204.* University Park: Pennsylvania State University Press, 2012.

Halberstam, Jack. "What's That Smell?: Queer Temporalities and Subcultural Lives." *Scholar and Feminist Online* 2.1 (Summer 2003). http://sfonline.barnard.edu/ps/printjha.htm.

———. *In a Queer Time and Place: Transgender Bodies, Subcultural Lives.* New York: New York University Press, 2005.

———. *The Queer Art of Failure.* Durham, NC: Duke University Press, 2011.

Hall, Marcia B. *The Sacred Image in the Age of Art: Titian, Tintoretto, Barocci, El Greco, Caravaggio.* New Haven, CT: Yale University Press, 2011.

——— and Tracy E. Cooper, eds. *The Sensuous in the Counter-Reformation Church.* Cambridge: Cambridge University Press, 2013.

Hamel, Marie Pierre. *Nouveau manuel complet du facteur d'orgues: nouvelle édition contenant l'orgue de dom Bédos de Celles . . . précédé d'une notice historique par M. Hamel . . .* Paris: L. Mulo, 1903.

Hampton, Timothy. *Writing from History: The Rhetoric of Exemplarity in Renaissance Literature.* Ithaca, NY: Cornell University Press, 1990.

Hankins, Thomas L., and Robert J. Silverman. *Instruments and the Imagination.* Princeton, NJ: Princeton University Press, 1995.

Hannaway, Owen. *The Chemists and the Word: The Didactic Origins of Chemistry.* Baltimore: Johns Hopkins University Press, 1975.

Harkness, Deborah E. *John Dee's Conversations with Angels: Cabala, Alchemy, and the End of Nature.* Cambridge: Cambridge University Press, 1999.

Harlow, Summer. "It Was a 'Facebook Revolution': Exploring the Meme-Like Spread of Narratives during the Egyptian Protests." *Revista de comunicación* 12 (2013): 59–82.

Harrison, Steve, Phoebe Sengers, and Deborah Tatar. "The Three Paradigms of HCI." Conference Paper, *CHI 2007,* San Jose, California, 28 April 2007. people.cs.vt.edu/~srh/Downloads/TheThreeParadigmsofHCI.pdf.

Harrison, Thomas P. "Birds in the Moon." *Isis* 45, no. 4 (1954): 323–30.

Harvey, L. P. *Muslims in Spain, 1500 to 1614.* Chicago: University of Chicago Press, 2005.

Haspels, Jan Jaap. *Automatic Musical Instruments, Their Mechanics and Their Music, 1580–1820.* Niroth: Muiziekdruk C. V. Koedijk, 1987.

al-Hassan, A., Y. Maqbul Ahmed, and A. Z. Iskandar, eds. *The Different Aspects of Islamic Culture,* vol. 4, *Science and Technology in Islam.* Paris: UNESCO, 2001.

Hassel Jr., R. Chris. "Donne's 'Ignatius His Conclave' and the New Astronomy." *Modern Philology* 68, no. 4 (1971): 329–37.

Heck, Michèle-Caroline, ed. *LexArt: Words for Painting (France, Germany, England, the Netherlands, 1600–1750).* Montpellier: Presses universitaires de la Méditerranée, 2018.

Hegedüs, Agnes. "Memory Theater VR: An Installation in and about Virtual Reality." Unpublished thesis, Karlsruhe, 1 December 1998. Archive of Peter Matussek.

Hegel, Georg Wilhelm Friedrich. *Werke in zwanzig Bänden.* Edited by Eva Moldenhauer and Karl Markus Michel. Frankfurt am Main: Suhrkamp, 1995.

Heilbron, J. L. *The Sun in the Church: Cathedrals as Astronomical Observatories.* Cambridge, MA: Harvard University Press, 1999.

Hernández, Francisco. *The Mexican Treasury: The Writings of Dr. Francisco Hernández.* Edited by Simon Varey. Stanford, CA: Stanford University Press, 2000.

Hérouard, Jean. *Journal de Jean Héroard.* Edited by Madeleine Foisil. Paris: Fayard, 1989.

Hess, Catherine. "Brilliant Achievements: The Journey of Islamic Glass and Ceramics to Renaissance Italy." In *The Arts of Fire: Islamic Influences on Glass and Ceramics of the Italian Renaissance,* edited by Catherine Hess, Linda Komaroff, and George Saliba. Los Angeles: J. Paul Getty Museum, 2004.

Hilgers, Joseph. "Censorship of Books." In *The Catholic Encyclopedia,* vol. 3. New York: Robert Appleton, 1908. www.newadvent.org/cathen/03519d.htm.

Hollanda, Francisco, Manuel Denis, and Elías Tormo. *De la pintura antigua.* Madrid: Real Academia de Bellas Artes de San Fernando, 1921.

Hone, William. *The Every-Day Book and Table Book.* London: William Tegg, 1825–27.

Hornsby, Stephen, and Michael Hermann. *British Atlantic, American Frontier: Spaces of Power in Early Modern British America.* Lebanon, NH: University Press of New England, 2005.

Houdard, Georges. *Les châteaux royaux de Saint-Germain-en-Laye, 1124–1789: étude historique d'après des documents inédits recueillis aux Archives Nationales et à la Bibliothèque Nationale.* Saint-Germain-en-Laye: Maurice Mirvault, 1910–11.

Huguet-Termes, Teresa. "New World *Materia Medica* in Spanish Renaissance Medicine: From Scholarly Reception to Practical Impact." *Medical History* 45 (2001): 359–75.

Hülsen, Christian. "Ein deutscher Architekt in Florenz (1600)." *Mitteilungen des Kunsthistorischen Instituts in Florenz* 2 (1912–1917): 152–93.

Hurtado de Mendoza, Diego. *Guerra de Granada, hecha por el Rey D. Felipe II. contra los moriscos de aquel reino, sus rebeldes.* 1627; Valencia: Librería de Mallén y Berard, 1830.

Jacob, Margaret C. *The First Knowledge Economy: Human Capital and the European Economy, 1750–1850.* Cambridge: Cambridge University Press, 2014.

James, Henry. *Italian Hours.* Boston: Houghton Mifflin, 1909.

Jardine, Lisa. *Francis Bacon: Discovery and the Art of Discourse.* London: Cambridge University Press, 1974.

Jensen, William B., ed. *The Leyden and Stockholm Papyri: Greco-Egyptian Chemical Documents from the Early 4th Century AD.* Translated by Earle Radcliffe Caley. Cincinnati, OH: Oesper Collections in the History of Chemistry, University of Cincinnati, 2008.

Jones, Marjorie G. *Frances Yates and the Hermetic Tradition.* Lake Worth, FL: IBIS Press/ Nicolas Hays, 2008.

Jones, Michael. "Theatrical History in the Croxton Play of the Sacrament." *ELH* 66, no. 2 (1999): 221–51.

Jones, Pamela M. "Leading Pilgrims to Paradise: Guido Reni's *Holy Trinity* (1625–26) for the Church of SS. Trinità dei Pellegrini e Convalescenti and the Care of Bodies and Souls." In *Altarpieces and Their Viewers in the Churches of Rome from Caravaggio to Guido Reni,* 261–324. Aldershot: Ashgate, 2008.

Kagan, Richard L. "Prescott's Paradigm: American Historical Scholarship and the Decline of Spain." *American Historical Review* 101, no. 2 (April 1996): 423–46.

———. "La luna de España: mapas, ciencia y poder en la época de los Austrias." *Pedralbes: revista d'història moderna* 25 (2005): 171–90.

Kaniari, Assimina, and Marina Wallace, eds., with Martin Kemp. *Acts of Seeing: Artists, Scientists and the History of the Visual.* London: Artakt and Zidane Press, 2009.

Kant, Immanuel. *Critique of Judgment, Including the First Introduction.* Translated and introduction by Werner S. Pluhar, foreword by Mary J. Gregor. Indianapolis: Hackett, 1987.

Karreman, Laura. "Camillo '93: Rieks Swarte's Memory Theatre." *Performance Research* 17, no. 3 (2012): 39–45.

Katzenberg, Dena S. *Blue Traditions: Indigo Dyed Textiles and Related Cobalt Glazed Ceramics from the 17th through the 19th Century.* Exhibition catalog. Baltimore Museum of Art, 1973.

Keller-Dall'Asta, Barbara. *Heilsplan und Gedächtnis: Zur Mnemologie des 16. Jahrhunders in Italien.* Heidelberg: Carl Winter, 2001.

Kemp, Martin. *The Science of Art: Optical Themes in Western Art from Brunelleschi to Seurat.* New Haven, CT: Yale University Press, 1990.

———. "'Wrought by No Artist's Hand': The Natural, the Artificial, the Exotic and the Scientific in Some Artifacts from the Renaissance." In *Reframing the Renaissance: Visual Culture in Europe and Latin America 1450–1650,* edited by Claire Farago, 177–196. New Haven, CT: Yale University Press, 1995.

———. *Behind the Picture: Art and Evidence in the Italian Renaissance.* New Haven, CT: Yale University Press, 1997.

———. *Seen/Unseen: Art, Science, and Intuition from Leonardo to the Hubble Telescope.* Oxford: Oxford University Press, 2006.

Kessler, Herbert L. *Seeing Medieval Art.* Peterboro, Ontario: Broadview Press, 2004.

King, Elizabeth. "Clockwork Prayer: A Sixteenth-Century Mechanical Monk." *Blackbird: An Online Journal of Literature and the Arts* 1, no. 1 (2002).

———. "Perpetual Devotion: A Sixteenth-Century Machine That Prays." In *Genesis Redux: Essays in the History and Philosophy of Artificial Life*, edited by Jessica Riskin, 263–82. Chicago: University of Chicago Press, 2007.

Kircher, Athanasius. *Ars magnesia*. Würzburg: E.M. Zinck, 1631.

———. *Musurgia universalis*. Rome: Francisi Corbelletti, 1650.

———. *Oedipus aegyptiacus, hoc est, vniuersalis hieroglyphicae veterum doctrinae temporum iniuria abolitae instauration*. Rome: Vitalis Mascardi, 1652–54.

Klein, Robert. *Le forme et l'intelligible: écrits sur la Renaissance et l'art modern*. Edited by André Chastel. Paris: Gallimard, 1970.

Kleinbub, Christian. *Vision and the Visionary in Raphael*. University Park: Pennsylvania State University Press, 2011.

Knoll, Gillian. "How to Make Love to the Moon: Intimacy and Erotic Distance in John Lyly's Endymion." *Shakespeare Quarterly* 65, no. 2 (2014): 164–79.

Knox, Peter E. "The Poet and the Second Prince: Ovid in the Age of Tiberius." *Memoirs of the American Academy in Rome* 49 (2004): 1–20.

Koerner, Joseph Leo. *The Reformation of the Image*. Chicago: University of Chicago Press, 2004.

Komaroff, Linda. "Color, Precious Metal, and Fire: Islamic Ceramics and Glass." In *The Arts of Fire: Islamic Influences on Glass and Ceramics of the Italian Renaissance*, edited by Catherine Hess, Linda Komaroff, and George Saliba. Los Angeles: J. Paul Getty Museum, 2004.

König, H. J. "*Plus Ultra*: ¿Emblema de conquista e imperio universal? América y Europa en el pensamiento político de la España de Carlos V." In *Carlos V/Karl V, 1500–2000*, edited by A. Kholer, 577–99. Madrid: Sociedad Estatal para la Conmemoración de los Centenarios de Felipe II y Carlos V, 2001.

Krokos, Eric, Catherine Plaisant, and Amitabh Varshney. "Virtual Memory Palaces: Immersion Aids Recall." *Virtual Reality* (16 May 2018): 1–15.

Kulikov, Antón. "Fox News Is Going Bananas." *Pravda*, August 12, 2011. http://english. pravda.ru/russia/politics/08-12-2011/119886-fox_news-0/.

Laborde, le Comte de. *Les Ducs de Bourgogne: études sur les lettres, les arts et l'industrie pendant le XVe siècle, et plus particulièrement dans les Pays-Bas et le duché de Bourgogne*. Vol. II. Paris: Plon frères, 1849–52.

Laborde, Léon Emmanuel Simon. *Notice des emaux, bijoux et autres objets divers, exposés dans les galeries du Musée du Louvre*. Paris: Vinchon, 1853.

Lamalle, Edmond. "La propagande du P. Nicolas Trigault en faveur des missions de Chine (1616)." *Archivum Historicum Societatis Jesu* 9, no. 1 (1940): 49–120.

Lambarde, William. *A Perambulation of Kent: Conteining the Description, Hystorie, and Customes of that Shire. Written in the Yeere 1570*. Edited by Richard Church. Bath: Adams and Dart, 1970.

———. *Dictionarium angliæ topographicum & historicum. An alphabetical description of the chief places in England and Wales; with an account of the most memorable events which have distinguish'd them. By . . . William Lambarde . . . Now first publish'd from a manuscript under the author's own hand*. London: F. Gyles, 1730.

Landes, David. *A Revolution in Time: Clocks and the Making of the Modern World*. Cambridge, MA: Belknap, 2000.

Landrus, Matthew. "Salvator Mundi: Why Bernardino Luini Should Be Back in the Frame." *Art Newspaper*. 3 September 2018. www.theartnewspaper.com/feature/salvator-mundi-why-bernardino-luini-should-be-back-in-the-frame.

Laughland, Oliver. "How the CIA Tortured Its Detainees." *The Guardian*. December 9, 2014. www.theguardian.com/us-news/2014/dec/09/cia-torture-methods-water-boarding-sleep-deprivation.

Laurel, Brenda. *Computers as Theatre*. Reading, MA: Addison-Wesley, 1991.

Lea, Henry Charles. *The Moriscos of Spain*. London: Bernard Quaritch, 1901.

Leitch, Stephanie. *Mapping Ethnography in Early Modern Germany: New Worlds in Print Culture*. Basingstoke: Palgrave Macmillan, 2010.

Leonardo da Vinci. *Codex Arundel*. MS 263. London, British Library.

———. *Codex Madrid I*. MS Madrid, Biblioteca Nacional.

———. *Paris Manuscript C*. MS Paris, Institut de France.

———. *Paris Manuscript, G*. MS Paris, Bibliothèque Nationale de France. 1510–1516.

———. *Leonardo da Vinci on Movement of the Heart and Blood*. Edited by D. Kenneth Keele. London: Harvey and Blythe, 1952.

———. *Treatise on Painting [Codex Urbinas Latinus 1270]*. Translated by A. Philip McMahon, 2 vols. Princeton, NJ: Princeton University Press, 1956.

———. *Leonardo da Vinci's Elements of the Science of Man*. Edited by Kenneth D. Keele. New York: Academic Press, 1983.

———, Kenneth D. Keele, and Carlo Pedretti. *Corpus of the Anatomical Studies in the Collection of Her Majesty, the Queen, at Windsor Castle*. London: Johnson Reprint Co., 1978.

——— and Ove C. L. Vangensten. *Quaderni d'anatomia di Leonardo da Vinci: ... fogli della Royal Library di Windsor; pubblicati da O. C. L. Vangensten, A Fonahn and H. Hopstock*. Christiania [Oslo]: Dybwad, 1911.

——— and Irma A. Richter. *Selections from the Notebooks of Leonardo da Vinci: With Commentaries*. Oxford: Oxford University Press, 1977.

Levin, Harry. *The Myth of the Golden Age in the Renaissance*. Oxford: Oxford University Press, 1969.

Lewis, Ben. *The Last Leonardo: The Secret Lives of the World's Most Expensive Painting*. New York: Penguin Random House, 2019.

Lincoln, Evelyn. *Brilliant Discourse: Pictures and Readers in Early Modern Rome*. New Haven, CT: Yale University Press, 2014.

Lindberg, David C. *The Beginnings of Western Science: The European Scientific Tradition in Philosophical, Religious, and Institutional Context, 600 B.C. to A.D. 1450*. Chicago: University of Chicago Press, 1992.

Livingstone, David N. *The Geographical Tradition: Episodes in the History of a Contested Enterprise*. Oxford: Blackwell, 1992.

Lomazzo, Giovanni Paolo. *Scritti sulle arti*. Pisa: Marchi e Bertolli, 1973.

Lomazzo, Paolo. *Idea del tempio della pittura, 1590*. Hildesheim: Georg Olms, 1965.

López Piñero, José María, et al. *Bibliographia medica hispanica*. Valencia: Instituto de Estudios Documentales e Históricos sobre la Ciencia, Universidad de Valencia, 1987–1989.

———. *El códice Pomar (ca. 1590), el interés de Felipe II por la historia natural y la expedición Hernández a América*. Valencia: Universidad de Valencia/CSIC, 1991.

———. "The Pomar Codex (ca. 1590): Plants and Animals of the Old World and from the Hernández Expedition to America." *Nuncius* 7 (1992): 35–52.

López Piñero, José María, and José Pardo Tomás. *Nuevos materiales y noticias sobre la historia de las plantas de Nueva España, de Francisco Hernández.* Valencia: Instituto de Estudios Documentales e Históricas sobre la Ciencia, 1994.

———. *La influencia de Francisco Hernández (1515–1587) en la constitución de la botánica y la materia médica modernas.* Valencia: Universitat de València, 1996.

Lyly, John. *Endimion, The Man in the Moon: Play'd Before the Queene's Majestie at Greenwich on Candlemas day, at night, by the Children of Paule's.* London: H. Holt, 1894.

Lynch, John. *Spain under the Habsburgs,* 2 vols., 2nd ed. New York: New York University Press, 1981.

MacCulloch, Diarmaid. *The Reformation: A History.* New York: Penguin, 2003.

Maggi, Armando. *Satan's Rhetoric: A Study of Renaissance Demonology.* Chicago: University of Chicago Press, 2001.

Maindron, Ernest. *Marionnettes et guignols.* Paris: Félix Juven, 1897.

Maldonado, Juan. *Ioannis Maldonati geniale iudicium siue bacchanalia,* vol. 24. Edited by Warren S. Smith and Clark Andrews Colahan. Leuven: Leuven University Press, 2009.

Maldonado-Torres, Nelson. "On the Coloniality of Being: Contributions on the Development of a Concept." *Cultural Studies* 21, nos. 2–3 (2007): 240–70.

Manzo, Silvia. "Utopian Science and Empire: Notes on the Iberian Background of Francis Bacon's Project." *Studii de Ştiinţă şi Cultură* 6, no. 4 (2010): 111–23.

Marcus, Leah S. "The Silence of the Archive and the Noise of Cyberspace." In *The Renaissance Computer: Knowledge Technology in the First Age of Print,* edited by Neil Rhodes and Jonathan Sawday, 18–28. London: Routledge, 2000.

Marie, Alfred. *Jardins français créés à la Renaissance.* Paris: Vincent Fréal, 1955.

Marr, Alexander. *Between Raphael and Galileo: Mutio Oddi and the Mathematical Culture of Late Renaissance Italy.* Chicago: The University of Chicago Press, 2011.

———, Raphaële Garrod, José Marcaida, and Richard Oosterhoff. *Logodaedalus: Word Histories of Early Modern Ingenuity.* Pittsburgh: Pittsburgh University Press, 2018.

Martínez Ruiz, Juan. "La indumentaria de los moriscos según Pérez de Hita y los documentos de la Alhambra." *Cuadernos de la Alhambra* 3 (1967): 55–124.

Marx, Walter. "Motivos reiterados o la estructura simétrica del *Quijote* de 1605." In *Cervantes y su mundo,* edited by Eva Reichenberger and Kurt Reichenberger. Kassel: Editio Reichenberger, 2004.

Matin, Moujan, and Mark Pollard. "Historical Accounts of Cobalt Ore Processing from the Kashan Mine, Iran." *British Institute of Persian Studies* 53 (2015): 171–84.

Matussek, Peter. "Literature as a Technique of Recollection." In *Memory, History and Critique: European Identity at the Millenium,* Proceedings of the Fifth Conference of the International Society for the Study of European Ideas, edited by Frank Brinkhus and Sascha Talmor. Utrecht: ISSEI/University of Humanist Studies, 1998. CD-ROM.

———. "Memory Theatre in the Digital Age." *Performance Research* 17, no. 3 (2012): 8–16.

Mavor, Carol. *Blue Mythologies: Reflections on a Colour.* London: Reaktion, 2013.

McLuhan, Herbert Marshall. *The Gutenberg Galaxy.* Toronto: University of Toronto Press, 1962.

Meixell, Amanda S. "Queen Caroline's Merlin Grotto and the 1738 Lord Carteret Edition of *Don Quixote:* The Matter of Britain and Spain's Arthurian Tradition." *Cervantes: Bulletin of the Cervantes Society of America,* 25, no. 2 (2005): 59–82.

Melius, Jeremy Norman. "Art History and the Invention of Botticelli." PhD diss., University of California, Berkeley, 2010.

Méril, Edelestand du. *Origines latines du théâtre moderne.* Paris: Franck, 1849.

Michalski, Sergiusz. *The Reformation and the Visual Arts: The Protestant Image Question in Western and Eastern Europe.* New York: Routledge, 1993.

Michel Eyquem de Montaigne, Lord of Montaigne. *Essays.* Book 1. Bordeaux: Simon Millanges, 1580.

Mignolo, Walter. "Delinking." *Cultural Studies* 21, nos. 2–3 (2007): 452–54.

———. "Epistemic Disobedience and the Decolonial Option: A Manifesto." *Transmodernity: Journal of Peripheral Cultural Production of the Luso-Hispanic World* 1, no. 2 (2011): 44–66.

Miller, George A. "The Magical Number Seven Plus or Minus Two: Some Limits on Our Capacity for Processing Information." *Psychological Review* 63 (1956): 81–97.

Mokyr, Joel. *The Gifts of Athena: Historical Origins of the Knowledge Economy.* Princeton, NJ: Princeton University Press, 2002.

Moll, Jaime. "Problemas bibliográficos del libro del Siglo de Oro." *Boletín de la Real Academia Española* 59 (1979): 49–107.

Monardes, Nicolás. *Historia medicinal de las cosas que se traen de nuestras Indias Occidentales.* Seville: Fernando Diaz, 1580.

———. *Joyfull Newes out of the Newe Founde Worlde.* Translated by John Frampton. London: William Norton, 1580.

Monnier, Philippe. *Le Quattrocento, essai sur l'histoire littéraire du XVè siècle italien.* Paris: Perrin et Cie., 1908.

Montaigne, Michel de. *Travel Journal.* Edited and translated by Donald M. Frame. San Francisco: North Point, 1983.

Montañes Fonteñla, Luis. "Los relojes del emperador." *Cuadernos de relojería* 18 (September 1958): 3–22.

Moran, Bruce. *Distilling Knowledge: Alchemy, Chemistry, and the Scientific Revolution.* Cambridge, MA: Harvard University Press, 2006.

Morel, Philippe. *Les grottes maniéristes en Italie au XVIe siècle: théâtre et alchimie de la nature.* Paris: Macula, 1998.

Morton, Charles, Theodore Hornberger, and Samuel Eliot Morison. *Compendium physicae ex authoribus extractum . . .* Publications of the Colonial Society of Massachusetts, vol. 33. Boston: The Society, 1940.

Mousset, Albert. *Les Francine, créateurs des eaux de Versailles, intendants des eaux et fontaines de France de 1623–1784.* Paris: E. Champion, 1930.

Moxey, Keith. *Visual Time: The Image in History.* Durham, NC: Duke University Press, 2013.

Muir, Edward. *Ritual in Early Modern Europe.* Cambridge: Cambridge University Press, 1997.

Mukerji, Chandra. *Territorial Ambitions and the Gardens of Versailles.* Cambridge: Cambridge University Press, 1997.

Muñoz Iglesias, Salvador. *Lo religioso en El Quijote.* Toledo: Estudio Teológico de San Idelfonso, 1989.

Münster, Sebastian. *Cosmographiae universalis.* Basel: Heinrich Petri, 1550.

Museum of Fine Arts, Boston. *Blue: Cobalt to Cerulean in Art and Culture from the Collection of the Museum of Fine Arts, Boston*. San Francisco: Chronicle Books, 2015.

Muzio, Girolamo. *Lettere, a cura di A.M. Negri*, vol. 2. Alessandria: Edizioni dell'Orso, 2000.

Nadeau, Carolyn. *Women of the Prologue: Imitation, Myth and Magic in Don Quixote I*. Lewisburg, PA: Bucknell University Press, 2002.

Nagel, Alexander. *The Controversy of Renaissance Art*. Chicago: University of Chicago Press, 2011.

——— and Christopher S. Wood. *Anachronic Renaissance*. New York: Zone Books, 2010.

The Natural Sciences and the Arts: Aspects of Interaction from the Renaissance to the 20th Century: An International Symposium. (Uppsala) Stockholm: Almqvist and Wiksell International, 1985.

Navarrete, Ignacio. *Orphans of Petrarch: Poetry and Theory in the Spanish Renaissance*. Berkeley: University of California Press, 1994.

Nebrija, Antonio de. *Gramática castellana*. Edited by Pascual Galindo Romero and Luis Ortiz Muñoz. Madrid: Edición de la Junta Centenario, 1946.

Neri, Achille, ed. "Una lettera inedita di G. Muzio." *Giornale storico della letteratura italiana* 4 (1884): 229–40.

Neri, Antonio. *The Art of Glass*. Translated by Christopher Merrett. London: Octavian Pulleyn, 1662; orig. 1612 in Italian.

Newton, Arthur. *Travel and Travellers of the Middle Ages*. London: Routledge, 2013.

Newton, Isaac. *Philosophiae naturalis principia mathematica*. London: Jussu Societatis Regiæ ac Typis Josephi Streater, 1687.

Nieremberg, Juan E. *Curiosa, y oculta filosofia*. Alcalá de Henares: M. Fernandez, 1649.

Ogilvie, Brian. *The Science of Describing: Natural History in Renaissance Europe*. Chicago: University of Chicago Press, 2006.

O'Hara, Matthew D. *The History of the Future in Colonial Mexico*. New Haven, CT: Yale University Press, 2018.

Oldfield, Peter. *World Memory Theater*. Website, 2009. www.worldmemorytheatre.org.

Oloff, Kerstin. "*Terra Nostra* and the Rewriting of the Modern Subject: Archetypes, Myth, and Selfhood." *Latin American Research Review* 46, no. 3 (2011): 3–20.

O'Malley, C. D., and J. B. de C. M. Saunders. *Leonardo da Vinci on the Human Body: The Anatomical, Physiological and Embryological Drawings of Leonardo da Vinci*. 1952; New York: Gramercy, 2006.

d'Orléans, Anne-Louise, duchesse de Montpensier. *Mémoires de Mlle. de Montpensier*. Edited by Bernard Quilliet. Paris: Mercure de France, 2005.

Orwell, George. *Nineteen Eighty-Four*. New York: Plume/Harcourt Brace, 2003.

———. *All Art Is Propaganda*. Edited by George Packer. New York: First Mariner Books, 2009.

Overhill, Heidi Ellis. "THE MUSEUM OF ME (MoMe): An Exhibition of Conceptual Art." MFA thesis, University of Waterloo, Ontario, 2009.

Ovid. *Metamorphoses*. Translated by Frank Justus Miller. Cambridge, MA: Harvard University Press, 1976.

———. *Tristia: ex Ponto*. Translated by A. L. Wheeler. Cambridge, MA: Harvard University Press, 1996.

Pacheco, Francisco. *El arte de la pintura*. Edited by Bonaventura Bassegoda i Hugas. Madrid: Cátedra, 1990.

Pagden, Anthony. *The Fall of Natural Man: The Amerindian and the Origins of Comparative Ethnology*, 2nd ed. Cambridge: Cambridge University Press, 1986.

Page, William, ed. *The Victoria History of the County of Kent*. Rochester, NY: Boydell and Brewer, 1974.

Palomino, Antonio. *El museo pictório y escala óptica*. 1723; Madrid: Aguilar, 1988.

Panofsky, Erwin. *Meaning in the Visual Arts: Papers in and on Art History*. Garden City, NY: Doubleday Anchor Books, 1955.

——— and Fritz Saxl. "A Late-Antique Religious Symbol in Works by Holbein and Titian." *Burlington Magazine for Connoisseurs* 49 (1926): 177–81.

Park, Katharine. *Doctors and Medicine in Early Renaissance Florence*. Princeton, NJ: Princeton University Press, 1985.

———. *Secrets of Women: Gender, Generation, and the Origins of Human Dissection*. New York: Zone Books, 2006.

Parker, Geoffrey. *Imprudent King: A New Life of Philip II*. New Haven, CT: Yale University Press, 2014.

Pastoureau, Michel. *Blue: The History of a Color*. Translated by Markus I. Cruse. Princeton, NJ: Princeton University Press, 2001.

Patino, Loira J. "Camillo Delminio, Giulio." In *Encyclopedia of Renaissance Philosophy*, edited by Marco Sgarbi. Berlin: Springer, 2017.

Patton, Pamela. "Arts." *Journal of Medieval Iberian Studies*, special issue, *Shards of Memory: Reflections on the Legacy of María Rosa Menocal* 5, no. 2 (2013): 111–17.

Pedretti, Carlo. "Leonardo at Lyon." *Raccolta vinciana* 19 (1962): 267–72.

———. *Leonardo architetto*. Milan: Electa, 1973.

———. *Leonardo: A Study in Chronology and Style*. New York: Johnson Reprint, 1982.

——— and Carlo Vecce. *Libro di pittura: Codice urbinate lat. 1270 nella Biblioteca Apostolica Vaticana*. Florence: Giunti, 1995.

Pen American Center. *Chilling Effects: NSA Surveillance Drives U.S. Writers to Self-Censor*. November 12, 2013. https://pen.org/sites/default/files/Chilling%20Effects_PEN%20American.pdf.

Penzer, N. M. "A Fourteenth-Century Table Fountain." *Antique Collector* 28 (June 1957): 112–17.

Pérez-Arantegui, J., et al. "Materials and Technological Evolution of Ancient Cobalt-Blue-Decorated Ceramics: Pigments and Work Patterns in Tin-Glazed Objects from Aragon (Spain) from the 15th to the 18th Century AD." *Journal of the European Ceramic Society* 29, no. 12 (September 2009): 2499–509.

Pfister, Louis. *Notices biographiques et bibliographiques sur les Jésuites de l'ancienne mission de Chine* (1552–1773). Shanghai: Imprimerie de la Mission Catholique, 1932–1934.

Pico della Mirandola, Giovanni. *De hominis dignitate*. Edited by E. Garin. 1496; Florence: Vallecchi, 1942.

Piemontese, Alessio. *I secreti*. Venice: np, 1555.

Pile, Steve. "Introduction: Opposition, Political Identities and Spaces of Resistance." In *Geographies of Resistance*, edited by Steve Pile and Michael Keith. London: Routledge, 1997.

Pimentel, Juan. "Baroque Natures: Juan E. Nieremberg, American Wonders, and Preterimperial Natural History." In *Science in the Spanish and Portuguese Empires, 1500–1800*, edited by Daniela Bleichmar et al. Stanford, CA: Stanford University Press, 2009.

Piumati, Giovanni, Fedor V. Sabashnikov, and Leonardo. *I Manoscritti di Leonardo da Vinci della Reale Biblioteca di Windsor: dell'anatomia, fogli B: pubblicati da Teodoro Sabach-*

nikoff. Trascritti ed annotati da Giovanni Piumati con traduzione in lingua francese. Torino: Roux e Viarengo, 1901.

Plutarch. *Lives.* London: W. Heinemann, 1914.

Pormann, Peter E. *Islamic Medical and Scientific Tradition: Critical Concepts in Islamic Studies,* vol. II. London: Routledge, 2010.

Prager, Frank D., and Gustina Scaglia. *Brunelleschi: Studies of His Technology and Inventions.* Cambridge, MA: MIT Press, 1970.

Prendergast, Ryan. *Reading, Writing and Errant Subjects in Inquisitorial Spain.* Burlington, VT: Ashgate, 2011.

Price, Michael. "Separation and Preparation of Azurite for Use in Oil Painting." *Leonardo* 33, no. 4 (2000) 281–88.

Prieto, Andrés I. *Missionary Scientists: Jesuit Science in Spanish South America, 1570–1810.* Nashville: Vanderbilt University Press, 2011.

Proctor, Robert W., and Kim-Phuong L. Vu. "Human Information Processing: An Overview for Human-Computer Interaction." In *The Human-Computer Interaction Handbook: Fundamentals, Evolving Technologies, and Emerging Applications,* edited by Andrew Sears and Julie A. Jacko, 43–62. Boca Raton, FL: CRC Press, 2007.

Quevedo, Francisco de. *Las tres musas últimas castellanas, segunda cumbre del parnaso español.* Edited by Felipe B. Pedraza Jiménez and Melquíades Prieto Santiago. Madrid: Universidad de Castilla-La Mancha, 1999.

Quijano, Aníbal. "Coloniality of Power, Eurocentrism, and Latin America." *Nepantla: Views from the South* 1, no. 3 (2000): 533–80.

Ramelli, Agostino. *The Various and Ingenious Machines of Agostino Ramelli.* Edited by Eugene S. Ferguson. Translated by Martha Teach Gnudi. 1588; Baltimore: Johns Hopkins University Press, 1976.

Ramírez, Catherine S. "*Deus ex Machina:* Tradition, Technology, and the Chicanafuturist Art of Marion C. Martinez." *Aztlán: A Journal of Chicano Studies* 29, no. 2 (2004): 55–92.

———, ed. "The Time Machine, from Afrofuturism to Chicanafuturism and Beyond." *Aztlán: A Journal of Chicano Studies* 40, no. 2 (Fall 2015): 127–257.

Ramus, Peter. *Scholarum mathematicarum libri unus et triginta.* 1569; Frankfurt, 1627.

Reilly, Lisa A. "Res et Significatio: The Material Sense of Things in the Middle Ages." *Gesta* 51, no. 1 (2012): 1–17, special issue, edited by Lisa Reilly with Libby Parker, Aden Kumler, and Christopher R. Lakey.

Reilly, Patricia. "The Taming of the Blue: Writing Out Color in Italian Renaissance Theory." In *The Expanding Discourse: Feminism and Art History,* edited by Norma Broude and Mary D. Garrard, 86–99. New York: HarperCollins, 1992.

Ricci, Matteo. *China in the Sixteenth Century: The Journals of Matthew Ricci, 1583–1610.* Translated by Louis J. Gallagher. New York: Random House, 1953.

Richard, Jules-Marie. *Une petite-nièce de saint Louis. Mahaut, comtesse d'Artois et de Bourgogne (1302–1329); étude sur la vie privée, les arts et l'industrie, en Artois et à Paris au commencement du XIVe siècle.* Paris: Champion, 1887.

Richardson, Brian. *Print Culture in Renaissance Italy: The Editor and the Vernacular Text, 1470–1600.* Cambridge: Cambridge University Press, 1994.

Riggs, Stephanie, Justin Berry, Johannes DeYoung, Lance Chantiles-Wertz, and Jack Wesson. *Evaluating Embodied Navigation in Virtual Reality Environments.* Blended Reality:

Applied Research Project at Yale, 4 April 2018. blendedreality.yale.edu/news/evaluating-embodied-navigation-virtual-reality-environments.

Robeck, Nesta de. *The Christmas Crib*. Milwaukee: Bruce, 1956.

Roberts, J. M., and Odd Arne Westad. *The Penguin History of the World*, 6th ed. London: Penguin, 2013.

Robinson, Cynthia. *In Praise of Song: The Making of Courtly Culture in al-Andalus and Provence, 1065–1135 A.D.* College Park: Pennsylvania State University Press, 2002.

———. *Imagining the Passion in a Multi-Confessional Castile: The Virgin, Christ, Devotions, and Images in the Fourteenth and Fifteenth Centuries*. College Park: Pennsylvania State University Press, 2013.

——— and Leyla Rouhi, eds. *Under the Influence: Questioning the Comparative in Medieval Iberia*. Leiden: Brill, 2005.

Robinson, Kate. *A Search for the Source of the Whirlpool of Artifice: The Cosmology of Giulio Camillo*. Edinburgh: Dunedin Academic Press, 2006.

Rodden, John. *George Orwell: The Politics of Literary Reputation*. New Brunswick, NJ: Transaction, 2002.

Roldán, Clodoaldo, Jaume Coll, and José Ferrero. "Case Study: EDXRF Analysis of Blue Pigments Used in Valencia Ceramics from the 14th Century to Modern Times." *Journal of Cultural Heritage* 7 (2006): 134–38.

Romero Pastor, Julia. "Benefit of Applying Spectrometric Techniques and Principal Component Analysis." PhD diss., Universidad de Granada, 2011.

———, et al. "Elemental, Molecular and Mineralogical Characterization of Polychromes in the Oratory Room of Granada's Madrasah (Spain)." *Macla* 13 (September 2013): 185–86.

Rosenthal, Earl. "*Plus Ultra, Non Plus Ultra* and the Device of Emperor Charles V." *Journal of the Warburg and Courtauld Institutes* 34 (1971): 204–28.

———. *The Palace of Charles V in Granada*. Princeton, NJ: Princeton University Press, 1985.

Rosheim, Mark Elling. *Leonardo's Lost Robots*. New York: Springer, 2006.

Rossbach, Nikola, ed. *Titelliste*. Website, DFG-Projekt "Welt und Wissen auf der Bühne: Die Theatrum-Literatur der Frühen Neuzeit." Universität Kassel / HAB Wolfenbüttel 2009–2012. www.theatra.de/index.php?searchRes = 0&cPage = 2&sPage = 2.

Rossi, Paolo. *Clavis universalis: arte mnemoniche e logica combinatoria da Lullo a Leibniz*. Naples: Ricciardi, 1960.

Rossi Monti, Paolo. *I filosofi e le machine, 1400–1700*. Milan: Feltrinelli, 1962.

———. *Philosophy, Technology and the Arts in the Early Modern Era*. Translated by Salvator Attanasio. New York: Harper & Row, 1970.

Rössler, Hole. "Weltbeschauung: Epistemologische Implikationen der Theatrum-Metapher in der Frühen Neuzeit." In *Theatralität von Wissen in der Frühen Neuzeit*, edited by Costanze Baum and Nikola Rossbach. Wolfenbüttel: Herzog August Bibliothek, 2013. diglib.hab.de/ebooks/ed000156/id/ebooks_cd000156_article02.

Rothschild, James de, ed. *Le mistère du viel testament*. Paris: Firmin-Didot, 1878–91.

Routledge, Donald Hill. *Islamic Science and Engineering*. Edinburgh: Edinburgh University Press, 1993.

Rowland, Ingrid D., ed. *Introduction to Vitruvius: Ten Books on Architecture, The Corsini Incunabulum with the Annotations and Drawings of Giovanni Battista da Sangallo*. Rome: Edizioni dell'Elefante, 2003.

Russell, Peter Edward. *Temas de la Celestina y otros estudios: del Cid al Quijote*. Barcelona: Ariel, 1978.

Russell, Stephen C. "Reading Ovid's Medea: Complexity, Unity, and Humor." PhD diss., McMaster's University, 2011.

Sabbattini, Nicola. *Manual for Constructing Theatrical Scenes and Machines [Pratica di fabricar scene e macchine ne' teatri, 1638]*. Edited by Barnard Hewitt. Coral Gables: University of Miami Press, 1958.

Saliba, George. *Islamic Science and the Making of the European Renaissance*. Cambridge, MA: MIT Press, 2007.

———. "The World of Islam and Renaissance Science and Technology." In *The Arts of Fire: Islamic Influences on Glass and Ceramics of the Italian Renaissance*, edited by Catherine Hess, Linda Komaroff, and George Saliba. Los Angeles: J. Paul Getty Museum, 2004.

Salies, Alexandre de. "Lettre sur une tête automatique autrefois attachée à l'orgue des Augustins de Montoire." *Bulletin de la Société archéologique, scientifique et littéraire du Vendômois* 6, no. 2 (1867): 97–118.

Sánchez, José María, and María Dolores Quiñones. "Materiales pictóricos enviados a América en el siglo XVI." *Anales del Instituo de Investigaciones Estéticas* 95 (2009): 45–67.

Schaber, Wilfried. *Hellbrunn: Schloss, Park und Wasserspiele*. Salzburg: Schlossverwaltung Hellbrunn, 2004.

Schmidt, Benjamin. *Inventing Exoticism: Geography, Globalism, and Europe's Early Modern World*. Philadelphia: University of Pennsylvania Press, 2015.

Schneider, Mark A. "Culture-as-Text in the Work of Clifford Geertz." *Theory and Society* 16, no. 6 (1987): 809–39.

Schott, Peter. *Petri schotti argentinensis patricii: juris utriusque doctoris consultissimi: oratoris et poetae elegantissimi: graecaeque linguae probe aeruditi: lucubraciunculae ornatissimae*. Edited by Jacob Wimpheling. Strassburg: Martin Schott, 1498.

Seldes, Alicia M., José Emilio Burucúa, Marta S. Maier, Gonzalo Abad, Andrea Jáuregui, and Gabriela Siracusano. "Blue Pigments in South American Painting (1610–1780)." *Journal of the American Institute for Conservation* 38, no. 2 (Summer 1999): 100–23.

Shakespeare, William. *Shakespeare's Twelfth Night*, CD-ROM. San Francisco: Exploratorium, 1991.

———. *The Tragedy of Othello, the Moor of Venice*. Edited by Russ McDonald. New York: Penguin Books, 2001.

Sherwood, Merriam. "Magic and Mechanics in Medieval Fiction." *Studies in Philology* 44 (October 1947): 567–92.

Silver, Sean. "The Prehistory of Serendipity, from Bacon to Walpole." *Isis* 106 (2015): 235–56.

Simunkova, E., J. Brothankova-Bucifalova, and J. Zelinger. "The Influence of Cobalt Blue Pigments on the Drying of Linseed Oil." *Studies in Conservation* 30, no. 4 (November 1985): 161–66.

Skovjerg, Camilla, and Jacob Wamberg, eds. *Art, Technology and Nature: Renaissance to Postmodernity*. Farnham: Ashgate, 2015.

Slater, John. *Todos son hojas: literatura e historia natural en el barroco español*. Madrid: Consejo Superior de Investigatiociones Científicas, 2010.

Smith, Cyril Stanley, and John G. Hawthorne, eds. *Mappae Clavicula: A Little Key to the World of Medieval Techniques*. Philadelphia: American Philosophical Society, 1974.

Smith, Pamela H. *The Body of the Artisan: Art and Experience in the Scientific Revolution*. Chicago: University of Chicago Press, 2004.

————. "Science on the Move: Recent Trends in the History of Early Modern Science." *Renaissance Quarterly* 62 (2009): 345–75.

————. "Historians in the Laboratory: Reconstruction of Renaissance Art and Technology in the Making and Knowing Project." *Art History*, special issue, *Art and Technology* 39, no. 2 (2016): 210–33.

Smith, Pamela H., Amy R. W. Meyers, and Harold J. Cook, eds. *Ways of Making and Knowing: The Material Culture of Empirical Knowledge.* Ann Arbor: University of Michigan Press, 2014.

Smith, Pamela H., Christy Anderson, and Anne Dunlop, eds. *The Matter of Art: Materials, Practices, Cultural Logics, c. 1250–1750.* Manchester: Manchester University Press, 2015.

Solla Price, Derek J. de. "Automata and the Origins of Mechanism and Mechanistic Philosophy." *Technology and Culture* 5, no. 1 (1964): 9–23.

Sorbiers de la Tourrasse, Lionel du. *Le Château-neuf de Saint-Germain-en-Laye, ses terrasses et ses grottes.* Paris: Gazette des Beaux-Arts, 1924.

Spence, Jonathan D. *The Memory Palace of Matteo Ricci.* New York: Penguin, 1985.

Spivak, Gayatri Chakravorty. "Can the Subaltern Speak?" In *Colonial Discourse and Post-Colonial Theory: A Reader,* edited by Patrick Williams and Laura Chrisman, 66–111. New York: Columbia University Press, 2010.

Spring, Marika, et al. "Colour Changes in 'The Conversion of the Magdalen' Attributed to Pedro de Campaña." *National Gallery Technical Bulletin* 22 (2001): 54–63.

Sterling-Maxwell, William. *The Cloister Life of Charles V.* London: John C. Nimmo, 1891.

Stolzenberg, David, ed. *The Great Art of Knowing: The Baroque Encyclopedia of Athanasius Kircher.* Stanford, CA: Stanford University Library, 2001.

Stow, John, and Edmund Howes. *Annales, or, a generall chronicle of England. Begun by John Stow: continued and augmented with matters forraigne and domestique, ancient and moderne, unto the end of this present yeere, 1631.* London: [Printed by John Beale, Bernard Alsop, Thomas Fawcett, and Augustine Mathewes] Richard Meighen, 1632.

Stowell, Steven F. H. *The Spiritual Language of Art: Medieval Christian Themes in Writings on Art of the Italian Renaissance.* Leiden: Brill, 2015.

Strada, Famiano. *De bello Belgico: The history of the Low-Countrey warres.* Translated by Sr. Rob. Stapylton. London: H. Moseley, 1650.

Strauss, Leo. *Persecution and the Art of Writing.* Chicago: University of Chicago Press, 1988.

Summers, David. *Michelangelo and the Language of Art.* Princeton, NJ: Princeton University Press, 1981.

————. *The Judgment of Sense: Renaissance Naturalism and the Rise of Aesthetics.* Cambridge: Cambridge University Press, 1987.

Szeemann, Harald. *Museum der Obsessionen: Von/über/zu/mit Harald Szeemann.* Berlin: Merve Verlag, 1981.

Tacey, D. J. "Australia's Otherworld: Aboriginality, Landscape and the Imagination." *Meridian* 8, no. 1 (1989): 48–65.

Tanner, Marie. *The Last Descendant of Aeneas: The Hapsburgs and the Mythic Image of the Emperor.* New Haven, CT: Yale University Press, 1993.

Taton, René, Curtis Wilson, and Michael Hoskin, eds. *Planetary Astronomy from the Renaissance to the Rise of Astrophysics, Part A, Tycho Brahe to Newton,* vol. 2. Cambridge: Cambridge University Press, 2003.

Tonelli, Giorgio. "Genius from the Renaissance to 1770." In *Dictionary of the History of Ideas*, vol. II, 294–97. Edited by Philip P. Weiner, 5 vols. New York: Charles Scribner's Sons, 1973.

Topper, David. "Interrelationships of the Arts, Sciences, and Technology: A Bibliographic Up-Date." *Leonardo* 18, no. 3 (1985): 197–200.

———. "On a Ghost of Historiography Past." *Leonardo* 21, no. 1 (1988): 76–78.

——— and John H. Holloway. "Interrelationships between the Visual Arts, Science, and Technology: A Bibliography." *Leonardo* 13, no. 1 (1980): 29–33.

Tramelli, Barbara. "The Art of Writing/The Writing of Art: Giovanni Paolo Lomazzo's Context, Connections, and Influences in His *Trattato dell'Arte della Pittura*." PhD diss., Free University of Berlin, 2015,

Trapp, Joseph Burney. "Frances Amelia Yates 1899–1981." In *Biographical Memoirs of Fellows*, vol. 2, edited by British Academy, 527–54. Oxford: Oxford University Press, 2004.

Trigault, Nicholas, ed. *China in the Sixteenth Century: The Journals of Matthew Ricci*. Translated by Louis J. Gallagher. 1615; New York: Random House, 1953.

Tripps, Johannes. *Der Handelnde Bildwerk in der Gotik*. Berlin: Gebr. Mann, 1998.

Tulving, Endel. "Episodic and Semantic Memory." In *Organization of Memory*, edited by Endel Tulving and Wayne Donaldson, 381–403. New York: Academic Press, 1972.

Turchin, Peter V. *Historical Dynamics: Why States Rise and Fall*. Princeton, NJ: Princeton University Press, 2003.

———. *War and Peace and War: The Rise and Fall of Empire*. New York: Plume Books and Penguin Group, 2006.

Turnbull, David. *Maps Are Territories: Science Is an Atlas*. Chicago: University of Chicago Press, 1987.

Twycross, Meg, and Sarah Carpenter. *Masks and Masking in Medieval and Early Tudor England*. Studies in Performance and Early Modern Drama. Abingdon: Routledge, 2016.

Urbino, Alessandro Giorgi da. *Spirituali di herone alessandrino*. Urbino: Bartholomeo e Simone, 1592, 1595.

Uricchio, William. "A Palimpsest of Place and Past." *Performance Research* 17, no. 3 (2012): 45–49.

Valla, Giorgio. *Georgii Vallae Placentini viri clari de expetendis, et fugiendis rebus opus*. Venice: Aldi Romani, 1501.

Varey, Simon, ed. *The Mexican Treasury: The Writings of Dr. Francisco Hernández*. Stanford, CA: Stanford University Press, 2000.

——— and Rafael Chabrán. "Medical Natural History in the Americas: The Strange Case of Francisco Hernández." *Huntington Library Quarterly* 57 (1994): 124–51.

Vasari, Giorgio. *Lives of the Most Eminent Painters, Sculptors & Architects*. Translated by Gaston de Vere. London: Philip Lee Warner, 1912–14.

———. *Vasari on Technique*. Edited and introduced by G. Baldwin Brown. Translated by Louisa S. Machelose. 1907; New York: Dover, 1960.

Vickers, Brian. *Occult and Scientific Mentalities in the Renaissance*. Cambridge, MA: Cambridge University Press, 1984.

Vidal, M. "Notre-Dame du Montement à Rabastens." In *Bulletin historique et philologique du Comité des travaux historiques et scientifiques*. Paris, 1908.

Viola, Bill. "Will There Be Condominiums in Data Space?" *Video* 80, no. 5 (1982): 36–41. Reprinted in Bill Viola, *Reasons for Knocking at an Empty House: Writings 1973–1994*, 98–111. London: Thames & Hudson, 1995.

Virgil. *Eclogues, Georgics, Aeneid.* Translated by H. R. Fairclough. Cambridge, MA: Harvard University Press, 1916.

Vitet, Ludovic. *Histoire de Dieppe.* Paris: Ch. Gosselin, 1844.

Wallace, Lindsay. *Isidori hispalensis episcopi etymologiarum sive originum libri XIV.* Oxford: Clarendon Press, 1911.

Walley, Virginia M., Claudia A. Keon, Mandana Khalili, David Moher, Martine Campagna, and Wilbert J. Keon. "Ionescu-Shiley Valve Failure I: Experience with 125 Standard-Profile Explants." *Annals of Thoracic Surgery* 54, no. 1 (1992): 111–16.

Waterworth, James, ed. and trans. *The Canons and Decrees of the Sacred and Ecumenical Council of Trent.* London: Dolman, 1848.

Wells, Francis. *The Heart of Leonardo.* London: Springer, 2016.

Wernham, R. B. *The Return of the Armadas: The Last Years of the Elizabethan Wars against Spain 1595–1603.* Oxford: Clarendon Press, 1994.

Wesemann, Arnd. "A Drive-in Ballet in Ljubljana." *ballett international/tanz aktuell* 68 (2000): 8–9.

Wharton, Edith. *Italian Villas and Their Gardens.* 1904; New York: Da Capo, 1977.

William, Gareth. "Ovid's Exile Poetry: *Tristia, Epistolae ex Ponto* and *Ibis.*" In *The Cambridge Companion to Ovid,* edited by Philip Hardie. Cambridge: Cambridge University Press, 2002.

Wilson, Bronwen. *The World in Venice: Print, the City, and Early Modern Identity.* Toronto: University of Toronto Press, 2005.

Wins, Alphonse. *L'horloge à travers les âges.* Mons: Léon Duquesne, 1924.

Wittkower, Rudolf. "Genius, Individualism in Art and Artists." In *Dictionary of the History of Ideas,* vol. II, 297–312. Edited by Philip P. Weiner, 5 vols. New York: Charles Scribner's Sons, 1973.

Woodcraft, Bennett, ed. *The Pneumatics of Hero of Alexandria.* London: Taylor Walton and Maberly, 1851.

Woolley, Benjamin. *The Queen's Conjurer: The Science and Magic of Dr. John Dee, Advisor to Queen Elizabeth I.* New York: Henry Holt, 2001.

Wriothesley, Charles. *A Chronicle of England During the Reign of the Tudors, 1485–1559.* Edited by William Hamilton. London: Printed for the Camden Society, 1875.

Wunderkammer des Abendlandes: Museum und Sammlung im Spiegel der Zeit. Bonn: Bundeskunsthalle, 1994.

Yates, Frances A. *Giordano Bruno and the Hermetic Tradition.* London: Routledge, 1964.

———. *The Art of Memory.* London: Routledge, 1966.

———. *The Rosicrucian Enlightenment.* London: Routledge, 1972.

———. *Astraea: The Imperial Theme in the Sixteenth Century.* London: Routledge and Keagan Paul, 1975.

———. "Autobiographical Fragments." *Collected Essays III.* London: Routledge, 1984.

Zamberlan, Renato and Franco. "The St. Mark's Clock, Venice." *Horological Journal* 143, no. 1 (January 2001): 11–14.

Zilsel, Edgar. *The Social Origins of Modern Science.* Dordrecht: Kluwer Academic, 2003.

Zwijnenberg, Robert. "*St. John the Baptist* and the Essence of Painting." In *Leonardo da Vinci and the Ethics of Style,* edited by Claire Farago, 96–118. Manchester: Manchester University Press, 2008.

CONTRIBUTORS

MARI-TERE ÁLVAREZ, PHD is Project Specialist at the J. Paul Getty Museum and Associate Director of USC's International Museum Institute. She has recently co-edited *Remix: Changing Conversations in Museums of the Americas* (University of California Press) as well as *Beyond the Turnstile: Making the Case for Museums and Sustainable Values* and *Arts, Crafts, and Materials in the Age of Global Encounters, 1492–1800*, a special edition of the *Journal of Interdisciplinary History*.

FREDERICK A. DE ARMAS is a literary scholar, critic, and novelist who is currently Andrew W. Mellon Distinguished Service Professor in Humanities at the University of Chicago. His scholarly work focuses on the literature of Early Modern Spain. His interests include the politics of astrology; magic and the Hermetic tradition; ekphrasis; the relations between the verbal and the visual, particularly between Spanish literature and Italian art; and the interconnections between myth and empire during the rule of the Habsburgs.

WILLIAM EAMON is distinguished Achievement Professor, Regents Professor of History at New Mexico State University. He is a specialist in the history of science and has published on various aspects of Medieval and Early Modern science, medicine, and technology. His most influential work is on the history of the "books of secrets" tradition in Medieval and Early Modern culture. His work has also looked at the history of magic and the occult sciences in Early Modern Europe.

CLAIRE FARAGO is Professor Emerita of Art History at the University of Colorado Boulder. She has published widely on Early Modern art theory, historiography, and transcultural studies. Her books and edited volumes on Leonardo include

Leonardo da Vinci's Paragone (1992); *Leonardo da Vinci: Selected Scholarship in English*, 5 vols. (1999); *Leonardo da Vinci and the Ethics of Style* (2008); *Re-Reading Leonardo: The Treatise on Painting across Europe, 1550–1900* (2009); and *The Fabrication of Leonardo da Vinci's* Trattato della pittura, *with a Scholarly Edition of the Italian* Editio princeps *(1651) and an Annotated English Translation* (2018).

MORTEZA GHARIB, PHD is the Hans W. Liepmann Professor of Aeronautics and Bio-Inspired Engineering at Caltech. Professor Gharib's research interests cover a range of topics in conventional fluid dynamics and aeronautics. Professor Gharib received the G. I. Taylor Medal from the Society of Engineering Science in 2016 and the American Physical Society's Fluid Dynamics award in 2015. He is a member of the American Academy of Arts and Sciences and the National Academy of Engineering.

PETER MATUSSEK is Professor and Chair of Media Aesthetics at the University of Siegen, Germany. He has also taught literature and media cultural science at the Humboldt University in Berlin and the Heinrich-Heine University in Düsseldorf, and has held visiting professorships at several international universities, mainly in East Asia. His research is centered around paradigm shifts of knowledge representation, historical anthropology, mediatized recollection, and e-Humanities.

JESSICA RISKIN is Professor of History at Stanford where she teaches Modern European history and the history of science. She was educated at Harvard and UC Berkeley, and has also taught at Iowa State, MIT, and Sciences Po, Paris. She is the author most recently of *The Restless Clock: A History of the Centuries-Long Argument over What Makes Living Things Tick*. She is currently working on various projects in the history of evolutionary theory.

CHARLENE VILLASEÑOR BLACK is Professor of Art History and Chicana/o Studies at the University of California, Los Angeles, the author of *Creating the Cult of St. Joseph: Art and Gender in the Spanish Empire*, editor of *Tradition and Transformation: Chicana/o Art from the 1970s to the 1990s*, editor of *Aztlán: A Journal of Chicano Studies*, and founding editor of *Latin American and Latinx Visual Culture*. In 2016–17 she was awarded UCLA's Gold Shield Faculty Prize for Academic Excellence.

FRANCIS WELLS is a cardiothoracic surgeon at Royal Papworth Hospital, Cambridge. Dr. Wells is a recognized world leader in the field of mitral and tricuspid valve surgery. He has the most extensive experience in mitral valve reconstruction in the UK and among the most extensive in the world, with over 3,000 cases completed. He is also an accomplished artist with a specific interest in Leonardo da Vinci's drawings of the heart.

INDEX

Founded in 1893,
UNIVERSITY OF CALIFORNIA PRESS
publishes bold, progressive books and journals
on topics in the arts, humanities, social sciences,
and natural sciences—with a focus on social
justice issues—that inspire thought and action
among readers worldwide.

The UC PRESS FOUNDATION
raises funds to uphold the press's vital role
as an independent, nonprofit publisher, and
receives philanthropic support from a wide
range of individuals and institutions—and from
committed readers like you. To learn more, visit
ucpress.edu/supportus.